THE THYSSEN-BORNEMISZA COLLECTION

Early Italian painting
1290–1470

THE THYSSEN-BORNEMISZA COLLECTION

Early Italian painting 1290–1470

Miklós Boskovits

in collaboration with Serena Padovani

TRANSLATED FROM THE ITALIAN BY

Françoise Pouncey Chiarini

GENERAL EDITOR IRENE MARTIN

Sotheby's Publications

© The Thyssen-Bornemisza Collection 1990
First published 1990 for Sotheby's Publications by
Philip Wilson Publishers Ltd
26 Litchfield Street, London WC2H 9NJ

Distributed in the USA and Canada by
Rizzoli International Publications, Inc
300 Park Avenue South
New York
NY 10010

ISBN 0 85667 381 1
LC 90-081680

 Distribuzione esclusiva in Italia: Electa, Milano
Elemond Editori Associati

Designed by Gillian Greenwood
Photography of the Thyssen Collection by Giuseppe Pennisi
Typeset in Photina by Southern Positives and Negatives (SPAN), Lingfield, Surrey
Printed and bound by Snoeck, Ducaju & Zoon, NV, Ghent, Belgium

Contents

Acknowledgements

In collecting the bibliographical material, reconstructing the critical analysis and examining the state of the paintings to be catalogued I have been greatly assisted by Serena Padovani, who also undertook the writing of some of the artists' biographies. Her contribution has also been invaluable in discussing with me various problems of attribution and reconstruction. Without her help this task would have been far more laborious and certainly less thorough. I should also like to thank all those colleagues and friends, curators and collectors, who have assisted this work through their kind co-operation and by supplying information, suggestions or photographs. In particular I wish to thank Luigi Artini, Etienne Breton, Keith Christiansen, Carlo De Carlo, Nereo Fioratti, Marco Grassi, Rodolfo Marcolin, Vittorio Mezzomonaco, Maria Laura Nocentini Parlavecchia, Lino Pasquali, Bruno Scardeoni, Karl Strehlke, Cornelia Syre, Vilmos Tátrai, Radoslav Tomić, Maria Rosaria Valazzi, Roberto Visconti and Federico Zeri. This catalogue would never have been possible without the efficient and kind collaboration of the director Irene Martin, the conservator Emil Bosshard and the assistant curators Maria de Peverelli, Floriana Vismara and Maria Antonia Reinhard of the Thyssen-Bornemisza Foundation. Paul Holberton and the editorial staff of Philip Wilson Publishers Ltd contributed with attentive and patient work to give the publication its present shape. To all my heartfelt thanks, as also to the staff of the Biblioteca Berenson, of the Fondazione Roberto Longhi and particularly of the Kunsthistorisches Institut of Florence, where much of the bibliographical research was carried out. Finally I should like to thank Françoise Chiarini for her careful translation of the Italian text and Angelo Tartuferi for his help in the final stages of the work and for compiling the index.

Miklós Boskovits

Foreword

Two aspects of the Early Italian paintings in the Thyssen-Bornemisza Collection are seldom noted: the quantitative and qualitative degree to which the present Baron Hans Heinrich Thyssen-Bornemisza has contributed to the formation of this part of the Collection, and the number of important paintings which have been purchased from American collections.

Baron Heinrich Thyssen-Bornemisza's (1875–1947) collection of Old Master paintings has been known since it was first exhibited at the Neue Pinakothek in Munich in 1930. Since then the acquisition of Old Master paintings has generally been attributed to him. In fact, his son, Baron Hans Heinrich Thyssen-Bornemisza, has added many Old Master works to the Collection. In this volume, which catalogues thirty-two paintings of early Italian masters from 1270 to 1470, thirteen were acquired by the father and nineteen by the son. The late Baron Thyssen-Bornemisza acquired the Fra Angelico, Vitale da Bologna and Paolo Uccello, while the present Baron Thyssen-Bornemisza has added such significant works as the Duccio panel, the *St Catherine before the pope at Avignon* by Giovanni di Paolo, the Luca di Tommè *Adoration of the Magi* and the Lorenzo Monaco *Madonna and Child enthroned with six angels*.

We have heard of Bernard Berenson's purchases of early Renaissance Italian paintings for collectors in the United States, but we seldom hear of these paintings being bought from American collections and brought back to Europe. As early as 1933 Baron Heinrich Thyssen-Bornemisza bought *The Madonna of Humility* by Giovanni di Paolo from a New York collector, and in 1935 the Fra Angelico *Madonna of Humility* from the Pierpont Morgan Collection. His son continued this tradition by acquiring in 1971 the most important early Italian painting in the Collection, *Christ and the Samaritan Woman* by Duccio di Buoninsegna, from the John D. Rockefeller Collection, where it had been since 1929. One of the most remarkable works of the fifteenth century which documents the assimilation of styles and techniques in Southern Italy, the Franco-Flemish *Crucifixion*, was purchased from the Henschel Collection, New York, in 1976. Three years later, *The Nativity* by Taddeo Gaddi, which was owned by the Boston Antheneum and on deposit in the Museum of Fine Arts, Boston, from 1876 to 1977, was added to the Thyssen-Bornemisza Collection.

Dr Miklós Boskovits here illuminates the history and authorship of each painting. He has reconstructed altarpieces and carefully selected comparative images to assist the reader in visualizing the original context and in clarifying arguments of attribution. Good translations are the product of a skill to convey the nuances of language, and a thorough knowledge of the subject. Françoise Chiarini has produced a masterful translation of Dr Boskovits's text.

With this volume, the ninth of a projected total of twenty catalogues of the Thyssen-Bornemisza Collection, the general editorship has changed hands. Simon de Pury, while curator of the Collection, started the project with Philip Wilson Publishers and the first volume appeared in 1986. These scholarly catalogues have been the envy of many museums, and it is now my challenge as general editor to continue at the same high level of quality.

Irene Martin
ADMINISTRATIVE DIRECTOR AND CURATOR

Introduction

Notes
1 See G.Biermann, 'Die Sammlung Schloss Rohoncz', *Cicerone* XXII (1930) pp.355–68; M.J.Friedländer, 'Die Sammlung Schloss Rohoncz', *Kunst und Künstler* XXVIII (1930) p.502; E.Hanfstaengl, 'Castle Rohoncz Collection shown in Munich', *Art News* XXVIII (1930) p.3f.; A.Mayer, 'The Exhibition of the Schloss Rohoncz Collection in the Munich Neue Pinakothek', *Apollo* XII (1930) pp.89–98; *idem*, 'Die Ausstellung der Sammlung Schloss Rohoncz in der Neuen Pinakothek', *Pantheon* VI (1930) pp.297–321; W.Suida, 'Die italienischen Bilder der Sammlung Schloss Rohoncz', *Belvedere* XVI (1930) pp.175–80; R. van Marle, 'I quadri italiani della raccolta del Castello Rohoncz', *Dedalo* XI (1930–1) pp.1365–92.
2 F.Dörnhöffer, introduction to the catalogue *Sammlung Schloss Rohoncz. Gemälde* (Munich, 1930) p.VIIf.
3 *Ibidem.*
4 See for example F.Kugler, *Beschreibung der Gemälde-Gallerie des Königl. Museums zu Berlin* (Berlin, 1838) p.VIf.: 'Daneben aber besitzt die Gemälde-Gallerie ... einen Vorzug, der sie von allen ähnlichen Sammlungen ... unterscheidet: den nämlich, dass sie sich nicht einseitig auf diese oder jene Epochen künstlerischer Thätigkeit beschränkt, sondern dass sie ganze Perioden christlicher Kunstübung, von den dunkleren Zeiten des Mittelalters an bis in das zuletzt verflossene Jahrhundert hinab ... umfasst'.

The exhibition held in 1930 at the Neue Pinakothek in Munich, which presented the collection of 'Schloss Rohoncz' to the general public for the first time, was a sensational event. The numerous enthusiastic reviews[1] all stressed its exceptional character, remarking that such an important collection had been assembled in a relatively short time and comparing it to some of the famous princely collections created in the eighteenth century.[2] In fact, the collection of Baron Heinrich Thyssen-Bornemisza (1875–1947), forming as it did a highly intelligent and systematic assemblage of paintings, sculptures and works of art, resembled rather some of the great public collections founded at the beginning of the nineteenth century. After a relatively modest beginning in the 1910s, when the Baron began acquiring works of art to furnish and decorate Rohoncz Castle in the north-west of Hungary,[3] he conceived the far more ambitious idea of a great picture gallery which, like those realized by the founders of the National Gallery of London and the Königliches Museum of Berlin,[4] would illustrate the entire course of the history of painting: it was to include not only important examples by the great masters but also the works of artists belonging to the various schools which either anticipated or developed their innovations.

With the help and advice provided by the expertise of friends such as Wilhelm von Bode and Max J.Friedländer, and the art-dealer and connoisseur Rudolf Heinemann, Baron Thyssen's collection continued to grow even after the Munich exhibition; by 1936, when it was opened to the public, newly housed in the Villa Favorita at Lugano-Castagnola, it already numbered more than five hundred paintings, many of which were by Italian masters. The collection's growth, which was temporarily interrupted during the War years, continued with renewed vigour thanks to the founder's son, Baron Hans Heinrich, who has since almost tripled the number of paintings. Not only has he extended the collection to include contemporary works but he has also acquired numerous late medieval and Renaissance paintings, concentrating in particular on the collection of Italian 'primitives', which emerges as one of the finest of its kind outside Italy. It is true – and it could hardly be otherwise – that it lacks works by some of the greatest names, Giotto, Simone Martini, Orcagna or Masaccio. However, it includes important works by several other major figures in the history of fourteenth- and fifteenth-century painting. Duccio is represented by a panel which belonged to his *Maestà* painted for the high altar of Siena Cathedral, and Vitale da Bologna by a dramatic *Crucifixion*, which is certainly one of the masterpieces not only of Trecento Bolognese painting but of North Italian painting of that century. There is a superb *Madonna* by Fra Angelico, possibly from Santa Maria Novella in Florence, two very remarkable panels by Giovanni di Paolo and an intensely expressive *Crucifixion* by Paolo Uccello. Another panel of the same subject, formerly attributed to the Neapolitan Colantonio and by some critics today to Antonello da Messina, which is here catalogued as probably by a Franco-Flemish artist working in the Kingdom of Naples, may be regarded as one of the most beautiful paintings executed in that area during the fifteenth century.

Alongside the more famous pieces there are others which, although less well known, would deserve a place in any history of Italian painting as significant pieces by their authors. This is

the case of the precious *Madonna* signed by Barnaba da Modena, or of the predella panel by Giovanni Boccati, originating from an altarpiece dated 1473, or again of the *Madonna* by Bernardo Daddi which formed the centre of a polyptych now divided among various collections. Equally high in quality are the *Nativity* by Taddeo Gaddi, an important work of his early period, the large *Madonna* which shares a place among Lorenzo Monaco's masterpieces and the exquisite and beautifully preserved small triptych by Lorenzo Veneziano. The list cannot fail to include the large and rare *Madonna* by the thirteenth-century Master of the Magdalen or the *Coronation* dated 1355 by an important but so far little known painter active in Emilia and Lombardy who, on the basis of the Thyssen painting, is here called the 'Master of 1355'.

This brings up the point that in this volume the reader will encounter a number of new attributions. Unknown to critical literature is the *Coronation of the Virgin* here ascribed to Giovanni da Bologna. The *Madonna* formerly catalogued under the conventional name of 'Ugolino-Lorenzetti' is now given to Bartolomeo Bulgarini, the already mentioned *Crucifixion* attributed to Colantonio is classified as 'Franco-Flemish master probably active in Naples, *c*1435–45'. New conventional names have been coined for the *Crucifixion* hitherto described as 'Florentine contemporary of Giotto' or 'Paduan Master', which is here attributed to the 'Master of the Pomposa Chapterhouse', and for two panels of the *Crucifixion* and *Last Judgement* which, previously called anonymous Venetian, are here given to the 'Master of the Dotto Chapel'. Changes have also been made regarding the no longer tenable attributions to Cavallini (a *Deposition* here given to the 'Master of Forlì'), Paolo Veneziano (the *Madonna of Humility* here called 'Venetian, *c*1360'), Semitecolo (the above-mentioned *Coronation* of 1355) and Vigoroso da Siena (a problematic triptych here classified as 'Venetian, early fourteenth century').

Several paintings included in previous catalogues but which no longer form part of the Collection are, of course, omitted: the half-length *Madonna and Child* attributed to Segna di Bonaventura (Rohoncz (1937) no.386), another *Madonna* enthroned with saints and angels also attributed to Segna (Thyssen-Bornemisza (1971) no.282), but more likely by his son Nicolò, a *Madonna of Humility* (Rohoncz (1937) no.251; Thyssen-Bornemisza (1971) no.172) by the so-called Master of the Bambino Vispo (an artist now generally identified with Gherardo Starnina) and a *St Jerome in the desert* (Thyssen-Bornemisza (1971) no.25a), which had a false signature of Jacopo Bellini and was therefore given to that artist, but which comes from the circle of Antonio Vivarini and Giovanni d'Alemagna.

The paintings discussed in the present volume belong to the span of time between *c*1290 and *c*1470. What is probably the earliest picture of the Collection, the *Madonna and Child with saints* by the Master of the Magdalen, seems to have been executed around 1290, whereas the latest work included, the predella by Giovanni Boccati, formed part, as we have seen, of an altarpiece dated 1473. All the authors of these paintings have in common in some measure the ascendancy of Gothic art. They were all born before *c*1420, at a time when Gothic taste still determined the orientation of artists and exerted its influence, however fleetingly, at the beginning of their careers. The absence of this common background accounts for the exclusion from the present choice of paintings by masters of a younger generation, such as Benozzo Gozzoli, Francesco del Cossa, Alvise Vivarini or Marco Zoppo, even though they were probably executed before 1473.

It has been the aim of the present writer to collect as much useful data as possible for a better understanding of the historical, artistic, religious and cultural significance of the paintings

discussed, supplying further explanatory comments on the place they occupy in the œuvre of their authors. The entries provide information relating to the state of conservation and the history of each work, where possible from the time of its execution to the present day, followed by a detailed discussion of opinions expressed in the critical literature. This leads on to an analysis of the stylistic character of the paintings which aims to define on the basis of the most recent research their attribution and date. Obviously not all the items of the comprehensive bibliography preceding each entry, which in some cases reaches a considerable length, are equally important. However, I hope it will prove useful in providing an interesting survey of changing opinions over the last decades. According to the wishes of its founder, the early Italian paintings gathered in the Thyssen-Bornemisza Collection provide the equivalent of a 'vertical section' of Gothic and early Renaissance pictorial art. But this ensemble of pictures also commands interest in its own right. Indeed, both the items included and the very choice quality of each work make this a precious document of twentieth-century collecting.

Notes on the catalogue

Exhibitions are listed by city, title, date and catalogue number (where known). All the exhibitions of paintings from the Thyssen-Bornemisza Collection have been abbreviated in the text as follows:

Munich, 1930
Munich, *Sammlung Schloss Rohoncz, Gemälde*, Neue Pinakothek
Rotterdam and Essen, 1959–60
Rotterdam, *Collectie Thyssen-Bornemisza*, Museum Boymans-van Beuningen, 1959–60
Essen, *Sammlung Thyssen-Bornemisza*, Museum Folkwang, 1960
London, 1961
London, *From Van Eyck to Tiepolo: An Exhibition of Pictures from the Thyssen-Bornemisza Collection.*
National Gallery
USA tour, 1979–80
Old Master Paintings from the Collection of Baron Thyssen-Bornemisza
Washington, DC, National Gallery of Art
Detroit, MI, Detroit Institute of Arts
Minneapolis, MN, Minneapolis Institute of Arts
Cleveland, OH, Cleveland Museum of Art
Los Angeles, CA, Los Angeles County Museum of Art
Denver, CO, Denver Art Museum
Fort Worth, TX, Kimbell Art Museum
Kansas City, MO, William Rockhill Nelson Gallery of Art-Atkins Museum of Fine Arts
New York, NY, Metropolitan Museum of Art
(catalogue edited by Allen Rosenbaum, published Washington, National Gallery of Art)
Paris, 1982
Paris, *Collection Thyssen-Bornemisza: Maîtres Anciens*, Musée du Petit Palais
USSR tour, 1983–84
Master Paintings from the Thyssen-Bornemisza Collection
Moscow, Pushkin Museum
Leningrad, The Hermitage
Kiev, State Museum of Ukrainian Plastic Arts
Hungary tour, 1985–86
Meisterwerke des 15.–20. Jahrhunderts aus der Sammlung von Baron Thyssen-Bornemisza
Budapest, Nationalgalerie
Szombathely, Neue Galerie
USSR tour, 1987
Old Master Paintings from the Thyssen-Bornemisza Collection
Moscow, Pushkin Museum
Leningrad, The Hermitage
Madrid, 1987–88
Madrid, *Maestros Antiguos de la Coleccion Thyssen-Bornemisza*, Real Academia de Bellas Artes de San Fernando
London, 1988
London, *Old Master Paintings from the Thyssen-Bornemisza Collection*, Royal Academy of Arts
Stuttgart, 1988–89
Stuttgart, *Meisterwerke der Sammlung Thyssen-Bornemisza*, Staatsgalerie

Bibliographical abbreviations

Allgemeines Künstlerlexikon
 Allgemeines Künstlerlexikon. Die bildenden Künstler aller Zeiten und Völker (Leipzig, 1983–)
Berenson, *Central Italian Painters* (1909)
 B. Berenson, *The Central Italian Painters of the Renaissance*, 2nd edn. (New York and London, 1909)
Berenson, *Italian Pictures* (1932)
 B. Berenson, *Italian Pictures of the Renaissance* (Oxford, 1932)
Berenson, *Pitture Italiane* (1936)
 B. Berenson, *Pitture italiane del Rinascimento* (Milan, 1936)
Berenson, *Italian Pictures* (1957)
 B. Berenson, *Italian Pictures of the Renaissance. Venetian School*, 2 vols. (London, 1957)
Berenson, *Italian Pictures* (1963)
 B. Berenson, *Italian Pictures of the Renaissance. Florentine School*, 2 vols. (London, 1963)
Berenson, *Italian Pictures* (1968)
 B. Berenson, *Italian Pictures of the Renaissance. Central Italian and North Italian Schools*, 3 vols. (London, 1968)
Boskovits, *Pittura fiorentina*
 M. Boskovits, *Pittura fiorentina alla vigilia del Rinascimento* (Florence, 1975)
Boskovits, *Corpus* (1984)
 M. Boskovits, *A Critical and Historical Corpus of Florentine Painting*, III, IX. *The Painters of the Miniaturist Tendency* (Florence, 1984)
Boskovits, *Berlin. Katalog* (1987)
 M. Boskovits, *Gemäldegalerie Berlin. Katalog der Gemälde. Frühe italienische Malerei* (Berlin, 1987)
Cavalcaselle and Crowe, *Storia*
 G. B. Cavalcaselle and J. A. Crowe, *Storia della pittura in Italia dal secolo II al secolo XVI*, Italian edn., 11 vols. (Florence, 1883–1908)
Crowe and Cavalcaselle, *History*
 J. A. Crowe and G. B. Cavalcaselle, *A New History of Painting in Italy from the Second to the Sixteenth Century*, 1st English edn., 3 vols. (London, 1864–6); 2nd English edn., edd. R. L. Douglas and T. Borenius, 6 vols. (London, 1903–14); 3rd English edn., ed. E. Hutton, 3 vols. (London, 1908–9)
Crowe and Cavalcaselle, *Geschichte*
 J. A. Crowe and G. B. Cavalcaselle, *Geschichte der italienischen Malerei*, German edn., 6 vols. (Leipzig, 1864–76)
Dizionario Bolaffi
 Dizionario enciclopedico Bolaffi dei pittori e degli incisori italiani dall'XI al XX secolo, 11 vols. (Turin, 1972–6)
Duecento e Trecento (1986)
 La pittura in Italia. Il Duecento e il Trecento (Milan, 1986)
Galetti and Camesasca, *Enciclopedia*
 U. Galetti and E. Camesasca, *Enciclopedia della pittura italiana*, 3 vols. (Milan, 1951)
Garrison, *Italian Romanesque Panel Painting* (1949)
 E. B. Garrison, *Italian Romanesque Panel Painting. An Illustrated Index* (Florence, 1949)
Gothique siennois (1983)
 L'art gothique siennois, exhibition catalogue (Musée du Petit Palais, Avignon, 1983)
Gotico a Siena (1982)
 Il Gotico a Siena, exhibition catalogue (Palazzo Pubblico, Siena, 1982)
Kaftal, *Iconography* (1952)
 G. Kaftal, *Iconography of the Saints in Tuscan Painting* (Florence, 1952)
Kaftal, *Central and South Italian Schools* (1965)
 G. Kaftal, *Iconography of the Saints in Central and South Italian Schools of Painting* (Florence, 1965)
Klesse, *Seidenstoffe* (1967)
 B. Klesse, *Seidenstoffe in der italienischen Malerei des 14. Jahrhunderts* (Berne, 1967)
Le origini (1985)
 La pittura in Italia. Le origini (Milan, 1985)
Lexikon christlichen Ikonographie
 Lexikon der christlichen Ikonographie, 8 vols. (Rome, Freiburg, Basle and Vienna, 1968–76)
Marcucci, *Firenze. Dipinti toscani secolo XIII* (1958)
 L. Marcucci, *Gallerie Nazionale di Firenze. I dipinti toscani del secolo XIII – scuole bizantine e russe* (Rome, 1958)

Marcucci, *Firenze. Dipinti toscani* (1965)
> L. Marcucci, *Gallerie Nazionali di Firenze. I dipinti toscani del XIV secolo* (Rome, 1965)

van Marle, *Development*
> R. van Marle, *The Development of the Italian Schools of Painting*, 19 vols. (The Hague, 1923–38)

van Marle, *Scuole*
> R. van Marle, *Le Scuole della Pittura Italiana*, Italian edn., 2 vols. (The Hague and Milan, 1932–4)

Meiss, *Black Death* (1951)
> M. Meiss, *Painting in Florence and Siena after the Black Death* (Princeton, 1951)

Offner, *Corpus*
> R. Offner, *A Critical and Historical Corpus of Florentine Painting. The Fourteenth Century*, Section III, 8 vols. (New York, 1930–58); Section IV, in collaboration with K. Steinweg, 6 vols. (New York, 1960–79). New edn., with additional material, ed. M. Boskovits (Florence, 1986–)

Offner, *Legacy* (1981)
> R. Offner, *A Critical and Historical Corpus of Florentine Painting*, Supplement. *A Legacy of Attributions*, ed. H. B. J. Maginnis (New York, 1981)

Pallucchini, *Trecento* (1964)
> R. Pallucchini, *La pittura veneziana del Trecento* (Venice and Rome, 1964)

Quattrocento
> *La pittura in Italia. Il Quattrocento*, 1st edn. (Milan, 1986); 2nd edn. (Milan, 1987)

Rohoncz (1937)
> R. Heinemann, *Sammlung Schloss Rohoncz*, 2 vols. (Zurich, 1937)

Rohoncz (1949)
> R. Heinemann, *Aus der Sammlung Stiftung Schloss Rohoncz* (Lugano, 1949)

Rohoncz (1952)
> R. Heinemann, *De la Collection Fondation Château de Rohoncz* (Lugano, 1952)

Rohoncz (1958)
> R. Heinemann, *Sammlung Schloss Rohoncz* (Lugano, 1958)

Rohoncz (1964)
> R. Heinemann, *Collection Château de Rohoncz* (Lugano, 1964)

Rusk Shapley, *Washington. Catalogue* (1979)
> F. Rusk Shapley, *Catalogue of the Italian Paintings. National Gallery of Art*, 2 vols. (Washington DC, 1979)

Sandberg Vavalà, *Croce dipinta* (1929)
> E. Sandberg Vavalà, *La croce dipinta italiana e l'iconografia della Passione* (Verona, 1929)

Schiller, *Ikonographie*
> G. Schiller, *Ikonographie der christlichen Kunst*, 6 vols. (Gütersloh, 1966–80)

Shorr, *Devotional Images* (1954)
> D. C. Shorr, *The Christ Child in Devotional Images in Italy during the XIV Century* (New York, 1954)

Thieme and Becker, *Lexikon*
> U. Thieme and F. Becker, *Allgemeines Lexikon der bildenden Künstler*, 36 vols. (Leipzig, 1907–50)

Thyssen-Bornemisza (1970)
> I. Schlégl and S. S. Berkes, *Praktischer Führer durch die Sammlung Thyssen-Bornemisza* (Lugano, 1970)

Thyssen-Bornemisza (1971)
> J. C. Ebbinge-Wubben, C. Salm, C. Sterling, R. Heinemann, *Sammlung Thyssen-Bornemisza* (Zurich, 1971)

Thyssen-Bornemisza (1977)
> S. S. Berkes and G. Borghero, *Sammlung Thyssen-Bornemisza: Katalog der ausgestellten Kunstwerke* (Lugano, 1977)

Thyssen-Bornemisza (1981)
> G. Borghero, *The Thyssen-Bornemisza Collection: Catalogue of the Exhibited Works of Art* (Lugano, 1981)

Thyssen-Bornemisza (1986)
> G. Borghero, *Thyssen-Bornemisza Collection: Catalogue Raisonné of the Exhibited Works of Art* (Milan, 1986)

Thyssen-Bornemisza (1989)
> C. de Watteville, *Thyssen-Bornemisza Collection: Guide to the Exhibited Works* (Milan, 1989)

Toesca, *Trecento* (1951)
> P. Toesca, *Il Trecento* (Turin, 1951)

Vasari, ed. Milanesi
> Giorgio Vasari, *Le Vite de' più eccellenti Pittori, Scultori e Architettori*, ed. G. Milanesi, 9 vols. (Florence, 1878–85)

Venturi, *Storia*
> A. Venturi, *Storia dell'arte italiana*, 11 vols. (Milan, 1901–40)

List of paintings

Andrea di Bartolo
The Way to Calvary [1]
Fra Angelico
The Madonna of Humility [2]
Barnaba da Modena
The Madonna and Child with two angels [3]
Bartolomeo di Messer Bulgarino
*The Madonna and Child enthroned with a female martyr,
St John the Baptist and four angels* [4]
Benedetto di Bonfiglio
The Annunciation [5]
Bicci di Lorenzo
Three panels: *Announcing angel, God the Father
blessing and a cherub; Christ on the Cross with the
Virgin, St John and a cherub; Annunciate Virgin and a
cherub* [6]
Giovanni Boccati
St Sabinus conversing with St Benedict [7]
Cenni di Francesco di Ser Cenni
*The Madonna of Humility, the Eternal Father, the Holy
Spirit and the twelve apostles* [8]
Bernardo Daddi
The Crucifixion [9]
The Madonna and Child [10]
Duccio di Buoninsegna
Christ and the Samaritan Woman [11]
Franco-Flemish master probably active in Naples,
*c*1435–45
The Crucifixion [12]
Agnolo Gaddi
The Crucifixion [13]
Taddeo Gaddi
The Nativity [14]
Giovanni da Bologna
The Coronation of the Virgin and four angels [15]
Giovanni di Paolo
The Madonna of Humility [16]
St Catherine before the pope at Avignon [17]

Lorenzo Monaco
The Madonna and Child enthroned with six angels [18]
Lorenzo Veneziano
Portable altarpiece with a central *Crucifixion* [19]
Luca di Tommè
The Adoration of the Magi [20]
Master of the Dotto Chapel
The Crucifixion; The Last Judgement [21]
Master of Forlì
The Deposition [22]
Master of the Magdalen
*The Madonna and Child enthroned with St Dominic,
St Martin and two angels* [23]
Master of the Pomposa Chapterhouse
The Crucifixion [24]
Master of 1355
The Coronation of the Virgin with five angels [25]
Niccolò di Tommaso
The Madonna and Child with six saints [26]
Paolo Uccello
*Christ on the Cross, the Virgin and three mourning
saints* [27]
Pietro da Rimini
Episodes from Christ's infancy [28]
Ugolino di Nerio
Christ on the Cross between the Virgin and St John [29]
Venetian, *c*1300–10
The Virgin and Child; Scenes from the Life of Christ [30]
Venetian, *c*1360
The Madonna of Humility with angels and a donor [31]
Vitale da Bologna
The Crucifixion [32]

Andrea di Bartolo active from the 1380s; died 1428

1 The Way to Calvary

c1415–20
Tempera on panel, 54.5 × 49.2 cm with modern wood support; original painted surface 52 × 46 cm
Accession no.1929.1

Provenance
Freiherr von Tucher, Rome and Lindau
Cassirer & Helbing, Berlin, 8 December 1927, lot 60
Galerie Fleischmann, Munich, 1927
Thyssen-Bornemisza Collection, 1929

Exhibition
Munich, 1930, p.5, no.15

Literature
F.Wickhoff, 'Die Sammlung Tucher', *Münchner Jahrbuch der bildenden Kunst* III (1908) I, p.22
O.von Falke, *Die Sammlung Heinrich Freiherr von Tucher*, sale catalogue (Berlin, 8 December 1927) p.35, lot 60,
 fig.XIX
A.L.Mayer, 'Die Ausstellung der Sammlung Schloss Rohoncz in der Neuen Pinakothek München', *Pantheon* VI
 (1930) p.314
R.van Marle, 'I quadri italiani della raccolta del Castello Rohoncz', *Dedalo* XI (1930–1) p.1368
van Marle, *Scuole* II (1934) p.550 note
L.Rigatuso, 'Bartolo di Fredi', *Diana* IX (1934) p.233
H.D.Gronau, *Andrea Orcagna und Nardo di Cione* (Berlin, 1937) p.83 note 111
Rohoncz (1937) I, p.7, no.18
Rohoncz (1949) pp.12–13, no.18
Rohoncz (1952) p.12, no.18
Rohoncz (1958) p.7, no.18
G.Coor, 'A further Link in the Reconstruction of an Altarpiece by Andrea di Bartolo', *Journal of the Walters Art
 Gallery* XXIV (1961) pp.55–60
Rohoncz (1964) p.12, no.18
Berenson, *Italian Pictures* (1968) I, p.7
Thyssen-Bornemisza (1970) p.25, no.16
Thyssen-Bornemisza (1971) pp.25–6, no.16
F.Zeri, *Italian Paintings in the Walters Art Gallery* (Baltimore, 1976) I, pp.50, 51
Thyssen-Bornemisza (1977) p.17, no.16
H.B.J.Maginnis, 'The Literature of Sienese Trecento Painting 1945–1975', *Zeitschrift für Kunstgeschichte* XL (1977)
 p.299
F.Zeri, 'The Final Addition to a Predella by Andrea di Bartolo', *Journal of the Walters Art Gallery* XXXV (1977) p.87
F.Zeri and E.Gardner, *Italian Paintings. A Catalogue of the Collection of the Metropolitan Museum of Art. Sienese and
 Central Italian Schools* (New York, 1980) pp.1–2
Thyssen-Bornemisza (1981) p.23, no.16
A.Cecchi in *Gotico a Siena* (1982) p.313; (1983) p.280
L.B.Kanter, 'A *Massacre of the Innocents* in the Walters Art Gallery', *Journal of the Walters Art Gallery* XLI (1983)
 pp.24–5
Thyssen-Bornemisza (1986) p.13, no.2d
E.Kasten, 'Andrea di Bartolo,' in *Allgemeines Künstlerlexikon*, II (1986) pp.974–5
M.Leoncini, 'Andrea di Bartolo', in *Duecento e Trecento* (1986) p.552
V.Maderna, *Il polittico di Andrea di Bartolo a Brera restaurato* (Florence, 1986)
Thyssen-Bornemisza (1989) p.14

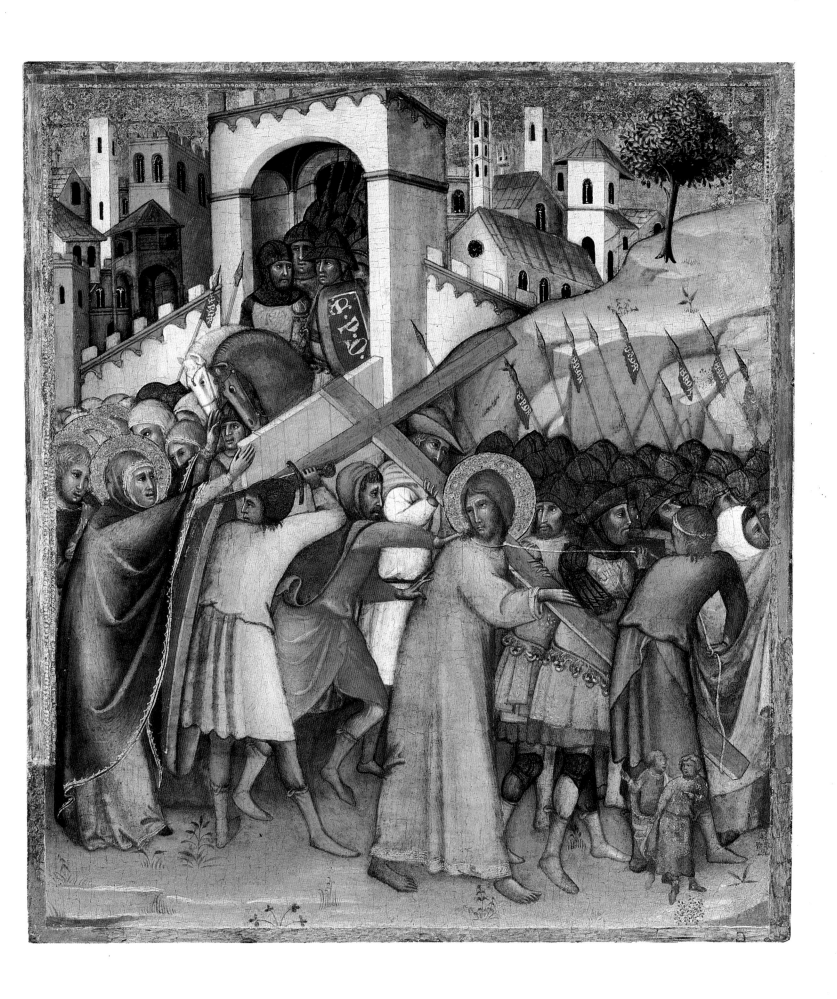

At the centre, in the foreground, Christ carries the Cross, led with a rope round his neck by an executioner and pushed by another from behind, while Simon of Cyrene helps to carry the weight of the Cross. Christ turns his gaze towards his mother who, on the far left of the scene, is followed by St John and a group of holy women. Mary utters a cry and stretches out her arms towards her Son, while a soldier threatens her with his raised sword. In the background is the bare mount of Golgotha and the city of Jerusalem, with a crowd emerging from the city gate followed by soldiers on horseback.

The painted surface appears to be fairly well preserved. Before entering the Collection, the painting was restored and transferred with its gesso preparation from the original panel to a new wood support, 16 mm thick. The margins of the new panel, which is slightly larger than the painted surface, were gilded and the various colour losses filled in (eg Christ's robe and the tunic of the executioner on the left).

This small painting, which clearly formed part of a predella, belonged in 1908 to Heinrich Freiherr von Tucher, a German diplomat in Rome, and was sold with his collection at auction in Berlin (8 December 1927). The other panels belonging to the same predella (see FIG 1), now dispersed in various collections, comprise the *Capture of Christ* (51 × 46 cm; Paris, art market in 1972; FIG 1c), which started the sequence on the left; the *Crucifixion* (52.7 × 98.7 cm; New York, Metropolitan Museum, no.12.6; FIG 1e),[1] which followed on from the present *Way to Calvary*; the *Lamentation* (54 × 49 cm; Stockholm, Nationalmuseum, no.4463; FIG 1f);[2] and finally the *Resurrection* (53 × 48 cm; Baltimore, Walters Art Gallery, no.37.74; FIG 1g).[3]

No clue is provided by these five panels of the original destination of the polyptych to which they belonged, nor have the main panels so far been identified. The hypothesis, cautiously put forward by Coor (1961, p.60), that they could be the predella of one of the two large altarpieces recorded by Fabio Chigi (1625/6) in the church of San Domenico in Siena seems to be unfounded.[4] The only fact of any certainty, as observed by Coor,[5] is that the polyptych must have been about three metres wide and the central panel equal in width to the two lateral panels. One may perhaps add that, considering its impressive proportions, the polyptych must have been destined for the high altar of a church. It presumably resembled other known polyptychs by Andrea di Bartolo with predellas representing Passion scenes, namely the polyptych in the Cathedral of Tuscania (which is also about three metres wide), and another supposedly from a church in Sant'Angelo in Vado.[6]

No lateral panels from a polyptych, of those hitherto attributed to Andrea di Bartolo, answer to the requirements or the measurements of the predella under discussion. However, two impressive laterals, as yet unpublished, which turned up on the Italian art market in 1985, may be taken into consideration. Including their frames (which seem to be partly modern) they each measure 225 × 105 cm. The left wing represents *Sts Louis of Toulouse and John the Baptist*, full length, with a bust of *St Paul* in the medallion above them; the right wing has *Sts John the Evangelist and Francis* with a bust of *St Peter* (FIGS 1a and 1b). The presence of the two Franciscan saints indicates a provenance from a church of that order. St John the Baptist's scroll (ECCE AGNUS DEI...), as also his gesture towards the centre, confirm that the central panel represented the Madonna and Child. The very choice of saints represented is similar to that in Andrea's altarpiece in the Franciscan church of Tuscania and in his Osservanza polyptych in Siena.

The first art historian to discuss the Thyssen *Way to Calvary* was Wickhoff (1908), who noted the composition's derivation from a model by Simone Martini and proposed an attribution to Taddeo di Bartolo, dating the work towards the end of the 1380s. Falke (1927) remained non-committal, limiting himself to listing the painting as anonymous Sienese of the fourteenth century. Expertises by August L. Mayer ('a Sienese work of c1350/60, close to Barna da Siena'), Georg Gronau ('a Sienese master of c1350') and Raymond van Marle (an early work by Bartolo di Fredi) date from 1929 (copies are preserved in the Thyssen archives). The attribution to Bartolo was taken up by Heinemann (Munich, 1930), who quoted Longhi as being of the same

Notes

1 Prior to its acquisition by the Metropolitan Museum in 1912, the *Crucifixion* belonged to the collection of the painter Friedrich August von Kaulbach (1850–1920) of Munich.

2 The *Lamentation* was bought from Agnew's, London, in 1948.

3 The *Resurrection* was acquired in 1902 from the Masserenti collection in Rome.

4 In the case of at least one of Andrea di Bartolo's altarpieces executed for the Sienese Dominicans, that of the lost Malavolti altar dated 1397, the information on the signature provided by the sources is contradictory (Andrea di Bartolo according to some, Taddeo di Bartolo according to others). In any case the style of the panel here discussed would seem to exclude such an early date.

5 G. Coor, 'A new Link in the Reconstruction of an Altarpiece by Andrea di Bartolo', *Journal of the Walters Art Gallery* XXIX–XX (1956–7) p.97.

6 I am referring to the panels representing *Episodes from the life of Christ* divided between the Galleries of Bologna, Toledo, OH, and private collections (formerly Rome, Ruffini collection). Cf. L. Kanter, 'Giorgio di Andrea di Bartolo', *Arte Cristiana* LXXIV (1986) p.19f. This predella, as the measurements of the Toledo *Crucifixion* suggest, probably belonged to the *Assumption* in the Virginia Museum of Art, Richmond VA.

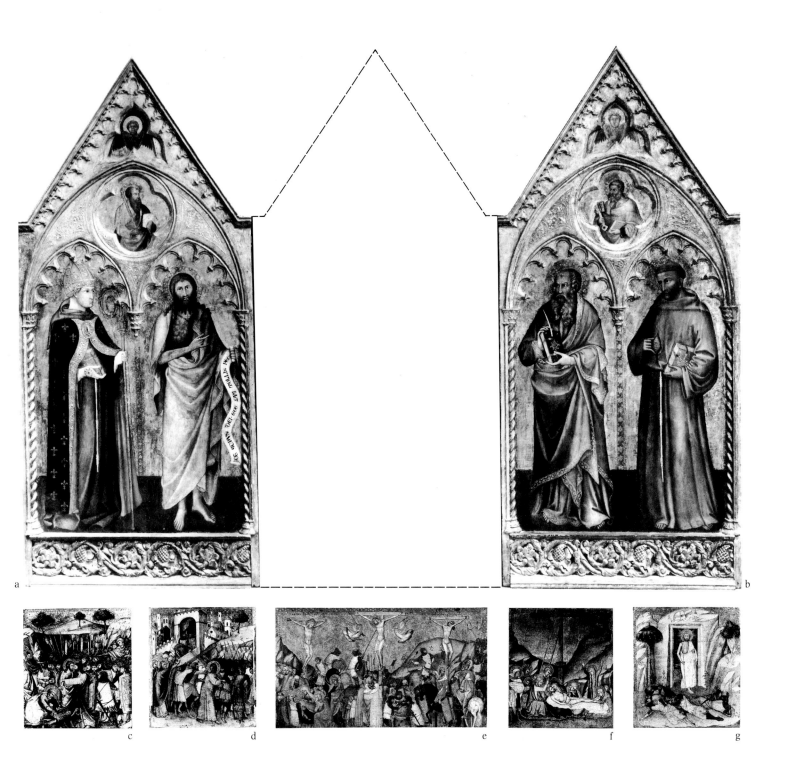

FIG I Andrea di Bartolo, hypothetical reconstruction of a polyptych:
a *St Louis of Toulouse and St John the Baptist* (above: *St Paul*) (whereabouts unknown; Italian art market 1985)
b *St John the Evangelist and St Francis* (above: *St Peter*) (whereabouts unknown; Italian art market 1985)
c *The Capture of Christ* (whereabouts unknown; formerly Paris art market)
d *The Way to Calvary* (Thyssen Collection)
e *The Crucifixion* (New York, Metropolitan Museum)
f *The Lamentation* (Stockholm, Nationalmuseum)
g *The Resurrection* (Baltimore, Walters Art Gallery)

opinion. In reviewing the Munich exhibition of that year Mayer (1930) also agreed with the attribution to Bartolo di Fredi. Van Marle (1930/1), after first confirming Bartolo's authorship, referred to it later (1934) as only 'very probable'. Rigatuso (1934) quoted van Marle's former proposal without expressing a personal opinion. Heinemann again listed the painting under Bartolo di Fredi (Rohoncz (1937) and (1958)). Meanwhile Hans Gronau identified the panel as a work by Andrea di Bartolo (1937) and this attribution was discussed at length by Coor (1961), after she had connected it (1956/7) with the companion panels in New York, Baltimore and Stockholm, which had already been grouped together by Faison.[7] According to Coor this is an early work, which she initially placed at the beginning of the 1400s (1956/7) and later connected hypothetically with a lost altarpiece painted in 1397 for San Domenico, Siena. The panel is listed under Andrea di Bartolo's name also by Berenson (1968) and by most later critics. The only exceptions are the authors of the catalogues of the Collection who proposed the name of Bartolo di Fredi with a question mark (Thyssen-Bornemisza (1970), (1971), (1977), (1981)). Zeri (1976) must be given the credit for having discovered the missing predella panel of the *Capture of Christ* (formerly in Paris). Like Coor, Zeri, Kasten and Maderna (1986), all regard this as an early work by the artist, and Kanter (1983) dates it specifically to the decade of the 1390s. The attribution to Andrea di Bartolo is accepted in the recent catalogue of the Collection (Thyssen-Bornemisza (1989)).

Although most critics agree more or less on the early dating, Andrea's chronology is complicated by the artist's tendency to repeat the motifs and compositions of his own paintings as well as those of other masters. As has already been observed,[8] the Metropolitan Museum *Crucifixion* echoes faithfully the composition of the same scene attributed to 'Barna' (San Gimignano, Collegiata). However, this fact cannot be taken as evidence for an early date, since it was common practice at the turn of the fifteenth century to go back to models by great artists of the early Trecento.[9] In particular, the *Way to Calvary* is known to derive from Simone Martini's famous composition (Paris, Louvre), which was also used as a prototype by artists such as Giovanni di Paolo on more than one occasion (see Coor (1961)).

Our point of departure, therefore, for dating this work must be a careful analysis of the stylistic changes in the artist's œuvre. On examining the polyptych of 1413 (Siena, Osservanza), one may note, compared to the Tuscania polyptych, a reduced interest in plastic values and, at the same time, a search for more flowing contours, an emphasis on the rhythmic movement of the draperies and more intense physiognomical expressions. The greater adherence to late-Gothic trends in the 1413 polyptych is probably to be attributed to new developments in Andrea di Bartolo's style around that date. Similar observations may be made if one compares the Tuscania polyptych with the certainly earlier panels in the Museum at Buonconvento. Here the heavily proportioned figures, stiff in posture and severe in expression, would seem to be decidedly more archaic, in keeping with the traditional date of 1397 ascribed to the Buonconvento altarpiece. By contrast the saints of the Sant'Angelo in Vado polyptych, like the population of the *Assumption* in Richmond (Virginia Museum of Art), appear strangely elongated with sharp, tense expressions, and their smooth but rhythmically complex forms are rendered with an almost metallic luminosity. In certain respects these paintings seem to anticipate the bizarre moods of an artist like Giovanni di Paolo and I would be inclined to place them rather late in Andrea's œuvre.

Within this sequence the predella under discussion may best be examined in relation to the panels of the polyptych executed by Bartolo di Fredi and his son for the church of San Francesco at Montalcino in 1388.[10] Andrea's share in the altarpiece included the predella scene of the *Lamentation*, which provides an interesting comparison with the Stockholm panel of the same subject. While the two compositions are extremely similar and are based, as Coor observed, on a prototype by Ambrogio Lorenzetti, they differ in style: in the Montalcino predella (now Siena, Pinacoteca) the placing of the figures in space is much freer and the forms are more consistent, whereas in the Stockholm panel the more compact grouping of the mourners around the dead

Notes

7 L. Faison, 'A Note on a Sienese Resurrection', *Journal of the Walters Art Gallery* IV (1941) p.97f.

8 R. Offner, 'Italian Pictures in the New-York Historical Society', *Art in America* VII (1919) p.152.

9 As in Niccolò di Buonaccorso's *Crucifixion* (Budapest, Museum), which also follows the composition of the San Gimignano fresco. Cf. M. Boskovits, 'Su Niccolò di Buonaccorso, Benedetto di Bindo e la pittura senese del primo '400', *Paragone* XXXI, nos. 359–61 (1980) p.5f.

10 G. Freuler, 'Bartolo di Fredis Altar für die Annunziata-Kapelle in S. Francesco in Montalcino', *Pantheon* XLIII (1985) p.21f.

11 See above note 6. For the five ex-Ruffini panels see also Foto Anderson no.41613.

12 F. Zeri, *Toledo Museum of Art. European Paintings* (Toledo, Ohio, 1976) p.19.

13 Sandberg Vavalà, *Croce dipinta*, p.266f.; Schiller, *Ikonographie*, II (1966) pp.88–93.

The iconography of the Thyssen *Way to Calvary* was modelled, as we have seen, either on Simone Martini's painting (Paris, Louvre, no.1383) or on another similar work. The subject is based on Luke 13:16f., the most detailed of the four Gospels, which records not only the episode of Simon of Cyrene but also the words spoken by Christ to the crowd of weeping women following him to Golgotha: 'Daughters of Jerusalem, weep not for me but for yourselves . . .'. However, faithful to the long iconographical tradition and to the version given by St John 19:17, who is alone in stating that Christ carried the Cross by himself, the artist attributes to Simon only a secondary rôle. The apocryphal Gospel of Nicodemus and its reflection in late mediaeval mystic literature inspired a whole series of representations from the thirteenth century onwards in which, as here, the words addressed by Christ to the women of Jerusalem are transformed into a dialogue between Jesus and his mother.

FIG 2 Andrea di Bartolo, *The Way to Calvary* (Tuscania, Cathedral)

FIG 3 Andrea di Bartolo, *The Way to Calvary* (formerly Rome, Ruffini collection)

Christ is accompanied by a diminished impression of depth and a more accentuated linear rhythm, while the attention to detail creates a more descriptive and relaxed mood. Considering these differences between the two versions, I doubt whether they could have been painted within a relatively short span of time. The Thyssen *Way to Calvary* and its companions are, so far as I can see, much later than the Montalcino altarpiece and probably close in date to a late work, such as the panels in Tuscania Cathedral. The *Way to Calvary* in the Tuscania predella (FIG 2) has less emotional tension and a looser arrangement of the figures than the Thyssen panel, while the scene is dominated by a more restless compositional order. Instead, in our panel, despite the accentuated and pathetic gestures, the figures appear so huddled together as to be practically impeded in their movements. Besides, the view of the city beyond has no spatial relation to the foreground scene.

To conclude, I feel justified in referring the present panel and the others of the series to a relatively late phase in Andrea's development. Stylistically, the predella is close to that composed of the ex-Ruffini *Passion* scenes (see the *Way to Calvary*, FIG 3)[11] and the *Crucifixion* in Toledo, Ohio (Museum of Art, no. 552.103),[12] which in all probability stood under the Richmond *Assumption*. In this last, the silhouetted figures, the crowded scenes against backdrops devoid of any spatial connection, and the theatrical gestures are all part of Andrea's way of creating an intense, vibrating narrative, which in spite of its numerous realistic details remains phantasmagorical – the materialization of a dream-world which recalls aspects of Giovanni di Paolo's painting. If this dispersed altarpiece is, as I believe, a mature work executed around 1410, the predella of which the Lugano panel is a part represents a further step forward. I would date it not earlier than the mid-1410s, and certainly after the Osservanza altarpiece of 1413.[13]

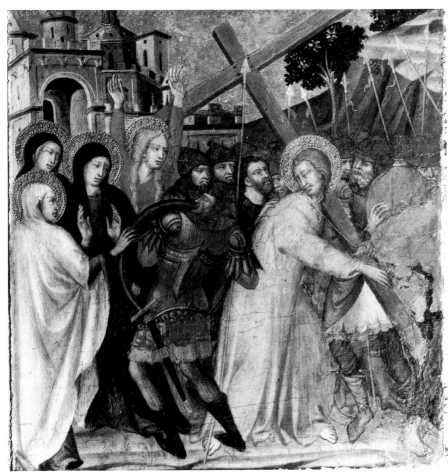

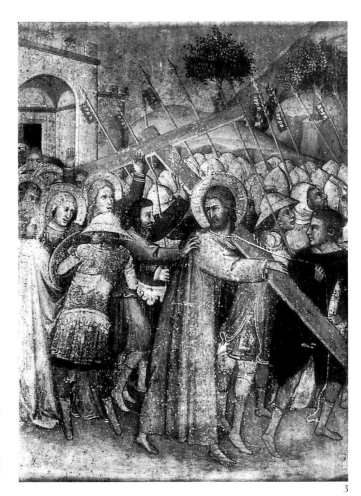

2

3

Fra Angelico *c*1390/5–1455

2 The Madonna of Humility

*c*1433/5
Panel, 98.6 × 49.2 cm; painted surface 95 × 46.5 cm; thickness 1.4 cm
Accession no.1986.10

Provenance
Palazzo Gondi, Florence?
Princess Charlotte of Wales, by 1816
Leopold of Saxe-Coburg (from 1831 King Leopold I of Belgium), 1816–1865
King Leopold II of Belgium, 1865–1909
F.Kleinberger, Paris, 1909
Pierpont Morgan, New York, 1909–1935
Thyssen-Bornemisza, 1935; inherited by Countess Margrit Batthyány, 1948; purchased by Thyssen-Bornemisza
 Collection, 1986

Exhibitions
Brussels, *Exposition rétrospective de Bruxelles*, 1886
New York, Kleinberger Galleries, 1917, no.18
Manchester NH, Currier Gallery of Art, summer 1951
Florence, *Mostra delle opere del Beato Angelico*, Museo di San Marco, 1955, no.21bis
London, 1961, no.3
Hungary tour, 1985–6, no.17
USSR tour, 1987, no.4
Madrid, 1987–8, no.28

Literature
E.Cartier, *Vie de Fra Angelico da Fiesole* (Paris, 1857) p.444 (English edn. 1865)
H.Hymans, 'Correspondance de Belgique, L'Exposition Rétrospective de Bruxelles', *Gazette des Beaux-Arts*, sér.II,
 XXVIII (1886) p.334
G.Lafenestre and R.Richtenberger, *La Peinture en Europe, La Belgique*, Paris, n.d. [1896] p.131
G.F[rizzoni], review, 'G.Lafenestre-R.Richtenberger, La Peinture en Europe. La Belgique', *Archivio Storico dell'Arte*,
 ser.II, II (1896) p.399
F.M., 'König Leopolds Verkäufe', *Cicerone* I (1909) pp.334, 401
R.E.D., 'Art in France', *Burlington Magazine* XV (1909) p.379
W.Roberts, 'The King of the Belgians' Collection of Old Masters', *Connoisseur* XXIV (1909) p.209
Ruhemann, 'Der Verkauf der Gemäldesammlung König Leopolds', *Kunstchronik* XX (1909) p.445
A.Venturi, 'Corriere di Parigi', *L'Arte* XII (1909) p.319
Venturi, *Storia*, VII/I (1911) pp.45–8
O.Sirén and M.Brockwell, *Catalogue of a Loan Exhibition* (Kleinberger Galleries, New York, 1917) p.50, no.18
F.Schottmüller, *Fra Angelico* (Stuttgart, 1911) pp.92, 244; 2nd edn. (Stuttgart, Berlin and Leipzig, 1924) pp.260–1
C.Ciraolo and B.M.Arbib, *Il Beato Angelico, la sua vita, le sue opere* (Bergamo, 1925)
van Marle, *Development*, X (1928) p.140
P.Muratoff, *Fra Angelico* (London and New York, 1929) p.39
L.Venturi, *Pitture italiane in America* (Milan, 1931) pl.CXLVI
Berenson, *Italian Pictures* (1932) p.22
'Auslandsverkäufe am amerikanischen Markt', *Die Weltkunst* IX (14 April 1935) p.1f.
'Thyssen buys Morgan Angelico, Madonna and Child with angels ...', *Art News* (30 March 1935) p.3f.
Berenson, *Pitture italiane* (1936) p.19
Rohoncz (1937) p.3, no.8
L. and C.L.Ragghianti in G.Vasari, *Le Vite ...*, IV (Milan and Rome, 1949) p.343
Rohoncz (1949) p.10, no.7
L.Collobi Ragghianti, 'Zanobi Strozzi pittore, 2', *Critica d'Arte* XXXIII (1950) p.25
'A Madonna by Fra Angelico', *Bulletin. The Currier Gallery of Art* (summer, 1951) n.p.
Rohoncz (1952) p.10, no.7
J.Pope-Hennessy, *Fra Angelico* (London, 1952) p.201
V.Alce, O.P., 'L'Arte del Beato Angelico', *Memorie Domenicane* XXXI (1955) p.90
L.Berti in *Mostra delle opere del Beato Angelico*, exhibition catalogue (Florence, 1955) pp.30, 138

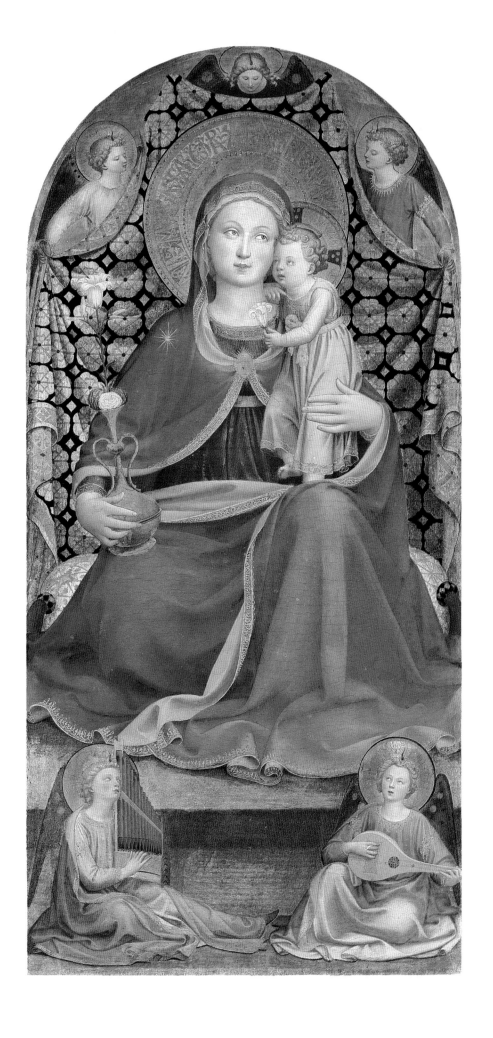

I. Taurisano, O.P., *Beato Angelico* (Rome, 1955) p.137

C. Gomez Moreno, 'A Reconstructed Panel by Fra Angelico and Some New Evidence for the Chronology of his
Works', *Art Bulletin* XXXIX (1957) pp.184, 186, no.11

Rohoncz (1958) p.2, no.8

M. Salmi, *Il Beato Angelico* (Milan, 1958) pp.16–7, 86, 102

G. Urbani, 'Angelico' in *Enciclopedia Universale dell'Arte*, I (Venice, Rome and Florence, 1958) p.407

Berenson, *Italian Pictures* (1963) I, p.14

Rohoncz (1964) pp.9–10, no.8

S. Orlando, O.P., *Beato Angelico* (Florence, 1964) p.37f.

R. Fremantle, 'Masaccio e l'Angelico', *Antichità Viva* IX, no.6 (1970) p.46

E. Morante and U. Baldini, *L'opera completa dell'Angelico* (Milan, 1970) pp.90, 117

Thyssen-Bornemisza (1970) p.110, no.3

Thyssen-Bornemisza (1971) pp.13, 14, no.3

J. Pope-Hennessy, *Fra Angelico*, 2nd edn. (London, 1974) pp.221, 229

M. Boskovits, 'Appunti sull'Angelico', *Paragone* XXVII, no.313 (1976) p.42

D. E. Cole, *Fra Angelico: His Role in Quattrocento Painting and Problems of Chronology*, Ph.D dissertation (University of
Virginia, 1977) pp.544–6

Rusk Shapley, *Washington. Catalogue* (1979) p.13

Thyssen-Bornemisza (1981) p.13, no.3

V. Alce, O.P., *Beato Angelico. Miscellanea di Studi* (Rome, 1984) pp.354, 370, 379

Thyssen-Bornemisza (1986) p.14, no.3

U. Baldini, *Beato Angelico* (Florence, 1986) p.231

Thyssen-Bornemisza (1989) p.15

The Virgin, seated on a cushion, draws the Christ Child towards her as he stands on her knee, leaning against her shoulder with a lily in his left hand. In her right hand she holds a vase of red and white roses with a lily. At her feet are two seated angels, one playing an organ, the other a lute (details, pp.28–9). Three other angels hold up a richly decorated hanging behind the Virgin and Child.[1] Mary's halo is engraved with the inscription 'AVE MARIA GRATIA PLENA'; that of the Child 'ALFA/OM < EGA >'.[2] The edge of Mary's mantle (over her head and across her lap) is also inscribed 'AVE.MARIA.GRATIA.PLENA'.

The panel was described by Venturi in 1909 as being in exceptionally fine state, and is in fact well preserved. The wood has been thinned down, restored and provided with a cradle. Beneath the cradling are traces of three horizontal battens, each 5 cm high, which may not have been original. The carpentry work was probably done when William Suhr restored the panel around 1955. On the back is a label inscribed 'Fogg Art Museum, Loan 1493',[3] and a circular stamp with the number '99/11', besides a label relating to its present ownership. The picture surface has a black painted edge covering the area which was originally hidden by the engaged frame. The paint is rubbed in the Madonna's right hand, in the face and tunic of the left music-making angel and also in the faces of the three angels holding up the curtain, revealing the underdrawing in several places. A number of small retouches are visible in the Madonna's dress and mantle. Two colour losses, one between her nose and left eye, the other covering her chin and lower lip, have been integrated. In 1980 Marco Grassi re-examined its state and went over the restored parts.

This painting, which probably formed part of a polyptych,[4] was first mentioned by Cartier in 1857 in the collection of King Leopold I of Belgium, but with a provenance from the Gondi family in Florence. The source of this information is unknown, but it may relate to Vasari's statement (1568 edn.), that 'a large painting, a small one and a crucifix' by Fra Angelico

Notes
1 For the iconography of the Madonna of Humility, represented seated on the ground instead of on a throne, see Meiss, *Black Death* (1951) p.132f., and H. W. van Os, *Marias Demut und Verherrlichung in der sienesischen Malerei, 1300–1450* (The Hague, 1969) p.75f. The roses are symbols of the Virgin and red roses allude specifically to her sufferings during Christ's Passion: M. Levi d'Ancona, *The Garden of the Renaissance* (Florence, 1977) pp.336, 339 and 291. The lily, besides symbolizing purity and Mary's virginity in particular (*ibidem*, p.210f.), is also a Christological symbol: Schiller, *Ikongraphie*, I, p.62. For the musical instruments, see R. Hammerstein, *Die Musik der Engel* (Berne and Munich, 1962).
2 The letters A–Ω symbolize Christ, as the eternal presence, beginning and end, in the sense of *Apocalypse* 1:8; 21:6; 22:13.
3 The painting must have been on temporary loan, it is not clear when, to the Fogg Art Museum, Cambridge MA.
4 This hypothesis, advanced by Collobi Ragghianti (1950), is based on the painting's relatively large scale and elongated proportions, which are approximately those of the central panel of the triptych of *St Peter Martyr* (Florence, Museo di San Marco; 107 × 57 cm).

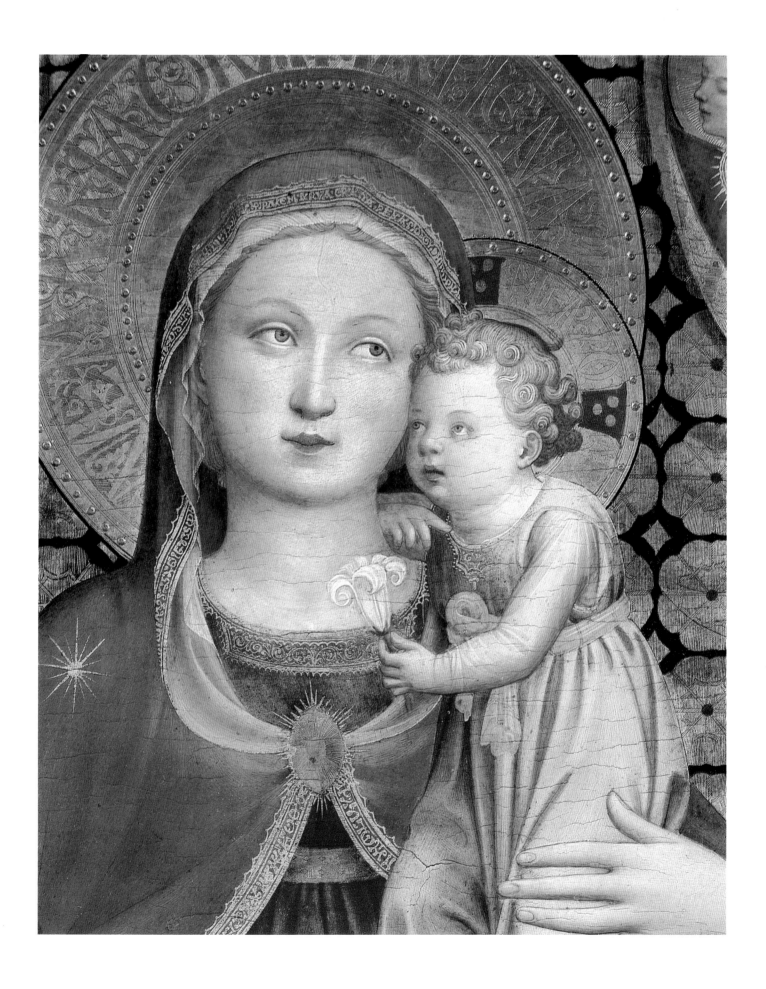

belonged in his day to Bartolomeo Gondi.[5] What is certain is that the painting was formerly in England, in the collection of Charlotte of Wales (Lafenestre and Richtenberger (1896)), the first wife of Leopold of Saxe-Coburg, who became King of Belgium in 1831. The princess, who is thought to have received the painting as a gift from her father, George IV of England,[6] on the occasion of her marriage in 1816 (see Venturi (1909); Sirén and Brockwell (1917)), died the following year and the picture remained in the collection of her husband, probably at Claremont in Surrey, until it was removed to Belgium. It then passed by inheritance to the King's son, Leopold II, who, having no direct heirs, sold it in May 1909 to the Paris dealer F. Kleinberger ('F.M.' (1909) and Ruhemann (1909)). It was acquired in August of the same year by J. Pierpont Morgan ('R.E.D.' (1909) and Roberts (1909)); the Pierpont Morgan Library put it up for sale in March 1935. It was bought in the same year for the Thyssen Collection (see 'Auslandsverkäufe …' (1935) and 'Thyssen buys …' (1935)) and has since been loaned to several exhibitions (as above).

Cartier (1857), who included the painting in the catalogue of Angelico's works, did not offer any suggestion regarding its place in the artist's œuvre. A late dating was proposed in a note signed by 'R.E.D.' (1909), where it is described as 'the only single picture known of the painter's last Roman period', while other writers (Hymans (1886), Lafenestre and Richtenberger (1896), Frizzoni (1896), Roberts (1909) and Ruhemann (1909)) limited themselves to mentioning it as a work by the Dominican painter. Meanwhile, the painting was also examined by Adolfo Venturi (June 1909) who suggested a different date, in 'the last years of Beato Angelico's first Fiesole period … shortly before the Madonna "dei Linaioli"',[7] and it was probably on this basis that 'F.M.' (1909) dated the panel 'c1435'. Venturi later confirmed his opinion (1911), comparing the Madonna with the small Annunciation and Adoration (Florence, Museo di San Marco).[8] His opinion was subsequently accepted by Sirén and Brockwell (1917), who proposed a date around 1430, relating it to two other Madonnas in the Galleries of Berlin[9] and Parma,[10] and by Lionello Venturi (1930, 1931), who insisted on the Masaccesque component in the work. A dating between the Linaioli tabernacle of 1433 and the series of frescoes in the convent of San Marco (begun in the late 1430s) was put forward by Schottmüller (1911, 1924), Ciraolo and Arbib (1925) and Muratoff (1929), whereas van Marle (1928) dated it to the artist's late period, defining it 'nearer to Benozzo Gozzoli than Angelico and doubtless for the greater part by the former'.

However, most critics accept the Thyssen Madonna as an autograph work by Angelico. They include Berenson (1932, 1936, 1963), Heinemann (Rohoncz (1937, 1949, 1952, 1958, 1964, 1971)), Ragghianti and Collobi Ragghianti (1949, 1950), the anonymous author of the pamphlet 'A Madonna by Fra Angelico' (1951), Taurisano (1955), Hendy (in London (1961)), Fremantle (1970), Baldini (in Morante and Baldini (1970)), the authors of the catalogues of the Collection (Thyssen-Bornemisza (1970, 1977, 1981, 1986, 1989)), Alce (1984), and the authors of the catalogues of the Hungary tour (1985–6), the USSR tour (1987) and of the Madrid exhibition (1987–8). Different opinions are held by Pope-Hennessy (1952), who regards it as a workshop product of around 1445/50 or (1974) even later, contemporary with the Louvre Coronation of the Virgin;[11] by Berti (1955), who describes it as 'a lifeless work' painted in the workshop; by Gomez Moreno (1957), who calls it a school product; and by Cole (1977), who attributes the execution to an 'imitator of the master'. Rusk Shapley (1979) notes analogies with the Madonnas in the Rijksmuseum, Amsterdam,[12] in Berlin[13] and in the National Gallery, Washington,[14] and observes that the Thyssen painting 'is close enough to Angelico to have been painted in his studio, if not by the master himself, around 1430/35'.

It is not so much the painting's authorship as its dating that has given rise to different views. Father Alce (1955) favours a late date, around 1445/50, as does Urbani (1958), while Salmi (1958) stresses the influence of Masaccio apparent in the painting and proposes a date earlier even than the Linaioli tabernacle of 1433. He also draws attention to a version of the composition formerly in Wiesbaden (Henckell collection),[15] which he believes was executed

Notes

5 Vasari-Milanesi, II, p.512. It is reasonable to assume that some of these paintings entered the family collection in 1503, when Giovanni and Federigo Gondi obtained the patronage of the chapel to the left of the high altar in the church of Santa Maria Novella and proceeded to renovate it; W. and E. Paatz, Die Kirchen von Florenz (Frankfurt, 1952) III, p.711. All the editors of the Vite are agreed that the works mentioned by Vasari are lost, except for C.L. and L. Ragghianti (1949), who believe that the Thyssen Madonna came from that collection.

6 Sirén and Brockwell (1917) seem to have been the first to record that the picture was a 'wedding present from King George IV'. Were this the case, it need not necessarily have come from the King's collection. Although a refined collector, he concentrated on English, Dutch and Flemish seventeenth- and eighteenth-century paintings and it seems unlikely that he would have acquired a work of this kind or period; cf. O. Millar, The Later Georgian Pictures of H. M. the Queen (London, 1969) and, in general, idem, The Queen's Pictures (London, 1977) p.129f. Thanks to the kindness of Christopher Lloyd, Surveyor of the Queen's Pictures, Serena Padovani examined the manuscript catalogues of the Royal collections on my behalf, but was unable to trace any possible reference to the Thyssen Madonna (the catalogues consulted were the following: A Catalogue of His Majesty's Collection of Paintings in Windsor Castle (1813 and 1816), and A Catalogue of Pictures, forming the Collection of His Royal Highness the Prince Regent, in Carlton House (1816), both of which are preserved in the Surveyor's Office, Buckingham Palace, London). I consider it likely that the picture was acquired for the occasion on the market shortly before it was presented to the Princess in 1816.

7 That is, the Guild or Arte dei Linaioli, Rigattieri e Sarti, which commissioned the artist to paint a tabernacle in July 1433. This painting representing the Madonna and Child with twelve music-making angels and Sts John the Baptist and the Evangelist and, on the outside of the wings, St Mark and St Peter, is now in the Museo di San Marco, Florence.

8 This is one of the three small reliquary panels in the Museo di San Marco (the fourth belongs to

the Isabella Stewart Gardner Museum, Boston), commissioned from Fra Angelico by Fra Giovanni Masi of the convent of Santa Maria Novella. The death of this friar in June 1434 (Orlandi (1964) p.22) therefore constitutes a *terminus ante quem* for these four paintings.

9 Staatliche Museen, Gemäldegalerie, no.60 (*Madonna and Child with Sts Dominic and Peter Martyr*). This painting is difficult to judge today owing to its very abraded and restored state.

10 Pinacoteca Nazionale, no.429 (*Madonna and Child with Sts John the Baptist, Dominic, Francis and Paul*). This painting is usually dated around or shortly before 1430; Pope-Hennessy (1974) p.231. A date in the late 1420s would seem more likely to the present writer.

11 No.1290. Most critics agree in placing this altarpiece, which was painted for San Domenico, Fiesole, somewhere between 1430 and 1435. It is virtually certain that in October 1435 it was already in place, when the church of San Domenico and its three altars were consecrated; Orlandi (1964, p.24f.).

12 No.17a. Gomez Moreno (1957, p.183f.) has pointed out that the *Madonna and Child* group originally included two angels holding up the curtain and proposed a date around 1438/40. However, considering its numerous affinities with the triptych in the Museo Diocesano of Cortona and with the *Madonna* of Pontassieve (Uffizi, no.143 dep.), it could be a few years earlier in date.

13 See above, note 9.

14 No.5. Dated by Rusk Shapley (1979, p.13) around 1430/5. The painting, which is rubbed and repainted, was probably executed nearer the earlier of these two dates.

15 This painting is recorded in the following collections: Barker collection, London; Lord Ward at Dudley House; A. Schaeffer, Frankfurt; Henckell, Wiesbaden and a private collection in Basle (Pope-Hennessy (1974) p.221). Although badly rubbed, it seems to be free of repaint. Its composition is very similar to that of the Thyssen *Madonna*, but certain Gothicizing elements would suggest that it was painted a few years earlier.

16 This painting (*Madonna and Child with six saints*) is now in the Museo di San Marco but it came from the convent of San Vincenzo, which was founded by Annalena Malatesta in 1453.

shortly after the Thyssen painting in Angelico's workshop. Baldini (1970), after accepting a date around 1430/3, but with some doubts whether the work was entirely autograph, later (1986) included the painting in the master's œuvre, around 1433. Berti (1955), without excluding some workshop assistance, proposed a slightly later date ('the period of the Annalena altarpiece, around 1435'),[16] which has been confirmed by the present writer (1976). Indeed, the Thyssen painting comes close to the *Lamentation over the dead Christ* of 1436, which is the only secure chronological point of reference for these years.[17]

One may conclude that, despite differences of opinion, on the whole critics tend to date the painting to the first half of the 1430s and, interestingly enough, even Pope-Hennessy (1952, 1974), who places it late in Angelico's œuvre, relates the Thyssen *Madonna* stylistically to three important works which we have reason today to suppose were executed before 1435: the Louvre *Coronation*, the Annalena altarpiece and the *Deposition* from Santa Trinita (both Florence, Museo di San Marco).[18] In attempting to define the position of our painting within the artist's chronology, it is therefore necessary to concentrate our attention on the relationship of the Thyssen *Madonna* to this group of works.

An interesting approach towards establishing the sequence of a number of Angelico's undated works was made by Gomez Moreno (1957) on the basis of decorative motifs in the haloes. She observes, for instance, that 'the Gothic lettering does not occur in any of Fra Angelico's extant works from the earlier 1430s on', and that 'in Fra Angelico's works subsequent to the Linaioli triptych the field of incised rays is made a permanent feature in the design, not only of the Virgin's halo, but in that of the other main figures as well'.[19] Gomez Moreno's conclusions undoubtedly have a measure of truth, although they do not take into account that the transition from one type of ornamentation to another is not abrupt, but goes through an intermediary phase between Gothic lettering and classical Latin lettering. The first steps of transformation, even if not evident in the haloes, can be found in the borders of Mary's mantle and the Child's tunic in the Linaioli tabernacle, where in fact the Gothic lettering or, more precisely, the Gothic capitals are slightly deformed and interwoven with leafy patterns in order to give the impression of an oriental script.

This example shows that the process of transformation was by no means complete in the early 1430s.[20] I believe it is possible to argue that the type of Romanizing Gothic capitals interlaced with oriental-type motifs of the kind present in the haloes and elsewhere in the Thyssen, Washington and Basle *Madonnas*, as also in the Louvre *Coronation*, are not to be found in Angelico's work before the late 1420s[21] and disappear again from his ornamental repertoire towards the mid-1430s.

Similarly, one may observe changes in the decoration of the sumptuous golden hangings draped, or held up by angels, behind the Madonna and Child. During the third decade these materials (inspired by the examples of Gentile da Fabriano) were usually incised freehand or

Most critics date it considerably earlier, towards the second half of the fourth decade. A date *c*1437/8, as proposed by Pope-Hennessy (1952, p.172), seems to me convincing.

17 See the commissioning contract published by Orlandi (1964, p.187f.). The painting is now in the Museo di San Marco.

18 This altarpiece, begun by Lorenzo Monaco around 1420 and completed after his death by Fra Angelico, has been variously dated: cf. Pope-Hennessy (1974) p.210. In the light of recently discovered documents (Orlandi (1964) p.45f.; R.Jones in *La Chiesa di Santa Trinita a Firenze*, edd. G.Marchini and E.Micheletti (Florence, 1987) p.125f.), a date in the first half of the fourth decade, on which most scholars are generally agreed, appears to be confirmed more specifically as 1432.

19 Gomez Moreno (1957) p.188f.

20 See on this point D.Covi, 'Lettering in Fifteenth Century Florentine Painting', *Art Bulletin* XLV (1963) pp.1–17.

21 Imitations of 'oriental' lettering also appear in the works of Gentile da Fabriano, who sometimes actually copied arabic inscriptions: K.Christiansen, *Gentile da Fabriano* (London, 1982) p.99. They are also included in the hem of the Madonna's dress in Fra Angelico's triptych of St Peter Martyr. Only at a later date, for instance in the *Madonna* of the Duke of Alba (Pope-Hennessy (1974) pl.10), do they form the words of prayers, as in the present painting. From the mid-1430s (the Annalena altarpiece and the Cortona *Annunciation*), the border decoration becomes either purely ornamental or contains words formed of Romanizing Gothic capitals.

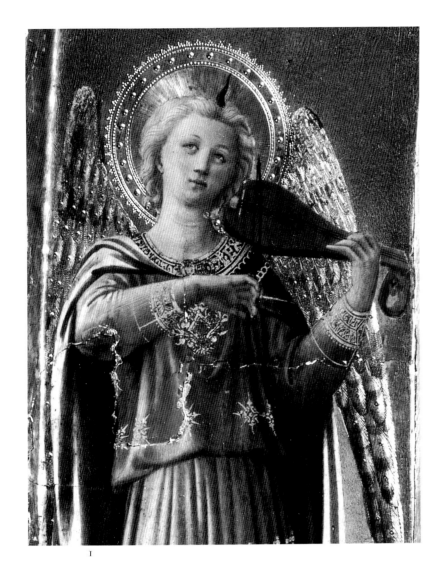

I

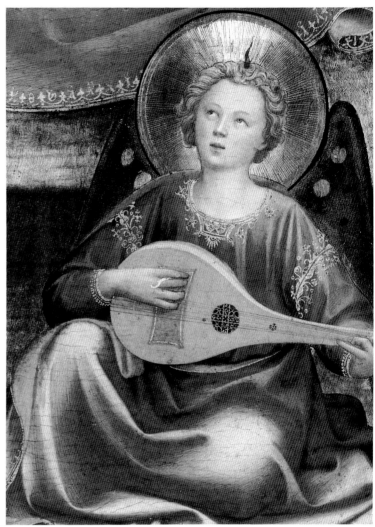

Detail [2] right-hand angel

decorated with punches, but in a regular pattern as though the cloth were laid out flat, with the folds rendered by means of transparent varnishes over the gold to suggest a slight undulating movement.[22] Later the artist attempted to achieve more illusionistic effects, simplifying the decorative patterns which, partly incised and partly painted, he designed in perspective foreshortening according to the folds of the material. In the Thyssen *Madonna* the curtain held up by the angels has an unforeshortened pattern, which partly overlaps in the deep folds at either side. In the Linaioli tabernacle, on the other hand, the artist attempted a bold new method: in the hollow of the niche created by the sumptuous hanging the pattern is proportionately smaller than in the foreground, where the same material is spread out on either side. This optically convincing solution must have been very slow and laborious, and by the mid-1430s the artist had gone back to the system whereby the material formed a flat surface, decorated with regular patterns, which could be easily rendered in perspective. The convincing illusionistic effect of the brocade covering the cushion in the Thyssen *Madonna*, and likewise the fabric behind the throne in the Louvre *Coronation* and in various other paintings generally dated after the Linaioli tabernacle, is obtained by stretching out the material like a tapestry over a flat surface.[23] This simplified method of giving his hangings a foreshortened effect persisted in Angelico's works until the end of his career.

As for the composition, the presence of the three angels holding up the curtain, and in particular the strongly foreshortened one at the top, have rightly been related to similar

FIG 1 Fra Angelico, Linaioli tabernacle, detail showing angel playing rebec (Florence, Museo di San Marco)

FIG 2 Fra Angelico, *The Deposition*, detail showing David playing cither (Florence, Museo di San Marco, formerly Santa Trinità)

Notes
22 See, for instance, the Prado *Annunciation*, the Parma *Madonna* or the *Madonna and Child and the Holy Trinity* (Florence, Museo di San Marco).
23 Materials with a foreshortened geometrical design are used for the cushion in the Pontassieve *Madonna* (Uffizi), for the draped seat in the Cortona *Annunciation* and for the Madonna's draped throne in the altarpieces of Cortona, Annalena and Bosco ai Frati (today in the Museo di San Marco in Florence), of 1450/2.

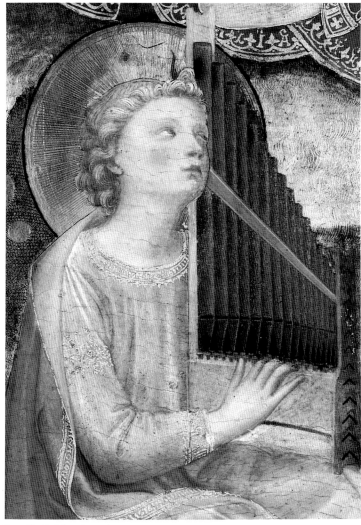

Detail [2] left-hand angel

2

24 Noted in particular by L. Venturi (1930, 1931) and Salmi (1958), with reference to the angels holding up the curtain in the *Madonna and Child with Saint Anne* (Uffizi); to which one can add the earlier version of the same motif in the National Gallery, Washington *Madonna*. Cf. L. Berti, *Masaccio* (Florence, 1988) pp.121, 131.

25 The motif of angels holding up a curtain behind the Madonna enthroned was already well known to Tuscan painters in the fourteenth century. The group of the Madonna and Child is reminiscent of such Giottesque prototypes as the *Madonna* in the St Nicholas Chapel in the Lower Basilica at Assisi; G. Previtali, *Giotto e la sua bottega* (Milan, 1967) fig.130.

26 This panel, executed in 1438/40, is now in the Museo di San Marco in Florence; Pope-Hennessy (1974) p.199f.

examples in Masaccio's works.[24] In other respects, however, the artist seems to have progressed beyond his strictly Masaccesque phase and one might even hypothesize that both artists took over the motive from an earlier fourteenth-century prototype. This would also explain certain slightly archaic aspects of the Thyssen *Madonna*, such as the frontal pose of the Virgin, which is unusual in Angelico's œuvre.[25] There is nothing archaic, on the other hand, in the execution. The sculptural forms outlined by slowly undulating contours are built up, wherever possible, by means of broad expanses of colour, without using strong tonal contrasts or sharp outlines. Delicately graduated shades model the features where the fall of intense light excludes the use of chiaroscuro. The luminous but subdued hues are enriched by a few unusual touches, such as the shot tints in the angels' tunics in the foreground. Lastly, the pensive and absorbed expressions of the figures have neither the sweet, child-like devotional quality still present in the *Last Judgement* of 1431 nor the subtle analytical introspection to be found in certain figures in the *Lamentation* of Santa Maria della Croce al Tempio.[26]

The works that come closest to the Thyssen *Madonna* remain the Louvre *Coronation*, in which the figure of St Catherine (in the foreground to the right) and the pose of her right arm and hand remind one of the *Madonna* and the Linaioli tabernacle (FIG 1). The angels both in the tabernacle and in the Santa Trinita *Deposition* (FIG 2) evoke those in the painting discussed here. These factors strongly suggest that the *Madonna* was executed some time between 1433 and 1435, but probably nearer the former date.

Barnaba da Modena *c*1328/30–1386 or after

3 The Madonna and Child with two angels

*c*1374
Tempera on panel, 51.5 × 37.6 cm; painted surface, 48 × 34.5 cm; thickness *c*1.2 cm
Signed ' + BARNABAS DE MUTINA PINXIT IN JANUA'
Accession no.1989.8

Provenance
New York, private collection
Thyssen-Bornemisza Collection, 1989

The Virgin, half length, is seated before a gold hanging held up by two angels, with the Child standing on her lap. In his left hand is a scroll with the words 'Beati q < ui > / audiunt/ verbum / dei < et > cus/todiunt/ illud'. The Madonna's halo is inscribed 'AVE + GRATIA + PL[ENA]'.[1]

The painting, which has lost its original engaged frame, is generally well preserved. Two vertical cracks on the left have caused some flaking in the hanging and in the Madonna's cloak and there is a third, smaller crack under her right arm. There are other more or less small colour losses in the Virgin's cloak, face and neck (under her right eye and near her chin) and in the Child's tunic, all of which were inpainted during the course of the restoration carried out by Marco Grassi. The back of the panel is covered with a layer of brick-red paint, except for three horizonal strips corresponding to a wooden support added at some later date. These areas reveal remains of the gesso preparation and of the dark brown paint which originally coated the whole surface.

Note
1 These are, of course, the words of the angelic salutation (Luke 1: 28), while the words on the scroll correspond to another passage from the same Gospel (11:28). For the type of composition, which may have been inspired by a Tuscan prototype similar to the *Madonna* by Lippo Memmi (Berlin, Gemäldegalerie, no.1081a), see Shorr, *Devotional Images*, p.90.

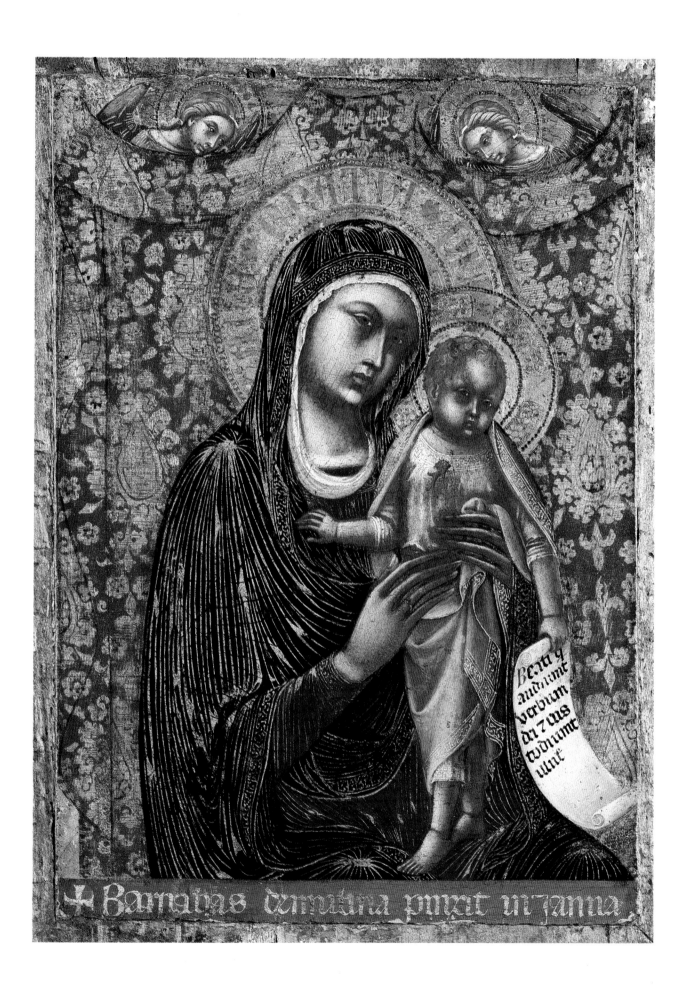

One of the artist's many signed works, this hitherto unpublished painting stands out for its jewel-like beauty and fine workmanship. This, its small scale, and the fact that it was primed and painted on the back suggest that it may have been the left wing of a diptych intended for private devotion – a hypothesis which cannot be proved, owing to the loss of the frame. As to the painting's place in the artist's œuvre, one may note the close similarities – in the faces, in the dense chiaroscuro of the modelling and in the careful execution – with another small signed *Madonna* by Barnaba (London, Courtauld Institute Art Galleries, Lee collection).[2] The Lee *Madonna* is undated; however, another similar panel (Turin, Galleria Sabauda; FIG 1)[3] is dated 1370 and has the same motif of the standing Infant, holding a scroll, stepping forward and looking towards the spectator, present in the Thyssen painting. A possible clue to the Thyssen painting's date is also provided by the motif of the two angels holding up the rich hanging behind the Madonna;[4] they are to be found in one of the shutters of a small altarpiece dated 1374 (London, National Gallery),[5] and again in the *Madonna* of San Giovanni at Alba (1377),[6] in the *Madonna 'dei Mercanti'* (c1380; Pisa, Museo Nazionale)[7] and in other presumably late paintings,[8] but not in Barnaba's earlier works. These considerations, which suggest placing the Thyssen panel not earlier than the mid-1370s, are supported by stylistic analysis as well. The emphasis on the linear element, which in both the Frankfurt panel (1367)[9] and in the one formerly in Berlin (1369),[10] develops into an almost geometric pattern, transforming the folds of the Madonna's lightly draped mantle into a delicate gilded cobweb, tends to diminish from 1370 onwards. Barnaba's works of the eighth decade are characterized by dense shadows round the eyes, along the nose and under the lower lip and chin, shadows which, together with the intense highlights, emphasize the elongation of the fingers and the rotundity of the faces, and give an almost illusionistic sharpness to the image. Mary's gold-striated robe, unlike that in works such as the Alba *Madonna* with its wider and more regular lines, is no longer an abstract symbol of majesty, but a means of giving luminosity to the material and, through its gathers and folds, of defining the volume and movement of the figure. However, already in the Alba *Madonna*, and in the probably slightly later Ventimiglia and Pisa *Madonnas*, the chiaroscuro contrasts are less strong and the figures have a softer and more fleshy consistency, together with heavier, square-set forms, that suggest the influence of Tuscan models. Since in the Thyssen panel this trend is totally absent, and since the angels holding up the hanging are almost traced from the music-making angels in the *Coronation of the Virgin* in one of the National Gallery panels, its date is in all probability around 1374.

Notes

2 See [P. Murray], *Catalogue of the Lee Collection. Courtauld Institute of Art* (London, 1962) p.1 (not illus.) and Berenson, *Italian Pictures* (1968) fig.275. For another very similar *Madonna*, in the church of San Michele at Tortona, see P. Toesca, 'Dipinti di Barnaba da Modena', *Bollettino d'Arte* II (1922–3) p.292.

3 See N. Gabrielli, *Galleria Sabauda. Maestri italiani* (Turin, 1971) p.61f., no.21.

4 Whereas in other pictures by the artist the ornamental motifs of the hanging are painted in gold over a coloured background, in the Thyssen panel the purple of the fabric is painted in a transparent glaze over the gold (which is enriched by a punched design).

5 No.2927; for these panels, representing the *Coronation of the Virgin*, the *Trinity*, the *Virgin and Child with donors* and the *Crucifixion*, see M. Davies and D. Gordon, *National Gallery Catalogues. The Early Italian Schools before 1400* (London, 1988) p.7f.

6 L. Mallé, *Le arti figurative in Piemonte*, I (Turin n.d. [1973]) fig.301.

7 See E. Carli, *Il Museo di Pisa* (Pisa, 1974) p.56f., fig.66.

8 Such as the *Madonna* in Pisa, Museo Nazionale (Carli (1974) p.56, pl.XIII), or that in the Cathedral of Ventimiglia; *La pittura a Genova e in Liguria dagli inizi al Cinquecento* (Genoa, 1970) fig.44.

9 No.807; Städelsches Kunstinstitut. *Verzeichnis der Gemälde* (Frankfurt, 1966) p.14, fig.2.

10 No.1171; Staatliche Museen Berlin. *Die Gemäldegalerie. Die italienischen Meister, 13. bis 15. Jh.* (Berlin, 1930) p.9. The picture was destroyed in 1945.

FIG 1 Barnaba da Modena, *Madonna and Child* (Turin, Galleria Sabauda)

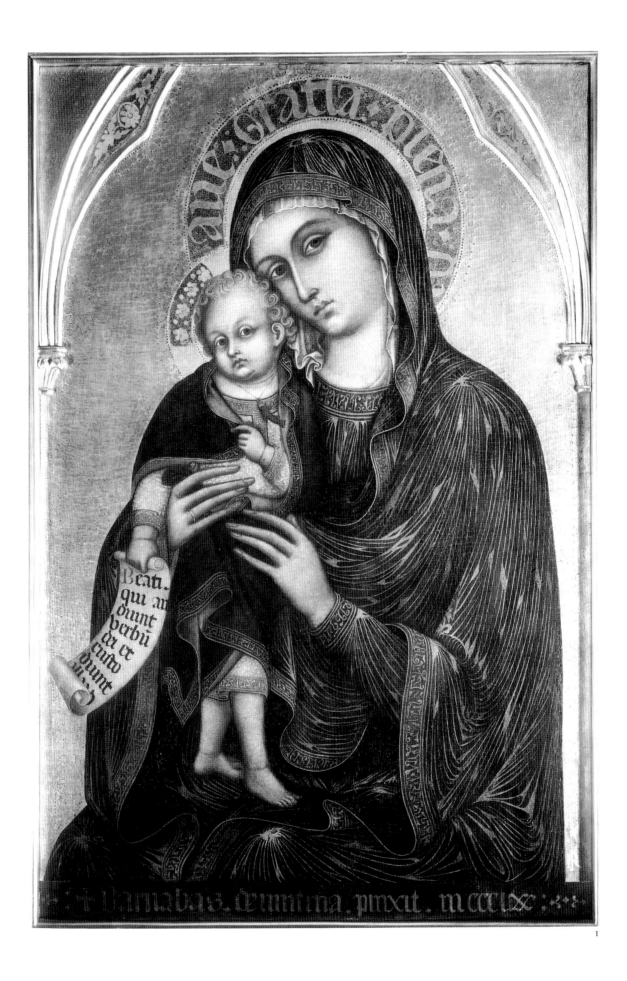

Bartolomeo di Messer Bulgarino (or Bulgarini) *c*1300/10–1378

4 The Madonna and Child enthroned with a female martyr, St John the Baptist and four angels

*c*1340–5
Tempera on panel, 48 × 26 cm; thickness 1.5 cm
Accession no.1981.35

Provenance
Rev.H.Hawkins, England
Christie's, London, 25 March 1977, lot 18
Thyssen-Bornemisza Collection, 1981

Literature
Important Old Master Pictures, sale catalogue (Christie's, London, 25 March 1977) lot 18
G.Chelazzi Dini in *Gotico a Siena* (1982) pp.163, 254
J.Pope-Hennessy, 'Some Italian Primitives', *Apollo* CVIII (1983) p.12
Thyssen-Bornemisza (1986) p.181, no.176c
Thyssen-Bornemisza (1989) p.59

The Madonna, wearing a crown, is seated almost frontally on a large throne draped with a rich brocade canopy embroidered with gold. On her lap sits the Christ Child who looks up towards her, holding a bird on a string in his right hand.[1]

The condition is generally good except for some rubbed areas in the gold ground and a few very small colour losses (in the tunic of the upper right-hand angel and in the female saint's dress). The Madonna's face and those of the saints are also somewhat rubbed. The circular depression in the gable of the throne (diameter 3.5 cm) was probably intended for a coloured-glass inlay or a semi-precious stone.[2] The original frame is lost and the present one is modern. The back of the panel, which is painted to imitate porphyry, has a stamped number '538 Y A' and another in white 'IMP 831'.

This is the central panel of a small triptych the wings of which have not so far been traced. It was first published in Christie's sale catalogue in 1977 as a work by 'Ugolino Lorenzetti'. This attribution is accepted by Chelazzi Dini (1982), who dates it around 1335 when the artist, in her opinion, was still in Pietro Lorenzetti's workshop; by Pope-Hennessy (1983), who considers it to have been painted with the help of assistants; and by the authors of the catalogues of the Collection (Thyssen-Bornemisza (1986) and (1989)).

Notes
1 The little bird, which the Christ Child often holds in Italian paintings dating from the fourteenth to the sixteenth centuries, and which can sometimes be identified as a goldfinch or robin, is a realistic motif: such birds were commonly children's pets in that period. At the same time, it was intended as a symbol of Christ's Passion and Resurrection, that is, of his triumph over death: cf. H.Friedmann, *The Symbolic Goldfinch. Its History and Significance* (New York, 1946).
2 Borghero (Thyssen-Bornemisza, 1986) believes that the cavity may have contained a relic. However, both its small size and its position (the gable of the throne would have been a most unlikely place for a relic) suggest a setting for a stone, in keeping with the tradition found in thirteenth- and sometimes fourteenth-century painting.

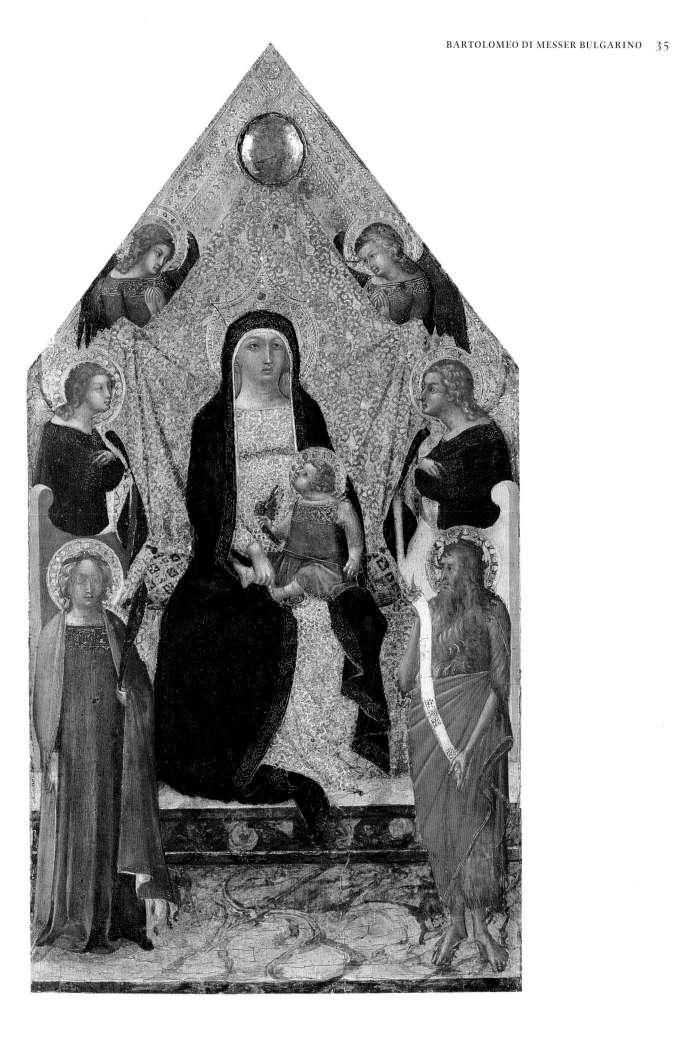

As is explained below (in the Biographies, p.214), there is no reason to doubt the identification of 'Ugolino Lorenzetti' with Bartolomeo Bulgarini. Little need be added to confirm the authorship of this work, which fits easily into the artist's œuvre. As is often the case in his paintings, the composition has the hallmark of the Lorenzetti,[3] and also typical of the artist are the golden brocade draperies falling in deep folds, the facial types and the gentle communicative mood. One may compare the Madonna with that in a panel in Siena (Museo dell'Opera del Duomo),[4] the St John with the same saint at the centre of the triptych formerly in the New-York Historical Society,[5] the other saint with the *St Catherine* in the National Gallery, Washington,[6] and the angels with some of the figures in the triptych now divided between the Isabella Stewart Gardner Museum, Boston (see FIG 1 and detail), and the Johnson Collection, Philadelphia.[7] It is less clear where to include the Thyssen panel within the still uncertain chronological sequence of Bartolomeo's œuvre. The diminutive figures of the two *biccherna* panels dated 1329 and 1339 respectively[8] are too badly preserved to allow for comparison. We are left with the predella panels of the triptych painted in about 1351 for Siena Cathedral (Paris, Louvre, and Frankfurt, Städelsches Kunstinstitut),[9] which display a structural grandeur and sumptuousness in the draperies that would point to a later phase in the artist's career. A possible *terminus post quem* may be provided by the polyptych in Florence (formerly Museo di Santa Croce),[10] which is so close in its compositional layout to Ambrogio Lorenzetti's San Procolo triptych of 1332[11] as to suggest a roughly contemporary date. Bartolomeo Bulgarini's Santa Croce polyptych, with its surly, slender figures, strongly linear design and sharp-edged folds, fits in with the earliest group of works given to the artist.[12] There are evident differences between it and our painting, which has closer analogies instead with the polyptych formerly in San Cerbone in Lucca,[13] with the *Madonna* in the Seminario of Pienza[14] and with the *Madonna of Humility* in the Rijksmuseum, Amsterdam.[15]

The Virgin's matronly figure and the lively spontaneity of the Child, lifting up his head as if to speak to her, clearly belong to the phase in which Bartolomeo modelled his style on the Lorenzetti's grandiose forms and natural poses. At the same time, his volumes are slightly lacking in plasticity and his drawing, although freer and more fluid than in his earlier compositions, is occasionally slowed by descriptive minutiae. These distinguishing elements point to his full maturity, probably in the 1340s, and a likely date for the Thyssen panel would be early in that decade, when the artist achieved a particularly felicitous blend between late-Gothic refinement and his own warm artistic personality: the result is this intensely human image of the Queen of Heaven surrounded by her court.

Notes

3 The composition is similar for instance to that of Pietro Lorenzetti's triptych (Dijon, Musée, Grangier bequest); E. De Wald, 'Pietro Lorenzetti', *Art Studies* VII (1929) p.157, fig.77.
4 For the panel, from the church of Fogliano, see Berenson, *Italian Pictures* (1968), I, p.435f., fig.65.
5 This painting, published by R. Offner ('Italian Pictures of the New-York Historical Society', *Art in America* VII (1919) p.193, fig.3), was sold at auction in the 1970s and is now in a private collection in Florence.
6 No.521; Rusk Shapley, *Washington. Catalogue* (1979) p.270f., pl.186
7 P. Hendy, *European and American Paintings in the Isabella Stewart Gardner Museum* (Boston, 1974) p.51; B. Sweeny, *John G. Johnson Collection. Catalogue of Italian Paintings* (Philadelphia, 1966) p.18, no.92.
8 I refer to no.K9222 in the Kunstgewerbemuseum, Berlin (Boskovits, *Berlin. Katalog*, p.180f., no.71) and to other inventories as Cod.It.1669 in the Bibliothèque Nationale, Paris (F. Avril in *Gothique siennois*, 1983, p.198f.).
9 No.312 and no.2135 respectively; cf. E. H. Beatson, N. E. Muller and J. B. Steinhoff, 'The St Victor Altarpiece in Siena Cathedral: A Reconstruction', *Art Bulletin* LXVIII (1986) p.621, figs.9 and 10.
10 For a reproduction of this work, which is at present in the storerooms of the Gallerie Fiorentine, see B. Berenson, 'Ugolino Lorenzetti', *Art in America* VI (1918) p.26.
11 Florence, Uffizi, inv.(1890) nos.8731, 8732, 9411; L. Marcucci, *Firenze. Dipinti toscani* (1965) p.159f.
12 I would include in this group, datable to the 1320s or slightly later, the triptych in Siena (Galleria Nazionale and Museo dell'Opera; Berenson (1968) figs.64–6), the *Crucifixion* in Florence (Biblioteca Berenson, Villa I Tatti, Florence; Berenson (1968) p.38, fig.6), two *Saints* in Cologne (Wallraf-Richartz-Museum, nos.610 and 611; B. Klesse, *Katalog der italienischen Gemälde bis 1800 im Wallraf-Richartz-Museum* (Cologne, 1973) p.65f.), the *Crucifixion* in Leningrad (Hermitage, no.5507; *The State Hermitage. West European Paintings. Album of Reproductions* (Moscow, 1957) p.6, fig.3), and the large painted crucifix in S. Maria dei Servi,

Siena (van Marle, *Development*, I, p.161, fig.109, with an erroneous attribution to Niccolò di Segna).
13 Now divided between Lucca, Museo Nazionale; Rome, Museo Capitolino and Washington, National Gallery; Berenson (1968) figs.67–9; M.Meiss, 'Ugolino Lorenzetti', *Art Bulletin* XIII (1931) p.380f., figs.1–5.
14 L.Martini, *Pienza e la Val d'Orcia. Opere d'arte restaurate* (Genoa, 1984) p.26f.
15 No.A4002; *All the Paintings of the Rijksmuseum in Amsterdam* (Amsterdam, 1976) p.635f.

FIG 1 Bartolomeo Bulgarini, *Madonna and Child, saints and angels* (detail) (Boston, Isabella Stewart Gardner Museum)

1

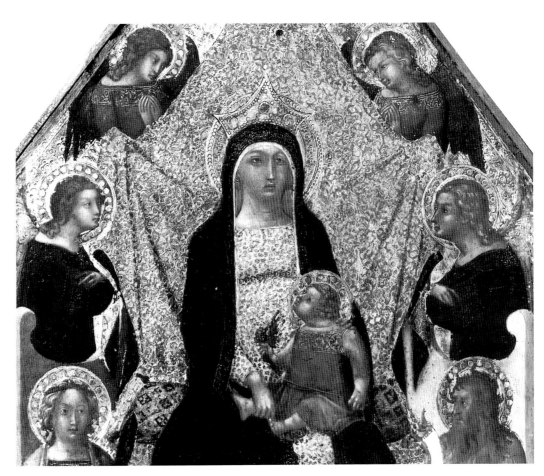

Detail [4] the Madonna and Child

Benedetto di Bonfiglio (or Bonfigli) *c*1420–1496

5 The Annunciation

*c*1455
Panel, 51 × 36.5 cm; thickness 1.2 cm (thinned)
Accession no.1977.23

Provenance
Thomas Pelham Hood, Springmount, Co. Antrim, Ulster, 19th century
Rome, private collection
Thyssen-Bornemisza Collection, 1977

Literature
F. Zeri, 'An Annunciation by Benedetto Bonfigli', *Apollo* CIII, no.12 (1978) pp.394–5
Thyssen-Bornemisza (1981) p.42, no.34A
J. Pope-Hennessy, 'Some Italian Primitives', *Apollo* CVIII, no.3 (1983) p.14
F. Santi, *Galleria Nazionale dell'Umbria. Dipinti, sculture e oggetti dei secoli XV–XVI* (Rome, 1985) p.44
Thyssen-Bornemisza (1986) p.41, no.34a
B. Toscano in *Quattrocento* 1st edn. (1986), p.335; 2nd edn. (1987) pp.368, 381 n.72
M. R. Silvestrelli, *ibidem* p.588
Thyssen-Bornemisza (1989) p.43
F. Todini, *La pittura umbra dal Duecento al primo Cinquecento*, I (Milan, 1989) p.42

The Archangel Gabriel kneels on the left with a lily in his left hand and the other raised in blessing as he pronounces the words 'AVE MARIA GRATIA PLENA', which appear in capital letters against the marble-panelled parapet. At the centre, in the foreground, facing the angel, Mary kneels on a low step listening to the message with her hands joined. Behind her, in the middle distance, is a small cupboard with a lectern on which rests an open prayer-book. Inside the cupboard are two shelves with various books and next to it is a wooden chair with an inlaid back and pierced sides. The open terrace on which the scene takes place is enclosed by a richly decorated parapet, with marble panels framed by pilasters and a classical frieze, resting on a bench-shaped base. Beyond, to the right is a building with a double loggia, presumably intended to be the Virgin's house, and on the left is an extensive landscape with a view of a walled city, two cypresses and distant mountains around a lake. In the upper left corner appears the Eternal Father, surrounded by cherubs, sending forth rays of light with the Dove of the Holy Spirit.[1]

The panel has been thinned and the back has a layer of brown paint coated with wax. A label reads: 'Thomas Pelham Hood of Springmount in the county of Antrim', and another has the inventory number 'cat.34A'. There are many worm-holes, scratches and fine vertical cracks in the painted surface. The colours are rubbed and the modelling, especially in the faces, has suffered considerably. The numerous small colour losses in the faces and draperies have been retouched.

Note
1 For the iconography of the Annunciation in general, see G. Prampolini, *L'Annunciazione nei pittori primitivi italiani* (Milan, 1939) and D. B. Robb, 'The Iconography of the Annunciation in the 14th and 15th Centuries', *Art Bulletin* XVIII (1936) pp.480–526. For the motif of the rays of golden light, obviously referring to Luke 1:35 ('Spiritus sanctus superveniet in te et virtus Altissimi obumbrabit tibi'), see M. Meiss, 'Light as Form and Symbol in some XVth Century Paintings', *Art Bulletin* XVII (1945), pp.175–81. The roses are a common attribute of the Virgin Mary; see M. Levi d'Ancona, *The Garden of the Renaissance* (Florence, 1977) pp.336, 339 and 291. The lilies, commonly regarded as symbols of purity, were originally a symbol of Christ; see Schiller, *Ikonographie*, I, p.62.

As we learn from the label, the painting belonged to Thomas Pelham Hood in the last century. It appeared on the art market in 1977 and was acquired for the Collection the same year. It was published soon after with the correct attribution to Benedetto Bonfiglio by Zeri (1978), who described it as 'a delightful small panel'. He places it 'around 1440–5' and comments on the carefully planned perspective of the richly decorated architectural elements, which are partly Renaissance and partly still Gothic in taste. He also draws attention to analogies with the *Adoration of the Magi* (Berlin, Gemäldegalerie), which is possibly the earliest work known to us by Domenico Veneziano.[2]

The attribution to Benedetto has been accepted by all subsequent critics (Thyssen-Bornemisza (1981, 1986, 1989); Pope-Hennessy (1983); Toscano (1986 and 1987); Silvestrelli (1987); Todini (1989)). Only Santi (1985) questions Zeri's dating and regards the Thyssen panel as a repetition with variations of the large *Annunciation* in Perugia (Galleria Nazionale, no.138), which he maintains was executed not earlier than 1462 and probably even after 1470.[3] However, there seems to be no sufficient reason for such an assertion, which, of course, would imply rather a late place for the picture in the artist's career.

The clarity of the design and the classicizing character of many of the details reveal both the artist's gift for observation and his command of perspective. The space is more carefully thought out and constructed than in the *Nativity* in the Berenson Collection (FIG 1) or in the contemporary works of Boccati,[4] for which Domenico Veneziano seems to have been the most advanced stylistic point of reference. It is true that since the frescoes in Palazzo Baglioni are lost we can only hypothesize what Domenico's style was like at the time of his stay in Perugia (1437/8).[5] On the other hand very little, if anything, of the luminous classical style of Angelico's polyptych, painted for San Domenico in Perugia probably around 1447,[6] seems to be reflected in the works of Bonfigli and Boccati from the end of the fifth decade. The elaborate composition and somewhat ostentatious classicism of our *Annunciation*[7] reflect Fra Angelico's style in his Roman frescoes, a trend which was subsequently taken up by Benozzo Gozzoli, who was also in Rome from 1447 and was then active for over a decade in various towns of Umbria and Lazio.[8] The panelling of different coloured marbles, the fluted pilasters and the festoons in the frieze in the Thyssen *Annunciation* are all elements which presumably became part of Benedetto's repertoire after his stay in Rome around the middle of the century. Apart from this, the presence of Gothic architectural motifs, such as the mullioned windows of the loggia, although persistent in the artist's works, is more compatible with an earlier dating. The carefully realistic rendering of buildings, the wealth of detail and the self-confident use of foreshortening suggest that the execution of the Thyssen panel coincided roughly in date with the artist's first series of frescoes in the Cappella dei Priori.[9]

It seems to me that the *Annunciation* in the Perugia Galleria Nazionale, with its studied elegance in the gestures, petrified draperies and the loggia behind the Virgin apparently inspired by Piero della Francesca, belongs to a considerably later phase. The Thyssen *Annunciation*, however, compares well with the altarpiece of the *Adoration of the Magi* in the same museum,[10] which, although usually included among the artist's early works, has the same grandiose conception and feeling for portraiture as that found in the frescoes of *St Louis* in the Palazzo dei Priori. Certain details of the *Adoration*, such as the landscape with its sequence of uniform hills stretching towards the horizon, the drapery patterns, the arrangement of the Virgin's veil or the types of the angels, come significantly close to the Thyssen *Annunciation*. I would therefore date the Thyssen painting shortly before the *Adoration*, around the mid-1450s.

Notes

2 This painting, no.95a in the Berlin Gallery, is discussed by H. Wohl, *The Paintings of Domenico Veneziano* (Oxford, 1980) p.120f., who plausibly dates it around 1440.

3 Santi (1985) p.42f.

4 For the Berenson *Nativity* see F. Russoli, *La raccolta Berenson* (Milan, 1962) p.LVIII; for the *Madonna 'del Pergolato'* by Boccati, executed in 1446/7 (Perugia, Galleria Nazionale, nos.150, 151) see Santi (1985) p.22f.

5 A badly preserved fragment in the Galleria Nazionale in Perugia (no.443), which probably formed part of the decoration executed for the Baglioni, unfortunately does not help to give an idea of the artist's mature style at that date; cf. Santi (1985) p.13f., and Wohl (1980) p.210f.

6 Perugia, Galleria Nazionale, nos.91–108. Generally dated, on the basis of a sixteenth-century source, to 1437, it has now been convincingly dated by A. De Marchi, 'Per la cronologia dell'Angelico: il trittico di Perugia', *Prospettiva*, no.42 (1985) p.53f., to 1447 or soon after.

7 A slightly less pronounced *all'antica* decoration, using similar motifs to those of the parapet in the Thyssen *Annunciation*, is to be found, for instance, in the scene of St Lawrence before Valerian in the Chapel of Nicholas V in the Vatican (c1447/9; J. Pope-Hennessy, *Fra Angelico*, 2nd edn. (London, 1974) pl.113).

8 See especially Gozzoli's *Annunciation* in the predella of the Montefalco altarpiece (Pinacoteca Vaticana, c1451/2), and one of the lost frescoes of the Santa Rosa cycle at Viterbo (1453), in which the scene is similarly surrounded by a marble parapet with a frieze like the one in the Thyssen panel (A. Padoa Rizzo, *Benozzo Gozzoli pittore fiorentino* (Florence, 1972) figs.41, 85).

9 For this important cycle, probably executed for the most part in the late 1450s, see Santi (1985) p.46f.

10 Nos.140, 141; Santi (1985) p.40f. The composition of the main scene, which is usually related to Gentile da Fabriano's famous Uffizi *Adoration* of 1423, seems to have been inspired instead by later models, such as the *Adoration* today in the National Gallery, Washington, begun by Angelico and completed by Filippo Lippi probably in the late 1440s (Rusk Shapley, *Washington. Catalogue*, p.10f., no.1085).

Bicci di Lorenzo 1373?–1452

6 Three panels
Announcing angel, God the Father blessing and a cherub
Christ on the Cross with the Virgin, St John and a cherub
Annunciate Virgin and a cherub

*c*1430
Tempera on panel
Announcing angel
104.5 × 40.5 cm (including original frame); painted central surface, 69.3 × 30.8 cm; thickness 8.2 cm including
 frame elements
Christ on the Cross
126 × 43.8 cm (including original frame); painted central surface, 75.5 × 31.4 cm; thickness 7.7 cm including
 frame elements
Annunciate Virgin
103.3 × 42.4 cm (including original frame); painted central surface, 69 × 31.9 cm; thickness 7.7 cm including
 frame elements
Accession nos.1976.102.1–3

Provenance
Mrs Peter Somerwell, Fettercairn House, Kincardine
Sotheby's, London, 24 June 1970, lot 12
Thyssen-Bornemisza Collection, 1976

Literature
Catalogue of Important Old Master Paintings, sale catalogue (Sotheby's, London, 24 June 1970) lot 12
Thyssen-Bornemisza (1977) p.21, no.30a
Thyssen-Bornemisza (1981) p.36
Thyssen-Bornemisza (1986) p.35, no.30a
Thyssen-Bornemisza (1989) p.37

On the whole these three panels have reached us in excellent state and complete with their original frames, re-gilt and repaired in a few places, for instance in the capitals of the pilasters. The original lobed trefoil base of the two side panels, which would have resembled that of the central panel, has been cut off and replaced by a strip of wood. The painted surface is practically intact except for some minor losses in the angel's wings, a few worm-holes and a thin vertical crack beneath the cherub in each pinnacle. On the back of the *Crucifixion* and of the *Announcing angel* is the stamp of the Soprintendenza export office of Florence and the date 8 September 1970; on the back of the central panel there is also the number 253 painted in blue. Behind the panel with the Virgin, besides traces of a sealing wax stamp, is a label stating: 'Quadro di Tommaso detto Giottino trovato in una stanza murata, di una delle fabbriche di S. Maria del Fiore di Firenze, le quali sono state demolite per ingrandire la piazza di detta Metropolitana'.
The three panels were acquired on the Florence art market in 1976. Previously they had

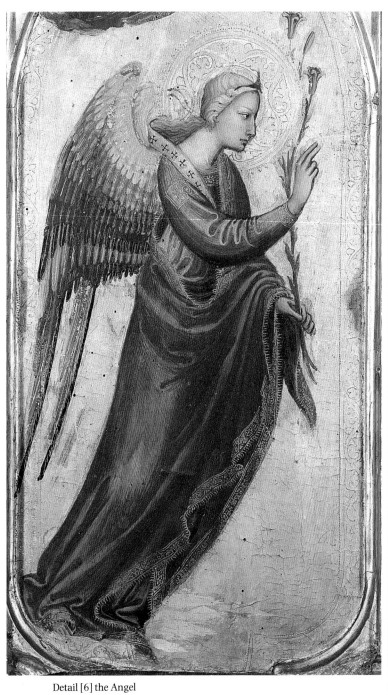

Detail [6] the Angel

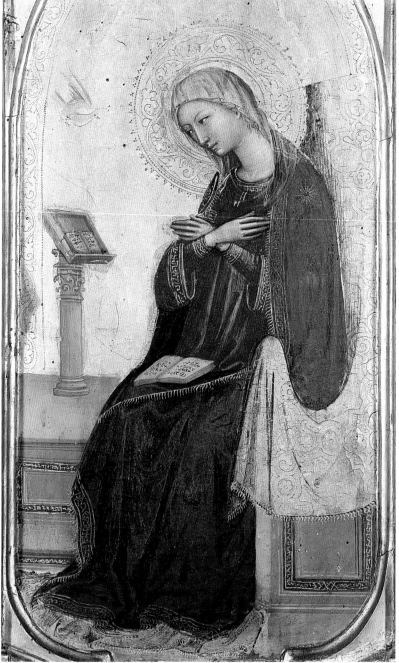

Detail [6] the Virgin

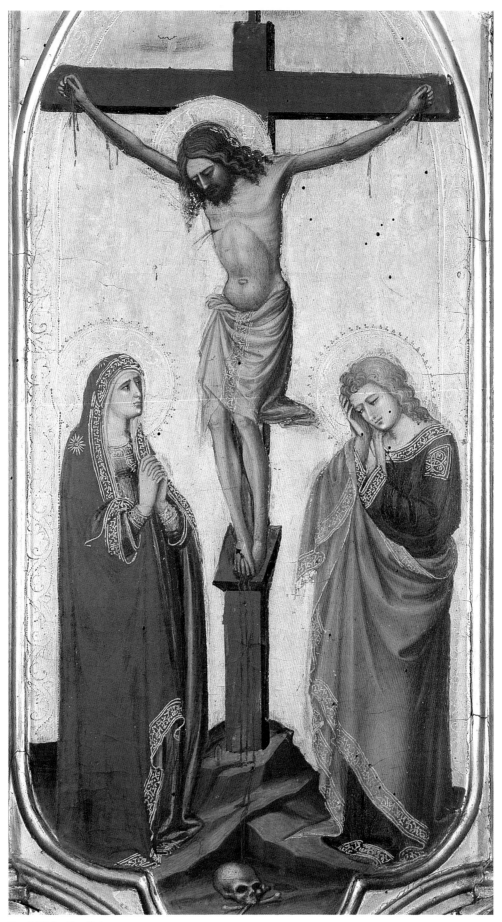

Detail [6] the Crucifixion

appeared at a sale at Sotheby's in London of 24 June 1970 (lot 12) as the 'property of Mrs Peter Somerwell, removed from Fettercairn House, Kincardine'. Peter Somerwell may have been a descendant of Graham Charles Somerwell, the collector who exhibited a number of Italian primitives at Edinburgh in 1883,[1] but I can find no proof of this. There is no reason to doubt the accuracy of the information concerning the provenance of the painting contained in the label. It is known that in 1826 it was decided to pull down the old house of the canons of Florence Cathedral in order to enlarge the Piazza.[2] The three panels would presumably have been sold around that date.

As for their original location, one may assume on the evidence of other examples that they formed the pinnacles decorating the summit of a very large polyptych. Bicci's œuvre as known to us today includes only one polyptych complete with the same elements, the altarpiece dated 1435 in the Pieve of Bibbiena.[3] However, the pinnacles of this work, which represent the Death, Resurrection and Ascension of Christ, are quatrefoil in shape and their style is more in keeping with late-Gothic tendencies compared to the Thyssen panels. More similar in subject, size and shape are the three crowning elements of a polyptych by Mariotto di Nardo (Florence, Accademia),[4] which measures altogether two and a half metres in width and almost three metres in height. If it is justified to attempt, on the basis of this example, to reconstruct the approximate shape and dimensions of the lost complex to which these three panels belonged, then the complex must have represented two or more saints in the wings (measuring about 160/80 cm by 80/90 cm), flanking a central panel of just over the same size.

The three panels were published for the first time in the 1970 sale catalogue, already correctly attributed to Bicci di Lorenzo. This attribution was accepted in the Collection catalogue (Thyssen-Bornemisza, 1981) and a date in the 1430s was later proposed (Thyssen-Bornemisza, 1986). The panels figure under the same name in Thyssen-Bornemisza (1977, 1981, 1986, 1989).

The problem of the chronology of Bicci's vast œuvre is still open to discussion, despite the fact that many of his works are signed and dated. The reason for this is the general consistency of the artist's compositional formulae, which he often repeated with imperceptible changes. However, if one compares the Stia triptych of 1414 with works such as the Vertine triptych[5] of 1430 or the polyptych formerly in the Florentine church of San Niccolò a Cafaggio of 1433,[6] it is evident that over a period of twenty years Bicci's style gradually lost the emphatic quality present in his paintings of the second decade and took on a more volumetric consistency, greater ease in design and finer modelling. The Vertine triptych would seem to come closest to the panels discussed here: the tall, slender figures, poised in their gestures, are attired in thickly pleated robes that still reflect late-Gothic taste, while their well defined forms and secure placing in space are a tribute to Masolino's Florentine works of the 1420s. Many of Bicci di Lorenzo's paintings are stylistically akin to the three Thyssen-Bornemisza panels, but, except for the lost Berlin predella of 1423 (formerly Kaiser-Friedrich Museum, no.1064a), the triptych of 1427, recently discovered in the Archivio Capitolare of Florence Cathedral,[7] and the Vertine triptych, they are all of uncertain date. They include panels from altarpieces representing *Saints* (Arezzo, Museo Diocesano; Cortona, Accademia Etrusca;[8] Florence, Accademia, no.12 dep.; Parma, Pinacoteca Stuard; Rome, Galleria Doria Pamphili; San Francisco, De Young Memorial Museum, no.554.869), a painted crucifix (Santa Maria della Croce al Tempio, Florence) and numerous devotional works representing mostly the *Madonna and Child with saints*.[9] All these works are datable approximately to the decade 1423/33.

The execution of the three Thyssen panels is to be placed, in my opinion, close to 1430 and, in any case, after the Florentine triptych of 1427. Stylistically they are particularly close to the two laterals of a polyptych at Parma (FIGS 1 and 2). Apart from their compatible size[10] and similarity in style, there are also other factors to be considered. It is known that the two Parma panels were acquired in Florence at the end of the eighteenth century and that an important, venerated relic of St James the Great, who is represented in the place of honour in the left lateral,

Notes
1 *Old Masters and Scottish National Portraits Exhibition*, at the Royal Scottish Academy.
2 C.J.Cavallucci, *Santa Maria del Fiore. Storia documentata dall'origine fino ai nostri giorni* (Florence, 1881) p.95.
3 Berenson, *Italian Pictures* (1963) fig.511.
4 Nos.3258–60, 8612–3; G.Bonsanti, *La Galleria dell'Accademia* (Florence, 1987) reproduced p.71.
5 Today in deposit in the Galleria Nazionale, Siena: P.Torriti, *La Pinacoteca Nazionale di Siena. I dipinti dal XII al XV secolo* (Genoa, 1977) p.411.
6 Now divided between the Parma Gallery and the Metropolitan Museum, New York (Lehman collection). Berenson (1963) fig.506; for the triptych in Santa Maria Assunta in Stia, *ibid*, fig.498.
7 M.Sframeli, 'Due inediti fiorentini del Quattrocento ritrovati nell'Archivio Capitolare fiorentino', *Paragone* XXXIV, no.395 (1983) pp.35–40
8 Photograph Soprintendenza, Florence, no.49592.
9 Assisi, Museo del Sacro Convento, no.10; Fabriano, Pinacoteca; Greenville, Bob Jones University Collection of Religious Art, no.57.11; Florence, formerly Ameri collection, photograph Soprintendenza no.501; Montepulciano, Museo Civico; etc.
10 The panels at Parma measure 119 × 74 cm and 120 × 72 cm respectively.

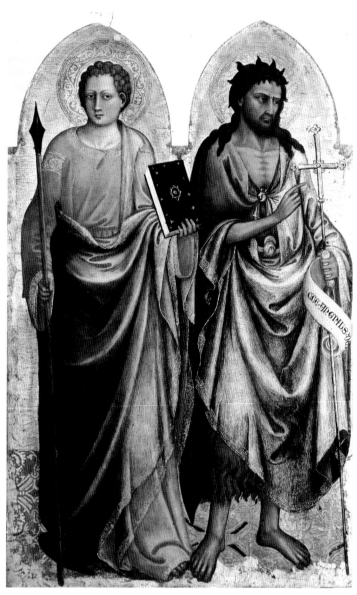

FIG 1 Bicci di Lorenzo, *Sts Thaddaeus and John the Baptist*
(Parma, Pinacoteca Stuard)

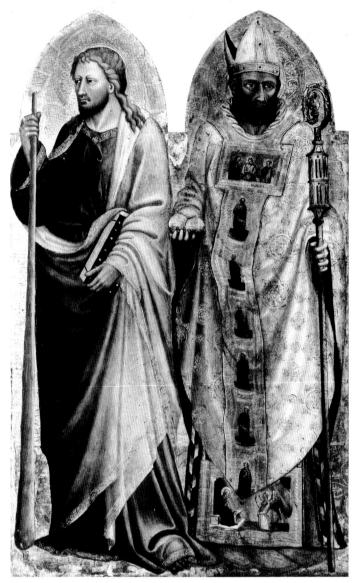

FIG 2 Bicci di Lorenzo, *Sts James the Less and Nicholas of Bari*
(Parma, Pinacoteca Stuard)

11 G. Richa, *Notizie istoriche delle Chiese fiorentine*, VI (Florence, 1757) pp. 193, 196.

12 G. Prampolini, *L'Annunciazione nei pittori primitivi italiani* (Milan, 1939) and Schiller, *Ikonographie*, I, p. 5f.

13 Luke 1:35.

14 For example the mosaic by Jacopo Torriti in Santa Maria Maggiore, Rome.

15 G. Freuler in *De Arte et Libris. Festschrift Erasmus, 1934–1984* (Amsterdam, 1984) p. 153f.

was preserved in Florence Cathedral.[11] One may hazard the conjecture, albeit with due caution, that both the Lugano and the Parma panels originally belonged to the same polyptych in this latter church.

The iconography of the Annunciation with the Virgin seated, as she is represented from the earliest Christian times, is also that most commonly found in Tuscan painting of the fourteenth and fifteenth centuries.[12] The dove of the Holy Spirit (in the panel with the Virgin) and the rays of light (above the Angel) also belong to the traditional iconography of the scene and are to be found already in the eleventh century illustrating the Angel's words, 'virtus Altissimi obumbrabit tibi'.[13] From the end of the thirteenth century,[14] God the Father was frequently represented half-length sending forth the rays and portrayed – in Tuscan painting of the fourteenth and early fifteenth centuries – with the features of Christ. The open book on the stand, according to the tradition already recorded in the *Meditationes Vitae Christi* by Pseudo-Bonaventura, represents the Holy Bible open at the words of the prophet Isaiah (VII, 14): 'Ecce Virgo concipiet'. The influence of Pseudo-Bonaventura is probably also reflected in the way Gabriel is shown flying down towards the Virgin.[15]

Giovanni Boccati c1410–1480 or after

7 St Sabinus conversing with St Benedict

1473
Panel, 27 × 35.9 cm; thickness c1.9 cm
Accession no.1977.4

Provenance
Chapel of San Savino, Palazzo Petrangeli, Orvieto
Church of the Holy Angels, Hoar Cross, Staffordshire, property of Mrs Emily Meynell, by 1871
Christie's, London, sold 5 December 1969, lot 127
Finarte, Milan, sold 5 April 1973, lot 58
Thyssen-Bornemisza Collection, 1977

Exhibition
Milan, Finarte, 1971, no.20

Literature
Highly Important Pictures by Old Masters, sale catalogue (Christie's, London, 5 December 1969) p.81, lot 127
C.Volpe, *Mostra di dipinti del XIV e XV secolo*, exhibition catalogue (Finarte, Milan, 1971) p.48, no.20
P.Zampetti, *Giovanni Boccati* (Milan and Venice, 1971) pp.14, 201, pl.126
L.Colli, 'Giovanni Boccati', in *Dizionario Bolatti*, II (Turin, 1972) p.164
Asta di dipinto dal XIV al XVIII secolo, sale catalogue (Finarte, Milan, 5 April 1973) p.14, lot 58, fig.L
G.Dillon, 'Per Giovanni Boccati', *Paragone* xxx, no.357 (1979), p.76 and no.4, pp.79–80
Thyssen-Bornemisza (1981) p.39, no.33A
J.Pope-Hennessy, 'Some Italian Primitives', *Apollo* cxviii, no.3 (1983) p.14
A.Vastano in *Urbino e le Marche prima e dopo Raffaello*, exhibition catalogue (Florence, 1983) p.41, no.4
Thyssen-Bornemisza (1986) p.38, no.33a
Thyssen-Bornemisza (1989) p.40

The painting represents Sts Benedict and Sabinus (or Savinus), Bishop of Canosa, seated on a bench cut out of a rock, outside the chapel of a rustic monastery, near a ruined tower. The scene, which is set in an extensive hilly landscape with a view of a walled city, illustrates the first episode of the story of St Sabinus, when he met St Benedict at Monte Cassino to discuss Totila's entry into Rome.[1]

This small panel, which was sawn from the predella to which it originally belonged and now has a protective wooden strip along the edges, is on the whole in fair condition. A narrow horizontal crack across the faces of the two figures has damaged the painted surface, and another deeper crack, running from the right side of the panel to the hand of St Sabinus, has caused some small colour losses, which were inpainted when the picture was restored between 1969 and 1971. There are various lacunae in the foreground, at the centre and on the left, in the tower and in the landscape on the right and along the right edge; these losses have been inpainted in a neutral shade. On the back of the panel is a patch of original light-grey colour on the left; the rest of the wood is bare. There is also a stamp with the number 'N.32SG' and two indecipherable wax seals.

This was originally part of the predella of an altarpiece, dated 1473, painted for the Chapel of San Savino at Orvieto, which is first recorded in the early nineteenth century as a work by Perugino.[2] It was later attributed to Boccati by Cavalcaselle, who observed that the Madonna's face had been repainted.[3] Although the panel is said in the literature to have originated from a chapel of San Savino in Orvieto Cathedral,[4] this does not find confirmation in the local guides,

Notes
1 On the life of St Sabinus, who died in 566, see *Gregorii Magni Dialogi libri IV*, ed. U.Moricca (Rome, 1924) pp.102–3, 145–6; G.Kaftal, *Central and South Italian Schools* (1965) p.988; Dillon (1979) p.80 note 5.
2 See *Descrizione del Duomo di Orvieto e del pozzo detto di San Patrizio per servir di guida al viaggiatore* (Orvieto, 1857) p.46 (based on a manuscript of 1829 now in the Biblioteca Comunale of Orvieto).
3 Crowe and Cavalcaselle, III (1866) p.116 note 3.
4 Nor is there any record of a chapel dedicated to St Sabinus in the Cathedral: see for instance *Notizie Istoriche dell'Antica, e Presente Magnifica Cattedrale d'Orvieto* (Rome, 1781).

1

which mention the altarpiece in connection with the Chapel of San Savino in Palazzo Pietrangeli. This palace had previously been owned by the Counts of Marsciano, 'a noble and powerful family of Orvieto', which presumably commissioned the painting from Boccati;[5] after several changes of ownership, the palace passed to the Pietrangeli family in 1807.[6] Boccati's altarpiece is also described there in later years and it is likely that it remained *in situ* until the end of the nineteenth century, when it appeared on the Florence art market and was acquired by the Museum of Fine Arts of Budapest in 1895, still complete with its fine original frame (as it remains today; FIG 4) but without its predella. The fact that the latter finds no mention in the sources has been explained by Dillon (1979) as due probably to its poor condition compared to that of the main panel and to its dismemberment before the altarpiece was first published.

Two of the predella scenes were discovered in private collections and attributed to Boccati by Borenius. Constable then recognised the subjects as relating to the legend of St Sabinus and suggested their connection with the altarpiece of 1473.[8] Now that the two further scenes have reappeared, it can be confirmed that the series illustrates the life of St Sabinus, the titular saint of the chapel, as narrated in the early ninth-century text on the saint's life and the *Dialogi* of Gregory the Great. The sequence can be reconstructed as follows: the first scene (the Thyssen panel) represents Sts Benedict and Sabinus meeting at Monte Cassino to discuss Totila's entry into Rome; the second (formerly Rome, Mario Lanfranchi collection; auctioned by Semenzato, Venice, 1985; FIG 1) shows St Sabinus, who had become blind, giving proof of his powers of divination by recognising Totila at a banquet; the third (Urbino, Galleria Nazionale; FIG 2) represents Archdeacon Vindemius attempting to poison Bishop Sabinus in order to succeed to his office, with Sabinus drinking from the cup unharmed while Vindemius dies ('ac si per os episcopi ad archidiaconi viscera illa venena transissent'); the fourth scene (formerly Paris, Spiridon collection and later New York, Weitzner collection; FIG 3) represents the saint's death.[9]

Notes
5 B.Feliciangeli, 'Opere ignorate di Giovanni Boccati', *Rassegna bibliografica dell'arte italiana* IX (1906) p.9; see also *idem*, *Sulla vita di Giovanni Boccati da Camerino* (Sanseverino, 1906) p.13.
6 After belonging to the Marsciano family, the palace and the adjoining Chapel of San Savino passed to Monsignor Carvajal Simoncelli, Bishop of Soana (1589). The Pietrangeli family acquired it in 1807 from the Marchese del Monte of Florence: T.Piccolomini Adami, *Guida Istorico-artistica della città di Orvieto* (Siena, 1883) p.198.
7 T.Borenius, 'Some Reconstructions', *Apollo* II (1925) pp.200–3.
8 W.G.Constable, 'A Reconstruction continued', *Apollo* VII (1928) p.155.
9 Some doubts on the identification of this scene as the death of St Sabinus, as proposed by Constable (1928), were expressed by the compiler of the exhibition catalogue, *Italian Art from the 13th to the 17th century* (Birmingham, 1955) p.12. See, however, Kaftal (1965) cols. 988–90.

FIG 1 Giovanni Boccati, *St Sabinus recognising Totila* (formerly Rome, Mario Lanfranchi collection)

FIG 2 Giovanni Boccati, *Archdeacon Vindemius attempting to poison St Sabinus* (Urbino, Galleria Nazionale)

2

FIG 3 Giovanni Boccati, *Death of St Sabinus* (formerly Paris, Spiridon collection; present whereabouts unknown)

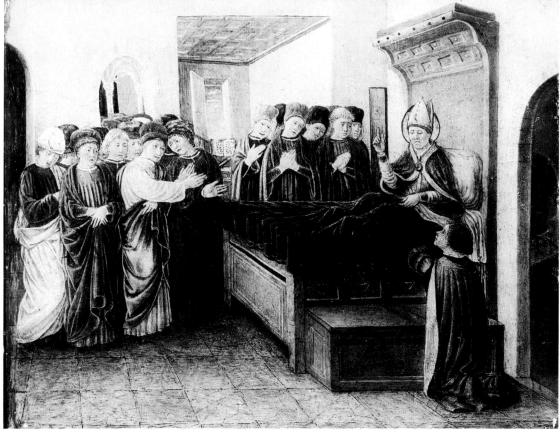

3

The Thyssen panel was first published in Christie's sale catalogue for 5 December 1969, attributed to Boccati and identified as part of the dismembered predella of the 1473 altarpiece. The provenance was given as the church of the Holy Angels of Hoar Cross, Staffordshire, founded by Mrs Emily Meynell in memory of her husband who died in 1871. One may assume that the painting already belonged to the Meynells before that date.

The panel then came to Italy and was exhibited in 1971 at Finarte in Milan. In the catalogue entry, Volpe – and subsequently also Zampetti (1971) – confirmed the connection with Boccati's San Savino altarpiece, taking into consideration the measurements of the main panel (Budapest, Museum, no.1209)[10] and those of the two other known scenes (*St Sabinus recognising Totila* and the *Death of St Sabinus*)[11] and accepting van Marle's suggestion[12] that the predella was originally composed of four scenes. After the panel of *Sts Benedict and Sabinus* was sold by Finarte in 1973 and acquired for the Thyssen-Bornemisza collection in 1977, the missing predella panel, of *Archdeacon Vindemius attempting to poison St Sabinus*, which had been divided into two sections, was identified by Dillon in Venice (in 1979). This scholar subsequently aided its acquisition for the Italian State galleries (in 1981). It has now been restored to its original aspect and is in the Galleria Nazionale of Urbino.[13] Both the catalogues of the Collection (Thyssen-Bornemisza (1981, 1986, 1989)) and Pope-Hennessy (1983) confirm the Thyssen panel's attribution and provenance from the 1473 altarpiece.

This date, which is inscribed along the pedestal of the throne in the Budapest altarpiece, enables us to assess Boccati's style in a monumental work of his mature phase. Only vague echoes of the artist's Paduan experiences are apparent, for instance in the Squarcionesque typology of the music-making putti. However, in its conception, this 'sacra conversazione', peacefully and solemnly set in the empirical but effective perspective of the tiled floor with adoring angels behind the throne, shows that Boccati was aware of recent developments in Tuscan painting; the determining influence on his late style seems, however, to have been that of Piero della Francesca. His predella scenes have a straightforward narrative quality which recalls Benozzo Gozzoli, although Boccati's treatment of the human figure and of details in his settings and landscapes is highly individualized, creating the sharp, analytical vision peculiar to his painting.

Notes

10 See A.Pigler, *Museum der bildenden Künste. Katalog der Galerie alter Meister* (Budapest, 1967) p.71f.; painted surface 186.5 × 162 cm. The total width of the altarpiece with its original frame is 217 cm (230 cm along the wooden base); the predella was probably flanked at either end by panels with the coat-of-arms of the original patron.

11 *St Sabinus recognises Totila* (27.5 × 39 cm) was published by Borenius (1925) when still in the Woodward collection; it came from the sale of the William Graham collection in 1886 (sale catalogue, Christie's, London, 8 April 1886, lot 171). Subsequently it was bought by Knoedler of New York and was exhibited in *Masterpieces of Italian Religious Painting* at Indiana University, Bloomington, Indiana (catalogue n.d. but 1–21 May 1949) no.6. It then passed to Sir Thomas Barlow, London, who lent it to the exhibition in Manchester, *European Old Masters. Art Treasures Centenary* (1957) p.15, no.15. It was sold at Sotheby's, London (24 March 1971, lot 31) and bought by Mario Lanfranchi of Rome. In 1985 it was auctioned by Semenzato, Venice (15 December 1985, lot 35).

The panel of the *Death of St Sabinus* (27.3 × 35 cm) was published by Borenius (1925) when still in the Spiridon collection in Paris, with which it was sold in Berlin in 1929; O.Fischel, *Die Sammlung Joseph Spiridon, Paris*, sale catalogue (Berlin, Bachstitz, 31 May 1929) no.6. It was acquired by Sir Thomas Barlow of London and lent to the Birmingham exhibition of 1955 (pp.11–2, no.14). It was sold at Sotheby's, London (11 March 1964, lot 81) and bought by Julius Weitzner (London and New York).

12 Van Marle, *Development*, XV p.17.

13 See Vastano (1983) in p.41, no.4; 30 × 39.5 cm.

FIG 4 Giovanni Boccati, reconstructed altarpiece:
a *The Virgin and Child enthroned with angels and saints* (Budapest, Museum of Fine Arts)
b *St Sabinus conversing with St Benedict* (Thyssen Collection)
c *St Sabinus recognising Totila* (formerly Rome, Mario Lanfranchi collection)
d *Archdeacon Vindemius attempting to poison St Sabinus* (Urbino, Galleria Nazionale)
e *Death of St Sabinus* (formerly Paris, Spiridon collection; present whereabouts unknown)
f base of the altarpiece (Budapest, Museum of Fine Arts)

a

b–e

b c d e

f

Cenni di Francesco di Ser Cenni active 1369–c1415

8 The Madonna of Humility with the Eternal Father in glory, the dove of the Holy Spirit and the twelve apostles

c1375–80
Panel, 76.6 × 51.2 cm (without the neo-Gothic frame); thickness 2.2 cm (thinned)
Accession no.1930.13

Provenance
Solly collection, Berlin
Kaiser-Friedrich Museum, Berlin (no.III.59), 1821–1928
Benedict & Co., Berlin, 1928–30
Thyssen-Bornemisza Collection, 1930

Exhibition
Munich, 1930, p.21, no.71

Literature
G.F.Waagen, *Verzeichnis der Gemälde-Sammlung der königlichen Museen zu Berlin* (Berlin, 1830) p.271 (and following edns.)
Königliche Museen zu Berlin. Verzeichnis der im Vorrat der Galerie befindlichen sowie der an andere Museen abgegebenen Gemälde (Berlin, 1886) p.169
Königliche Museen zu Berlin. Beschreibendes Verzeichnis der Gemälde, 4th edn. (Berlin, 1898) p.434; 6th edn. (1906) p.519; 7th edn. (1912) p.582; 8th edn. (1925) p.622
J.Trübner, 'Zwei unbekannte sienesische Primitive in Berlin', *Cicerone* XIX (1927) pp.272–3
Munich (1930) p.21, no.71
R.van Marle, 'I quadri italiani della raccolta del Castello Rohoncz', *Dedalo* XI (1930–1) p.1368
Berenson, *Italian Pictures* (1932) p.240
Berenson, *Pitture italiane* (1936) p.208
Rohoncz (1937) p.30, no.82
F.Antal, *Florentine Painting and its Social Background* (London, 1948) p.335
Rohoncz (1949) p.21, no.50
Rohoncz (1952) p.21, no.50
D.C.Shorr, *The Christ Child in Devotional Images in Italy during the XIV Century* (New York, 1954) p.61
Rohoncz (1958) pp.21–2, no.82
Rohoncz (1964) p.21, no.82
Berenson, *Italian Pictures* (1963) I, p.215
F.Zeri, 'La mostra "Arte in Valdelsa" a Certaldo', *Bollettino d'Arte* XLVIII (1963) p.255 note 5
Klesse, *Seidenstoffe* (1967) p.170
M.Boskovits, 'Ein Vorläufer der spätgotischen Malerei in Florenz: Cenni di Francesco di Ser Cenni', *Zeitschrift für Kunstgeschichte* XXXI (1968) pp.273, 299 notes 4, 5
Offner and Steinweg, *Corpus*, IV/V (1969) p.214
Thyssen-Bornemisza (1970) p.25, no.59
Thyssen-Bornemisza (1971) pp.76–7, no.59
Boskovits, *Pittura fiorentina* (1975) pp.128, 220 nos.122, 289
Thyssen-Bornemisza (1977) p.31, no.59
Thyssen-Bornemisza (1981) p.67, no.59
Offner, *Legacy* (1981) p.51
H.Mayer Brown, 'Catalogus. A Corpus of Trecento Pictures with Musical Subject Matter', *Imago Musicae* I (1984) p.228
A.Paolucci, *Il Museo della Collegiata di S. Andrea in Empoli* (Florence, 1985) p.51
Thyssen-Bornemisza (1986) p.65, no.59
A.Tartuferi in *Dipinti italiani del XIV e XV secolo in una raccolta milanese*, ed. M.Boskovits (Milan, 1987) p.48
Thyssen-Bornemisza (1989) p.70

The Madonna, seated on a rich cushion placed on a precious carpet, nurses the Child on her lap. He reaches for his mother's breast while turning towards the spectator. The twelve apostles are disposed symmetrically to either side: reading downwards, on the left (see detail), Matthias and James the Lesser, Simon and Thaddeus, James the Greater and Peter; on the right, Thomas and Matthew, Andrew and Philip, John the Evangelist and Bartholomew. In the upper part of the panel is a mandorla of cherubim with God the Father sending down the Holy Spirit, surrounded by two groups of adoring and music-making angels.[1]

The panel, which originally terminated in a pointed arch, has been cut above, thinned down and cradled. On the back a piece of the original wood has been preserved with the wax seal of the Berlin Museum, and the stamped inventory number '1.1511'. There is also an old label inscribed in pencil 'Jacopo di Cione' and another referring to its present ownership. To either side of the partially truncated gable the gold ground was extended in the nineteenth century to cover part of the area which would have been concealed by the frame. On the whole, the state of the painting is good. There are a few darkened retouches in the Virgin's blue mantle, in the robes of the apostles, and in the faces. There are also some minute colour losses in the cherubim and a few worm-holes.

In the various editions of Waagen's catalogue of the Berlin Museum the painting, which was acquired in 1821 with the collection of Edward Solly (1776–1844), was given the number 'III.59' and classified as 'Schule von Siena, zwischen 1350 und 1400'; and so again in the catalogues of 1886, 1898 and all later editions until 1921. Trübner published the painting with an attribution to Luca di Tommè in 1927. Shortly afterwards it was deacquisitioned by the Museum in exchange for other works,[2] and acquired, through the art dealer Dr Benedict of Berlin, for the Thyssen-Bornemisza Collection in 1930.

Around this date specialists began to argue for the painting's Florentine origin, and both Voss (1928) and Gronau (1929) privately proposed the name of Jacopo di Cione.[3] Heinemann in the Munich exhibition catalogue (1930) recorded this attribution and was the first to draw attention to similarities with Cenni di Francesco. Van Marle (1930/1) confirmed the attribution to Jacopo di Cione, while Berenson (1932, 1936) listed the painting under Giovanni del Biondo. Heinemann (in Rohoncz, 1937) insisted on the attribution to Cenni di Francesco, comparing the work with the signed frescoes at Volterra of 1410 and the *Madonna* in the church of San Lorenzo at San Gimignano. Berenson, in the more recent edition of his *Lists* (1963), removed the Thyssen panel from Giovanni del Biondo's œuvre and grouped it with other works by a so-called 'Master of the Kahn St Catherine'.[4] Offner (see Shorr (1954) and Offner, *Legacy* (1981)), followed by Steinweg (see Offner and Steinweg, IV/v (1969)) assembled round this panel a small group of works under the name of the 'Rohoncz Orcagnesque Master'.[5]

The attribution to Cenni di Francesco, proposed in all the catalogues of the Thyssen-Bornemisza Collection, was accepted by Antal (1948). It was taken up again by Klesse (1967) with a dating in the early fifteenth century, and by Boskovits (1968), who attempted to reconstruct the artist's œuvre incorporating the works of the 'Master of the Kahn St Catherine' (a hypothesis previously advanced by Zeri in 1963) and the 'Rohoncz Orcagnesque Master'. In 1975 Boskovits elaborated this reconstruction further, suggesting a date for the Thyssen painting towards 1380/5. The attribution to Cenni has also been accepted by Mayer Brown (1984), Paolucci (1985) and Tartuferi (1987), while Padoa Rizzo, without specifically mentioning the Thyssen *Madonna*, is uncertain whether or not to include the Kahn St Catherine group of paintings in the catalogue of Cenni's works.[6]

Reconsidering the question today, the paintings assembled under the conventional name of the 'Kahn St Catherine Master' have all the requirements for being regarded as early works by Cenni, in a phase when he was particularly close to Giovanni del Biondo. Cenni's now fragmentary polyptych in San Cristofano a Perticaia (1370; detail FIG 1), with its rather rigid and solemn figures, carefully rounded and chiselled forms and slow flowing contours, silhouetted against the background, seems to have been influenced by the style of artists such as

Notes

1 The representation of the Virgin and Child seated on a cushion placed on the ground, instead of on a throne, as well as the attitude of the Child who draws his mother's breast to his mouth but turns his head away towards the spectator, follows the iconography of the Virgin of Humility (see Meiss, *Black Death*, pp.132–56), and implies that Mary is nurse and mother not only of Christ, but of all mankind. The heavenly choirs of angels and the group of apostles, standing on the dark blue sky studded with stars, indicate that she is also the Queen of Heaven.

For the identification of the musical instruments played by the angels, see Mayer Brown (1984) p.228.

2 According to a letter from Hermann Voss dated 20 November 1928 (in the Thyssen archives), the painting had already been sold by that date.

3 For the attribution by Georg Gronau see the manuscript expertise in the Collection's archive. The attribution to Jacopo di Cione is also confirmed by Voss's letter mentioned above.

4 The group centres on a small painting formerly in the Kahn collection in New York (now Metropolitan Museum), which represents *St Catherine* in discussion with two young men dressed as doctors or lawyers (Boskovits (1975) fig.307). It includes a *Madonna del Parto* (Pinacoteca Vaticana, no.520), which is also by Cenni, and a small triptych (Portland, Art Museum, no.61.51) which can be attributed to Pietro Nelli. Zeri (1963), while admitting the possibility of Cenni's authorship, also added to the brief catalogue of the 'Kahn St Catherine Master' a small panel formerly in the Boucheny-Bénézit collection in Paris.

5 The group includes most of the works attributed by Berenson to his 'Kahn St Catherine Master' and coincides basically with Cenni's catalogue of works.

6 A.Padoa Rizzo 'Cenni di Francesco', in *Dizionario biografico degli Italiani*, XXIII (Rome, 1979) p.536.

7 The two artists collaborated on at least one occasion, namely on the panel of *St John the Evangelist enthroned* (Florence, Accademia, no.444), the predella of which, representing the *Ascension of St John*, was attributed to Cenni by Boskovits (1968, p.275) and to the 'Rohoncz Orcagnesque Master' by Offner (Offner and Steinweg IV/v (1969) p.66).
8 The half-length *Madonna and Child* (Lawrence, University of Kansas, no.60.46) and the *St Agnes* (Nantes, Musée, no.195).
9 Munich, Alte Pinakothek, no.WAF 304.
10 See note 7 above.
11 See Boskovits (1975) pl.137.

the Master of the Misericordia and Pietro Nelli. Later, Cenni's works reveal the influence of Giovanni del Biondo's more candid and straightforward world, probably as a consequence of their having worked together.[7] Giovanni del Biondo's typically broken rhythms, dense shadows and sharp characterization are reflected in paintings now universally given to Cenni, such as the polyptych panels in Lawrence (University of Kansas) and Nantes (Musée),[8] the *Lamentation for Christ* in the Alte Pinakothek, Munich,[9] the *Ascension of St John the Evangelist* (Florence, Accademia)[10] and the works connected with the Kahn *St Catherine*. All these paintings make up a homogeneous group in which the figures acquire new ease and sculptural plasticity, sometimes carving out the surrounding space with their strongly foreshortened forms. The atmosphere is both friendly and informal and, in the wake of late-Gothic trends, the artist reveals his interest in elegant and precious effects. In later years Cenni gradually drew away from the rustic spirit and bizarre fantasies of Giovanni del Biondo, as is shown by the *Nativity* in the church of San Donato in Polverosa, near Florence, of 1383.[11] Compared with the spaciousness of this last and the more relaxed attitudes of the figures, the Thyssen panel would appear to belong to an earlier phase. The display of elegance in the slender figures, wrapped in their fine and richly decorated robes, as also the flattened treatment of space would suggest a date prior to 1380.

Detail [8] six apostles

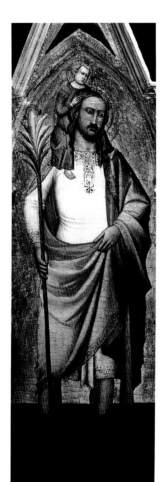
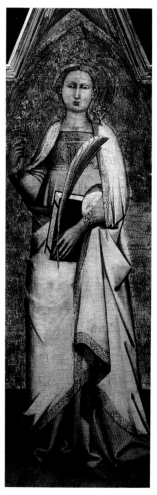

FIG 1 Cenni di Francesco, details of two *Saints* from a polyptych (Rignano sull'Arno, San Cristofano a Perticaia)

Bernardo Daddi active 1312/20–1348

9 The Crucifixion

*c*1330–5
Arched panel, height 37.4 cm (sides 14.6 cm), width 22.2 cm including the original engaged frame; painted surface
30 × 17.7 cm; thickness 2.7 cm
Accession no.1972.13

Provenance
Lamberto Cristiano Gori, Florence, late 18th century
M.Blanchard, Brussels
René Withofs, Brussels, by 1959
Florence, private collection
Thyssen-Bornemisza Collection, 1972

Literature
Thyssen-Bornemisza (1977) p.40, no.83a
Thyssen-Bornemisza (1981) p.91, no.83A
Boskovits, *Corpus*, III/IX (1984) p.353
Thyssen-Bornemisza (1986) p.92, no.83a
Thyssen-Bornemisza (1989) p.97
Boskovits in Offner, *Corpus*, new edn., III/III (1989) pp.356 note 1, 384

The crucified Christ is flanked by two groups of figures. To his right, the Madonna is fainting, supported by St John and one of the Holy Women, behind whom are two other Holy Women mourning. The Magdalen kneels with her arms round the base of the Cross. On the other side is the centurion pointing towards Christ and drawing the attention of a Pharisee and two soldiers.[1]

The state of this work, which was cleaned some time between 1959 and 1972,[2] is fair. Prior to 1959 (photograph in the *Corpus* archive, Florence), the ground had been re-gilded and arbitrarily provided with an ornamental decoration, while the painted surface was obscured by dirt. Although rather rubbed and scratched (especially in the figure of Christ and in the centurion's face), the painting is clearly legible. There are numerous small colour losses which have been filled in. Little remains of the original gold of the engaged frame which follows the elegant curvilinear shape of the panel, ending in a point. On the back, which is painted brown, is an old, fragmentary inscription: 'Opera di fra Gio. Angelico di proprietà di . . .'. Further down, a coat of arms seems to be just visible under the brown paint.

In 1959, when in the possession of René Withofs in Brussels, who had acquired it from M.Blanchard, the painting was privately attributed by Offner to Daddi's shop.[3] It later came on to the art market and was bought as Daddi's work for the Thyssen-Bornemisza Collection in Florence in 1972.

Zeri regarded this small *Crucifixion* as the left leaf of a diptych of which the right leaf, a

Notes
1 For the iconography of the Crucifixion in general, see Schiller, *Ikonographie*, II, p.98f., particularly pp.164–71, and for the identification and iconography of the principal participants in the scene, see Sandberg Vavalà, *Croce dipinta*, pp.129–62.
2 The panel had already been cleaned before it entered the Thyssen-Bornemisza Collection (see Boskovits (1984) p.353).
3 *Ibidem*.

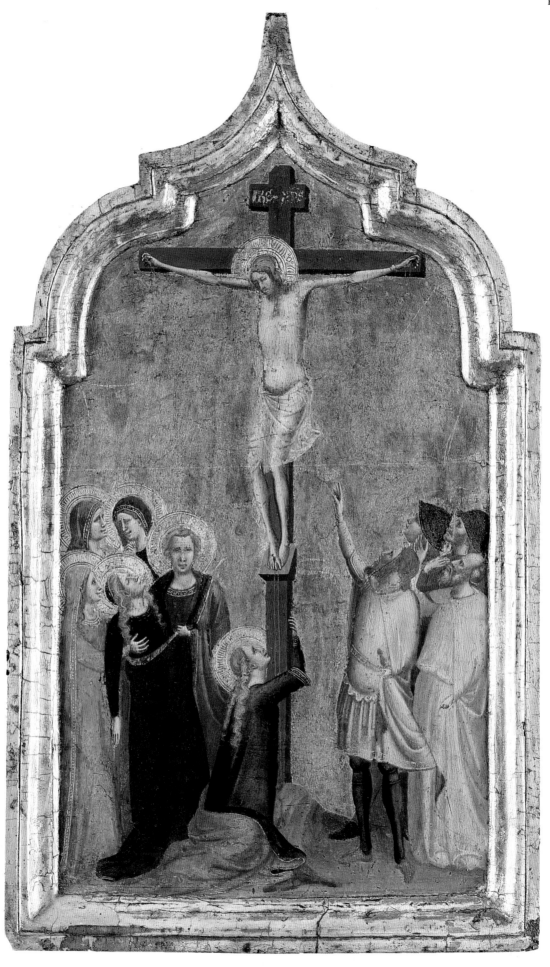

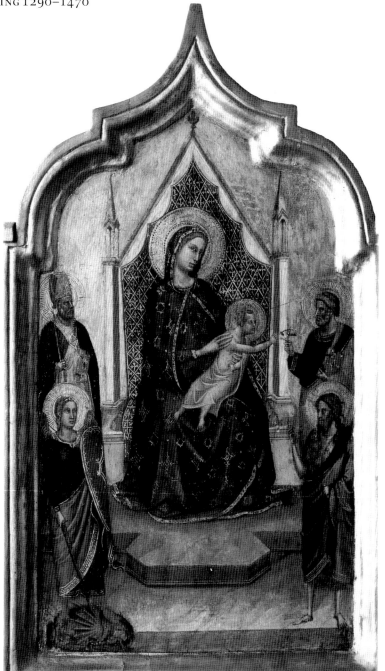

FIG 1 Bernardo Daddi, *Madonna and Child with four saints* (Nantes, Musée des Beaux-Arts)

Notes

4 This privately expressed opinion is quoted in Thyssen-Bornemisza (1986) p.92. The painting in question is a *Madonna and Child*, half-length, similar in size and shape to the *Crucifixion* panel (43.25 × 22.5 cm, including the small circular medallion with the *Annunciate Virgin* crowning the pointed gable; Boskovits (1984) pl.CLIXb). The fact that the Virgin faces left would imply that this was the right wing of a diptych.
5 L. Benoist, *Ville de Nantes. Musée des Beaux-Arts. Catalogue et Guide* (Nantes, 1953) p.80, no.72. The painting came from the collection of François Cacault and has been in the museum since 1810.
6 See Offner, *Corpus*, III/IV (1934) p.98. For information on L.C. Gori (Livorno 1730 – Florence 1801), cf. Thieme and Becker, *Lexikon*, XIV (1921) p.400. Another painting from his collection of 'primitives' is now in the Vatican Gallery; W.F. Volbach, *Catalogo della Pinacoteca Vaticana*, II, *Il Trecento. Firenze e Siena* (Vatican City, 1987) p.38f.
7 Both Daddi's small triptych of 1333 in the Museo del Bigallo, Florence (Offner, *Corpus*, III/III, pl.VII) and that in the Fogg Museum, Cambridge MA, no.1918.33, dated 1334 (Offner, *Corpus*, III/IV, pl.XXIV), are decorated with motif punches along the edges of the painted surface. By contrast, the panel from a dispersed polyptych today in the Museum of Philadelphia (Johnson Collection, no.344), which is also dated 1334, has a freehand decoration incised with the burin on the gold ground.

Madonna and Child, was in an English private collection.[4] Boškovits (1984) confirmed the attribution to Daddi himself and suggested that it could be the right leaf of a diptych, belonging together with a *Madonna and Child with four saints* in the Musée des Beaux-Arts, Nantes (FIG 1).[5] Catalogues of the Collection (Thyssen-Bornemisza (1986, 1989)) quote both these proposed reconstructions, without favouring either. However, not only is the Nantes panel similar to the *Crucifixion* both in shape and size (37 × 22 cm), but also the figures are similarly proportioned and have the same kind of haloes decorated with rays. A label on the back states: 'Del B. Gio. Angelico di proprietà di me Lamberto Cristiano Gori, 1 Dicembre 1788',[6] corresponding to what remains of a handwritten note behind the Thyssen *Crucifixion*. It is therefore extremely likely that the Thyssen panel also belonged to the painter and collector Gori at the end of the eighteenth century.

Thus reconstructed, the diptych fits easily into the group of small devotional works produced over the years in Daddi's workshop. It is less easy to define its place in the chronology of the artist's vast output, considering that he tended to repeat subjects and compositions in works of this kind, and dated them only rarely. Some clue may be provided by such 'external' evidence as

Evidently, the punches used for small-scale works were not considered suitable for altarpieces.

Some of the small devotional panels terminating in a composite arch produced in Daddi's workshop do not have punched decoration (the diptych in the Museo Horne, Florence (Offner, *Corpus*, III/IV, pl.I); the diptych in the convent of the Oblate at Careggi (Boskovits (1984) pl.CLXVIa); the Crucifix in the Museo Bardini, Florence (Boskovits in Offner, *Corpus*, III/III, 2nd edn. (1989) add. pl.III). On the other hand, punched decoration is found in the *Madonna and Child with saints* in Capodimonte, Naples (Offner, *Corpus*, III/III, pl.V); in the *Madonna and saints* in the Norton Simon Museum, Pasadena CA, and in another formerly in the Goldammer collection at Schloss Plausdorf (Offner, *Corpus*, III/IV, pl.III and add pl.V). None of these, however, would appear to date from after about 1335.

8 I refer to the triptych in the National Gallery, Edinburgh (no.1904; Offner, *Corpus*, III/IV, pl.XXXIV). The motif is also present in a *Crucifixion* formerly in the Stoclet collection, Brussels, in another formerly in the Smith collection, Worcester MA, and in the triptych no.871 in the Berne Museum (Offner, *Corpus*, III/IV, pls.XXXI, XXXIII and add pl.I). It recurs again, in a slightly modified form, in a small panel in the Boston Museum of Fine Arts (no.223.211; *ibidem*, pl.XXVII).

9 For the group to the right of the Cross, compare the panel formerly in the Verona Museum (Offner, *Corpus*, III/III, pl.X), the already mentioned *Crucifixion* in Boston and, with the addition of other figures on horseback in the background, the triptych in the Gemäldegalerie, Berlin (no.1064; Offner, *Corpus*, III/IV, pl.XXXV). For the motif of the Christ Child, seated on the Virgin's lap, turning his whole body to the right to receive a flower or a bird from one of the figures beside the throne, compare the altarpiece of San Giusto at Signano (Offner, *Corpus*, III/IV, pl.XVIII), and the panels in the Frick Museum, Pittsburgh, in the Louvre (*ibidem*, pls.XXIX and XLII) and in the National Gallery, Washington (Offner, *Corpus*, III/VIII, pl.III). For observations on the development of the typology of thrones in earlier Trecento painting, see Boskovits (1984) p.15f. and note 15.

10 See Offner, *Corpus*, III/IV, pls.I, XXXIII and XVII.

[9] shown to scale with FIG I

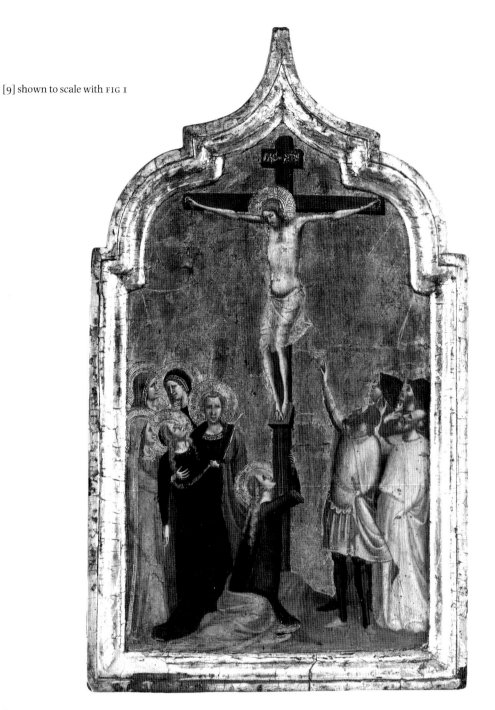

the composite arched top of the panel and the absence of punched motifs: the latter are to be found along the edges of practically all his panels from 1333 onwards, while the composite arch disappears from his mature works.[7]

A further indication is suggested by the figure of the fainting Virgin (her head turned in profile towards Christ, with her eyes closed, supported by St John and one of the Maries), which recurs in a very limited number of works, one of which – stylistically the most advanced – is dated 1338.[8] The group on the other side of the Cross, composed of two figures in the foreground and two soldiers behind, all seen in profile and looking up at Christ, is characteristic of Daddi's relatively early works. The same is true of certain motifs in the Nantes panel, such as the Child turning his head and body away from the Virgin and the simple, triangular gable of the throne terminating in a pinnacle on either side.[9] Our diptych would therefore seem to date from about 1330–5 (perhaps closer to the first of these dates), which would make it roughly contemporary with two other diptychs in the Museo Horne, Florence, and formerly in the Smith collection, Worcester MA, and also with the Madonna and Child of San Giusto at Signano, near Florence.[10]

Bernardo Daddi active 1312/20–1348

10 The Madonna and Child

c1340–5
Panel, 84 × 54.8 cm; thickness 2.8 cm
Accession no.1928.11

Provenance
Pieve di San Giovanni Maggiore, Panicaglia?
Italian art market, late 1860s
The Hon. Percy Scawen Wyndham of Clouds, by 1870
Captain Richard Wyndham (by descent)
Vicomte d'Hendecourt, London
Böhler and Steinmeyer, Lucerne, by 1927
Thyssen-Bornemisza Collection, 1928

Exhibitions
London, *Exhibition of Italian Art 1200–1900*, Royal Academy of Arts, 1930, p.41, no.19a
Munich, 1930, p.28, no.95

Literature
H.Comstock, 'The Bernardo Daddis in the United States', *International Studio* LXXXIX (1928) p.71
Exhibition of Italian Art 1200–1900, Royal Academy of Arts (London, 1930) p.41, no.19a
A Commemorative Catalogue of the Exhibition of Italian Art, Burlington House, January–March 1930 (London, 1930)
 p.14, no.19a
Munich (1930) p.28, no.95
G.Biermann, 'Die Sammlung Schloss Rohoncz', *Cicerone* XXII (1930) p.365
A.Mayer, 'The Exhibition of the Castle Rohoncz Collection in the Munich New Pinakothek', *Apollo* XII (1930) p.96
A.Mayer, 'Die Ausstellung der Sammlung Schloss Rohoncz in der Neuen Pinakothek München', *Pantheon* VI
 (1930) p.314
Offner, *Corpus*, III/III (1930) p.12
W.Suida, 'Die Italienischen Bilder der Sammlung Schloss Rohoncz', *Belvedere* IX (1930) p.175
R.van Marle, 'I quadri italiani della raccolta del Castello Rohoncz', *Dedalo* XI (1930–1) pp.1368, 1392 no.2
Berenson, *Italian Pictures* (1932) p.165
Berenson, *Pitture italiane* (1936) p.564
Rohoncz (1937) p.41, no.115
Offner, *Corpus*, III/V (1947) pp.60–1, 103–4, 150, 231
Rohoncz (1949) pp.26–7, no.72
W.Cohn, 'Aggiunte all' "Assistente di Daddi" e al "Maestro di Fabriano"', *Bollettino d'Arte* XLII (1957) p.176
Rohoncz (1952) p.27, no.72
Rohoncz (1958) p.30, no.115
Berenson, *Italian Pictures* (1963) I, p.55
Rohoncz (1964) pp.26–7, no.115
Klesse, *Seidenstoffe* (1967) p.23
Thyssen-Bornemisza (1970) pp.23–4, no.83
Thyssen-Bornemisza (1971) pp.109–110, no.83
Thyssen-Bornemisza (1977) pp.39–40, no.83
Thyssen-Bornemisza (1981) p.90, no.83
Boskovits, *Corpus*, III/IX (1984) pp.340–1
Thyssen-Bornemisza (1986) p.91, no.83
Thyssen-Bornemisza (1989) p.96

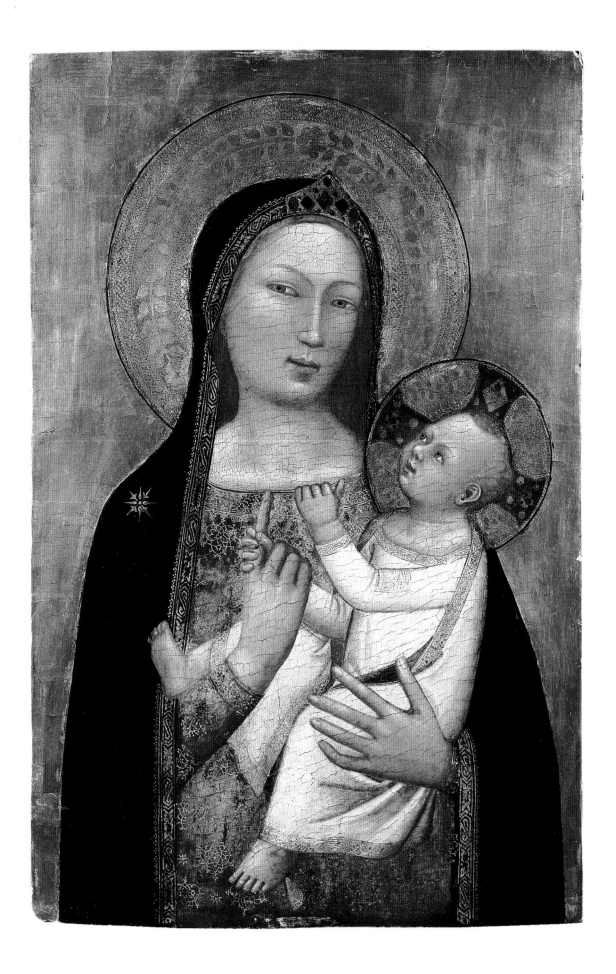

The Madonna is represented half-length, in a frontal position, holding the infant Jesus with her left arm. He clings to the edge of her dress with his left hand and holds on to her raised forefinger with the other. The liveliness of the Child is further emphasized by his right foot placed over the Virgin's bent right arm.[1]

The painting is clearly legible even though the surface has suffered from drastic former cleaning. The gold ground has been renovated and modern gold has been laid over the original decoration of the haloes. To judge from a photograph taken in about 1927, the gilded decoration on the Virgin's robes had also been gone over. These restorations, as well as some retouches in the Virgin's face, were subsequently removed,[2] although some inpainted areas still remain in the dress and mantle of the Virgin. The panel is worm-eaten and buckled. In order to reduce the warping the wood has been slightly thinned down on the sides. The back is covered with a layer of dark paint with a protective wax finish. Originally the panel had a gable starting at a height of 72.5/73 cm from the base; at this point two small wooden triangles have been inserted to make up the present rectangular shape. Besides a torn nineteenth-century label, there is another with the name 'The Hon.ble F. Wyndham' and a third referring to its present ownership.

The panel was apparently acquired in Italy around 1870 by the son of the first Baron Leconfield, the Hon. Percy Scawen Wyndham of Clouds, and was sold by his grandson, Captain Richard Wyndham, to the Vicomte d'Hendecourt.[3] It was then in the hands of the dealers Böhler and Steinmeyer of Lucerne, who exhibited it in their New York gallery in 1927 and sold it the following year to Baron Thyssen-Bornemisza.[4] Dating from the same year, 1928, are letters in the Thyssen archives from Gronau and Bode, both of whom accepted the attribution to Bernardo Daddi.

The painting was published in 1928 under Daddi's name by Comstock, who compared it to the Madonna in the Isabella Stewart Gardner Museum, Boston.[5] It was reproduced in the catalogues of the exhibitions held in London and in Munich in 1930. The numerous reviews of the latter exhibition mention the Madonna as a work of importance in Daddi's œuvre (Mayer, Biermann, Suida and van Marle, who thought it was early, close to the triptych of 1328). Berenson (1932, 1936, 1963) and Heinemann (in Rohoncz (1937)) also regarded it as autograph. On the other hand, Offner (1930) expressed doubts, initially listing the painting among 'works attributed to Bernardo Daddi' and later (1947) including it in the group given by him to the 'Assistant of Daddi'. In his opinion the Thyssen Madonna contained numerous motifs derived from Daddi but was executed by a different artist 'of rude and robust gifts, of small invention and of simple, genuine feeling'. The head of the Virgin, he states, 'repeats that of the St Catherine of the Duomo[6] in a way one may speak of as due to the same model, whose long narrow eyes, broad face, high cheek-bones, already appear in the Gardner panel. The position of Christ's legs and the left hand of the Virgin revert to the Gardner painting, both features having been anticipated in the Santa Maria Novella polyptych ...'.[7] Concluding his analysis, Offner places the Thyssen Madonna rather late, towards the middle of the fourteenth century, and suggests that it was at the centre of a lost polyptych.

All the catalogues of the Thyssen Collection maintain the attribution to Daddi (Rohoncz (1937, 1949, 1952, 1958, 1964); Thyssen-Bornemisza (1970, 1971, 1977, 1981, 1986 and 1989)). Cohn (1957), however, reverts to Offner's proposal in favour of the 'Assistant', and puts forward a first, partial reconstruction of the work's original appearance, relating it to the half-length figure of St John the Baptist at that time in the Pieve di San Giovanni Maggiore at Panicaglia, now in the church of Santo Stefano al Ponte in Florence (FIG 2d),[8] and to a Bishop saint (Zenobius?), then belonging to Lycett Green and today in the City Art Gallery of York (FIG 2e).[9] A different, but also partial, reconstruction was advanced by Boskovits (1984), who maintained, however, the attribution to Daddi: in his opinion two of the lateral panels of the Thyssen Madonna are to be identified in an Apostle in the Johnson Collection, Philadelphia (FIG 2a)[10] and in a St James the Great in the Cagnola collection, Fondazione Paolo VI, Gazzada,

Notes

1 The motif of the Virgin raising her forefinger in what would seem to be a gesture of reproof is not infrequent in Daddi's œuvre: other examples include the Bargello triptych, the Norton Simon, Wedells and Lanckoronsky panels (Offner, Corpus, III/III, pl.VII; III/IV, pls.III and XLVIII; III/VIII, pl.VIII). The Child's gesture, although apparently playful, probably had a symbolical, preadmonitory meaning; cf. Shorr, Devotional Images, p.168f.
2 In old photographs, like the one published in the 1937 catalogue (Rohoncz, pl.175), the decoration on the Virgin's dress and the outlines of her face and neck appear to have been gone over.
3 See Offner (1947) p.104.
4 In a letter to the dealer Steinmeyer of 4 July 1928 (Biblioteca Berenson, Florence), Berenson expresses his satisfaction at the acquisition by Baron Thyssen-Bornemisza of this 'exemplary Daddi'.
5 See Offner, Corpus, III/V, p.71f., pl.XIII.
6 Ie in the Cathedral of Florence; ibidem, p.93f., pl.XVIII.
7 Ie the altarpiece in the Spanish Chapel, dated 1344; ibidem, p.87f., pl.XVII.
8 See Offner, Corpus, III/VIII, p.151f., pl.XLI. The measurements are 62.5 × 36.5 cm.
9 See Offner, Corpus, III/V, p.123f., pl.XXIII. The panel, which has a modern repair at the top, measures 65.5 × 40 cm.
10 Boskovits (1984) p.340, pl.CLXVIIa; the measurements are 68 × 41 cm.
11 Ibidem, p.341, pl.CLXIIb; the measurements are 61 × 40 cm.
12 For this painting see Offner, Corpus, III/III, p.12, pl.XVIII and here (detail) FIG 2.
13 This was the opinion of Marcucci, Firenze. Dipinti toscani (1965), p.43. The works grouped under the name of the 'Assistant' are also given to Bernardo Daddi by Boskovits (Pittura fiorentina, p.20), by Bellosi (Gli Uffizi. Catalogo generale (Florence, 1979) p.237), by Damiani (in Dizionario biografico degli Italiani, XXXI (Rome, 1985) p.625) and by Bonsanti (La Galleria della Accademia. Guida e catalogo completo (Florence, 1987) p.66). Personally I have already expressed the opinion that 'the works assembled under the "Assistant" have the characteristics of the Master's last stylistic phase and are ... on the whole entirely autograph' (Boskovits, Berlin. Katalog, p.28).

detail [10] the Child

FIG I Bernardo Daddi, *Madonna and Child adored by angels* (detail of Child) (Florence, Orsanmichele)

Varese (FIG 2b).[11] Klesse (1967), according to whom the painting is a product of Daddi's workshop, notes similarities between the decoration of the Virgin's dress in the Thyssen panel and in Daddi's Orsanmichele *Madonna* of 1346/7.[12]

So far as the question of authorship is concerned, it should be pointed out that the works grouped by Offner under the conventional name of the 'Assistant of Daddi' do, in fact, fit into Bernardo Daddi's late œuvre. There are good reasons to suppose – as a growing number of critics agree[13] – that, rather than denoting a separate artistic personality, they mark a stylistic trend of Daddi's later career towards greater solidity and monumentality, which would become a dominating tendency of Florentine art in the third quarter of the fourteenth century. The

FIG 2 Bernardo Daddi,
hypothetical reconstruction of an
altarpiece:
a *St John the Evangelist*
(Philadelphia, Johnson
Collection)
b *St James the Great* (Gazzada,
Fondazione Paolo VI)
c *Madonna and Child* (Thyssen
Collection)
d *St John the Baptist* (Florence,
Santo Stefano al Ponte;
formerly Panicaglia, Pieve di
San Giovanni Maggiore)
e *Bishop saint* (York, City Art
Gallery)

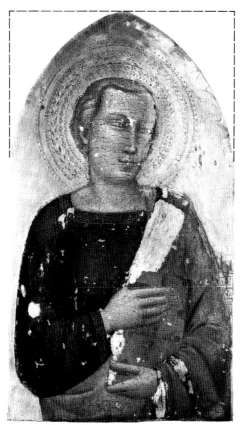

a

closest analogies with the Thyssen panel are indeed to be found in works such as the polyptych
of San Pancrazio (Florence, Uffizi)[14] datable to around 1340, and the Orsanmichele *Madonna*. It
comes particularly close to the latter (see detail and FIG 1), in which the search for an almost
abstract purity and simplicity of form is similarly combined with a subtle and penetrating
observation of the human qualities and feelings of the figures.

The two proposed reconstructions of the polyptych to which the Thyssen *Madonna* once
belonged appear to complement rather than contradict one another. Thanks to its recent,
partial cleaning (the modern gold of the background remains), the *Apostle* in the Johnson
Collection may now be considered an autograph work from the artist's last period, stylistically
close both to the Cagnola *St James* and to the panels today dispersed between Lugano, York and

Notes
14 See Offner, *Corpus*, III/III,
pl. XIV.
15 See F. Niccolai, *Mugello e Val
di Sieve. Guida topografica, storico-
artistica* (Borgo San Lorenzo,
1914) p.460f. The Minerbetti
family owned an altar, no longer
extant, in the choir screen and
another in the fourth bay of the
right aisle in Santa Maria Novella;
W. and E. Paatz, *Die Kirchen von
Florenz* (Frankfurt, 1952) III,
pp.703, 735.

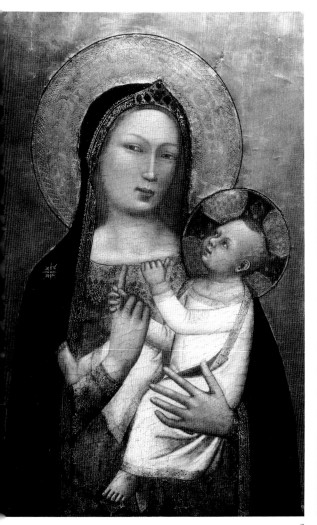

c

d

e

16 In 1338 Daddi signed an altarpiece of which only the predella survives (Offner, *Corpus*, III/III, p.2; III/v, p.65f.) In 1344 he signed the polyptych in the Spanish Chapel and presumably not long afterwards the *Coronation of the Virgin* in the Accademia, Florence (no.3449), which was also painted for Santa Maria Novella (Offner, *Corpus*, III/v, pls.XVII andXXII).

Florence. One may therefore hypothesize, despite their variously restored states, that all these panels had a common origin. Were this to prove correct, the polyptych's original location would presumably have been the Pieve di San Giovanni Maggiore at Panicaglia, where the image of the titular saint remained until a few years ago. It may seem surprising to find a polyptych by Daddi in a distant village of the Mugello. This can be explained, however, by the fact that, at the beginning of the sixteenth century and almost certainly also in the fourteenth, the Pieve di San Giovanni Maggiore was under the patronage of the powerful Minerbetti family of Florence.[15] Since this family lived in the parish of Santa Maria Novella and owned several chapels in the church, it may well have patronized a work painted by Daddi for Santa Maria Novella during the 1330s and 1340s, and later transferred to Panicaglia.[16]

Duccio di Buoninsegna · active by 1278; died 1319

11 Christ and the Samaritan Woman

1310–11
Tempera on panel, 43.5 × 46 cm; thickness 2.5 cm
Accession no.1971.7

Provenance
Siena Cathedral (between 1311 and 1506 on the high altar; afterwards, until 1771, in the left transept)
Church of Sant'Ansano in Castelvecchio, Siena, 1771
Giuseppe and Marziale Dini, Colle Val d'Elsa, by 1879
Robert H. and Evelyn Benson, London (through C.Fairfax Murray) 1886–1927
Duveen Brothers, New York, 1927–9
John D.Rockefeller, New York, 1929–71
Thyssen-Bornemisza Collection, 1971

Exhibitions
Colle Val d'Elsa, Palazzo Comunale, 6–8 September 1879, nos.80–3
London, New Gallery, 1893–4, no.56
London, Burlington Fine Arts Club, 1904, no.1
London, Grafton Galleries, 1911, no.5
Manchester, City Art Gallery, 1927, no.98
Cleveland, Museum of Art, 1936, no.123
USA tour, 1979–80, no.9
Paris, 1982, no.10
USSR tour, 1983–4, no.19
London, 1988, no.18
Stuttgart, 1988–9, no.18

Literature
Catalogo di Oggetti d'Arte Antica presentati alla Mostra Comunale di Colle Val D'Elsa tenuta nei giorni 6, 7 e 8 Settembre 1879. Coll'Aggiunta di una Piccola Guida Artistica della Città (Colle, 1879) p.4, nos.80–3
E. Dobbert, 'Duccio's Bild "Die Geburt Christi" in der königlichen Gemälde-Galerie zu Berlin', *Jahrbuch der königlich preuszischen Kunstsammlungen* VI (1885) p.157
Exhibition of Early Italian Art from 1300 to 1550 (The New Gallery, London, 1893–4) p.11, no.56
'Exhibition of Early Italian Art, The New Gallery, London, 1894', review in *Athenaeum* (27 January 1894) p.118
C.J.Ffoulkes, 'Le Esposizioni d'Arte Italiana a Londra', *Archivio Storico dell'Arte* VII (1894) p.154
J.P.Richter, 'Die Ausstellung italienischer Renaissancewerke in der New Gallery in London', *Repertorium für Kunstwissenschaft* XVII (1894) p.238
H.Ulmann, 'Photographische Reproduktionen der in der New Gallery 1894 aus englischem Privatbesitz ausgestellten italienischen Bilder', *Repertorium für Kunstwissenschaft* XVII (1894) p.489
L.Douglas, *History of Siena* (London, 1902) p.345
L.Douglas, 'Duccio', *Monthly Review* (August 1903) pp.142–5
Exhibition of Pictures of the School of Siena and Examples of the Minor Arts of that City (Burlington Fine Arts Club, London, 1904) pp.37–9, no.1
'Sienese Art at the Burlington Fine Arts Club', *Athenaeum* (4 June 1904) p.728
G.Frizzoni, 'L'Esposizione d'Arte Senese al "Burlington Fine Arts Club"', *L'Arte* VII (1904) pp.257–8
R.Fry, 'La Mostra d'Arte Senese al Burlington Club di Londra', *Rassegna d'Arte* IV (1904) p.116
S.Reinach, *Répertoire des Peintures du Moyen Âge et de la Renaissance (1280–1580)*, I (Paris, 1905) p.383
Venturi, *Storia*, V (1907) p.568
L.Cust, 'La Collection de M.R.-H.Benson', *Les Arts*, no.70 (October 1907) p.24
L.Douglas, in Crowe and Cavalcaselle, *History*, 2nd edn., II (London, 1908) p.11
Berenson, *Central Italian Painters* (1909) p.163
E.Hutton, in Crowe and Cavalcaselle, *History*, 3rd edn., III (1909) p.10 note 5
C.H.Weigelt, 'Contributo alla ricostruzione della "Maestà" di Duccio di Buoninsegna', *Bollettino Senese di Storia Patria* XVI (1909) p.11
A Catalogue of an Exhibition of Old Masters (Grafton Galleries, London, 1911) pp.4–7, no.5
R.Fry, 'Exhibition of Old Masters at the Grafton Galleries–I', *Burlington Magazine* XX (1911) p.71
C.H.Weigelt, *Duccio di Buoninsegna* (Leipzig, 1911) pp.95–6, 239–40

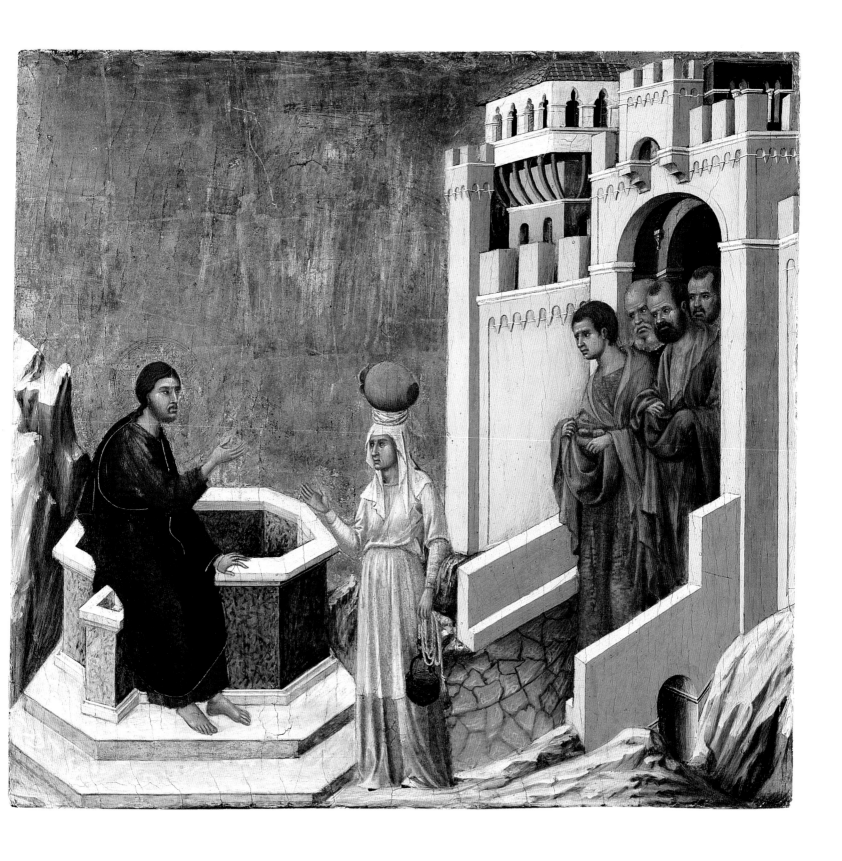

W.De Grüneisen, 'Tradizione orientale-bizantina, influssi locali e ispirazione individuale nel ciclo cristologico della Maestà di Duccio', *Rassegna d'Arte Senese* VIII (1912) pp.24, 25

V.Lusini, 'Catalogo dei dipinti', *Rassegna d'Arte Senese* VIII (1912) p.115

A.Jahn Rusconi, *Vita di Duccio di Buoninsegna* (Florence, 1913) pp.20–1

C.H.Weigelt, *Duccio di Buoninsegna*, in Thieme and Becker, *Lexikon*, X (1914) p.26

T.Borenius, *Catalogue of Italian Pictures . . . Collected by Robert and Evelyn Benson* (London, 1914) pp.3–5

van Marle, *Development*, II (1924) pp.21, 33–4

G.Vitzthum and W.F.Volbach, *Die Malerei und Plastik des Mittelalters in Italien* (Wildpark and Potsdam, 1924) p.239

L.Gielly, *Les primitifs siennois* (Paris, 1926) p.11 note 106

A.Alexandre, 'La Collection Benson', *La Renaissance de l'Art français* X (November 1927) pp.477–82

T.Borenius, 'The Benson Collection', *Apollo* VI (1927) pp.66, 68–70

Benson Collection of Old Italian Masters, exhibition catalogue (City Art Gallery, Manchester, 1927) no.98

R.L.Douglas, 'I dipinti senesi della Collezione Benson passati da Londra in America', *Rassegna d'Arte Senese ('La Balzana')* V (1927) pp.99–100

H.Comstock, 'Panels from Duccio's Majestas for America', *International Studio* LXXXVIII (1927) pp.63, 65, 67–8

F.E.Washburn Freund, 'Die Sammlung Benson', *Cicerone* XIX (1927) p.499

F.E.Washburn Freund, 'Die vier Duccios der Sammlung Benson', *Cicerone* XX (1928) pp.333–6

C.H.Weigelt, *Die sienesische Malerei des vierzehnten Jahrhunderts* (Munich, 1930) pp.13–14, 73, 86 note 56

L.Venturi, *Pitture italiane in America* (Milan, 1931) pl.XVI

Berenson, *Italian Pictures* (1932) p.176

P.Toesca, 'Duccio' in *Enciclopedia Italiana*, XIII (Rome, 1932) p.245

van Marle, *Scuole*, II (1934) pp.36–7

Exposition de l'Art italien de Cimabue à Tiepolo, exhibition catalogue (Paris, 1935) p.68

H.Tietze, *Meisterwerke europäischer Malerei in Amerika* (Vienna, 1935) p.325

Berenson, *Pitture italiane* (1936) p.152

Cleveland Museum of Art. Exhibition on the XXth Anniversary, exhibition catalogue (Cleveland, 1936) no.123

E.Lavagnino, *Storia dell'arte medievale italiana* (Turin, 1936) p.424

Duveen Pictures in Public Collections of America. A Catalogue Raisonné (New York, 1941) nos.6, 7, 8

C.Brandi, *Duccio* (Florence, 1951) p.144

M.Davies, *National Gallery Catalogues. The Earlier Italian Schools* (London, 1951) p.135 note 2

U.Galetti and E.Camesasca, 'Duccio', in *Enciclopedia della pittura italiana* (Milan, 1951) p.862

Toesca, *Trecento* (1951) pp.501 note 37, 505

E.T.De Wald, 'Observations on Duccio's *Maestà*', in *Late Classical and Medieval Studies in Honor of Albert Mathias Friend Jr.* (Princeton, 1955) p.367

C.Brandi, *Ministero della Pubblica Istruzione. Istituto Centrale del Restauro. Il restauro della Maestà di Duccio* (Rome, 1959) p.9

V.N.Lazarev, *Iskusstvo Trecento* (Moscow, 1959) p.161

E.Carli, *Duccio di Buoninsegna* (Milan, 1961) pp.22, 30

M.Davies, *National Gallery Catalogues. The Earlier Italian Schools*, 2nd edn. (London, 1961) p.174 note 2

E.Carli, *Duccio (I Maestri del Colore, no.16)* (Milan, 1964) p.6

F.A.Cooper, 'A Reconstruction of Duccio's *Maestà*', *Art Bulletin* XLVII (1965) pp.156, 159, 170

E.T.De Wald, *Italian Painting 1200–1600* (New York, 1965) p.117

M.Cämmerer-George, *Die Rahmung der toskanischen Altarbilder im Trecento* (Strasbourg, 1966) p.144f.

A.Parronchi, 'Segnalazione Duccesca', *Antichità Viva*, V, no.2 (1966) pp.3, 5 note 1

J.White, *Art and Architecture in Italy, 1250–1400* (Harmondsworth, 1966) p.153

P.P.Donati, 'La Maestà di Duccio', in *I Maestri del Trecento in Toscana* (Florence, 1967) pp.44–5

Berenson, *Italian Pictures*, I (1968) p.117

The Frick Collection. II, Paintings (New York, 1968) p.226

E.Carli, *I pittori senesi* (Siena, 1971) p.56

G.Cattaneo and E.Baccheschi, *L'opera completa di Duccio* (Milan, 1972) no.84

Lexikon christlichen Ikonographie, IV (1972) pp.27–9

A.Preiser, *Das Entstehen und die Entwicklung der Predella in der italienischen Malerei* (Hildesheim, 1973) pp.72–3, 78

J.White, 'Measurements, Design and Carpentry in Duccio's *Maestà*', *Art Bulletin* LV (1973) p.566

E.Carli, *Duccio di Buoninsegna. L'opera autografa* (Florence, 1975) no.38

'A Duccio for the Kimbell Art Museum', *Apollo* CII, no.3 (1975) p.224

E.Fowles, *Memories of the Duveen Brothers* (London, 1976) pp.183, 204

Thyssen-Bornemisza (1977) p.43, no.896

'A.G.', 'Nouveau regard sur la Collection Thyssen', *Connaissance des Arts*, no.306 (August 1977) p.53

J.H.Stubblebine, 'The Back Predella of Duccio's *Maestà*', in *Studies in Late Medieval and Renaissance Painting in Honor of Millard Meiss* (New York, 1977) pp.430, 435

E.Carli, *Il Duomo di Siena* (Siena, 1979) p.69

F.Deuchler, 'Duccio Doctus: New Readings for the *Maestà*', *Art Bulletin* LXI (1979) p.541

Rusk Shapley, *Washington. Catalogue* (1979) I, p.169

J.H.Stubblebine, *Duccio di Buoninsegna and his School* (Princeton, 1979) pp.31, 32, 36, 37, 56

J.White, *Duccio* (London and New York, 1979) p.80

A.Conti, review of J.White, *Duccio, Prospettiva* XXIII (1980) p.101

Thyssen-Bornemisza (1981) p.100, no.89B

Notes

1 The episode, recorded only in John, in which Christ openly admits to be the Messiah is interpreted in biblical exegesis as alluding to the water of Baptism (the living water offered by Christ to the woman) and to the Eucharist (the food brought by the Apostles); Schiller, *Ikonographie*, I, p.168f., and *Lexikon christlichen Ikonographie*, IV (1972) pp.27–9.

2 According to Richter (1894), who saw the Benson panels at the New Gallery exhibition in London, they were 'in bad condition' and 'heavily restored'. Ulmann (1894) also spoke of them as in 'very bad state', and Ffoulkes (1894) declared that they were 'so badly restored that one could barely recognise the author'. However, both the exhibition catalogue and the Braun photograph taken at that time reproduce the Thyssen panel in an extremely dirty but not repainted state.

3 White (1979, p.80) estimates the overall height of the altarpiece to have been 499 cm, and its width to have been 468 cm.

4 The various reconstructions that have been proposed are discussed by Deuchler (1984) p.76f. They are mostly confined, especially more recently, to the sequence of the panels in the pinnacles and the number of sections forming the back predella. For further discussion of the latter see pp.75–6 below.

5 According to Stubblebine (1979) and Deuchler (1984) the *Pentecost* was probably surmounted by the *Ascension* in the central pinnacle on the main side, and the *Death of the Virgin* by the *Coronation* on the reverse. In contrast, both White (1973, 1979) and Carli (1979) believe that the *Assumption* and *Coronation of the Virgin* would have been on the front and the *Ascension* and *Christ in Majesty* on the back. This theory seems to me more convincing: considering that the fragmentary panel with the *Death of the Virgin* is set in an interior, it is not clear how the composition could have joined up with the Assumption above. Iconographically, one would expect to find a *Christ in Majesty* over the *Ascension*, rather than over the *Pentecost*, as the crowning element of the Christological sequence on the back of the altarpiece. The central pinnacle might even have contained a grandiose *Last Judgement*, a subject sometimes associated with the Crucifixion (see, for instance, the Crucifix by Bernardo Daddi in the Accademia, Florence, no.442).

E.Carli, *La pittura senese del '300* (Milan, 1981) p.49

M.Boskovits, review of J.Stubblebine, *Duccio . . .* and of J.White, *Duccio, Art Bulletin* LXIV (1982) pp.498–9 note 1

J.Pope-Hennessy, 'Some Italian Primitives', *Apollo* CXVIII (1983) pp.10–1

F.Deuchler, *Duccio* (Milan, 1984) p.214

H.van Os, *Sienese Altarpieces 1215–1460* (Groningen, 1984) p.43

D.Sutton, 'Aspects of British Collecting. Part IV', *Apollo* CXXII (1985) p.123

R.Wilkins Sullivan, 'The Anointing in Bethany and other Affirmations of Christ's Divinity on Duccio's Back Predella', *Art Bulletin* LXVII (1985) pp.33, 36, 42, 47

Thyssen-Bornemisza (1986) p.99, no.89b

J.White, *Art and Architecture in Italy, 1250–1400*, 2nd edn. (Harmondsworth, 1987) pp.299–300

M.Davies and D.Gordon, *The Early Italian Schools before 1400*, 3rd edn. (London, 1988) pp.18, 21

Thyssen-Bornemisza (1989) p.104

Art in the Making. Italian Painting before 1400, exhibition catalogue by D.Bomford, J.Dunkerton, D.Gordon and A.Roy (National Gallery, London, 1989–90) p.190

The scene illustrates a passage in St John's Gospel (4:4–27). The Saviour is seated on the edge of the well and is speaking to the woman who stands with her water-pot on her head and holds the rope and pail in her left hand, while she raises her right in a gesture of wonder. The disciples, who meanwhile had gone to buy food, are seen returning from the city gate.[1]

Except for the gold ground which is worn, a few rubbed areas in the paint and occasional small retouches in the faces of Christ and the Samaritan woman and in the draperies, the painting is fairly well preserved. To judge from photographs taken at the end of the nineteenth century, the surface must then have been very dirty. This probably accounts for the over-pessimistic opinions on its state of conservation given at the time of the 1893/4 exhibition; in fact, once it had been cleaned, Frizzoni (1904) described the panel as 'marvellously preserved' except for 'some restoration here and there'.[2]

This panel formed part of the celebrated altarpiece known as the *Maestà*, about five metres high and almost as wide,[3] painted on both sides by Duccio for Siena Cathedral. It represented the Madonna and Child with saints and angels on the front, surmounted by a series of episodes from the life of the Virgin and busts of angels in the pinnacles, with a predella composed of scenes from Christ's infancy alternating with figures of prophets. On the reverse were 26 episodes from the life of Christ beginning with the Entry into Jerusalem and ending with the Journey to Emmaus. The predella on this side contained nine scenes from Christ's Ministry, while the various apparitions of the risen Christ and the Pentecost were represented in the pinnacles. Although the altarpiece was dismembered and the parts dispersed into various collections, almost all the components have survived and enable us to reconstruct it, at least on paper (FIG 1).[4] There is no record, however, of the original aspect of the frame, which was lost when the panels were dismembered. There is also some uncertainty concerning the missing central pinnacle, which probably represented the Assumption and Coronation of the Virgin surmounted by the figure of God the Father on the front and the Ascension with possibly Christ in Glory or the Last Judgement, crowned by another small gabled panel, on the back.[5]

Dating from 9 October 1308 is a document informing us that 'Duccio di Buoninsegna, the painter, citizen of Siena . . . accepted . . . the task of painting a certain panel to be placed on the

high altar of the church of Santa Maria of Siena ... and ... the said Duccio promised and agreed ... to make the said panel as well as he could ... and to work on the said panel without interruption in whatever time he was able to work on it and not to accept any other work to be carried out until the said panel shall have been made and completed'.[6] Until recently scholars have always regarded the date of this document as the starting point of the commission. Lately, however, it has been observed that the particularly firm attitude of the patrons towards the artist, and the fact that Duccio was forced to refund the Opera del Duomo of Siena the considerable sum of 50 gold florins only two months later (20 December 1308),[7] could mean that he had started work some time earlier and had not respected the initial terms of the contract.[8] There is no information regarding the progress he made afterwards but the work must have been completed by 9 June 1311, when musicians were paid to accompany the clergy and the crowd of the faithful on the painting's journey from Duccio's workshop to the Cathedral.[9] Another document, unfortunately undated, contains the estimate for the reverse side of the altarpiece at the time when work on it was still in progress.[10] Assuming that the artist began by working on the main panel of the front altarpiece (not mentioned in that document possibly because already completed), and that the two faces of the predella (references are also missing)[11] were executed last, the latter would have been painted some time between late 1310 and early 1311.

In 1506 the altarpiece was removed from the high altar and transferred to the left transept,[12] next to the altar of St Sebastian, where it remained until 1771. Then, 'on 18 July ... it was taken to the church of Sant'Ansano ... On the first day of August the said dossal was sawn into a number of pieces and removed to the last room in the apartment ... of Sig. Rettore < of the Opera del Duomo > in order to make several pictures ...'.[13] From then on it is difficult to follow the history of the various parts. By 1776 most of them were back again in the Cathedral: the *Maestà* was placed over the altar of St Ansanus in the left transept, the *Passion* scenes from the back of the altarpiece over the Holy Sacrament altar in the right transept, and several of the smaller panels in the sacristy.[14] Since an inventory of 1798 records only twelve pinnacle scenes and eight predella panels in the sacristy,[15] the remainder may already have been dispersed by then. The Thyssen *Christ and the Samaritan Woman* re-emerged in an exhibition held in 1879 at Colle Val d'Elsa as the property of the Dini brothers. Although the subject is not mentioned explicitly, it is virtually certain that it was one of the four 'Stories of Jesus Christ' attributed to Duccio listed in the catalogue. It was framed with the *Temptation on the Mountain* as a pendant to the *Calling of Peter and Andrew* and the *Raising of Lazarus*, all of which originally formed part of the back predella. In 1886 the four stories were bought by Charles Fairfax Murray for the collection of Robert and Evelyn Benson in London.[16] In July 1927, when the entire Benson collection was acquired by Duveen,[17] the two panels of *Christ and the Samaritan Woman* and the *Temptation of Christ* were still framed together. They were later divided and sold separately. The *Temptation* entered the Frick Collection and our panel, together with the *Raising of Lazarus*, the Rockefeller collection. The *Calling of Peter and Andrew* was bought by Clarence H. Mackay (Roslyn, New York) and sold in 1934 to Samuel H. Kress, who bequeathed it to the National Gallery, Washington.[18]

The *Christ and the Samaritan Woman* and also the other parts of the predella are generally considered completely autograph and have been described as 'works of extraordinary beauty' (Fry (1904)); particularly innovative in the representation of architecture (De Grüneisen (1912)); masterpieces in which Duccio 'took Byzantine iconography only as his starting point', enlarging the compositions 'with imagination ... and dramatic action' (Toesca (1951)). In these scenes the space is expanded and its recession in depth is used to enrich the narrative (Carli (1961)), while certain compositional solutions with which the artist had already experimented in the upper part of the altarpiece are reintroduced, revised and perfected (White (1979)). All these aspects, together with 'the intimate articulation of the narrative and the expressiveness of the gestures and the heads' (Pope-Hennessy (1983)), confirm the traditional

Notes

6 'Appareat omnibus evidenter quod ... Duccius pictor olim Boninsegne civis senensis ... accepisset ... ad pingendum quandam tabulam ponendam supra maiori altari maioris ecclesie sancte Marie de Senis ... dictus Duccius promisit et convenit ... pingere et facere dictam tabulam quam melius poterit et scjverit et ... laborare continue in dicta tabula temporibus quibus laborare poterit in eadem et non accipere vel recipere aliquod aliud laborerium ad faciendum donec dicta tabula completa et facta fuerit' (G. Milanesi, *Documenti per la storia dell'arte senese*, I (Siena, 1854) pp.166–8).
7 Milanesi (1854) pp.169–70.
8 This observation was made by J. Pope-Hennessy, 'A Misfit Master', *New York Review of Books* (20 November 1980) pp.45–7 (see also Pope-Hennessy (1983) p.10f.); and taken up again by Deuchler (1984) p.48.
9 A. Lisini, 'Notizie di Duccio pittore e della sua celebre ancona', *Bullettino senese di Storia Patria* v (1898) p.22.
10 Milanesi (1854) p.178.
11 The document refers exclusively to the 'lavorio de la parte dietro' of the altarpiece and states that it was to be composed of 34 scenes. These probably included, apart from the 26 episodes in the main panel, the six lateral pinnacles and the central pinnacle, probably divided into two scenes.
12 Lisini (1898) p.24. For further details see also Stubblebine (1979) p.33f.
13 The quotation is from the inventory of the objects in the Cathedral made in 1776, published by P. Bacci, *Francesco di Valdambrino* (Siena, 1936) p.186.
14 See the above mentioned inventory (Bacci, 1936); also G. Della Valle, *Lettere sanesi*, II (Siena, 1785) p.71f.
15 Bacci (1936) p.187.
16 Rusk Shapley (1979) quotes the following annotation made by Robert Benson in his personal copy of the catalogue of his collection: 'In 1886 I gave commission to C. Fairfax Murray to spend £2000 for me in Italy. These 4 Duccios were part of the spoils. They came out of a farm house in the Val d'Elsa, near Siena'. It is practically certain that these are the same four panels belonging to Dini which were exhibited at Colle Val d'Elsa in 1879; cf. also Davies (1951).
17 Alexandre, Borenius, Douglas and Washburn Freund (1927).

FIG I Duccio di Buoninsegna, the two faces of the *Maestà* altarpiece for Siena Cathedral reconstructed:

FRONT

F1 *The Annunciation* (London, National Gallery)
F2 *Isaiah* (Washington DC, National Gallery)
F3 *The Nativity* (Washington DC, National Gallery)
F4 *Ezechiel* (Washington DC, National Gallery)
F5 *The Adoration of the Magi* (Siena, Museo dell'Opera del Duomo)
F6 *Solomon* or *David* (Siena, Museo dell'Opera del Duomo)
F7 *The Presentation in the Temple* (Siena, Museo dell'Opera del Duomo)
F8 *Malachi* (Siena, Museo dell'Opera del Duomo)
F9 *The Massacre of the Innocents* (Siena, Museo dell'Opera del Duomo)
F10 *Jeremiah* (Siena, Museo dell'Opera del Duomo)
F11 *The Flight into Egypt* (Siena, Museo dell'Opera del Duomo)
F12 *Hosea* (Siena, Museo dell'Opera del Duomo)
F13 *Christ among the Doctors* (Siena, Museo dell'Opera del Duomo)
F14 *The Virgin and Child, saints and angels* (Siena, Museo dell'Opera del Duomo)
F15 *St Thaddaeus* (Siena, Museo dell'Opera del Duomo)
F16 *St Simon* (Siena, Museo dell'Opera del Duomo)
F17 *St Philip* (Siena, Museo dell'Opera del Duomo)
F18 *St James the Great* (Siena, Museo dell'Opera del Duomo)
F19 *St Andrew* (Siena, Museo dell'Opera del Duomo)
F20 *St Matthew* (Siena, Museo dell'Opera del Duomo)
F21 *St James the Less* (Siena, Museo dell'Opera del Duomo)
F22 *St Bartholomew* (Siena, Museo dell'Opera del Duomo)
F23 *St Thomas* (Siena, Museo dell'Opera del Duomo)
F24 *St Matthias* (Siena, Museo dell'Opera del Duomo)
F25 *The Annunciation of the Virgin's death* (Siena, Museo dell'Opera del Duomo)
F26 *The Virgin's farewell to St John* (Siena, Museo dell'Opera del Duomo)
F27 *The Virgin's farewell to the Apostles* (Siena, Museo dell'Opera del Duomo)
F28 *The Coronation of the Virgin* (lost)
F29 *The Assumption* (lost)
F30 *The Death of the Virgin* (Siena, Museo dell'Opera del Duomo)
F31 *The Funeral of the Virgin* (Siena, Museo dell'Opera del Duomo)
F32 *The Entombment of the Virgin* (Siena, Museo dell'Opera del Duomo)

BACK

B1 *John the Baptist bearing witness* (Budapest, Museum of Fine Arts)
B2 *Christ's Temptation on the Temple* (Siena, Museo dell'Opera del Duomo)
B3 *Christ's Temptation on the Mountain* (New York, Frick Collection)
B4 *The Calling of Peter and Andrew* (Washington DC, National Gallery)
B5 *The Wedding at Cana* (Siena, Museo dell'Opera del Duomo)
B6 *Christ and the Samaritan Woman* (Thyssen Collection)
B7 *The Healing of the Blind Man* (London, National Gallery)
B8 *The Transfiguration* (London, National Gallery)
B9 *The Raising of Lazarus* (Fort Worth, Kimbell Museum)
B10 *The Entry into Jerusalem* (Siena, Museo dell'Opera del Duomo)
B11 *The Washing of the Disciples' feet* (Siena, Museo dell'Opera del Duomo)
B12 *The Last Supper* (Siena, Museo dell'Opera del Duomo)
B13 *Christ taking Leave of the Apostles* (Siena, Museo dell'Opera del Duomo)
B14 *Judas taking the Bribe* (Siena, Museo dell'Opera del Duomo)
B15 *The Agony in the Garden* (Siena, Museo dell'Opera del Duomo)
B16 *The Betrayal of Christ* (Siena, Museo dell'Opera del Duomo)
B17 *The First Denial of St Peter* (Siena, Museo dell'Opera del Duomo)
B18 *Christ before Annas* (Siena, Museo dell'Opera del Duomo)
B19 *The Second Denial of St Peter* (Siena, Museo dell'Opera del Duomo)
B20 *The Third Denial of St Peter* (Siena, Museo dell'Opera del Duomo)
B21 *Christ accused by the Pharisees* (Siena, Museo dell'Opera del Duomo)
B22 *Christ before Pilate* (Siena, Museo dell'Opera del Duomo)
B23 *Christ before Herod* (Siena, Museo dell'Opera del Duomo)
B24 *The Mocking of Christ* (Siena, Museo dell'Opera del Duomo)
B25 *The Flagellation* (Siena, Museo dell'Opera del Duomo)
B26 *The Crowning with Thorns* (Siena, Museo dell'Opera del Duomo)
B27 *Pilate washing his hands* (Siena, Museo dell'Opera del Duomo)
B28 *Christ carrying the Cross* (lost)
B29 *The Crucifixion* (lost)
B30 *The Deposition* (Siena, Museo dell'Opera del Duomo)
B31 *The Entombment* (Siena, Museo dell'Opera del Duomo)
B32 *The Holy Women at the Tomb* (Siena, Museo dell'Opera del Duomo)
B33 *The Descent into Limbo* (Siena, Museo dell'Opera del Duomo)
B34 *Noli me tangere* (Siena, Museo dell'Opera del Duomo)
B35 *The Way to Emmaus* (Siena, Museo dell'Opera del Duomo)
B36 *The Apparition behind closed doors* (Siena, Museo dell'Opera del Duomo)
B37 *The Incredulity of St Thomas* (Siena, Museo dell'Opera del Duomo)
B38 *The Apparition on the sea* (Siena, Museo dell'Opera del Duomo)
B39 *Christ in glory* or *The Last Judgement?* (lost)
B40 *The Ascension* (lost)
B41 *The Apparition in Galilee* (Siena, Museo dell'Opera del Duomo)
B42 *The Apparition at supper* (Siena, Museo dell'Opera del Duomo)
B43 *Pentecost* (Siena, Museo dell'Opera del Duomo)

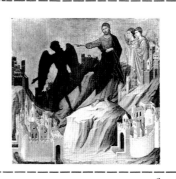

a b c d

FIG 2 Duccio di Buoninsegna, the back predella of the *Maestà* altarpiece reconstructed:

B1 *John the Baptist bearing witness* (Budapest, Museum of Fine Arts) 28.5 × 38 cm
B2 *Christ's Temptation on the Temple* (Siena, Museo dell'Opera del Duomo) 48 × 50.5 cm
B3 *Christ's Temptation on the Mountain* (New York, Frick Collection) 43 × 46 cm
B4 *The Calling of Peter and Andrew* (Washington DC, National Gallery) 43.5 × 46 cm

attribution to Duccio. Nevertheless, there have been some discordant views, retaining Duccio's authorship of the four ex-Benson panels as 'anything but certain' (Jahn Rusconi (1913)), and recently the execution of the back predella has even been ascribed to Pietro Lorenzetti (Stubblebine (1975, 1979)). According to the authors of *Art in the Making* (1989–90), the architecture at least in the *Healing of the Blind Man* in London (the scene next to the Thyssen panel on the back predella) is by a hand different from Duccio's. Considering the enormous task, Duccio must have been helped by assistants, but I am unable to see any detail of the predella scenes in which the contribution of a different artist can be clearly distinguished. Apart from the stylistic evidence, the insistence with which the artist's exclusive and personal responsibility is stipulated in the 1308 document would also lead one to assume that the altarpiece was substantially executed by his own hand.

As for the order in which the various components of the altarpiece were painted, Weigelt (1911) already observed that the predella was stylistically more advanced compared to the rest of the *Maestà*. Carli (1961) believes the predella to have been painted after the two main sides, but before the pinnacles, whereas White (1973, 1979) holds the view that the 'richness and variety' of the predella scenes 'seem to show that they were only planned and executed when the work on the main panel was nearly or even completely finished'.[19] White also thinks that the execution progressed from the upper zones downwards starting from the main side. Deuchler (1984) tries to confute this hypothesis but with scarcely convincing arguments. He seems to be right, however, in proposing that work on the altarpiece probably began before

Notes
18 For the *Temptation* panel, see Frick (1960) p.54f.; for the *Raising of Lazarus*, bought by the Kimbell Art Museum of Forth Worth, Texas, see *Apollo* CII (1975) p.224 and Deuchler (1984) pp.63f. and 215, while for an analysis of the pentimento visible in a reflectograph of Lazarus's figure, Deuchler (1979) p.545f. and R. Wilkins Sullivan, 'Duccio's Raising of Lazarus Reexamined', *Art Bulletin* LXX (1988) pp.37–87; for the *Calling of Peter and Andrew* in the National Gallery, Washington, no.252, see Rusk Shapley (1979).
19 J. White, *The Birth and Rebirth of Pictorial Space* (London, 1957) p.86 note 10. White has also made an extremely careful study of the *Maestà*'s chronology (1979, pp.102–19). On the whole his conclusions seem to me convincing; the only debatable point is his hypothesis of there having been changes in the execution of the iconographical

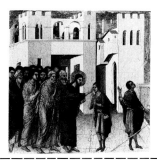

e f g h i

B5 *The Wedding at Cana* (Siena, Museo dell'Opera del Duomo) 47.7 × 50.1 cm
B6 *Christ and the Samaritan Woman* (Thyssen Collection) 43.5 × 46 cm
B7 *The Healing of the Blind Man* (London, National Gallery) 43 × 44.8 cm
B8 *The Transfiguration* (London, National Gallery) 48.1 × 50.5 cm
B9 *The Raising of Lazarus* (Fort Worth, Kimbell Museum) 43.5 × 46 cm

programme subsequent to the initial contract.
20 Cavalcaselle (in Crowe and Cavalcaselle, *History*, II (1864) p.44 note 1) thought that the 18 panels then in the Cathedral sacristy, in part elements of the predella and in part pinnacles, originally formed a double predella. E. Dobbert (1885, pp.153–163) was of the opinion that both predellas had seven scenes alternating with figures of prophets.

1308. Conti (1980) suggests that the predella was added after 1311 and must represent the artist's latest stylistic development. While admitting that the style of the back predella is in some ways more advanced than the scenes in the pinnacle, it is neither likely that there would have been a considerable lapse of time between them, nor that the patrons would have commissioned the back predella as an afterthought. In all probability the main panel, beginning with the pinnacle scenes representing the last episodes of the Virgin's life, was begun before the 1308 modification of an earlier, lost contract. This would explain the absence of certain compositional elements and perspective effects, which are to be found instead in the parts painted when the work was well under way.

One of the most debated issues concerns the original appearance of the *Maestà*. The earliest attempts at a reconstruction were made by Cavalcaselle and Dobbert, who did not yet know of the existence of the dispersed panels of the back predella, and made purely conjectural suggestions.[20] Later, after Douglas's identification (1902, 1903) of the Benson and London National Gallery panels as belonging to the back predella, Weigelt (1909, 1911, 1930) hypothesized a predella composed of ten elements, adding to the six known panels two others discovered by him (Siena, Opera del Duomo), and assuming that two more (representing the Baptism and First Temptation of Christ) were lost. Lusini (1912) suggested the possibility that the back predella contained eleven scenes; but most scholars, such as Brandi (1951), De Wald (1955) and Carli (1961), agree with Weigelt's theory, at least so far as this part of the altarpiece is concerned. Later, Cooper (1965) made an attempt to reconstruct the predellas of both sides

with the surviving panels only, rightly concluding that the back predella consisted of nine scenes. Less convincing is his suggestion that the *Christ among the Doctors* belonged to the back predella, instead of in its usual place in the Infancy cycle. This would also result in an incongruous *mise-en-page*, with the front predella beginning with a scene but ending with the single figure of a prophet. White (1973, 1979) has been able to demonstrate, on the basis of observations on the carpentry of fourteenth-century polyptychs and with the help of accurate measurements of the surviving parts, that the back predella had nine sections. His conclusion that 'on the evidence of all the other surviving altarpieces of the period', this predella 'was of the same width as the main panel and its outer frame' is accepted by most recent scholars. Stubblebine (1977, 1979), however, maintains that the biblical narrative would need to be completed by three further episodes, now missing: the *Baptist bearing witness* (like the *Raising of Lazarus* at the end of the sequence) would have been included on the short side of the altarpiece dividing the two painted surfaces, and the *Baptism* and the *Temptation in the wilderness* at the beginning of the predella. A similar view was also put forward by Wilkins Sullivan (1985); in her opinion the lost *Baptism* was on the left short side and the *Temptation in the wilderness* at the left end of the predella, while on the right short side there would have been a scene representing the *Anointing in Bethany*. Prior to the publication of the latter hypothesis, the present writer (1982) had expressed agreement with White's view that the back predella contained nine scenes, the first of which would have been the *Baptist bearing witness* (see FIG 2).

The idea of a predella extending round to the short sides of a two-faced polyptych seems to be far-fetched: what is the point of inventing a type of construction that has no prototype or parallel in early Trecento altarpieces when the elements at our disposal enable us to reach a convincing reconstruction? The *Baptist bearing witness* actually survives, though in poor condition and mutilated, in the Museum of Fine Arts in Budapest (FIG 3).[21] It is generally regarded as a work of Duccio's entourage and is sometimes given to Ugolino da Siena.[22] However, it not only preserves the essence and intensity of Duccio's narratives but also many of his stylistic characteristics, such as the grouping and poses of the figures, their particular serpentine drapery rhythms and facial expressions.[23] The figures are also on the same scale as those of the other panels of the back predella, and in all scenes the light falls from the left. All these considerations, and the fact that the *Baptist bearing witness*, a theme otherwise rare in Sienese art, fits perfectly in the iconographical sequence that interests us, would confirm their common origin. As for the original structure of the frame, the recent studies of White (1973, 1979) and Christa Gardner von Teuffel[24] provide the most convincing hypotheses.

The scene of *Christ and the Samaritan Woman* would therefore have been the sixth of the nine scenes of the back predella, coming after the *Wedding at Cana* (which on account of its Eucharistic symbolism was centrally placed) and before the *Healing of the Blind Man*.[25]

Notes
21 A. Pigler, *Museum der bildenden Künste. Katalog der Galerie alter Meister* (Budapest, 1967) p.197f., no.6. The painting was acquired by Johann Anton Ramboux in Siena before 1842 and sold with his collection in 1867. Ramboux may already have had the painting transferred to canvas, reducing it in size (its present measurements of 28.5 × 38 cm are those given in the 1867 sale catalogue). Probably at the same time the ground was re-gilt and the painted surface retouched in various areas. Despite its precarious state, the very fine quality of the painting is still perceptible and its style confirms Duccio's authorship and a date around 1310.
22 Attributed to Duccio not only by Ramboux but also by Crowe and Cavalcaselle (*History*, II, p.52), the painting was referred to Ugolino da Siena by Venturi (*Storia*, V, pp.581, 587) and various other scholars, whereas Pigler (1967) preferred to class it as 'School of Duccio'.
23 The most significant comparisons, to my mind, are with the scenes of *Christ taking leave of the Apostles*, the *Apparition behind closed doors* and the *Apostles' farewell to the Virgin*, all in the Museo dell'Opera del Duomo, Siena.
24 C. Gardner von Teuffel, 'The Buttressed Altarpiece: a Forgotten Aspect of Tuscan Fourteenth Century Altarpiece Design', *Jahrbuch der Berliner Museen* XIX–XXI (1979) pp.21–65; but also H. Hager, *Die Anfänge des italienischen Altarbildes* (Munich, 1962) p.146f., and Cämmerer George (1966).
25 All the recently proposed reconstructions agree on the following sequence of the last four predella scenes, as given in FIG 2. The sequence is now confirmed by X-radiographs which prove that the panels, though now separate, once formed a single plank in this order: cf. London (1989–90) p.83.

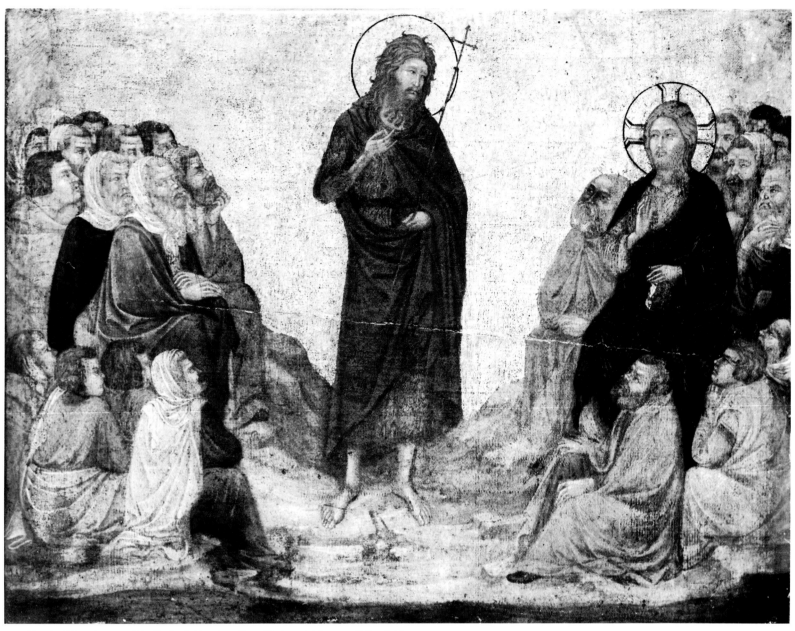

FIG 3 Duccio di Buoninsegna, *John the Baptist bearing witness* (Budapest, Museum of Fine Arts)

Franco-Flemish master probably active in Naples c1435/45

12 The Crucifixion

Panel (coniferous wood) 44.8 × 34 cm; thickness 0.5 cm (thinned)
Accession no.1976.1

Provenance
Private collection, France
Charles Henschel, New York, 1952
Thyssen-Bornemisza Collection, 1976

Exhibitions
USSR, 1987, no.7
London, 1988, no.12

Literature
C.R.Post, 'Flemish and Hispano-Flemish Paintings of the "Crucifixion"', *Gazette des Beaux-Arts*, sér.VI, XXXIX
 (1952) pp.234–42
R.Longhi, 'Una Crocifissione di Colantonio', *Paragone* VI, no.63 (1955) pp.3–10
R.Causa, *Pittura napoletana dal XV al XIX secolo* (Bergamo, 1957) p.8
J.Ainaud de Lasarte, 'La Flandre et l'indumentaire hispano-mauresque', in *Miscellanea Professor Dr D.Roggen*
 (Antwerp, 1957) pp.1–7
D.D'Agostino, 'Storia di un problema: vicenda critica di Colantonio', *Partenope* II (1961) p.21f.
M.Rostworowski, 'Trois tableaux d'Antonello da Messina', *Jaarboek Koninklijk Museum voor schone Kunsten,
 Antwerpen* IV (1964) pp.73f., 76 note 27
S.Bottari, 'Un "Cristo in croce" di Colantonio', *Pantheon* XXIV (1966) p.345f.
L.Castelfranchi Vegas, 'I rapporti Italia-Fiandra – II', *Paragone* XVII, no.201 (1966) p.44
C.Sterling, 'Observations on Petrus Christus', *Art Bulletin* LIII (1971) pp.9 note 38, 17 note 62
Dizionario Bolaffi, III (1972) p.391
R.Pane, *Il Rinascimento nell'Italia meridionale*, I (Milan, 1975) pp.76, 93 note 11
C.Sterling, 'Jan van Eyck avant 1432', *Revue de l'Art*, no.33 (1976) p.33
F.Bologna, *Napoli e le rotte mediterranee* (Naples, 1977) pp.91–3
Thyssen-Bornemisza (1977) p.35, no.65A
M.G.Paolini, 'Antonello e la sua scuola', offprint from *Storia della Sicilia*, V (Naples, 1979) p.15
M.G.Paolini, 'Problemi antonelliani. I rapporti con la pittura fiamminga', *Storia dell'arte*, nos.38–40 (1980)
 pp.152f., 166
J.Wright, 'Antonello da Messina. The origins of his style and technique', *Art History* III (1980) p.52
Thyssen-Bornemisza (1981) p.76, no.65A
A.Marabottini in *Antonello da Messina*, exhibition catalogue (Messina, 1981) pp.35, 48, 84, 96
F.Sricchia Santoro, *ibidem*, p.77f.
F.Bologna, 'Colantonio', in *Dizionario biografico degli italiani*, XXVI (Rome, 1982) p.700
J.Pope-Hennessy, 'Some Italian Primitives', *Apollo* CVIII (1983) p.12
L.Castelfranchi Vegas, *Italia e Fiandra nella pittura del '400* (Milan, 1983) pp.81, 84
F.Sricchia Santoro, *Antonello e l'Europa* (Milan, 1986) pp.38f., 154
F.Navarro, 'La pittura a Napoli e nel Meridione nel Quattrocento', in *Quattrocento* (1986) p.410
A.Marabottini, in *Antonello da Messina. Atti del Convegno di studi tenuto a Messina dal 29 novembre al 2 dicembre 1981*
 (Messina, 1987) p.12
L.Castelfranchi Vegas, *ibidem*, p.25f.
F.Navarro, 'La pittura a Napoli e nel Meridione nel Quattrocento', in *Quattrocento*, 2nd edn. (1987) pp.453, 601
D.Ekserdjian, in London (1988) p.44
J.Lauts, 'Zwei neue Bücher über Antonello da Messina', *Kunstchronik* XLI (1988) p.292
Thyssen-Bornemisza (1989) p.81

To either side of the Crucified Christ[1] are the two crosses with the dying thieves, Dismas and
Gestas. At the foot of Christ's Cross, which is surmounted by the inscription I.N.R.I., are Mary
Magdalen on her knees and the centurion standing, who contemplates the Saviour; the latter's

Note
1 For the iconography of
crowded Crucifixion scenes,
which became common from the
fourteenth century onwards, see
Schiller, *Ikonographie*, II, p.164f.,
and M.Meiss, 'Highlands in the
Lowlands', *Gazette des Beaux-Arts*,
sér. VI, LVII (1961) p.281f.
The painting has several unusual
details. The silver sphere in the
sky on the right probably does not
represent the moon (which is
traditionally placed on this side of
the Cross but always as a
counterpart to the sun on the left;
L.Hautecoeur, 'Le soleil et la lune
dans la Crucifixion', *Revue
archéologique*, N.S.II (June-
October 1921) pp.13–32): it is
more likely to be the veiled sun
mentioned in Luke 23:45, 'And
the sun was darkened . . .'. This
motif, later transformed into an
eclipse of the sun (Schiller, II,
p.171), is also to be found in Jan
van Eyck's *Crucifixion* (New York,
Metropolitan Museum,
no.33.92a; van Eyck's authorship
has sometimes been questioned:
see Sterling (1976) p.42f., and
A.Chatelet, *Les primitifs hollandais*
(Freiburg, 1980) p.196f.). It is
also unusual to find Veronica in a
central position among the
mourners. Her figure is sometimes
included in Crucifixion scenes in
northern painting from the
fifteenth century onwards, but
usually to one side, holding up the
veil impressed with Christ's
features (Schiller, II, p.170),
whereas here she gives vent to her
grief with the group of Maries and
the folded veil with the imprint of
Christ's face is tucked into her
belt.
 The figure wearing a helmet
who looks towards Christ on the
right of the Cross should be the
centurion, but the letters along
the hem of his costume (E. . .O/
VC. . .AT?) do not appear to be
related to the Gospel words (eg
Luke 24:48 'Vere hic homo justus
erat').

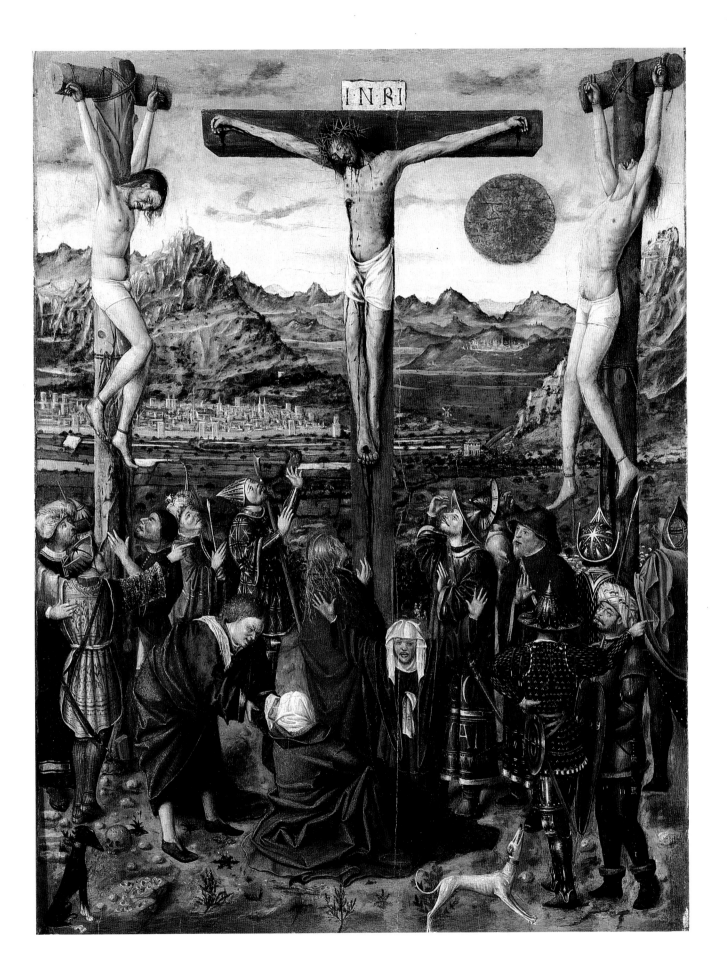

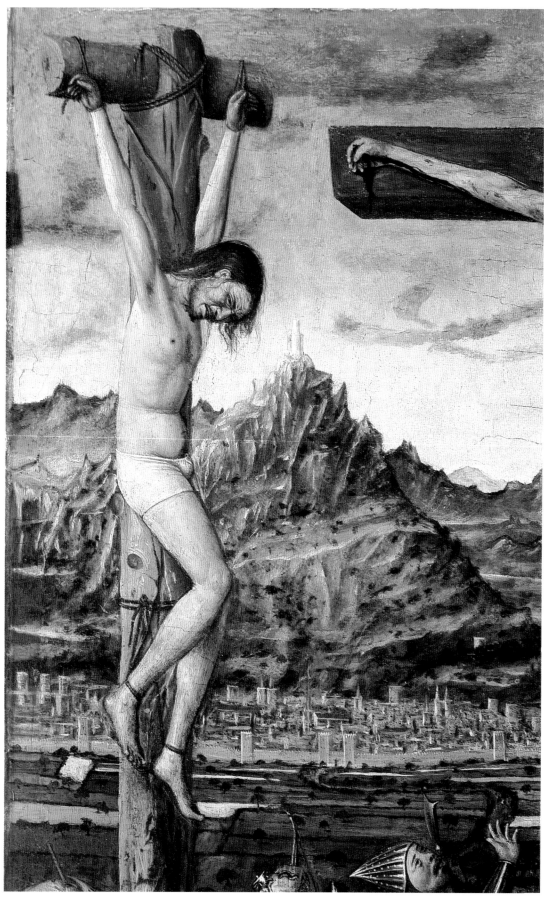

Detail [12] the left-hand thief
and the landscape

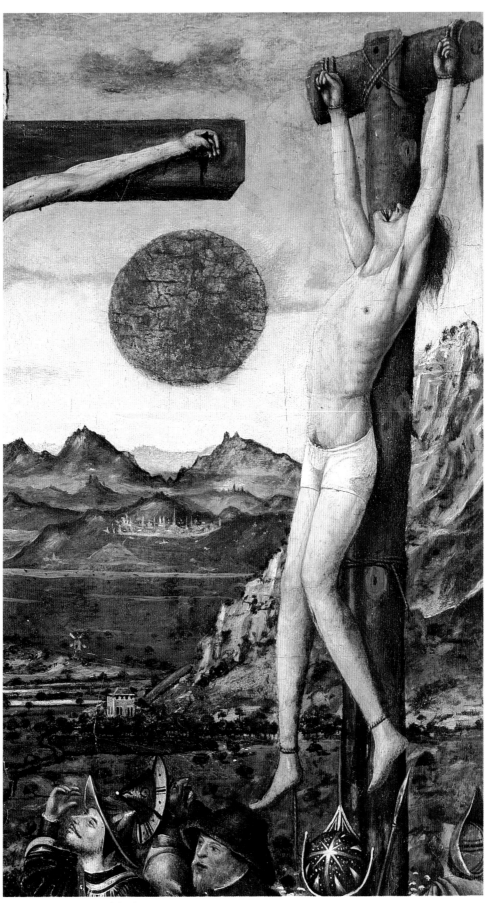

Detail [12] the right-hand thief,
the landscape and the sun

costume is decorated with a fragmentary inscription. In the foreground the swooning Virgin is comforted by St John the Evangelist (see detail, p.85) and one of the Maries, while Veronica, her arms raised, faces the spectator weeping. Around the group are a number of soldiers and Pharisees, In the background is an extensive landscape with a distant view of Jerusalem surrounded by mountains (see details, pp.80–81).

When the panel (thinned and cradled) was first reproduced, the sky was partially covered by repaint. Its removal during the restoration carried out in 1975 revealed some damage but also uncovered the silver disc of the sun. Other worn areas include the horizontal beam of Christ's cross and the landscape at the centre. The rest of the surface is generally well preserved. There is a long, thin crack running down from Christ's left shoulder to the mourning Veronica.

When our panel was first introduced into the critical literature by Post (1952), it was in the hands of Charles Henschel of New York. Sterling (1976) states that he had seen the painting shortly after the last War when it belonged to a private French collector. In Post's opinion this *Crucifixion* is 'as perplexing to connoisseurship as it is intrinsically beautiful' and may be 'possibly attributable to the Spaniard Luis Dalmau'. His proposal, involving this still very nebulous figure,[2] evidently intended to connect the painting with the circle of van Eyck's followers in Valencia. Post also drew attention to some extremely innovative aspects of the artist's style, observing, for instance, that the two thieves 'look forward to Antonello'. Longhi (1955) republished the work under the name of Colantonio,[3] thereby leading the discussion in another direction. While confirming the existence of certain affinities with Antonello's early *Crucifixion* (Bucharest, Galeria Universale),[4] he discerned in the picture both Italian figurative traditions and Flemish and Flemish-Catalan elements forming a 'cultural blend' which, he thought, 'could not have occurred elsewhere than in Southern Italy'. As for its date, considering that Antonello was born around 1430 and had become an independent artist in the mid-1450s,[5] he placed the *Crucifixion* a few years earlier, 'coinciding with the period when Antonello was learning the art of painting at Naples in Colantonio's studio'.

Longhi's opinion has been accepted for many years by the majority of Italian critics, including Causa (1957), D'Agostino (1961), Bottari and Castelfranchi Vegas (1966), the *Dizionario Enciclopedico Bolaffi* (1972) and Bologna (1977, 1982); it has recently been proposed again by Navarro (1986, 1987). Only Pane (1975) has expressed a different view, preferring the attribution to Dalmau. The Spanish art historian Ainaud de Lasarte (1957) maintained a cautious position: in view of the painting's cultural components it may or may not have been painted in Naples. He classified it as an anonymous work, though without excluding Colantonio's authorship altogether, and posed the question whether this artist, known from historical sources but not actually documented in his town, might not be identifiable with Antonio di Perrino, who was painter at the Neapolitan court between 1443 and 1458.[6]

Rostworowski (1964) favoured the attribution to Colantonio, pointing out similarities between our *Crucifixion* and that by Antonello at Bucharest. Sterling (1971), on the other hand, rejected the attribution to Colantonio as 'entirely arbitrary', stating that 'it is probably in Naples (because of its influence on Colantonio) that the dramatic and freely executed *Crucifixion* ... was painted ... by a Valencian artist in the 1440s'. Returning later to the discussion (1976), the same critic wrote: 'c'est une œuvre espagnole ... d'un peintre probablement valençois, ce dont témoignent sa couleur chaude et sa technique empatée', adding that the composition was probably inspired by a prototype either by Jan van Eyck or by his pupil in Bruges, Lluis Alimbrot, who settled in Valencia towards 1438.[7]

The question has been entangled still more by the studies of Paolini (1979, 1980), who considers the catalogue of works traditionally attributed to Colantonio stylistically heterogeneous and refers the Thyssen *Crucifixion* to a 'Hispano-Valencian hand, with interesting interventions which could be the work of a much more accomplished artist' than the Neapolitan master. The idea of a collaborator had already been hinted at by Longhi (1955),

Notes

2 For Dalmau, whose only certain work remains *The Virgin of the Councillors* (Barcelona, Museu d'Arte Cataluña), see C.R.Post, *A History of Spanish Painting*, VI/I (Cambridge MA, 1935) p.134f.; J.Gudiol Ricart, *Pintura gotica. Ars Hispaniae* IX (Madrid, 1955) p.239f., and A.Simonson Fuchs, 'The Virgin of the Councillors by Luis Dalmau', *Gazette des Beaux-Arts*, Sér VI, XCIX (1982) pp.45–54.

3 For the most recent profile of this artist, who is known from the sources to have enjoyed a considerable reputation but for whose œuvre no documentary evidence exists, see Bologna (1982) p.697f.

4 Inv. no.7981/15; cf. the relevant entries in the exhibition catalogue *Antonello da Messina* (1981) p.94f. and in Sricchia Santoro (1986) p.156.

5 This assumption is based on the fact that on 21 April 1457 one Paolo de Chacho is stated to have been his workshop assistant for over a year; Sricchia Santoro (1986) p.174.

6 This is obviously a mere conjecture, ignored by other critics. For Antonio di Perrino, by whom no works are known, see G.Filangieri, *Documenti per la storia, le arti e le industrie della provincia napoletana*, VI (Naples, 1891) p.267.

7 On Alimbrot (Allynckbrood) see the recent study by Sterling in *Actas del XXIII Congreso Internacional de Historia del Arte 1973* (Granada, 1976) pp.503–12.

8 I am thinking mainly of Jacomart, whose presence is documented in Naples (E. Tormo y Monzo, *Jacomart* (Madrid, 1913) and Post (1952) p.14f.), and the Catalan Huguet (C. R. Post, *A History of Spanish Painting* VII/1 (Cambridge MA, 1938) p.46f. and J. Ainaud, *Jaime Huguet* (Madrid, 1955)).

who did not exclude the possibility that the young Antonello might have had a hand in the execution of the *Crucifixion*. Paolini (1980) thinks that the collaborator responsible for the group of figures round the swooning Virgin could have been Antonello himself, working as an apprentice with his anonymous master, or, considering the persistence of Eyckian elements in the painting, some young Flemish artist active in Jan van Eyck's circle, such as Petrus Christus.

Colantonio's authorship is maintained in the catalogues of the Thyssen Collection (Thyssen-Bornemisza (1981, 1986, 1989); USSR (1987)) and by Bologna (1982), who believes it is a work probably inspired by a lost prototype by van Eyck, painted in Colantonio's mature phase when he followed rather than anticipated Antonello's early style. The attribution is cautiously accepted by Wright (1980) and by Ekserdjian (1988), while Pope-Hennessy (1983) wrote: 'whether or not this attribution is correct – I personally feel more than a little sceptical – this is a work of the highest quality ...'. Various other opinions have also been expressed: Marabottini (1981, 1987), and still more decidedly Sricchia Santoro (1981) advance the hypothesis that the painting may have been executed by the young Antonello alone. Castelfranchi Vegas (1983, 1987), revising her earlier view, excludes the authorship of both Colantonio and Antonello da Messina, observing that the 'almost miniature-like' execution, 'the intense movements ... frenzied gestures ... and the emphasis given to curious and exotic costumes and armour' would suggest a master of Flemish-Valencian rather than Neapolitan culture. In her attempted reconstruction of Antonello's development in the light of recent research, Sricchia Santoro (1986) includes the Thyssen *Crucifixion* among this master's early works. In her opinion 'the extremely high quality of this panel and its stylistic components have neither the rather wooden stiffness characteristic of Colantonio nor the expressive idiom of a Spanish artist ... In every respect, including the exotic variety of the costumes, it fits effortlessly into the œuvre of Antonello himself, who received his training in the Sicilian province of the kingdom of Aragon, where Flemish models found their finest interpretation'. Her attribution is rejected by Lauts (1989), who finds the 'expressions of the figures and the rather harsh pathos completely alien to Antonello's type of realism', preferring, it seems, the former reference to Colantonio. This summary of the studies carried out so far shows that the problem is still open and that any proposal has to be put forward with due caution.

To begin with, it seems to me that what is known at present of the style of Dalmau and Alimbrot, and of other major artists of Valencia or Catalonia influenced by Flemish art,[8] is marked by a severe and elaborate solemnity that has little in common with the impassioned spontaneity of our painting. This quality would seem to be more in keeping with the cultural milieu existing in Naples prior to Alfonso of Aragon's rise to power, at the time when the blend of Provençal and Flemish influences left its mark on the city's artistic production, contributing also to the formation of Colantonio's style. The affinities noted by Longhi between the Thyssen *Crucifixion* and details of the altarpiece of St Vincent Ferrer in the church of San Pietro Martire, or the *Deposition* in San Domenico Maggiore, both in Naples, are certainly significant, even if the attribution of our *Crucifixion* to Colantonio himself no longer seems to me plausible. The simple settings, the slightly dry and detached way of presenting the action, the rigid poses and the hard, metallic modelling of Colantonio's two altarpieces mentioned above reveal a different temperament and cultural formation to those of the artist of the panel under discussion. As critics have already observed, the author of the *Deposition* in San Domenico Maggiore looks for inspiration to the sunny and well arranged world of Petrus Christus, even though he then interprets it with a sharpness and lucidity worthy of the Spanish followers of van Eyck. The author of the Thyssen *Crucifixion*, on the other hand, is poignant and restless: his mountains look like ice that has just crystallized, his figures are loquacious and in continuous nervous movement, never ceasing to express the surprise, curiosity, amusement or distress that excites or afflicts them. Hence the need to hypothesize the influence, or even the collaboration, of an artist such as the young Antonello to justify these elements, unusual in Colantonio's work.

Another point to bear in mind is the fact that our *Crucifixion* seems directly to reflect a

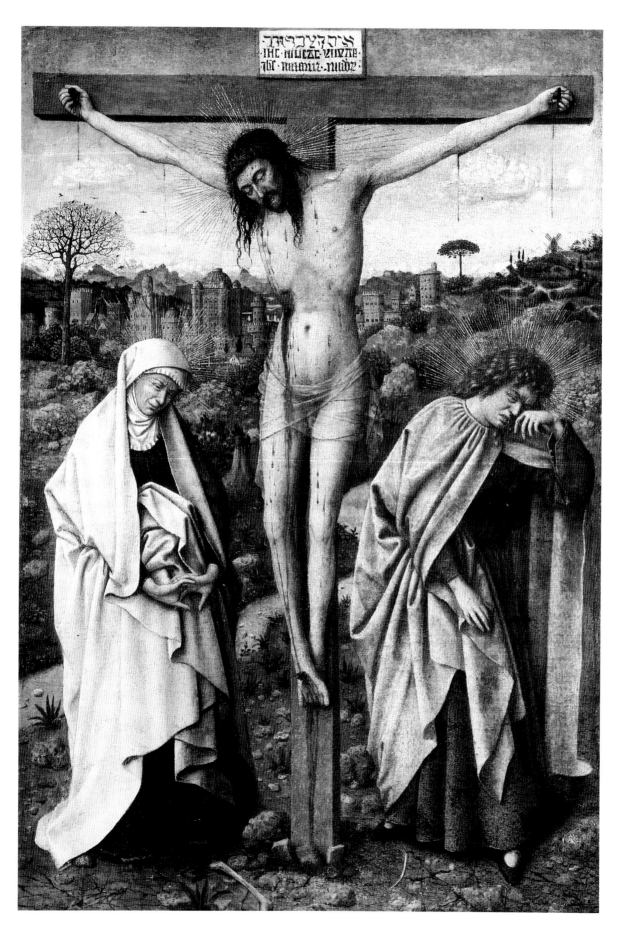

FIG 1 Jan van Eyck,
The Crucifixion
(Berlin, Staatliche Museen,
Gemäldegalerie)

Detail [12] St John comforts the swooning Virgin

Notes

9 See *Heures de Turin . . . de Jean de France, Duc de Berry*, reprint of the facsimile edition of 1902 with an introduction by A. Chatelet (Turin, 1967), besides the fundamental study by G. Hulin De Loo, *Les Heures de Milan* (Paris and Brussels, 1911) and the article by Sterling cited above (1976) p.12f.

10 Staatliche Museen, Gemäldegalerie, no.525F; Sterling (1976) p.48f. and Chatelet (1980) p.210. On the New York panel see above n.1.

11 Both the figure of the Magdalen and those of the two men seen from behind have analogies in van Eyck's *Crucifixion* in New York; this also has a windmill in the landscape background, an unusual feature in Italian painting which recurs in the Thyssen panel. The motif of the woman in the foreground seen from the back is reminiscent of f.34v., and the greyhounds of f.59v., of the Turin Hours (now lost; *Heures de Turin* (1902 and 1967) pls.xx and xxxvii).

12 Colantonio's borrowings from works by Petrus Christus have been pointed out by Bologna (1977) p.93f.

13 Compare the opinion of Sricchia Santoro (1986) p.69f.

14 As Sricchia Santoro (1986, p.39) rightly observes, the idea of 'the thief's face half hidden by his arm and of his uncontorted, outstretched legs . . . already foreshadow the radically Italian solutions of the Bucharest *Crucifixion*'. One should add, however, that the synthesis which gives the forms a sharp, rigid regularity and the vast, grandiose landscape background, apparently derived from Konrad Witz, which distinguish the Bucharest panel, are so far removed from the Thyssen *Crucifixion* as to make their common authorship difficult for me to accept.

relatively early stage in the style of Jan van Eyck and of his entourage: the closest analogies are to be found in the miniatures of the Turin-Milan Hours[9] and in two *Crucifixion* paintings (New York, Metropolitan Museum, and Berlin, Gemäldegalerie)[10] which are now generally dated to the third decade of the century or soon after. There are particularly close similarities with the Berlin painting (FIG 1): the figure of Christ and the face of St John weeping in the Thyssen panel seem to derive directly from this prototype, while other motifs, such as the *profil perdu* of the Magdalen kneeling at the foot of the Cross or the two men seen from behind conversing in the foreground as they walk towards the Cross, were probably borrowed from another van Eyck composition.[11] On the other hand, in his more mature phase, Colantonio's attention was directed towards Petrus Christus,[12] an artist whose style he evidently considered more suited to contemporary taste than that of Jan van Eyck; the same can also be said of Antonello's works of around 1460.[13] How then is one to explain a return in our *Crucifixion* to a model created by the great Flemish artist of the previous generation?

It has already been suggested that the Thyssen *Crucifixion* anticipates solutions that were later perfected by Antonello in his painting of the same subject at Bucharest,[14] and that it may

belong in a certain sense to the 'pre-history' of the artist of Messina. However, the very distinct emotional mood of our panel, the crowding-in of realistic details, the almost caricatural emphasis on expressions and the rustic, instinctive immediacy of behaviour do not, in my opinion, fit into Antonello's clear, well balanced world. Apart from the Moresque costumes, which are not sufficient alone to support a Spanish cultural origin for their author, there are many other elements – from an apparently first-hand knowledge of van Eyck's works to certain iconographical choices and such northern motifs as Christ's features on Veronica's crumpled veil or the windmill in the background – which point rather to another area influenced by Flemish culture, that of Burgundy and Provence. In short, the Thyssen *Crucifixion* brings to mind the production of paintings and miniatures at the court of René of Anjou, particularly works such as the Book of Hours in the Pierpont Morgan Library, New York, M358, and the Egerton Book of Hours (London, British Library);[15] miniatures which, like the particular choice of models derived from van Eyck, would suggest a date close to, but not necessarily coinciding with, the French king's stay in Naples.[16] Besides Enguerrand and Barthélemy d'Eyck, whose artistic personalities are only now beginning to emerge with some degree of clarity,[17] several other artists also worked for René, who was a cultivated and demanding patron, and perhaps it is among these artists that one may eventually identify the still anonymous author of this *Crucifixion*.

Notes

15 For the codex in the Pierpont Morgan Library see F. Avril, 'Pour l'enlumineure provençale. Enguerrand Quarton peintre des manuscrits?', *Revue de l'Art* no. 35 (1977) pp.9–40; for the Egerton MS 1070 in the British Library, O. Pächt, 'René Anjou Studien', *Jahrbuch der Kunsthistorischen Sammlungen in Wien* LXIX (1973) pp.85–126.

16 René d'Anjou, who came from Provence, resided in Naples from 1438 to 1442; cf. N. Coulet, A. Planche and F. Robin, *Le roi René: le prince, le mécène, l'écrivain, le mythe* (Aix-en-Provence, 1982) and Sricchia Santoro (1986) p.17f.

17 C. Sterling, *Enguerrand Quarton, le peintre de la Pietà d'Avignon* (Paris, 1983) and the recent article by N. Reynaud, 'Barthélemy d'Eyck avant 1450', *Revue de l'Art* no.84 (1989) pp.22–43, where, however, the attribution to Barthélemy of the *Holy Family* (a work worthy of Robert Campin) in the Cathedral of Le Puy is scarcely convincing.

Detail [12] the swooning Virgin and Veronica weeping

Agnolo Gaddi

active by 1369; died 1396

13 The Crucifixion

*c*1390
Tempera on panel, 32.5 × 30.3 cm; thickness 1.7 cm
Accession no.1977.98

Provenance
Milan, art market, by 1971
Florence, Carlo De Carlo
Thyssen-Bornemisza Collection, 1977

Literature
Boskovits, *Pittura fiorentina* (1975) p.300
Mostra Mercato Internazionale dell'Antiquariato, exhibition catalogue (Florence, 1977) p.85
Thyssen-Bornemisza (1981) p.115, no.104c
Thyssen-Bornemisza (1986) p.112, no.104g
Thyssen-Bornemisza (1989) p.117

This gold-ground panel, which has reached us in a fragmentary state, represents Christ on the Cross at the centre, flanked by Mary on the left and St John on the right, with Mary Magdalen kneeling on the ground as she embraces the Cross to kiss Christ's feet.

A photograph exists (FIG 1a) showing the panel in its original square shape, but trimmed below and on the sides, with the projecting spandrels above the inscribed arch apparently covered with modern repaint. Between 1971 and its acquisition for the Thyssen Collection, the panel was cut down to give it an arched top, cleaned and provided with a modern frame. Its present state is reasonably good, even though the colours appear slightly rubbed, as also the gold ground near the Cross. There is a vertical crack in the wood which has been repaired and a few small flaking losses in the gold ground and in Christ's halo, corresponding to the crack, which have been stuccoed and inpainted. On the back is an Italian customs stamp (1970).

The painting originally formed the upper part of a devotional image. Before it was trimmed on the sides, one can estimate that it was about 50 cm wide. Compositions of this kind were not unusual in Florentine painting of the late fourteenth century, with the lower section usually representing a half-length Madonna and Child or the Madonna of Humility flanked by saints.[1] Agnolo Gaddi's œuvre as it is known to us today includes no examples of this kind, but a small panel, formerly in a private collection in Düsseldorf, representing the *Madonna and Child with Sts John the Baptist, Catherine, Anthony Abbot and Peter* (FIG 1b), may, to judge from its almost square shape, have originally been surmounted by another, lunette-shaped scene representing the Crucifixion.[2] The painting in Düsseldorf, which is known today only from a poor reproduction, is very close in style and, considering its similar measurements (54×51 cm), it is very tempting to relate it to the Thyssen *Crucifixion* (as in FIG 1).

As is shown by the customs stamp, the Thyssen panel apparently came to Italy in 1970, with a temporary import licence. It was on the Milan market in 1971[3] and later passed to Carlo De Carlo in Florence, who exhibited it at the Mostra Mercato dell'Antiquariato in 1977. Soon after, it was bought for the Thyssen-Bornemisza Collection.

The *Crucifixion* was published by the present writer in 1975 as a work by Agnolo Gaddi to be dated around 1390/5. The catalogue of the 1977 exhibition, which reproduces it in its present state, accepts the attribution but suggests a date of c1370. The catalogues of the Collection (Thyssen-Bornemisza (1981, 1986 and 1989)) concur both on the attribution to Agnolo Gaddi and on the dating of c1390/5, which can be supported, in my opinion, by numerous comparisons. Christ's body, stretched on the Cross with its bold outlines emphasizing the angular forms and the strong chiaroscuro, is very close to that of the great painted cross in the church of San Martino at Sesto Fiorentino, which is generally given to Agnolo Gaddi and dated to the second half of the 1380s;[4] here the Madonna's sharp profile also finds its counterpart. Another typical work by the artist is a small panel, perhaps just slightly earlier in date (formerly Munich, von Nemes collection), which has a figure similar to that of the Magdalen in the scene of *St Andrew's martyrdom*,[5] throwing herself at the saint's feet. Still more interesting comparisons are provided by such securely datable works as the frescoes in the Cappella della Cintola in Prato Cathedral and the altar of the Crucifix in the church of San Miniato al Monte in Florence. One may note, in particular, the pose of St John, pointing towards Christ as he turns away to face the spectator, a motif frequently used by the artist. A similar figure occurs in Gaddi's Prato frescoes, for instance in the scene of the *Death of Michele Dragomari*,[6] in the young cleric pointing to the dying man as he speaks to his companions. St John's ample cloak with its sweeping V-shaped folds recalls those of the two women wrapped in their mantles on the extreme right in the *Burial of the Virgin* in the Prato cycle, while his youthful features are almost identical to those of a woman, in the middle distance of the same fresco, speaking to one of the two mourners on the extreme right.[7] The attribution to Agnolo Gaddi and a date around or soon after 1390 would therefore seem to be most likely for the fragment discussed here, which may be seen as a typical example of the master's late style.

FIG 1 Agnolo Gaddi, devotional panel (hypothetical reconstruction):
a *The Crucifixion* (Thyssen Collection; photograph of cat.[13] in its former state)
b *The Madonna and Child with four saints* (formerly Düsseldorf, private collection)

Notes
1 Half-length figures of the Madonna and Child crowned by a Crucifixion exist, for instance, in two panels by Giovanni del Biondo, one dated 1377 in the Pinacoteca, Siena, and the other of unknown location; Offner, *Corpus*, IV/v (1969) pls.VII and IX. Another example is a panel (Empoli, Pinacoteca) attributed to Ambrogio di Baldese (Boskovits (1975) pl.114), but which I now consider to be an early work by Mariotto di Nardo. The Madonna of Humility with saints beneath a Crucifixion occurs in works by Jacopo di Cione (Udine, Museo Civico; C.Someda de Marco, *Il Museo Civico e la Galleria antica e moderna in Udine* (Udine, 1956) p.194); by Lorenzo di Bicci (formerly Venice, private collection; Boskovits (1975) fig.135); and by a painter close to Agnolo Gaddi (formerly Florence, Landau Finaly collection; Soprintendenza ai BB.AA.SS, Florence, photo no.47684).
2 Düsseldorf, Galerie Stern, Horten sale (18 March 1933) lot 61, sale catalogue pl.1. In his numerous versions of the *Madonna of Humility with saints* Agnolo Gaddi usually includes angels holding a crown in the arched top of the panel above the Madonna.
3 I was able to examine the painting when it was with Finarte in Milan.
4 The date 1385/90 was suggested by Boskovits (1975) p.299, and by A.Conti (*I dintorni di Firenze* (Florence, 1983) p.127, whereas Cole (1977) p.16, pl.80, prefers to date the cross between 1380 and 1388.
5 See Boskovits (1975) fig.243; the painting was auctioned at Sotheby's, London, 8 July 1981, lot 87.
6 See B.Cole, *Agnolo Gaddi* (Oxford, 1977) pl.75.
7 See Cole (1977) pl.70.

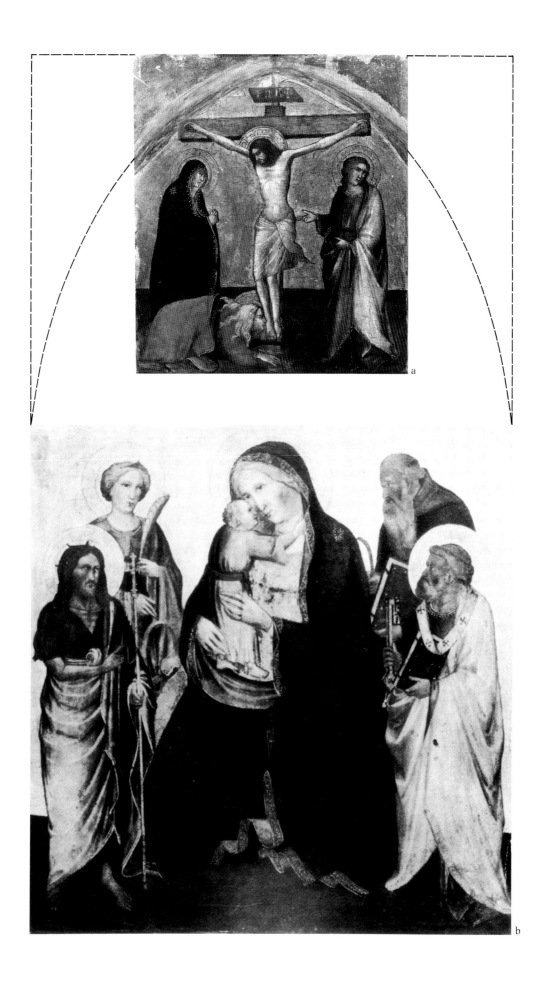

Taddeo Gaddi *c*1300–66

14 The Nativity

*c*1325
Panel (coniferous wood), 41.5 × 41.8 cm (painted surface 35.5 × 37 cm)
Accession no.1979.14

Provenance
Howe & Leonard's sale, Boston, 21 December 1846
Athenaeum, Boston (no.B.A.5.3; subsequently B.A.15.16 and B.A.10.5)
Museum of Fine Arts, Boston (on deposit) 1876–1977
Art market, New York
Thyssen-Bornemisza Collection, 1979

Literature
O.Sirén, 'Trecento Pictures in American Collections – I', *Burlington Magazine* XIV (1908) p.126
O.Sirén, *Giottino und seine Stellung in der gleichzeitigen florentinischen Malerei* (Leipzig, 1908) p.87
O.Sirén, 'Addenda und Errata zu meinem Giottino-Buch', *Monatshefte für Kunstwissenschaft* II (1908) p.1121
M.Wehrmann, *Taddeo Gaddi, ein florentiner Maler des Trecento* (Stettin, 1910) p.16
B.Khvosinsky and M.Salmi, *I pittori toscani dal XIII al XVI secolo*, II (Rome, 1914) p.15
O.Sirén, 'Some Early Italian Paintings in the Museum Collection', *Museum of Fine Arts Bulletin* XIV (1916) pp.11–5
O.Sirén, *Giotto and Some of his Followers*, I (Cambridge MA, 1917) p.268
B.C.Kreplin, 'Taddeo Gaddi', in Thieme and Becker, *Lexikon*, XIII (1920) p.32
Catalogue of Paintings. Preliminary Edition. Museum of Fine Arts (Boston MA, 1921) pp.12–3, no.23
Selected Oil and Tempera Paintings and Three Pastels, exhibition catalogue (Museum of Fine Arts, Boston MA, 1932) n.p.
W.G.Constable, *Summary Catalogue of European Paintings* (Boston MA, 1955) p.28
G.Previtali, *Giotto e la sua bottega* (Milan, 1967) p.144 note 224
B.B.Fredericksen and F.Zeri, *Census of Pre-Nineteenth Century Italian Paintings in North American Public Collections* (Cambridge MA, 1972) p.101
Thyssen-Bornemisza (1981) p.116, no.104D
Offner, *Legacy* (1981) p.67
A.Ladis, *Taddeo Gaddi* (Columbia and London, 1982) p.203
Thyssen-Bornemisza (1986) p.113, no.104d
Thyssen-Bornemisza (1989) p.118

The stable of Bethlehem, situated on a rocky slope and resting on uneven ground, shelters the Child in the manger. The Madonna, seated on the ground beside him, pulls up his coverlet. In the foreground is St Joseph absorbed in meditation while two young women – the midwives Zelomi and Salome – stand nearby commenting on the event. Above are three flying angels.[1]

The painted surface, which was described by Sirén in 1908 as being 'rather thickly covered with dirt and dust', is on the whole in fair condition. The painting is known to have been restored in 1919,[2] and again in 1977/8 by Marco Grassi. In its present state the colours appear to be particularly rubbed in the architecture and in the landscape. The top of the head of the angel on the extreme left is a modern reconstruction. There are also retouches in the faces of the two other angels and in that of the Child, the upper half of which is modern. Retouching is visible in St Joseph's left hand. Two horizontal cracks, one across the middle of his figure and the other at the level of the Virgin's head, have been filled in with gesso and inpainted. The extreme left of the composition has lost both its edge paint layer and its gesso preparation, except for the very damaged gold area above the hill now hidden by the frame. The panel has been thinned down and glued to a new wood support.

Notes
1 The composition would obviously have been completed on the left by figures of shepherds, possibly arranged as in Taddeo's Dijon predella; Ladis (1982) p.131. The two midwives recorded in the apocryphal Gospels are usually represented presiding over Jesus's first bath (cf. cat.[28]). Doubts concerning Mary's virginity, expressed, according to the legend, by one of the two women, probably explain their subdued conversation and their expression of surprise.
2 Records of the Boston Athenaeum, of which a copy exists in the Thyssen archives.

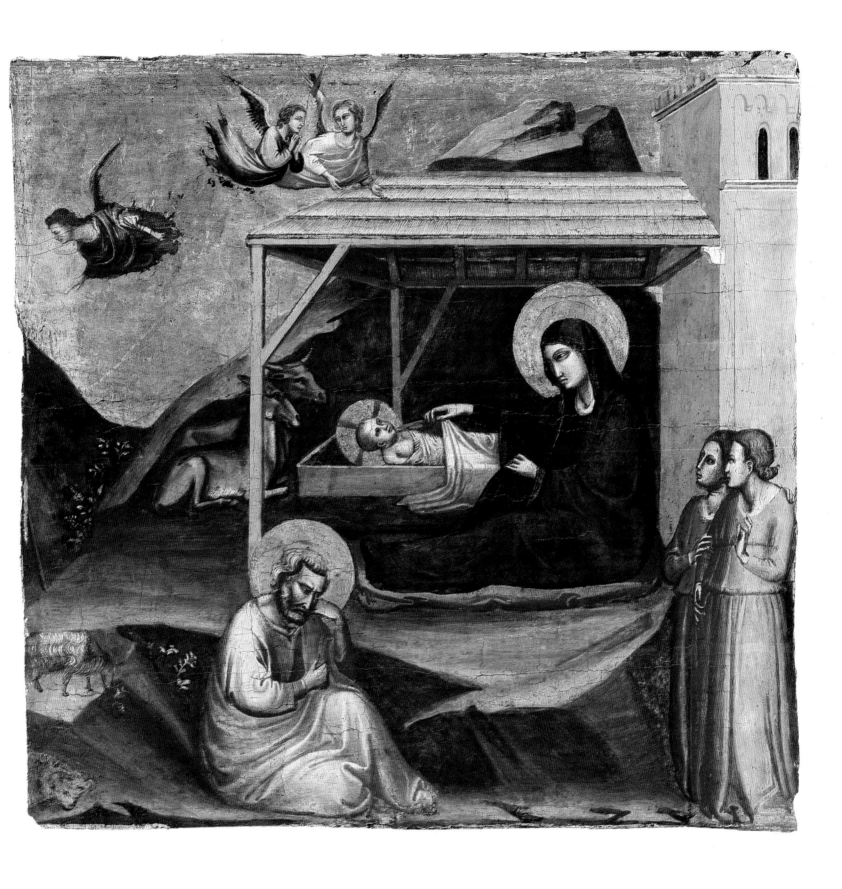

The *Nativity* must have belonged to a larger complex, of which it is difficult to reconstruct the original appearance. The fact that the panel extends well beyond the painted surface (probably to allow for an engaged frame) would seem to exclude the idea that it was part of a predella (Sirén (1908, 1916)). The hypothesis (Ladis (1982)) that it was one of a series of scenes flanking 'a larger image of the Madonna' is more likely. However, considering that this kind of altarpiece is rarely found in Tuscany at this date,[3] and that the scenes were framed separately, it might have formed part of an altarpiece composed of scenes in tiers, similar to that by Mariotto di Cristofano in the Accademia in Florence.[4] Yet another, more plausible possibility is that it may have been one of a horizontal sequence of scenes composing a low dossal.[5]

The latter proposal is supported by the structure of another panel which very probably once formed part of the same complex, a *Presentation in the Temple* recognised by Berenson to be by Taddeo and which is known to have come from the chapel of the castle of Brolio in Chianti, belonging to the Ricasoli family.[6] This painting is gabled and, although it is wider than the Thyssen *Nativity*, its height without the gable is the same (FIG 1).[7] The two works are not only very similar in style but also along the edges of the gold ground and in the haloes the carved decoration is identical. The horizontal cracks seem to match from one panel to the next. The ex-Ricasoli *Presentation* was presumably at the centre of the dossal with the *Nativity* on the left.

The original provenance of the *Presentation* is not known; it was apparently placed in Brolio castle only after the building was restored in the second half of the nineteenth century. One may assume that it came from a Ricasoli family chapel, perhaps that in Santa Croce.[8] The Thyssen *Nativity* is first recorded at a sale at Howe & Leonard in Boston, where it was acquired in 1846 for the Boston Athenaeum. There is no evidence of its alleged provenance from the J.J.Jarves collection (Sirén (1916)).[9] After being deposited on loan to the Boston Museum of Fine Arts in 1876, the painting was sold by the Boston Athenaeum in 1977.

The *Nativity* was first discussed by Sirén (1908), who regarded it as a work probably by Jacopo del Casentino, 'carried out in Taddeo [Gaddi]'s bottega under his supervision ... about the middle of the Trecento'. This scholar later changed his mind over the painting's attribution: in 1908, in his monograph on Giottino, he listed it among Gaddi's works, but called it in his *Addenda* (1908) a workshop product, while in 1916 and 1917 he regarded it again as autograph, relating it stylistically to the Pistoia polyptych of 1353. Meanwhile the attribution to Taddeo had been accepted by Wehrmann (1910), Khvosinsky and Salmi (1914), and later also by Kreplin (1920), who agreed with Sirén on the dating. In the 1921 catalogue of the Boston Museum it was classified as 'school of Giotto', and in that of 1932 as by an anonymous Florentine of the fourteenth century. Offner, according to an opinion recorded on a photograph (Frick Art Reference Library, New York), stated that 'the composition is Florentine and the heads are close to the Lorenzetti'. In Constable's catalogue (1955) it was still regarded as 'Giotto di Bondone (school)'. Previtali (1967) confirmed Gaddi's authorship, dating it to the artist's period in Giotto's workshop, and compared it with another early work, the Bromley Davenport polyptych at Capesthorne Hall.[10] Fredericksen and Zeri (1972) listed it among the works of Jacopo del Casentino, and in the posthumous list of Offner's attributions (1981) it is included as 'Taddeo Gaddi or school'. The catalogues of the Collection (Thyssen-Bornemisza (1981, 1986, 1989)) confirm the attribution to Taddeo, while Ladis (1982) thinks it is 'largely by the shop of Taddeo Gaddi', since 'the shed, the crib with the Christ Child, the animals and the other areas ... [are] too clumsily painted to attribute to Taddeo himself'. According to Ladis the painting was executed 'perhaps on [Taddeo's] design, soon after the Baroncelli Chapel' and possibly for the high altar of the church of the Santissima Annunziata, for which the artist was commissioned to paint an altarpiece in 1332.[11]

If one accepts the attribution to Gaddi, the reference to 'the artist's workshop' makes sense only if the work is to be dated after 1330, considering that until then Taddeo was himself a member of Giotto's workshop. On the other hand, the stylistic affinities rightly noted by Previtali between this painting and the Bromley Davenport polyptych or with the Stefaneschi

Notes

3 This type of structure, which was fairly common in the thirteenth century (see Garrison, *Italian Romanesque Panel Painting*, p.150f.), was occasionally used in Florence also in the fourteenth century and later. Examples are very rare and, to my knowledge, invariably connected with a particularly venerated saint; no similar fifteenth-century image of the Madonna is known to me.

4 No.8508; see G.Bonsanti, *La Galleria dell'Accademia, Firenze. Guida e catalogo completo* (Florence, 1987) pp.31, 41.

5 See for example the gabled dossal (or, as Offner preferred to call it, a 'three leaved tabernacle') now in the J.Paul Getty Museum, Malibu; Offner, *Corpus*, III/VI, pp.137–40.

6 The ex-Ricasoli panel was first listed by Berenson (*Italian Pictures* (1932) p.214) as a work by Taddeo Gaddi. The painting was apparently still hanging on the right wall of Brolio castle chapel in 1963 (Berenson, *Italian Pictures* (1963) p.69), but has since passed to another private collection. In 1979 Marco Grassi, who was able to examine both paintings closely, expressed the conviction (letter to Hanna Kiel in the Thyssen archive) that 'both pictures derive from the same altarpiece: the gold tooling both in the haloes and at the edges match perfectly, and the proportions are commensurate to some form of "paliotto"'. Ladis (1982) endorsed this opinion in discussing the *Presentation*, which was known to him only from photographs.

7 The painting is 62 cm high at the centre, 36.5 cm at the sides and 53.5 cm wide; the actual panel measures 74.5 cm (47 cm at the sides) by 59 cm. Its present frame conceals the unpainted area but not the ornamental band edging the gold ground.

8 This was the third chapel from the presbytery in the left transept; see W. and E.Paatz, *Die Kirchen von Florenz*, I (Frankfurt am Main, 1940) p.573. The other Ricasoli family chapels seem to be later in date: Paatz, III, p.703; IV, pp.15, 577.

9 J.J.Jarves seems to have started collecting Italian 'primitives' only after his stay in Florence in 1852; F.Stegmüller, *The Two Lives of J.J.Jarves* (New Haven, 1951) p.112f.

10 Published in Berenson (1963, p.83, fig.78) as by a 'contemporary of Giotto'. The polyptych was attributed to Taddeo Gaddi by F.Zeri ('Italian

FIG 1 Taddeo Gaddi, altar dossal (hypothetical reconstruction):

The Nativity (Thyssen Collection) *The Presentation in the Temple* (Florence, private collection)

polyptych (Vatican, Pinacoteca), once bearing Giotto's signature and apparently datable to the early 1320s,[12] would seem to exclude a much later date. The harsh, precise design, the simplified modelling and the slightly schematic arrangement of the composition would therefore be attributable, not to some pupil modifying the intentions of his master, but to the master himself in the phase when he was still closely tied to Giotto and attempting to define his own style. It is perhaps significant that of the many Nativity scenes painted by Taddeo, this is the only one in which both the shed and the Virgin seated on the ground[13] are placed parallel to the picture plane, according to a pattern used by Giotto early in the century.[14] Taddeo abandoned this static arrangement in the Baroncelli Chapel frescoes and in later works, preferring to emphasize the space by placing his figures and objects on a diagonal axis. It should also be noted that the device of the shed roof seen from below in the Thyssen panel, although more archaic than its presentation in the Baroncelli Chapel, makes the wooden structure very clear, revealing a remarkable grasp of perspective.

Another interesting feature, and a rather unusual one,[15] is that of the two women in the foreground. The idea of the serving-maid drawing her companion towards her and whispering in her ear is, of course, Giotto's invention and seems to be taken from a fresco in the Peruzzi Chapel.[16] It recurs in a more elaborate form, with the figures more brightly attired, in Taddeo's frescoes in the castle of Poppi. In our panel, however, the extreme simplicity of the block-like figures would suggest a date closer to Giotto's prototype, and earlier than the Gothic wave which left its mark on the elongated forms and the less rigorously balanced composition of Taddeo's frescoes in the Baroncelli Chapel.

Primitives at Messers Wildenstein', *Burlington Magazine* CVII (1965) p.252) and by R. Longhi ('Una "riconsiderazione" dei primitivi italiani a Londra', *Paragone* XVI, no.183 (1965) p.15). It is also accepted by other scholars as an early work; Ladis (1982) pp.84–5.

11 According to Vasari, Taddeo 'fu fatto dipingere la cappella dell'altar maggiore di quella chiesa, dove fece . . . la Nostra Donna con molti Santi . . . [e] nella predella . . . alcune storie di Nostra Donna' (Vasari, ed. Milanesi, I, p.575). However, as we have seen, our panel probably did not form part of a predella. The fact that the Santissima Annunziata polyptych was presumably begun only after 1332 is another reason for excluding any connection between this work and the Thyssen panel; cf. E. M. Casalini O.S.M., 'Una tavola di Taddeo Gaddi già alla SS.ma Annunziata', *Studi storici dell'Ordine dei Servi di Maria* XII (1962) pp.57–69.

12 This altarpiece, which came from Old St Peter's in Rome, was described in 1603 as executed by Giotto 'circa annum Domini MCCCXX'. It presumably then still had a signature and a fragmentary date. A date in the early 1320s is also convincing from the point of view of its style, even though this problem is still much debated; see J. Gardner, 'The Stefaneschi Altarpiece. A Reconstruction', *Journal of the Warburg and Courtauld Institutes* XXXVII (1974) pp.57–103.

13 Regarding the iconographic motif of the Virgin seated on the ground beside the manger, cf. Offner, *Corpus*, III/IV, p.150 note 4. While examples given by Offner showing the Virgin lifting the Child into her arms are datable to the second quarter of the century, the motif of Mary drawing up the coverlet and caressing the Child in the Thyssen *Nativity* is more archaic (cf. a miniature by Pacino di Buonaguida in the Pierpont Morgan Library in New York, and a small panel close to the early Jacopo de Casentino in a private collection in Panama (reproduced Offner, *Corpus*, III/II, 2nd edn. (1987) pl.LIVb, and Boskovits, *Corpus*, III/IX, pl.CXXVIb); both these paintings are datable around 1310/20).

14 On Gaddi's Nativity compositions see Ladis (1982) pp.101, 120, 128, 131, 194, 207, 210, and two shutters exhibited at Wildenstein's, *Religious Themes in Painting . . .*, exhibition catalogue (London, 1962) no.2.

15 I know of no Italian Trecento painting representing the midwives except in connection with the bath scene (cf. note 1 above). The two women are depicted, apparently talking together, in a *Nativity* by Jacques Daret in the Thyssen Collection (accession no.1935.17; see Thyssen-Bornemisza (1989) p.98).

16 See L. Tintori and E. Borsook, *Giotto. The Peruzzi Chapel* (New York, 1965) pls.56–7.

Giovanni da Bologna documented 1377–89

15 The Coronation of the Virgin and four angels

c1380–90
Tempera on panel, 45 × 21.7 cm; thickness 1.5 cm (2.5 cm with engaged frame)
Accession no.1972.1

Provenance
Florence, art market
Thyssen-Bornemisza Collection, 1972

The Virgin is seated on the left side of a large throne, with her hands joined in prayer. Christ is seated beside her, crowns her with his right hand and holds a sceptre in his left. To either side of the pinnacle of the throne are two adoring angels.

This was probably the central panel of a small portable triptych. The upper part of the frame, although considerably damaged by woodworm, is original; its left side and lower edge are lost, and the right side is only partially preserved. The state of the painting is reasonably good despite a certain number of losses that have been filled in recently (but before its acquisition for the Thyssen Collection) in a neutral shade.

The panel was acquired on the art market in June 1972 and does not seem to have been published hitherto. At the time of its purchase it was attributed to Altichiero, which, although mistaken, would be in keeping with the painting's likely area of origin and approximate date in the last quarter of the fourteenth century. Although extremely fine, this small picture cannot compare in quality with that of the great Veronese master, even in his minor works (such as the triptych in the Virginia Museum of Fine Arts, Richmond, no.59–5), nor does it have the same serene, grandiose figures or the neatly rendered and softly rounded forms typical of Altichiero's style. Here, instead, the artist seems to aim at a simplified and rational image, evoking the impression of the throne's spatial depth by means of a contrast between the forms in intense light and the areas in deep shadow. The figures are given shapes of almost geometric regularity; this is especially apparent in the sharp, precise folds of the draperies and in the almost cubic form created by the smooth fall of the Virgin's robes over her knees. The artist also uses strong contrasts of light and shade in the treatment of the features, creating an impression of structural solidity and intense feeling. This procedure reminds one of Jacopo degli Avanzi, who worked in Padua together with Altichiero on the frescoes of the Chapel of St James in the

Basilica of Sant'Antonio between 1376 and 1379. It is this artistic milieu which influenced the master of the Thyssen *Coronation*, who, like Jacopo, was a Bolognese artist and who, in my opinion, is to be identified with Giovanni (Zuane) di Albertino da Bologna.

Despite the existence of relatively numerous documents and of his signed works, Giovanni's personality still awaits clear definition. It is significant that even in the most recent comprehensive survey of Bolognese Trecento painting[1] his œuvre is totally overlooked. Longhi was the first to recognise Giovanni's hand in a polyptych from the Oratory of San Marco (now Bologna, Pinacoteca),[2] dating this work to the beginning of the artist's career, before he left Bologna for the Veneto. In Longhi's view, the artist tended to revert back to a more archaic style in later years, for instance in the paintings in the Brera, Milan and in the Accademia, Venice. This opinion, which has since been accepted by most scholars,[3] is nevertheless still open to discussion. It is, in fact, contradicted by an evident connection between the Bolognese polpytych and the works of the young Jacopo di Paolo dating from the later 1370s and early 1380s, such as the frescoes from Mezzaratta and the beautiful *Madonna* formerly in the Chiesa collection in Milan,[4] a connection which would imply that the San Marco polyptych had also been executed in those years.

The present writer has advanced a different chronology,[5] suggesting that Giovanni was probably active in the Veneto long before the existing records. At this initial stage, influenced by Guariento and Lorenzo Veneziano, he would have painted the panels today in Milan and Venice. His *St Christopher* of 1377, while revealing an interest in the realistic vision of Jacopo degli Avanzi, also shows Giovanni's tendency to soften certain harsher aspects of his colleague's naturalistic vision and to combine the search for spatial and plastic effects with more regular forms and elegant rhythmical outlines. Probably belonging to this phase is also the *Madonna and Child with two angels* (Moscow, Pushkin Museum, no.264),[6] a work which has not been connected with Giovanni's œuvre so far. The Thyssen *Coronation* would seem to me later in date, possibly from the time of one of Giovanni's visits to Bologna in the 1380s. Stylistically, it is close to the Bologna polyptych (FIG 1): the figures have the same bony structures, but the forms are as if moulded out of a harder substance and more finely chiselled, and his way of enhancing space and plasticity still reflects the method he would have acquired in the Veneto.

The iconography of the Coronation of the Virgin originated in Italy in the second half of the thirteenth century. It was derived from the theme of the Bride in the *Canticle of Canticles* who was identified with Mary, symbol of the Church.[7] The composition of our panel resembles Venetian Coronation scenes of the fourteenth century in which Christ places the crown on Mary's head with his right hand only and holds the sceptre, symbol of his regality, in his left. However, two features particularly dear to Venetian artists are absent, the starry sky (which gives a cosmic significance to the symbolical event), and a host of angels.[8] The bare scene dominated by the grandiose figures of Christ and the Virgin relates this painting to the two other *Coronation* scenes by Giovanni in the Pinacoteca of Bologna and in the Art Museum of Denver.

Notes
1 *Pittura bolognese del Trecento. Scritti di Francesco Arcangeli*, edited and completed with entries by P.G.Castagnoli, A.Conti and M.Ferretti (Bologna, 1978).
2 R.Longhi, *Viatico per cinque secoli di pittura veneziana* (Florence, 1952) p.47f. (essay of 1946).
3 M.Lucco in *Le origini* (1985) p.154.
4 Cf. D.Benati in *Duecento e Trecento* (1986) pp.225 and 587f., and, for the Chiesa *Madonna*, *The Achillito Chiesa Collection*, Part II (The American Art Association, New York, 1926) no.24.
5 In *Dizionario Bolaffi*, VI (1974) pp.23–5. A similar view has been expressed recently by M.Lucco in *Duecento e Trecento* (1986) II, p.581.
6 V.Markova, 'Inediti della pittura veneta nei musei dell'URSS . . .', *Saggi e memorie di Storia dell'Arte* XIII (1982) p.13f. and p.91, fig.1.
7 See Schiller, *Ikonographie*, IV/2, pp.147f.
8 Compare for example the compositions of Paolo Veneziano and Stefano da Sant'Agnese in the Accademia, Venice, of Caterino and Donato in the Pinacoteca Querini Stampalia also in Venice, and that attributed to Jacobello di Bonomo in the Pinacoteca in Fermo (reproduced in Pallucchini, *Trecento* (1964) figs.144, 579, 603, 634).

FIG 1 Giovanni da Bologna, *The Crucifixion* and two *Saints* (Bologna, Pinacoteca Nazionale)

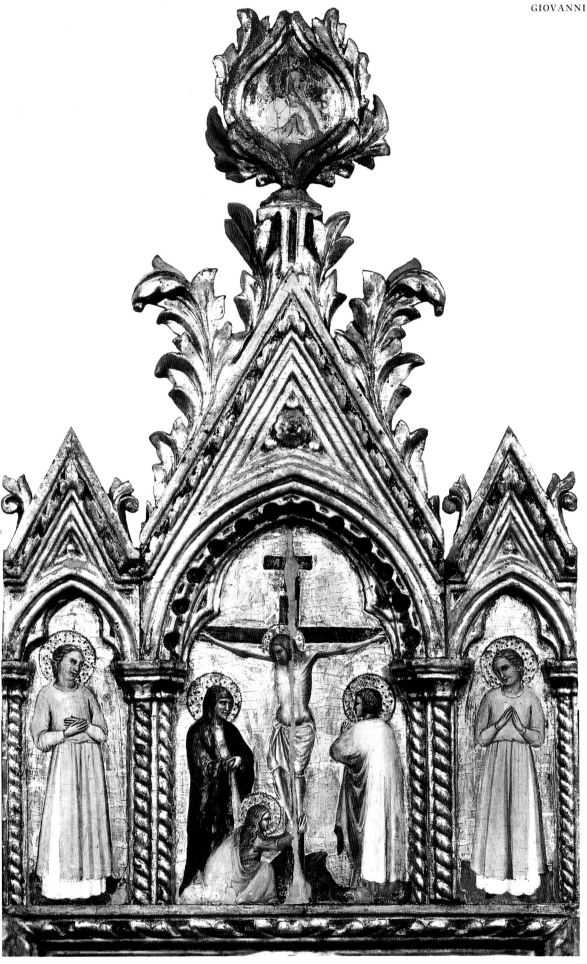

Giovanni di Paolo before 1400–1482

16 The Madonna of Humility

c1440
Tempera on panel, 32.5 × 22.5 cm; thickness 1.7 cm
Accession no.1933.9

Provenance
Enrico Frascione, Naples, by 1927
Paul Bottenwieser, Berlin and New York, 1927
Schniewind collection, New York, 1927–33
Thyssen-Bornemisza Collection, 1933

Exhibitions
Rotterdam and Essen, 1959–60, no.39
Stuttgart, 1988–9, no.23

Literature
J. Trübner, 'Primitive Italiener der Galerie Bottenwieser', *Cicerone* XIX (1927) pp.575–6
Art News XXVI (10 December 1927)
M.L. Gengaro, 'Eclettismo e arte nel Quattrocento senese', *Diana* VII (1932) p.25
Rohoncz (1937) p.58, no.153
J. Pope-Hennessy, *Giovanni di Paolo* (London, 1937) pp.93, 94, 112 note 90
J. Pope-Hennessy, 'Giovanni di Paolo by Cesare Brandi', review, *Burlington Magazine* LXXXIX (1947) p.138
Rohoncz (1949) p.49, no.153
Rohoncz (1958) p.40, no.153
Rohoncz (1964) p.34, no.153
Berenson, *Italian Pictures* (1968) I, p.178
H. van Os, *Marias Demut und Verherrlichung in der sienesischen Malerei 1300–1450* (The Hague, 1969) p.134
Thyssen-Bornemisza (1970) p.104, no.108
Thyssen-Bornemisza (1971) pp.144–5, no.108
Dizionario Bolaffi, VI (1974) p.55
Thyssen-Bornemisza (1977) p.52, no.108
Thyssen-Bornemisza (1981) p.121, no.108
Thyssen-Bornemisza (1986) p.119, no.108
Thyssen-Bornemisza (1989) p.124

The Virgin is seated on a cushion in a flowery meadow, with her prayer-book at her feet. She is represented with joined hands as she contemplates the infant Christ, who lies naked on her lap, surrounded by gold rays. Above, in a circle of radiating light, is the Dove symbolizing the Holy Spirit. Two standing angels on the right approach the divine group; one of them holds a cloth to cover the Child, the other looks at Him over his companion's shoulder.[1]

The panel, which must originally have been the left shutter of a diptych,[2] has a modern frame which follows the ogee arch formed by the punched decoration running along the border of the gold ground. The outer edge of the frame is covered with a coat of dark red paint. The back, which is painted white, has a number of labels: 'No.12' (possibly nineteenth-century), the inventory number 'CA 3723' (stamped on both the panel and the frame), a French customs stamp, and the numbers '108', '33' in pen, '153' in red (modern). Also on the back, towards the top, are nail holes at regular intervals.

Notes
1 For the iconography of the Madonna of Humility, see Meiss, *Black Death*, p.132f. and in particular p.140, where the author relates the garden setting of this type of composition to the idea of the *hortus conclusus* (*Canticle* 4, 12: 'Hortus conclusus soror mea'), symbol of virginity and hence of the Virgin Mary, but also symbol of Paradise (E. Börsch Supan, 'Garten', in *Lexikon christlicher Ikonographie*, II, col. 77f.). The cloth held by one of the angels is probably the veil used by Mary for her new-born babe and again to cover her son when, before being crucified, he was stripped of his clothes (*Meditations on the Life of Christ. An Illustrated Manuscript . . .*, edd. I. Ragusa and R.B. Green (Princeton, 1961) pp.33, 333). The presence of the angels, unusual in this context, seems to confirm the allusion to the Passion.

The book, evidently a prayer-book, has no legible text; it probably also refers to Christ's sufferings, even though, in some cases, it is open at the words of invocations, such as 'Deus in adiutorium meum . . .' (Psalm 70,2), for instance in the *Madonna of Humility* by Bartolomeo Bulgarini (Amsterdam, Rijksmuseum; van Os (1969) p.113, pl.9).
2 The only known diptych in Giovanni di Paolo's œuvre is the one practically destroyed during the War at Hannover (Landesmuseum, Kestner no.294; W. Kermer, *Studien zum Diptychon in der sakralen Malerei . . .* (dissertation, University of Tübingen, 1967) Part II, p.42f.). However, among his works are several single shutters, including a *Nativity* (Modena, Galleria Estense, no.18) and a *Madonna and Child with saints* (formerly Florence, Galleria Volterra; sold at Sotheby's, London, 24 March 1965, lot 38), both of which, like the Thyssen panel, seem to be left side-panels of a diptych. Their authentic frames, showing an ogee arch inscribed in a rectangle, probably give an idea of what the frame of our panel would have looked like.

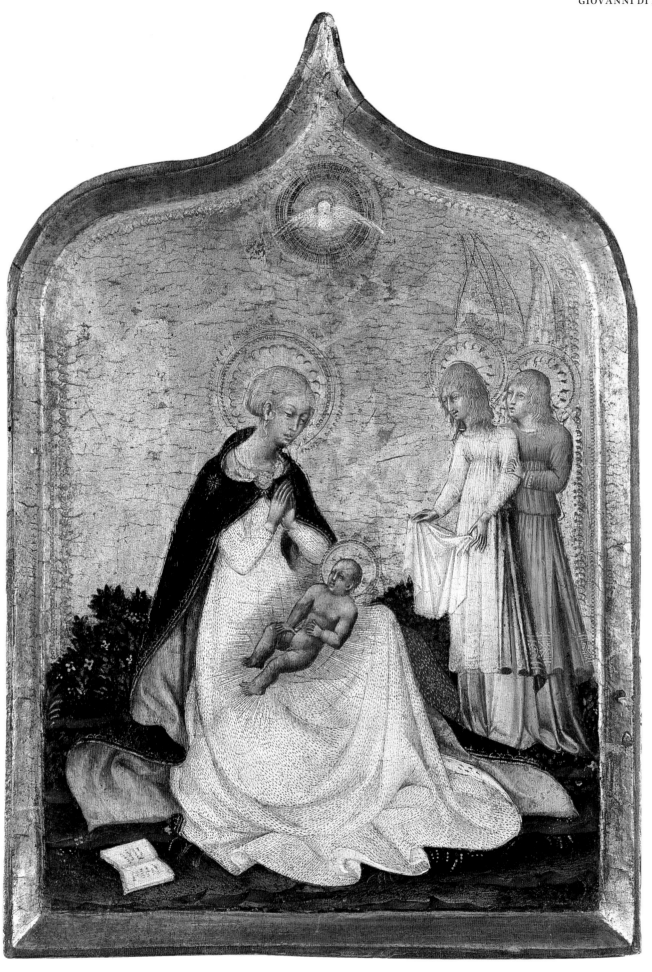

The condition of the painting is on the whole good. The gold is slightly rubbed in places. A few small retouches, that have darkened with time, are visible under a slight film of dirt.

In April 1927 the painting belonged to Enrico Frascione in Naples. A photograph, sent to Berenson at that time, was filed under Giovanni di Paolo.[3] The same attibution was made by both Wilhelm von Bode and Georg Gronau in expertises.[4] Gronau regarded the panel as a work of the artist's middle period, relating it to the *Paradise* now in the Metropolitan Museum in New York.[5] The acquisition of the *Madonna* 'by a prominent New York collector from the Gallery of Paul Bottenwieser, New York' was announced in *Art News* (10 December 1927). It was also published in the same year by Trübner, who considered it an early work by Giovanni di Paolo, close to the *Madonna* in the Propositura of Castelnuovo Berardenga and to another *Madonna* then in the Hirsch collection, Basle.[6] The attribution was also accepted by Gengaro (1932), Heinemann (in Rohoncz (1937)) and Pope-Hennessy in his monograph (1937). The last related the panel stylistically to two works dated by him shortly after 1445, a *Madonna and Child with saints* formerly in Florence, Galleria Volterra,[7] and a *Nativity* (Modena, Galleria Estense), compared to which he considered our panel 'finer in every respect, and probably a little earlier in date'. Commenting on the unusual iconography, with the two assistant angels, Pope-Hennessy wrote that this was '. . . the one instance in Giovanni di Paolo's career of his having depended directly on some northern design'.

Since then, the painting has not stimulated further discussion. Its place in Giovanni di Paolo's œuvre was again confirmed by Pope-Hennessy (1947) and by all the catalogues of the Collection (Rohoncz (1949, 1952, 1958, 1964), Rotterdam and Essen (1958–60), Thyssen-Bornemisza (1970, 1971, 1977, 1981, 1986 and 1989), and also by Berenson (1968), van Os (1969) and the *Dizionario Bolaffi* (1974)).

This *Madonna of Humility* owes its particular fascination to the artist's exquisite workmanship and to the gracefulness and sense of intimacy of its unusual composition. The delicate rendering of the meadow with its flowers and plants, and the elegance of the figures surrounded by cascades of drapery, also help to create the picture's charming, fairytale atmosphere. As far as its style is concerned, the painting lacks the sharp, incisive drawing and essentially static arrangement of Giovanni's works of before about 1430, in which the forms tend to be rather hard and metallic in appearance, although the colouring is very refined. Here, the artist is interested in the multiple, flowing rhythms which involve the whole composition. In disregard of the contemporary requirements of pictorial illusionism, the emphasis on fluttering outlines and the closely interwoven forms give the figures a two-dimensional quality. Their rôle in the pictorial narrative is subdued, and they appear as shy, discreet and slightly detached participants in the scene. They belong to an imaginary world, apparently free of logic or fixed rules, in which the melodious lines of Mary's dress, the child-like grace of the angels and the clumsiness of the Child (with the shoulders of a boxer on a fragile and disproportionately long body) mix in a completely natural way.

Similar motifs and forms and, above all, a similarly highly expressive mood are to be found in many of the artist's works dated by recent criticism around or shortly before 1440. These include a dispersed polyptych (New York, Metropolitan Museum; Houston, Museum of Fine Arts, and Siena, Monte dei Paschi),[8] the panels of a predella (now divided between West Berlin, Cleveland, Washington, New York and the Vatican),[9] and another fragmentary predella representing *Paradise* and the *Expulsion from Eden* (Metropolitan Museum).[10] Unfortunately, none of these paintings can be securely dated, but Giovanni's *Coronation* triptych (Siena, Sant'Andrea)[11] and his *biccherna* panel with the *Annunciation* (Vatican, Pinacoteca; FIG I),[12] both dated 1445, show a still greater rhythmic complexity, and an expressiveness which would seem to belong to a slightly later phase.

Notes
3 Hand-written note on the back of the photograph, classified as by Giovanni di Paolo, in the Biblioteca Berenson, Florence.
4 Copies are in the Thyssen archives, Lugano.
5 No.06.1046; Pope-Hennessy (1937) p.20f., pl.VIIIa.
6 For the first, dated 1426, see G. Chelazzi Dini in *Mostra di opere d'arte restaurate nelle province di Siena e Grosseto*, exhibition catalogue (Siena, 1981) p.72f. For the second, dated a year later, now belonging to the Norton Simon Museum at Pasadena CA, see F. Herrmann, *Selected Paintings in the Norton Simon Museum* (London and New York, 1980) p.14.
7 See above, note 2.
8 Metropolitan Museum, no.88.3.111, and Houston, Museum of Fine Arts, R.L. Blaffer memorial collection, nos.53–3, 54–2; see F. Zeri and E.E. Gardner, *Italian Paintings. The Metropolitan Museum of Art* (New York, 1980) p.19f.
9 *Crucifixion* (Berlin, Gemäldegalerie, no.1112c); *Adoration of the Magi* (Cleveland, Museum of Art, no.42.536); *Annunciation* (Washington, National Gallery, no.K412); *Presentation in the Temple* (Metropolitan Museum, no.41.100.4); *Nativity* (Pinacoteca Vaticana, no.132); see Zeri and Gardner (1980) p.27f.
10 Nos.06.1046 and 1975.1.31 (Lehman collection); see J. Pope-Hennessy, *Italian Paintings in the Robert Lehman Collection* (New York, 1987) p.115f.
11 See E. Neri Lusanna, *Die Kirchen von Siena*, I (Munich, 1985) p.284f.
12 No.131; see *Le biccherne. Tavole dipinte delle magistrature senesi* (Rome, 1984) p.152.

Detail [16] the Madonna

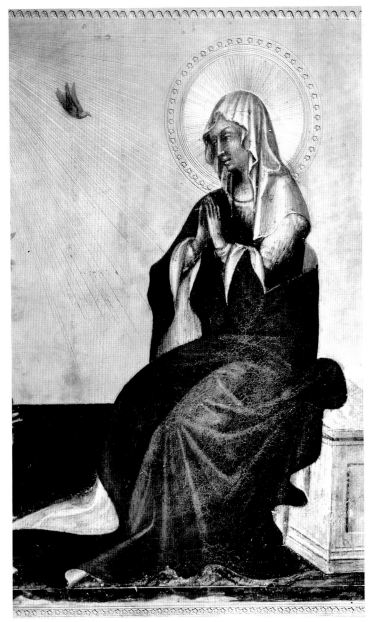

FIG 1 Giovanni di Paolo, *Biccherna* panel of 1445 (detail of the Annunciation) (Vatican, Pinacoteca)

Giovanni di Paolo
c1395/1400–1482

17 St Catherine before the pope at Avignon

Early 1460s
Tempera on panel, 29 × 29 cm (transferred)
Accession no.1966.6

Provenance
Siena, Hospital of Santa Maria della Scala
Trier and Cologne, Ramboux collection, by 1842
Ramboux Sale, Heberle, Cologne, 23 May 1867
Sigmaringen, Fürstlich Hohenzollern'sches Museum, c1871–c1920
Brussels, Stoclet collection, by 1922 until 1966
Thyssen-Bornemisza Collection, 1966

Exhibitions
Brussels, *Primitifs italiens de la Renaissance*, Musées Royaux des Beaux-Arts, 1921
Paris, *L'Art italien de Cimabue à Tiepolo*, 1935, no.203
USA tour, 1979–80, no.10
Paris, 1982, no.11
USSR tour, 1987, no.6
Madrid, 1987–8, no.29
New York, *Painting in Renaissance Siena*, 1988, no.381

Literature
G.C.Carli, *Notizie di Belle Arti*, MS Siena, Biblioteca Comunale, cod. VII-20, f.86v (c1775)
G.Milanesi, *Documenti per la storia dell'arte senese*, II (Rome, 1854) pp.241–2
J.A.Ramboux, *Catalog der Gemälde alter italienischer Meister in der Sammlung des Conservators J.A.Ramboux* (Cologne, 1862) p.22, no.119
Crowe and Cavalcaselle, *History*, III (1866) p.80 note 6; 2nd English edn., III (1909) p.126 note 8; V (1914) p.176 and note 6
Catalog der nachgelassenen Kunst-Sammlungen des Herrn Johann Anton Ramboux, Conservator des städtischen Museums in Cöln, auction catalogue (J.M.Heberle (H.Lempertz), 23 May 1867) p.24, no.119
Crowe and Cavalcaselle, *Geschichte*, IV (1871) p.89 note 102
H.Lehner, *Fürstlich Hohenzollern'schen Museum zu Sigmaringen. Verzeichnis der Gemälde* (Sigmaringen, 1871) pp.54–5
F.Harck, 'Quadri italiani nelle Gallerie private di Germania', *Archivio Storico dell'Arte* VI (1893) p.388
Cavalcaselle and Crowe, *Storia*, IX (1902) p.42 note 1
Primitifs italiens de la Renaissance, exhibition catalogue (Musées Royaux des Beaux-Arts, Brussels, 1921)
A.Venturi, 'Esposizione di primitivi italiani a Bruxelles', *L'Arte* XXV (1922) pp.167–8
P.Bautier, 'I primitivi italiani della Collezione Stoclet a Bruxelles', *Cronache d'Arte* IV (1927) p.316
van Marle, *Development*, IX (1927) pp.431–2
L.Dussler, 'Some Unpublished Works by Giovanni di Paolo', *Burlington Magazine* L (1927) p.36
L.Venturi, *Pitture italiane in America* (Milan, 1931) pl.CXXX
Berenson, *Italian Pictures* (1932) p.245
M.L.Gengaro, 'Eclettismo e arte nel Quattrocento senese', *Diana* VII (1932) p.26
L'Art italien de Cimabue à Tiepolo, exhibition catalogue (Paris, 1935) p.92
Berenson, *Pitture italiane* (1936) p.211
J.Pope-Hennessy, *Giovanni di Paolo* (London, 1937) pp.130–3
R.Langton Douglas, 'Giovanni di Paolo by J.Pope-Hennessy'; review, *Burlington Magazine* LXXII (1938) pp.44, 47
H.B.Whele, *Catalogue of Italian, Spanish, and Byzantine Paintings* (New York, 1940) p.88
C.Brandi, 'Giovanni di Paolo', *Le Arti* III (1940–1) pp.319–22
P.Bacci, 'Documenti e commenti per la storia dell'arte. Ricordi della vita e dell'attività artistica del pittore senese Giovanni di Paolo...', *Le Arti* IV (1941–2) p.24
M.Salinger, 'A new Panel in Giovanni di Paolo's Saint Catherine Series', *Bulletin of the Metropolitan Museum of Art*, N.S. I (1942) p.26
P.Bacci, *Documenti e commenti per la storia dell'arte* (Florence, 1944) pp.77–8
C.Brandi, *Giovanni di Paolo* (Florence, 1947) pp.36–42, p.79 note 60
J.Pope-Hennessy, 'Giovanni di Paolo by Cesare Brandi', review and letter, *Burlington Magazine* LXXXIX (1947) pp.138–9, 196

C.Brandi, letter, *Burlington Magazine* LXXXIX (1947) p.196
C.Brandi, *Quattrocentisti senesi* (Milan, 1949) pp.98–100, 201–7
G.Kaftal, *St Catherine in Tuscan Painting* (Oxford, 1949) pp.11, 37, 122
Kaftal, *Iconography* (1952) pp.236, 244
E.Carli, *La pittura senese* (Milan, 1955) p.224
M.Laclotte in *Exposition de la collection Lehman de New York*, exhibition catalogue (Musée de l'Orangerie, Paris,
 1957) pp.16–17, no.21
G.Coor, 'Quattrocento Gemälde aus der Sammlung Ramboux', *Wallraf-Richartz Jahrbuch* XXI (1959) pp.82–5
A.Carotti Oddasso in *Bibliotheca Sanctorum*, III (Vatican City, 1963) p.1040
St John Gore in *The Art of Painting in Florence and Siena from 1250 to 1500*, exhibition catalogue (London, 1965)
 p.55
L.Castelfranchi Vegas, *Il gotico internazionale in Italia* (Rome, 1966) p.52
E.Ourusoff de Fernandez-Gimenez, 'Giovanni di Paolo: the Life of St Catherine of Siena', *Bulletin of the Cleveland
 Museum of Art* (April, 1967) pp.103–10
Berenson, *Italian Pictures* (1968) p.17
H.van Os and M.Reinders in *Sienese Painting in Holland*, exhibition catalogue (Groningen and Utrecht, 1969)
 pp.33–4, no.8
H.J.Ziemke, 'Ramboux und die sienesische Kunst', *Städel-Jahrbuch*, N.S.11 (1969) pp.280, 298 note 189
Thyssen-Bornemisza (1970) p.104, no.107
E.Carli, *I pittori senesi* (Milan, 1971) p.27
Thyssen-Bornemisza (1971) p.144, no.107
H.van Os, 'Giovanni di Paolo's Pizzicaiuoli Altarpiece', *Art Bulletin* LIII (1971) pp.289–302
Dizionario Bolaffi, VI (1974) p.55
E.Ourusoff de Fernandez-Gimenez, *The Cleveland Museum of Art. European Paintings before 1500* (Cambridge MA,
 1974) pp.105–10
N.Pleister, 'Katharina von Siena', in *Lexikon christlicher Ikonographie*, VII (1974) col. 305
H.B.J.Maginnis, letter, *Art Bulletin* LVII (1975) p.608
Thyssen-Bornemisza (1977) p.52, no.107
P.Torriti, *La Pinacoteca Nazionale di Siena. I dipinti dal XII al XV secolo* (Genoa, 1977) p.316
F.Zeri, *Italian Paintings: A Catalogue of the Collection of the Metropolitan Museum of Art: Sienese and Central Italian
 Schools* (New York, 1980) pp.24–7
Thyssen-Bornemisza (1981) p.120, no.107
G.Chelazzi Dini in *Gotico a Siena* (1982) p.358
G.Chelazzi Dini in *Gothique siennois* (1983) p.317
D.Gallavotti Cavallero, *L'ospedale di Santa Maria della Scala a Siena* (Pisa, 1985) pp.192–7
Thyssen-Bornemisza (1986) p.118, no.107
J.Pope-Hennessy, *Italian Paintings in the Robert Lehman Collection* (New York, 1987) pp.130–1
L.Bianchi and D.Giunta, *Iconografia di S. Caterina da Siena* (Rome, 1988) p.255
C.B.Strehlke in *Painting in Renaissance Siena*, exhibition catalogue (New York, 1988) pp.235–8
Thyssen-Bornemisza (1989) p.123
K.Christiansen, 'Notes on "Painting in Renaissance Siena"', *Burlington Magazine* CXXXII (1990) p.211

St Catherine, accompanied by a sister of her order, kneels before the pope who, seated on a raised throne draped with a sumptuous cloth, gives her his blessing. Two cardinals on the left and another on the right listen to the saint's discourse which is recorded by two scribes seated at the foot of the throne.[1]

The condition of the original panel made it necessary to transfer the painting on to a new wood support; this was carried out by William Shur in New York in 1965. The painted surface is in reasonably good state. There are numerous fine horizontal cracks, some scratches and quite a number of retouches, especially along the lower right edge (restored by M.Modestini, 1965).

Writing in the second half of the eighteenth century, Abbot Giovan Girolamo Carli records the panel today in the Thyssen-Bornemisza Collection, together with nine others representing scenes from the life of St Catherine, as parts of 'un gran Quadro in tavola che prima stava nel Camposanto' (a large altarpiece painted on wood, formerly in the cemetery of the Santa Maria della Scala hospital). According to Carli, it had recently been 'cut into a number of small pictures for the Rector's office and some larger sections for the dormitory of the wet-nurses'.[2] It is practically certain that this polyptych was destined for the hospital church, and since Carli informs us that 'the main panel, which was in the centre, represents the Purification of Mary' (*ie* the Presentation of Christ in the Temple), one may logically assume that it was intended for

Notes
1 The subject was identified by Kaftal (1949) as *St Catherine of Siena giving her discourse before Pope Urban VI* at Avignon. The scene follows closely the description of Raimondo da Capua, the saint's confessor, in his *Vita miracolosa della serafica S. Caterina da Siena* (*Acta Sanctorum. Aprilis*, III (Paris, 1866) p.945). As St Catherine went to Avignon several times to convince the pope to return to Rome, the scene could conceivably be instead the saint before Gregory XI (Carotti Oddasso (1963)). However, it is more likely that Urban VI is represented; in fact, according to Raimondo da Capua, it was this pope who wished Catherine to speak in open consistory, in the presence of the cardinals.
2 *Notizie di Belle Arti*, MS VIII.20, Biblioteca Comunale, Siena (f.86v), published in Brandi (1947) p.39f.

FIG 1 Giovanni di Paolo, *The Presentation in the Temple* (the Pizzacaioli altarpiece) (Siena, Pinacoteca)

3 Bacci (1941) p.25f., doc.XXIV.

4 Egidio Bossio, *Visita apostolica* of 1575, archives of the Curia Arciscovile, Siena, MS 21, f.114. It is not clear whether this was the same altar as that previously dedicated to the Purification of the Virgin. It is possible that Giovanni di Paolo's altarpiece replaced Beccafumi's *St Michael banishing the rebel angels* (Siena, Pinacoteca, no.423), which was seen by Vasari (Vasari, ed. Milanesi, V, p.638) in the church of Santa Maria della Scala 'at the top of some steps near the high altar'. Beccafumi's altarpiece, which was left unfinished and described by Vasari as 'confused rather than not', was probably disliked and removed before long. It might have been replaced for a while by Giovanni di Paolo's *Presentation in the Temple*.

5 This altarpiece (247 × 172 cm) must originally have had painted gables and side pilasters, besides large lateral panels (see notes 6 and 24).

6 Ramboux returned to Germany from his second and last journey to Italy in 1842 (*Catalog* (1867) p.v). The series probably formed part of the considerable number of works bought by the artist in Siena in 1838 (Strehlke (1988)). According to Ramboux's catalogue (1862) the nine scenes 'which formed part of a predella ... came from the large Della Scala Hospital' and 'the related altarpiece ... represents the Presentation in the Temple'. Although he does not say so, Ramboux's collection also included other paintings with the same provenance, nos.150–3 of his catalogue, representing four figures that were described by Abate Carli, together with two more, as part of the same altarpiece which he records in the cemetery of the hospital. Two of these, representing Blesseds Ambrogio Sansedoni and Andrea Gallerani, are in the Metropolitan Museum, New York (Lehman collection, nos.1975.1.56 and 1975.1.55), and two others, with St Galgano and a Franciscan saint, in the Rijksmuseum, Utrecht (nos.14, 15).

an altar with the same dedication. According to a document of 11 April 1447, the Guild of the Pizzicaioli (meat-picklers and candle-makers) commissioned Giovanni di Paolo to paint 'unam tabulam ad altarem et pro altare cappelle noviter constructe in Ecclesia Hospitalis sancte Marie de la Schala de Senis, per dictam Universitatem, sub nomine et titulo Purificationis gloriose Virginis Mariae', stipulating that it was to be completed by 1449.[3] In 1575 the altarpiece is recorded still in the church, over the altar dedicated to St Michael,[4] complete with its 'predella ... lignea et congrua'. The 1447 document, however, does not specify the existence of a predella, and it therefore remains to be proved whether the St Catherine predella scenes belonged to the Pizzicaioli altarpiece, today in the Pinacoteca of Siena (no.211; FIG 1);[5] conceivably they did not belong at all, they may have been added later, or they may have been original despite not being mentioned in the 1447 document. What is certain is that towards 1838 (in any case, by 1842)[6] nine of the ten scenes were available on the Siena art market and

FIG 2 Giovanni di Paolo, altarpiece (hypothetical reconstruction proposed by C.Brandi)

FIG 3 Giovanni di Paolo, altarpiece (hypothetical reconstruction proposed by G.Coor)

FIG 4 Giovanni di Paolo, altarpiece (hypothetical reconstruction proposed by E.Ourosoff de Fernandez-Gimenez)

FIG 5 Giovanni di Paolo, altarpiece (hypothetical reconstruction proposed by H.van Os)

Notes
7 28.7 × 20 cm. From
W. W. Story it passed to
H. H. M. Lyle, New York, and,
through Weitzner, to Lehman in
1947.
8 28.9 × 23 cm. Like its
companion in the same museum,
it was bought through
R. Heinemann from the Stoclet
collection, Brussels.
9 28.6 × 28.6 cm. From the
Stoclet collection. Until 1987
(Pope-Hennessy (1987)) it
apparently belonged to
Heinemann, New York.
10 28.8 × 28.9 cm. For its
provenance see note 8.
11 28.6 × 22.9 cm. For its
provenance see note 9.
12 28.3 × 22 cm. In the 1920s it
was acquired by F. Kleinberger &
Co., New York, who sold it to
Philip Lehman between 1928 and
1932.
13 28.9 × 22.2 cm. Owned in the
1920s by Kleinberger, New York,
and acquired c1927 by Michael
Friedsam, who left it to the
Museum in 1931.
14 29 × 29 cm. Also from the
Stoclet collection and bought by
Heinemann (cf. note 8).
15 24.8 × 26 cm. Bought with
the rest of the series by Adolphe
Stoclet around 1920 (recorded in
his collection in 1923; Maginnis
(1975)). It was subsequently sold
and passed to the Van Derlip
collection, Minneapolis (Douglas
(1938) p.47). Bequeathed to the
Minneapolis Art Museum in
1935, the panel remained there
until 1958, when it was
deacquisitioned. It is now in an
American private collection
(Strehlke (1988)).
16 With the exception only of the
German edition of Crowe and
Cavalcaselle (1871); however,
considering that its provenance
from Santa Maria della Scala is
not recorded in the original
English edition, nor in the Italian
edition revised by Cavalcaselle
himself, this provenance must
have been added by the
translator.
17 Yale University Art Gallery,
no.1871.59; Fogg Museum,
no.21.13; the latter is reproduced
in van Marle (1927) p.441.

were bought by the painter Johann Anton Ramboux (1790–1866) for his collection, housed first at Trier and later at Cologne. The tenth panel, representing *St Catherine receiving the stigmata*, which had probably been sold earlier, was acquired by the sculptor William W. Story in the mid-nineteenth century and is now in the Metropolitan Museum, New York (Lehman collection, no.1975.1.34).[7]

The panels represent, in the order of the saint's biography, the following episodes (FIGS 6a–j): (a) *St Catherine taking the Dominican habit* (Cleveland Museum of Art, no.66.2);[8] (b) *Mystic Marriage of St Catherine* (New York, private collection);[9] (c) *St Catherine and the beggar* (Cleveland Museum of Art, no.66.3);[10] (d) *St Catherine exchanging her heart with Christ's* (New York, private collection);[11] (e) *St Catherine receiving the stigmata* (New York, Metropolitan Museum, Lehman collection); (f) *St Catherine beseeching Christ to resuscitate her mother* (New York, Metropolitan Museum, Lehman collection, no.1975.1.33);[12] (g) *Miraculous communion of St Catherine* (New York, Metropolitan Museum, no.32.100.95);[13] (h) *St Catherine dictating her dialogues* (Detroit, Institute of Fine Arts, no.666/15);[14] (i) the Thyssen-Bornemisza panel; (j) *Death of St Catherine* (private collection).[15]

The present panel was bought, together with the companion pieces in the Ramboux collection, through A. Müller in Düsseldorf for the Hohenzollern family collection at Sigmaringen. It is recorded there in 1871 (Lehner) and again in 1893 (Harck) and was put on the market when the collection was broken up in 1920. By 1921 it belonged to Adolphe Stoclet in Brussels, together with six other scenes of the series. One of the latter, (j), changed hands some time in the late 1920s or early 1930s (Douglas (1938)), while the others were bought by Rudolf Heinemann around 1965, before being dispersed once more. The Thyssen panel was acquired for the Collection in 1966.

The attribution to Giovanni di Paolo of the predella scenes, put forward by Ramboux (1862), has never been questioned; but, as to the structure, destination and date of the original complex, no convincing solution has been advanced so far. However, their provenance from the church of Santa Maria della Scala, and their connection with the altarpiece composed also of the *Presentation in the Temple* (Siena, Pinacoteca), were mentioned by Ramboux, probably on the basis of information provided at the time of their sale. This information was overlooked by later critics,[16] who, like van Marle (1927), referred to them merely as parts of a predella. The series has also been related to other images, to a *Story of a female saint* (now known to be *St Clare*) in the Yale University Art Gallery and to a full-length figure of *St Catherine* (Fogg Art Museum, Cambridge MA),[17] by Venturi (1931) and Pope-Hennessy (1937). Seymour de Ricci, in the catalogue *L'Art italien* (1935), tentatively connected the scenes with other panels extraneous to the original complex.

Pope-Hennessy (1937) was the first to examine the problem of the dispersed predella in detail. He traced the nine panels formerly belonging to Ramboux and confirmed their provenance from Santa Maria della Scala but rejected Ramboux's association of the predella with the *pala* of the Pizzicaioli. Without proposing a specific reconstruction, he remarked that the series of panels, instead of forming a horizontal sequence, may have been arranged around some larger image of St Catherine, such as the one in the Fogg Museum. The supposed connection of the series with the 1447/8 *Presentation in the Temple* was contradicted, in his opinion, by both stylistic and iconographic considerations; it was unlikely that St Catherine would have been honoured with a cycle devoted to her legend before 1461, the year of her canonization.

Pope-Hennessy's late dating was accepted by Salinger (1942), who identified and published the tenth scene (e). Douglas (1938), instead, regarded a date after 1461 as stylistically too late for the series. Wehle (1940) maintained the idea of their connection with the Pizzicaioli altarpiece of 1447/8. An entirely different reconstruction was proposed by Brandi (1940–1), basing himself on an unpublished manuscript of Abbot Carli. Brandi believed that only four of the scenes belonged to the predella, and had been arranged two on each side of a *Crucifixion*,

which he identified with a panel also from the Ramboux collection and belonging today to the Rijksmuseum of Utrecht (FIG 6k).[18] In his opinion, the predella composed of these five scenes was flanked at either end by a coat of arms now lost. The remaining scenes would have been arranged vertically, three to either side of the main panel (FIG 2). In his reconstruction, the altarpiece would also have had side pilasters decorated with the figures of saints, also recorded in the Ramboux collection and later dispersed.[19]

Bacci (1941–2, 1944) accepted this theory, which Brandi then confirmed (1947, 1949), while Pope-Hennessy (1947), reviewing Brandi's monograph on the artist, proposed a modified version of his previous idea, suggesting that the St Catherine scenes did constitute the predella of the *pala* of the Pizzicaioli, but were added to the *Presentation* panel some time after 1461. This view was accepted by Kaftal (1949, 1952) and Gore (1965), whereas both Laclotte (1957) and Torriti (1977) favoured Brandi's reconstruction and dating. A date before 1449 was also preferred by Enzo Carli (1955, 1971) and by Coor (1959), who proposed yet another reconstruction: in her opinion the predella consisted of four narrative panels to either side of the Utrecht *Crucifixion* with two further panels at right angles to the predella on the outer sides of the side pilasters (FIG 3). Coor's proposal was accepted by Ourusoff de Fernandez-Gimenez (1967), who also suggested an alternative scheme with a rather unusual two-tiered predella: (FIG 4); by Zeri (quoted by Ourusoff de Fernandez-Gimenez); by the catalogues of the Thyssen-Bornemisza Collection (1970, 1971 and 1977); and, implicitly, by Ziemke (1969). Reinders and van Os (1969) agreed that the St Catherine stories formed part of the *pala* of the Pizzicaioli, but without the Utrecht *Crucifixion*.

Returning to the problem in 1971, van Os hypothesized a new reconstruction (FIG 5), in which the *Presentation in the Temple* would have been flanked by two figures of saints, one of them St Catherine. This large-scale triptych would thus have corresponded approximately in width to the predella composed of the ten extant scenes of the Catherine legend plus the Utrecht panel and would have included projecting elements at either end of the predella and to either side of the central panel. What is certain, observes van Os on the basis of old photographs, is that four of the scenes (here given as (b), (c) and (h), (i)) originally made up two panels which were separated relatively recently.

Notes
18 No.16; 29.8 × 62.7 cm. Strehlke (1988) p.240.
19 See note 6.

FIG 6 Giovanni di Paolo, predella of an altarpiece (hypothetical reconstruction here proposed, and the constituent panels in corresponding order):

a *St Catherine taking the Dominican habit* (Cleveland, Museum of Art)
b *The Mystic Marriage of St Catherine* (New York, private collection)
c *St Catherine and the beggar* (Cleveland, Museum of Art)
d *St Catherine exchanging her heart with Christ's* (New York, private collection)
e *St Catherine receiving the stigmata* (New York, Metropolitan Museum of Art, Lehman collection)
f *St Catherine beseeching Christ to resuscitate her mother* (New York, Metropolitan Museum of Art, Lehman collection)
g *The miraculous communion of St Catherine* (New York, Metropolitan Museum of Art)
h *St Catherine dictating her dialogues* (Detroit, Institute of Arts)
i *St Catherine before the pope at Avignon* (Thyssen Collection)
j *The death of St Catherine* (Private collection)
k *The Crucifixion* (Utrecht, Rijksmuseum)

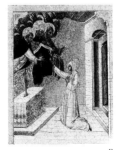

a

d

b

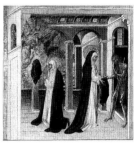

c

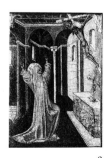

e

This theory met with the approval of Rosenbaum (USA tour, 1979–81), Chelazzi Dini (1982) and Gallavotti Cavallero (1985), who proposed to identify the second missing saint as St Andrew. Other critics, without expressing an opinion on the reconstruction, took it for granted that the St Catherine stories were contemporary with the main panel and formed its predella from the beginning (*Dizionario Bolaffi* and Ourusoff de Fernandez-Gimenez (1974); Thyssen-Bornemisza (1981, 1986)). Zeri (1980), however, disagreed, stating that the 'suggested reconstructions … are contrary to the principles of iconography and iconology … [as] an altarpiece with scenes from the life of a saint not represented in the main panel has no counterpart in Sienese painting'; on the other hand 'including St Catherine in one of the lateral panels would exclude from the complex the pilaster panel of St Catherine seen by Carli'. According to Zeri, 'the most likely hypothesis … is that they [the ten stories of St Catherine] were originally part of an altarpiece quite unrelated to that of the Pizzicaioli, which may … have shown a full-length figure of St Catherine surrounded … with scenes of her life. Such an altarpiece must have been commissioned and executed after her canonization in 1461'.

Pope-Hennessy (1987) and Strehlke (1988), while admitting the complexity of the problem and the difficulties of Giovanni's chronology, are both agreed on a late date. Pope-Hennessy also notes that 'four of the St Catherine scenes are painted on panels with horizontal grain. These [panels (b), (c) and (h), (i)] … and the *Crucifixion* [in Utrecht] are thus likely to have been the only panels in the predella, and their total width … is approximately that of the Siena *Presentation in the Temple*. The five scenes of narrower format [(a), (d), (e), (f), (g)] … painted on panels with a vertical wood grain … were thus almost certainly superimposed'. Pope-Hennessy concludes that 'there is … a strong case for supposing either that the narrative panels were a later accretion to the altarpiece, or that they were designed for a different structure'. Strehlke admits both these possiblities, stating somewhat pessimistically that 'in practice it is impossible to suggest an arrangement of the scenes that does not compromise the exigencies of either chronology or technical evidence'.

j

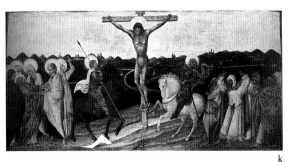

k g h i f

While one has to admit that the evidence we possess is insufficient to resolve once and for all the problem of the original appearance of the altarpiece to which the stories discussed here belonged, an attentive collation of the observations hitherto made on the physical state of the single panels, such as Christiansen (1990) has recently proposed,[20] may contribute towards a solution. The series is composed of two different kinds of panel: six 'narrow', ie higher than wide, painted on wood with vertical grain, and four square-shaped, on a wooden support with horizontal grain. The latter, placed in pairs, were probably painted directly on to the horizontal plank of the predella, and the former made separately and fixed to it. Today only two of the narrow panels retain, at least in part, their original thickness. One of them, (g), is gilded along both sides and the other, (f), only along the left side, but this has traces of an architectural setting (FIG 8) on its right, vertical edge. [21] Very likely, therefore, the scene with *St Catherine beseeching Christ* (f) (see also FIG 7), was at the extreme right side, with another episode at right angles to it, to complete the narrative on the lateral face of the predella. One might suppose this to have been the *Death of the Saint* (j), a hypothesis which unfortunately cannot be proven as the original wooden support of this panel has been thinned and transferred to another panel and the picture itself has been to a great extent repainted. The final two narrow scenes were preceded in all probability by two non-projecting square scenes which, following the sequence of the legend, should have been the *Saint dictating her dialogues* (h) and the *Saint before the pope* (i). These in their turn should have been flanked by a projecting element, possibly the *Miraculous communion* (g). At the other end of the predella an analogous disposition of the scenes may be hypothesized: on the left lateral face the *Saint taking the Dominican habit* (a) and, at right angles to it, on the front face of the predella, another narrow scene, possibly the *Exchange of hearts* (d), then the two remaining square stories, the *Mystic marriage* (b) and the *Saint with the beggar* (c), and then again a projecting narrow scene, probably the *Saint receiving the stigmata* (e). If the scenes were indeed disposed in this manner, or rather if projecting and non-projecting elements indeed alternated in the predella, it is necessary to suppose the existence in the centre, between panel (e) and (g), of two more square scenes, or of one corresponding 'double' panel. The missing element may hypothetically be identified with the Utrecht *Crucifixion* (k), the dimensions of which are equivalent to those of two square scenes, which is painted on wood with horizontal grain and which comes, like the rest of the sequence, from the Ramboux collection.[22]

Such a reconstruction would seem to me quite plausible even if it conflicts, in some details, with the chronology of the Saint's legend. More than a little doubt remains, on the other hand, about the connection of this predella with the Pizzicaioli altar. For one thing the Pizzicaioli altar was in a side-chapel, which could hardly house a very large altarpiece.[23] Moreover, usually projecting panels of the kind discussed were in line with the pilasters or other architectural elements dividing the main part of the polyptych;[24] here, the projecting bases that are supposed to have stood beneath the painted columns of the *Presentation in the Temple* now in the Pinacoteca in Siena would have no rationale. From an iconographic point of view, it is practically impossible to find a cycle of paintings in the Quattrocento dedicated to a person not yet canonized.[25] But it is above all on stylistic grounds that objections may be made. As Pope-Hennessy (1987) rightly observes 'whereas the Pizzicaioli altarpiece ... is a typical work of the late 1440s, the handling and palette of the St Catherine scenes are those of the Pienza painting', ie the *Virgin and Child with saints* (Pienza, Cathedral), signed and dated 1463. Giovanni's brushwork at this time becomes more rapid and he seems to be less concerned with the precise delineation of forms and the elaboration of details than with the dynamics of the composition and the expressiveness of his figures, which sometimes verge on caricature.[26] Significant comparisons can be made with the panel in the Pinacoteca Civica of Castiglion Fiorentino (1458) and with that in Sant'Agostino at Montepulciano (1456), in the way the forms are underlined, the gestures emphasized and the features made almost brutally explicit in their characterization. His arbitrary perspective in scenes such as *St Catherine beseeching Christ* and

Notes

20 The reconstruction suggested here essentially follows Christiansen (1990). I disagree only with his opinion that the predella formed part of the Pizzacaioli altarpiece.

21 The fragment shows a low wall with an open door leading into an interior and it is quite possible that it originally completed the left-hand side of the *Death of St Catherine* (j).

22 Ramboux, however (*Catalog* (1867) p.24, no.122), not only fails to mention any connection between this work and the St Catherine series but lists it under the name of Paolo di Neri with the date 1342.

23 In calculating the size of the predella to be about 275 cm (see Christiansen (1990) p.211), one should bear in mind the more modest proportions of the seventeenth-century altarpieces by Pietro Locatelli (*Assumption*, 390 × 230 cm), Giovanni Maria Morandi (*Annunciation*, 396 × 232 cm) and Ciro Ferri (*Vision of St Theresa*, 403 × 241 cm) now on the side altars of the church of Santa Maria della Scala (Gallavotti Cavallero (1985) p.313f.).

24 As, for instance, in the polyptychs by Giovanni Boccati in the Parrocchiale of Belforte in Chianti and by Giovanni Antonio da Pesaro in the church of Santa Croce at Sassoferrato; P.Zampetti, *La pittura marchigiana del '400* (Milan, n.d. [1969]) figs.68 and 124. Zeri's (1980) arguments quoted above also seem to confirm that the St Catherine predella was extraneous to the Pizzacaioli altarpiece.

25 Although, especially in the Trecento, exceptions do exist, towards the mid-fifteenth century it would be extremely unlikely for a cycle of paintings to be devoted to a saintly person not yet canonized; cf. M.Boskovits, 'La nascita di un ciclo di affreschi nel Trecento', *Arte Cristiana* LXXVII (1989) p.4f., and, in relation to the St Catherine series, Strehlke (1988) p.222f.

26 An eloquent example of the change in Giovanni di Paolo's style is provided by a comparison between the unidentified *Female saint* (Monica?) in the New York Metropolitan Museum polyptych (no.32.100.75) of 1454 with the analogous figure in the Pienza polyptych; although the pose and arrangement of the drapery are virtually the same, the artist strongly emphasizes the movement and distorts the

FIG 7 (= FIG 6f) Giovanni di Paolo, *St Catherine beseeching Christ to resuscitate her mother* (New York, Metropolitan Museum of Art, Lehman collection)

FIG 8 Giovanni di Paolo, fragment showing an architectural setting (on the right edge of FIG 7)

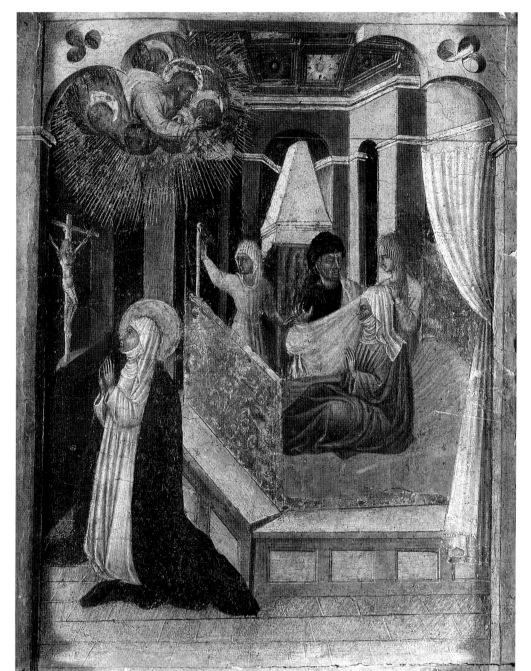

features of the saint in the latter version, painted in 1463. The expressive style of the predella seems to me the same as that of the four *Saints* (Metropolitan Museum and Utrecht); these panels, originally destined for side pilasters and also with a provenance from the Santa Maria della Scala hospital, must be of the same date and were most likely part of the same complex as the predella scenes.

27 See Strehlke (1988) p.214f.

28 It is known (*Mostra cateriniana di documenti. Agosto-Ottobre 1947. Catalogo* (Siena, 1947) p.27f.) that the Comune of Siena, which fostered the saint's canonization from the time of Pius II's election to the papacy, in August 1459 supplied the sums necessary for the canonization bulls, evidently certain of a successful outcome. Preparations for the related festivities may well have begun at that time and it is likely that they would have included a commission for works representing the saint's life.

the *Miraculous communion*, (f), (g), remind one of the *Miracle of St Nicholas of Tolentino* of 1456 (Vienna, Akademie) and the *Stories of St John the Baptist* (now divided between various collections),[27] which are probably to be dated around 1460: far from being a sign of incapacity on the artist's part, it is a deliberate choice intended to stress the restless mood of certain episodes and the underlying emotional tension of the action. One may therefore presume that the ten scenes were commissioned to complete an altarpiece (which was probably not the Siena *Presentation*) around 1461, the year of the saint's canonization.[28]

Lorenzo Monaco active from the late 1380s; died 1426

18 The Madonna and Child enthroned with six angels

*c*1415–20
Tempera on panel, 147 × 82 cm (including frame which is largely original; painted surface, 128 × 78 cm);
 thickness 3.8 cm
Inscription (along the base): AVE MARIA GRATIA PLENA
Accession no.1981.73

Provenance
Private collection, Florence, 1887
James Young, Kelly on the Clyde, Scotland
Mrs J. Walker (Mary Ann Young), Limefield, West Calder, Midlothian, by 1900
Alice M. Thom, Glasgow
Knoedler Galleries, London, no. A 5982, by 1958
Mrs Lore Heinemann, New York
Thyssen-Bornemisza Collection, 1981

Exhibition
Dallas, *The Arts of Man*, Museum of Fine Arts, 1962, no.45

Literature
Connoisseur CXLII, no.573 (1958) p.LXV
The Arts of Man, exhibition catalogue (Dallas Museum of Fine Arts, Dallas, 1962) p.39, no.45
Boskovits, *Pittura fiorentina* (1975) p.349
J. Pope-Hennessy, 'Some Italian Primitives', *Apollo* CVIII (1983) p.12
Thyssen-Bornemisza (1986) p.182, no.167d
Thyssen-Bornemisza (1989) p.187
M. Eisenberg, *Lorenzo Monaco* (Princeton, NJ, 1989) pp.65 note 120, 146f., 165, 173

The Madonna enthroned holds the Infant Jesus standing on her lap, his right hand raised in blessing. To either side of the throne is an angel with a censer and, partially visible behind them, four other angels, two on either side.

On the back of the panel are traces of a former horizontal batten. Besides an illegible label, there is the number 'A 5982' in blue and a label of the Thyssen Collection.

A photograph taken around 1956 (Sydney Newberry, London, no. 69921) shows the painting after cleaning but before restoration. There is a large colour loss on Mary's chin and minor losses in the faces of the Child and of the left foreground angel. The floor, the dais of the throne and the Virgin's mantle draped over her feet also have small rubbed and flaked spots. Before 1958 the painting was restored and inpainted by Mario Modestini. In 1982 it was given another light cleaning by Marco Grassi, who also remodelled the damaged part of the Virgin's face.

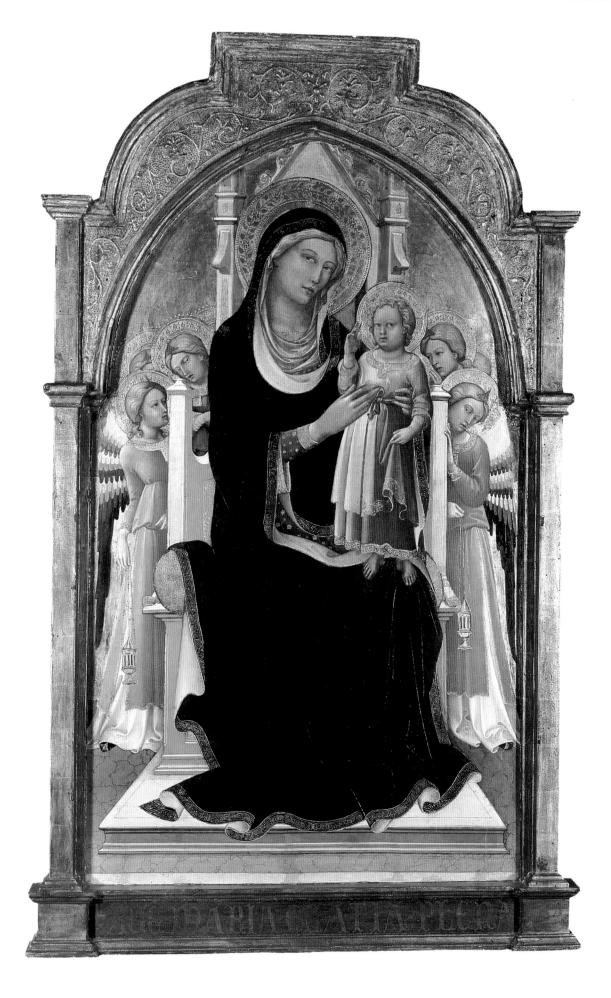

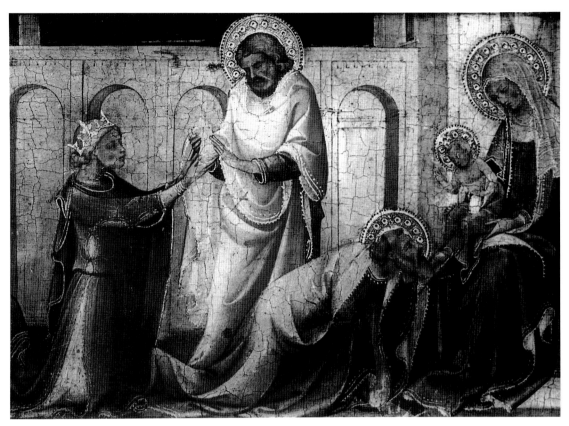

FIG 1 Lorenzo Monaco, *The Adoration of the Magi* (detail) (Poznan, Museum Narodowe)

Notes

1 Lorenzo Monaco's polyptychs (but also those of other Florentine artists of the early fifteenth century) representing the Madonna and Child enthroned at the centre have pairs of saints on either side and the Annunciation and the risen Christ blessing in the pinnacles, where these survive; cf. the artist's polyptychs in the Pinacoteca of Empoli (no.21.72), in the Accademia, Florence (no.468), and in the Galleria Comunale of Prato; those by Agnolo Gaddi in the Bode Museum, East Berlin (no.1039), in the Contini-Bonacossi bequest, Florence, and in the National Gallery, Washington (no.4); etc.

2 This virtually unknown painting, including the few surviving parts of the frame, measures 112 × 46 cm. The height of the missing side columns, originally separating the panels (*ie* the distance between the base of the painted surface and the springing of the arch), is in both of them approximately 80 cm. The *St Francis* panel was included in the sale of the Nevin collection (Galleria Sangiorgi, Rome, 22–7 April 1907, lot 241) attributed to 'Taddeo Bartoli' and again in the Serristori sale catalogue (Sotheby-Parke-Bernet, Florence, 9–16 May 1977, lot 18), where it was given the equally unlikely ascription to Taddeo Gaddi.

3 Inv. no.MO-21; 29 × 85 cm. Some time ago (Boskovits (1975) p.352) I dated the panel about 1405/10, but I am now of the opinion that the date of 1415/17 put forward by Sirén (1905, p.92) is more likely. If one compares it with the painting of the same subject (London, Courtauld Institute Galleries), which is generally dated 1405/10, or with the predella scene, also representing the *Adoration of the Magi*, belonging to the *Coronation* polyptych dated 1414 (Uffizi), it is clearly closer to the latter. The *Epiphany* (or Nativity with the Annunciation to the Shepherds) frequently occupies the central place in predellas beneath the Madonna enthroned: cf. for example, the Rinuccini polyptych by Giovanni del Biondo (1379; Florence, Santa Croce), a polyptych by Bicci di Lorenzo (Bibbiena, Sant'Ippolito; Berenson, *Italian Pictures* (1963) figs.300 and 511), etc.

In its present state the surface at the centre of the painting is slightly rubbed and the modelling somewhat impoverished, particularly in the faces of the Virgin and Child and of the right-hand angel. There are also slight vertical cracks corresponding to the joins in the wood and some worm-holes. In 1958 the frame, which is original, was provided with a pedestal and the two side pilasters. The gilded pastiglia decoration of the gable is new.

The Thyssen-Bornemisza panel was originally the centre of a polyptych of unknown provenance. The other components probably included full-length figures of saints in the lateral panels, the Annunciation and the risen Christ in the pinnacles, and stories of Christ or of the saints represented in the predella.[1] None of these parts can be identified with certainty, but on the grounds of stylistic affinities, measurements and the choice of colours (for instance, the identical olive-green shade of the floor), I think it is possible to identify one of the lost laterals in a *St Francis* today in a private Florentine collection (FIG 2a).[2] At the centre of the predella, beneath the Thyssen *Madonna*, there may originally have been the *Adoration of the Magi* in the Museum of Poznan (FIG 1 and 2c) which would fit for reasons of size, style and iconography.[3]

FIG 2 Lorenzo Monaco,
hypothetical reconstruction of a
polyptych:
a *St Francis* (Florence, private
 collection)
b *Madonna and Child enthroned
 with six angels* (Thyssen
 Collection)
c *The Adoration of the Magi*
 (Poznan, Museum Narodowe)

When the Thyssen *Madonna* was first reproduced in *The Connoisseur* (1958) as the property of Knoedler's in London, it was already attributed to Lorenzo Monaco. The attribution had been made two years earlier by Roberto Longhi in a letter addressed to Rudolf Heinemann.[4] According to Longhi, this is 'an absolutely typical work of Lorenzo Monaco. Comparisons . . . between this painting and the frescoes of the *Life of the Virgin* in Santa Trinita in Florence[5] . . . make me believe that this work is to be assigned to the last period of the master'. Some time later, in 1962, the painting was exhibited, as the property of Mrs Heinemann, in the Museum of Fine Arts at Dallas. However, it was overlooked in the literature until 1975, when it was included by the present writer in the catalogue of the artist's œuvre and dated by him *c*1410/15. This proposal was accepted by Pope-Hennessy (1983), according to whom the painting 'dates not long after the . . . altarpiece of 1410 in the Accademia',[6] and by the catalogues of the Collection (Thyssen-Bornemisza, 1986 and 1989). Eisenberg (1989), however, thinks that 'the execution was the work of the shop', as 'the draughtsmanship has none of the brilliance' of Don Lorenzo's autograph late paintings; 'the brushwork is coarse' and the 'mannered angels' only 'caricature Lorenzo's types'. He dates the painting *c*1422–3. It is possible that his unfavourable judgement was influenced in some measure by the colour losses and repairs, to which he does not refer in his entry. As regards dating, now that I have had occasion to examine the original, I feel that Longhi's dating is more convincing than the one suggested by me (1975). The painting has a blend of colours, apart from the heavily oxidized mantle of the Virgin, which ranges from delicate light tones of salmon pink and cyclamen to apple green, mother-of-pearl grey and canary yellow. It entirely lacks the livid tones and heavy shadows which distinguish Don Lorenzo's works around 1410 and in the following years; the latter are, more often than not, severely constructed compositions to which both the large, dramatic gestures and the deep shadows of the modelling give a peculiar gravity. In any case, the chronology of the artist's extensive œuvre remains largely uncertain, especially for the period between the *Madonna* dated 1415 in the church of Sant' Ermete at Pisa[7] and the documented *Adoration of the Magi* of 1421/2 (Uffizi).[8] In my opinion, the Thyssen *Madonna* is to be placed between these two dates. It has undeniable analogies with the *Madonna and Child* at the centre of the polyptych of 1410, from which the artist not only borrowed the outline of the composition but also the design of the two principal figures. Our panel differs, however, in the artist's attempt to render the outlines in a harmonious, flowing rhythm, even at the cost of the plastic consistency of his fragile figures. The reduced chiaroscuro, replaced by a refined play of tonal modulations, the silhouetting of the elongated and at times somewhat mannered forms against a strongly contrasted ground, the elegant and slightly affected poses and the languid expressions (for instance, in the angel on the left leaning backwards but stretching his head forwards to get a better view of the Child, and that on the other side hugging the throne as he turns his head; see detail), are more emphasized compared to the Uffizi *Coronation* and the Pisa *Madonna*. The painting anticipates solutions to be found in the *Madonnas* of Maastricht,[9] Empoli,[10] Tavernola,[11] and Edinburgh.[12] Although undated, this group of works seems to belong to a late phase in the artist's career, preceding the frescoes of the Bartolini-Salimbeni Chapel in Santa Trinita and the Uffizi *Adoration*. In these paintings of the early 1420s Don Lorenzo displays even greater elegance of line and introduces into his compositions an expressiveness still absent in the Lugano panel. The latter can therefore probably be dated towards the middle of the second decade or slightly later.

Notes

4 The photograph of the painting before restoration is preserved in the archive of the Fondazione Longhi, Florence, with the annotation: 'Dr Heinemann, 1956'. A copy of Longhi's typed expertise, dated 25 February 1956, exists in the Thyssen Archives.

5 For reproductions of these frescoes, which are generally dated around 1420, see A. Padoa Rizzo, in *La chiesa di Santa Trinita a Firenze*, edd. G. Marchini and E. Micheletti (Florence, 1987) p.108f.

6 For which see Sirén (1905) p.XI.

7 See E. Carli, *La pittura pisana del Trecento*, II (Milan, 1961) pp.33, 62.

8 See Sirén (1905) pl.XLVII and, for the documents relating to the commission, p.183f.

9 Formerly no.295 in the Aartsbischoppelijk Museum in Utrecht; H. van Os and M. Prakken, *The Florentine Paintings in Holland, 1300–1500* (Amsterdam and Maarsen, 1974) p.71, fig.36. The painting has recently been transferred to the Bonnefantsmuseum in Maastricht (inv. no.3410). It is probably to be dated shortly after 1415.

10 No.72 of the Pinacoteca, it is generally considered a late work; A. Paolucci, *Il Museo della Collegiata di S. Andrea in Empoli* (Florence, 1985) p.75f.

11 F. Arcangeli, *Dipinti restaurati del territorio di Grizzana. Soprintendenza alle Gallerie di Bologna* (Bologna, 1966) no.10.

12 H. Brigstocke, *Italian and Spanish Paintings in the National Gallery of Scotland* (Edinburgh, 1978) p.71f., no.2271.

Detail [18] the Virgin and Child

Lorenzo Veneziano

active 1356–72

19 Portable altarpiece with a central Crucifixion

c1370–5
Tempera on panel, central panel 83.6 × 30.7 cm; wings 83 × 15 cm; thickness 1.8–2.7 cm
Accession no.1979.1.1–3

Provenance
Count Alexander(?) Shouvaloff, St Petersburg, mid-nineteenth century
Count Alexander von Benckendorff, Copenhagen and London, by 1890s
Mrs Humphrey Brooke, London (by inheritance)
Christie's, London, 2 July 1976, lot 76
Carlo De Carlo, Florence
Thyssen-Bornemisza Collection, 1979

Exhibition
London, *Italian Art and Britain*, Royal Academy of Arts, 1960, no.292

Literature
Italian Art and Britain, exhibition catalogue (Royal Academy of Arts, London, 1960) p.110, no.292
Pallucchini, *Trecento* (1964) p.173
Highly Important Old Master Pictures, sale catalogue (Christie's, London, 2 July 1976) p.79, lot 76
Thyssen-Bornemisza (1981) p.177, no.164c
J.Pope-Hennessy, 'Some Italian Primitives', *Apollo* CVIII, no.3 (1983) p.12
Thyssen-Bornemisza (1986) p.183, no.164c
Thyssen-Bornemisza (1989) p.188

The upper part of the central panel of this triptych represents the *Crucifixion* with the three Maries to the left,[1] St John the Evangelist and a group of Pharisees to the right, the kneeling Magdalen at the foot of the Cross and soldiers in the background. Above the Cross is a symbolic pelican[2] and the inscription I.N.R.I.[3] flanked by two flying angels. Below, from left to right, are *St Lucy*, a *Bishop saint*, *St Helen* and *St Margaret*; above, in the pinnacle, is the *Head of Christ*. On the left shutter, reading downwards, are the *Angel Gabriel*, the *Trinity*,[4] the *Virgin and Child with St Anne*[5] and *St Francis receiving the stigmata*; in the pinnacle, an adoring *Angel*. On the right shutter, the *Annunciate Virgin*,[6] the *Baptism of Christ*, the *Conversion of St Paul*, *Sts Anthony of Padua*, *Anthony Abbot* and *Louis of Toulouse* and, in the pinnacle, an adoring *Angel*. On the

Notes
1 According to John 19:25, 'there stood by the Cross of Jesus his mother, and his mother's sister, Mary the wife of Cleophas, and Mary Magdalen'. A different tradition (Mark 15:40) records the presence of 'Mary Magdalen, and Mary the mother of James the Less and of Joses, and Salome'. The second Mary of this latter group is probably to be identified with the wife of Cleophas. (See also further below, cat.[24] note 1).
2 According to a Hellenistic-Christian tradition handed down by *Physiologus*, the pelican feeds its young with its own blood. This image, intended as a symbol of Christ's sacrifice, is to be found from the Early Christian era onwards; see A.Charbonneau-Lassay, *Le bestiaire du Christ* (Bruges, 1940) pp.558–60.
3 The abbreviation of 'Jesus Nazarenus Rex Iudeorum' (John 19:19).
4 From the thirteenth century onwards, one of the various representations of the Trinity showed God the Father enthroned holding up the crucified Christ with the Dove of the Holy Spirit between them. For this iconography, known as *thronum gratiae* (with reference to the Epistle of Paul to the Hebrews 9:5), see W.Braunfels, *Die heilige Dreifaltigkeit* (Düsseldorf, 1954).
5 The group is represented according to the iconography which became popular towards the end of the fourteenth century, as a consequence of the growing cult of St Anne, the Virgin's mother. She is portrayed with the Virgin seated on her lap, while the Virgin holds the Christ Child. See J.H.Emminghaus, 'Anna Selbdritt', *Lexikon christlicher Ikonographie*, V, cols.185–90.
6 The motif of Mary clinging to a column in her fright is not uncommon in Venetian painting (cf. the miniature in the Evangeliary in the Biblioteca Marciana, cod.lat.I.100, and the altarpiece attributed to Paolo Veneziano in the church of San Pantalon in Venice, repr. in Pallucchini (1964) figs.25 and 288) but is extremely rare in the

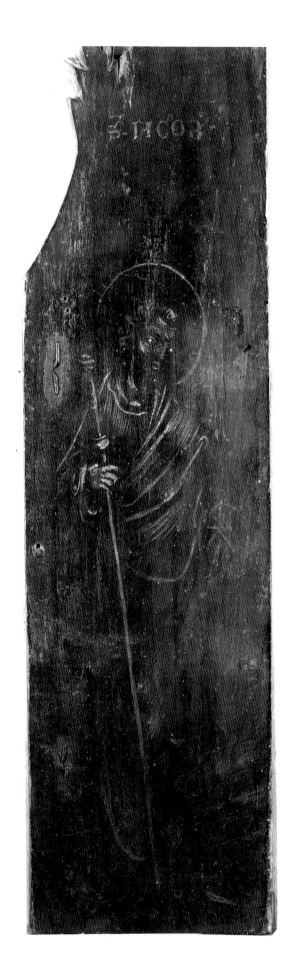

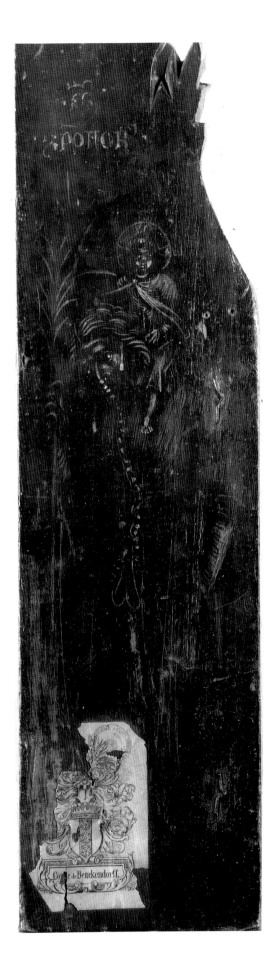

Back of the left shutter of [19]
St James the Great

Back of the right shutter of
[19] *St Christopher*

Detail [19] *Announcing angel*

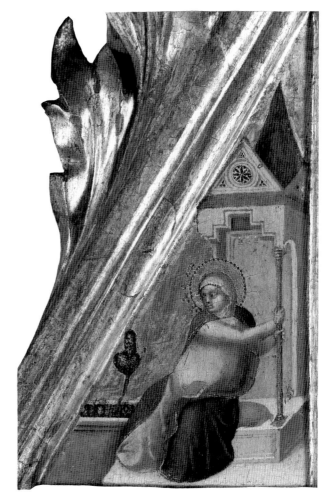

Detail [19] *The Annunciate Virgin*

Notes
rest of Italy. The fourteenth-
century descriptions of the Holy
Land, for instance the *Libro
d'Oltramare* by Fra Niccolò da
Poggibonsi, record that in the
Church of the Annunciation at
Nazareth there was the so-called
room of the Virgin, which 'had
inside the column which Mary
held on to in fright when the
Angel addressed her'; E.Borsook,
Gli affreschi di Montesiepi
(Florence, 1968) p.29f.
7 The reproduction in the sale
catalogue (1976) shows the
triptych before cleaning, but it
was already cleaned when it was
bought for the Thyssen-
Bornemisza Collection.
8 See *Italian Art and Britain*
(1960) p.110; the information
was presumably handed down by
the family. The sale catalogue
(1976, p.79) mentions Count
Alexander Shouvaloff; according
to G.F.Waagen (*Die
Gemäldesammlung in der
kaiserlichen Ermitage . . .* (Munich,
1864) p.433) the famous
collection in St Petersburg
belonged to Count Peter, *ie* Piotr
Andreevic Shouvaloff (1827–89).
9 It is stated in the 1976 sale
catalogue that 'the triptych is
visible in photographs of the

outside of the shutters, painted in white tempera on a dark ground, are the figures of *St James* (inscribed s.IACOB.) and *St Christopher* (inscribed s.XPOFOR.).

The triptych, which was cleaned between 1976 and 1979,[7] is on the whole in good condition. The central panel has a crack above left and below right and the frame is slightly bent. There are numerous lacunae in the gold of the frame and the gold ground of the scenes is rubbed. Some of the figures are also rubbed, particularly the groups of the *Trinity* and the *Virgin and Child with St Anne*, besides the saints in the lower section at the centre, where there are colour losses caused by the crack in the frame. The figure of *St Margaret* has been retouched. There are a number of worm-holes. On the back of the central panel is a label of the Thyssen-Bornemisza Collection and another with the printed number '304'. On the outside of the right shutter is a label with the family crest and the name of 'Comte de Benckendorff'. This label also has a stamp of the export office of the Florence Soprintendenza.

This small devotional altarpiece, representing all the saints which were the glory of the Franciscan order at that date with the exception of St Clare, could have been destined for a male member of that order. It apparently entered the Shouvaloff collection in St Petersburg towards the mid-nineteenth century.[8] It then passed as a gift to Count Alexander Shouvaloff's son-in-law, Count Alexander von Benckendorff (1849–1917), who seems to have owned it from at least 1897 when he was appointed Russian ambassador to Copenhagen.[9] In 1903 Count Benckendorff moved to London where the painting later belonged to his son, Count Constantin, and, from 1946, to his grand-daughter, Mrs Humphrey Brooke,[10] who sold it in 1976. By 1978 it was on the Florentine market,[11] where it was bought for the Collection in 1979.

This painting was unknown to scholars until 1960 when it was included in the exhibition *Italian Art and Britain*, catalogued as 'anonymous Venetian, *c*1370'. Pallucchini was the first to relate it to the group of works 'which are undoubtedly by Lorenzo Veneziano'. He dated it a little before 1370 on the grounds that the compositional arrangement of the scenes on the shutters

Detail [19] *The Trinity* Detail [19] *The Conversion of St Paul*

'anticipates, in a certain sense, that of the Berlin predella of 1370'.[12] The triptych was sold at Christie's (1976) with the attribution to Lorenzo Veneziano and mention was made in the catalogue of the two figures on the outer shutters as possibly also executed by the artist. The catalogues of the Thyssen-Bornemisza Collection (1981, 1986 and 1989) also accept the attribution to Lorenzo, while Pope-Hennessy (1983) describes the painting as 'an attractive and well preserved triptych by a miniaturist in the circle of Lorenzo Veneziano'.

The problem of attribution arises from the relative shortage of comparative material. The catalogue of Lorenzo Veneziano's œuvre – which awaits to be fully defined – is composed almost entirely of paintings representing the Madonna and Child or saints, most of which are considerably larger in scale. However, the Berlin predella panels (Gemäldegalerie, nos. 1140, 1140a, III.80), in which the carefully chiselled forms usually found in Lorenzo's major works give way to a softer touch and a more rapid and free execution, reveal definite analogies with parts of the work discussed here, such as to confirm fully, in my opinion, their common authorship. Significant comparisons may also be made with the small *Adoration of the Magi* in the predella of the polyptych in Vicenza Cathedral, and with the throne decoration in *Christ giving the Keys* in the Museo Correr. In both these paintings the artist moulds his figures in a denser substance and seems intent on giving solemnity to their poses by means of slow, almost hesitating gestures and well defined, rounded outlines. Comparing such details as the angel Gabriel portrayed on the throne behind Christ in the Correr painting with the same figure in the left shutter of our triptych, or the *Conversion of St Paul* in the Berlin predella with the same scene in the right shutter (see detail and FIG 1), one has to conclude that the Thyssen triptych belongs to a late phase in the artist's career, probably after 1370. In the first instance, the animated fervour of the Archangel causing the Virgin's fright in the Thyssen painting (see detail) is, in my opinion, a more developed version of the dignified attitude of the same figure in the altarpiece of 1370; and, in the second, both the greater dramatic tension and the compositional coherence

Notes

interior of their house in
Copenhagen'.
10 See *Italian Art and Britain* (1960).
11 This is shown by the presence
of the export office stamp (see
above).
12 The reference is to the *Scenes
from the lives of Sts Peter and Paul*
(nos.1140, 1140a, III.80) in the
Gemäldegalerie, Berlin, which are
known to have originally formed
part of the polyptych dated 1369
(modern style 1370), of which the
central panel with *Christ giving
the Keys to St Peter* is in the Museo
Correr in Venice; Boskovits,
Berlin. Katalog, pp.101–3.
13 No.988; Pallucchini, *Trecento*,
p.178, figs.549–52.

in the Thyssen triptych suggest a later date. The figures withdraw to the edges of the limited space to allow room for the dialogue between Paul, who struggles to rise from the ground, and Christ, hidden by the blue cloud above to the left. Instead of being emphatic, the gestures are essential and tend to underline the spontaneity of the action. This is also apparent in the *St Francis* who seems to have just fallen to his knees to receive the stigmata, or in the above mentioned figure of Mary, catching hold of a column of the loggia in her fear at the angelic apparition, or again in the kneeling angel assisting at Christ's baptism, which can be compared with the music-making angel in the foreground of the Brera tabernacle.[13] The last named painting, which is undated, is usually regarded as a work of Lorenzo's late period. The Thyssen-Bornemisza triptych would also appear to belong to the same moment, possibly around 1370/5, and its execution, although sketchy here and there, seems to me to be entirely by Lorenzo's hand. Also autograph are the two saints, rapidly outlined with a few brushstrokes, on the outer sides of the shutters. They are unique in the artist's œuvre, being more drawings than paintings; but every detail, from their subtle characterization to their facial types, would seem to confirm Lorenzo's authorship.

FIG 1 Lorenzo Veneziano,
The Conversion of St Paul (Berlin,
Staatliche Museen,
Gemäldegalerie)

Luca di Tommè $c1330$–1389 or after

20 The Adoration of the Magi

$c1360$–5
Panel, 41×42 cm; painted surface, $c37.5 \times 37.8$ cm; thickness 0.6 cm (thinned)
Accession no.1978.46

Provenance
Germany, private collection, before 1919
Galerie Helbing, Munich, 1 October 1919, lot 48
Thomas Agnew, London, 1924
Maitland F. Griggs, New York
Robert von Hirsch, Frankfurt-am-Main (later Basle) by 1927
London, Sotheby's, 21 June 1978, lot 102
Thyssen-Bornemisza Collection, 1978

Literature
Gemälde alter Meister, Skulpturen ... aus dem Besitz des Herrn Stallforth, Wiesbaden und aus anderem ... Privatbesitz,
 sale catalogue (Galerie Helbing, Munich, 1 October 1919) p.6
F.M.Perkins, 'Altre pitture di Luca di Tommè', *Rassegna d'Arte Senese* XVII (1924) pp.13–4
F.M.Perkins, 'Luca di Tommè', in Thieme and Becker, *Lexikon*, XXIII (1929) p.427
B.Berenson, 'Quadri senza casa: il Trecento senese–I', *Dedalo* XI, no.2 (1930–1) p.274; republished in English,
 International Studio (November 1931) p.27; reprinted in *Homeless Paintings of the Renaissance*, ed. H.Kiel (London,
 1969) p.26
Berenson, *Italian Pictures* (1932) p.312
Berenson, *Pitture italiane* (1936) p.268
M.Meiss, 'Notes on three Linked Sienese Styles', *Art Bulletin* XLV (1963) pp.48, 49 note 10
S.Wagstaff, in *An Exhibition of Italian Panels and Manuscripts ... in Honor of Richard Offner*, exhibition catalogue
 (Wadsworth Athenaeum, Hartford, 1965) p.27
F.Rusk Shapley, *Paintings from the Samuel H. Kress Collection: Italian Schools XIII–XV Century* (London, 1966) p.59
Berenson, *Italian Pictures* (1968) I, p.224
S.A.Fehm, 'Notes on the Exhibition of Sienese Paintings from Dutch Collections', *Burlington Magazine* CXI (1969)
 p.574
S.A.Fehm, *Luca di Tommè. A Dissertation ...* (Ann Arbor 1971) p.7 no.6; pp.26 note 5, 45–6
S.A.Fehm, *The Collaboration of Niccolò Tegliacci and Luca di Tommè* (Los Angeles, 1973) pp.30 note 24, 31 note 34
H.B.J.Maginnis, 'The Literature of Sienese Trecento Painting 1945–1975', *Zeitschrift für Kunstgeschichte* XL (1977)
 p.296
The Robert von Hirsch Collection. Old Master Drawings, Paintings and Medieval Miniatures, sale catalogue (Sotheby's,
 London, 21 June 1978) p.157, lot 102
C.De Benedictis, *La pittura senese 1330–1370* (Florence, 1979) p.89
Thyssen-Bornemisza (1981) p.176, no.164B
J.Pope-Hennessy, 'Some Italian Primitives', *Apollo* CXVIII, no.3 (1983) pp.11–2
Thyssen-Bornemisza (1986) p.186, no.164b
M.Laclotte, 'Quelques tableautins de Pietro Lorenzetti', in *"Il se rendit en Italie". Etudes offertes à A. Chastel* (Rome and
 Paris, 1987) pp.32f., 38
Thyssen-Bornemisza (1989) p.191
M.Eisenberg, *Lorenzo Monaco* (Princeton NJ, 1989) p.56 note 56

The shed of the Nativity is set into a niche formed by a rock. In the opening stands St Joseph who lifts the lid of a pyx. Mary, seated on a cushion on the ground, holds the infant Jesus on her lap as he blesses the elderly king kneeling in adoration. Behind him are the two other kings awaiting their turn to offer their gifts. Beyond is the traditional suite represented by two servants holding the bridles of a pair of camels. To the right are two standing angels in attitudes of prayer.[1]

Note
1 For the iconography in general see H.Kehrer, *Die heiligen drei Könige in Literatur und Kunst* (Leipzig, 1908–9). For the motif, rare in this context, of the Madonna seated, like the Madonna of Humility, on a cushion, Meiss (1963) p.48.

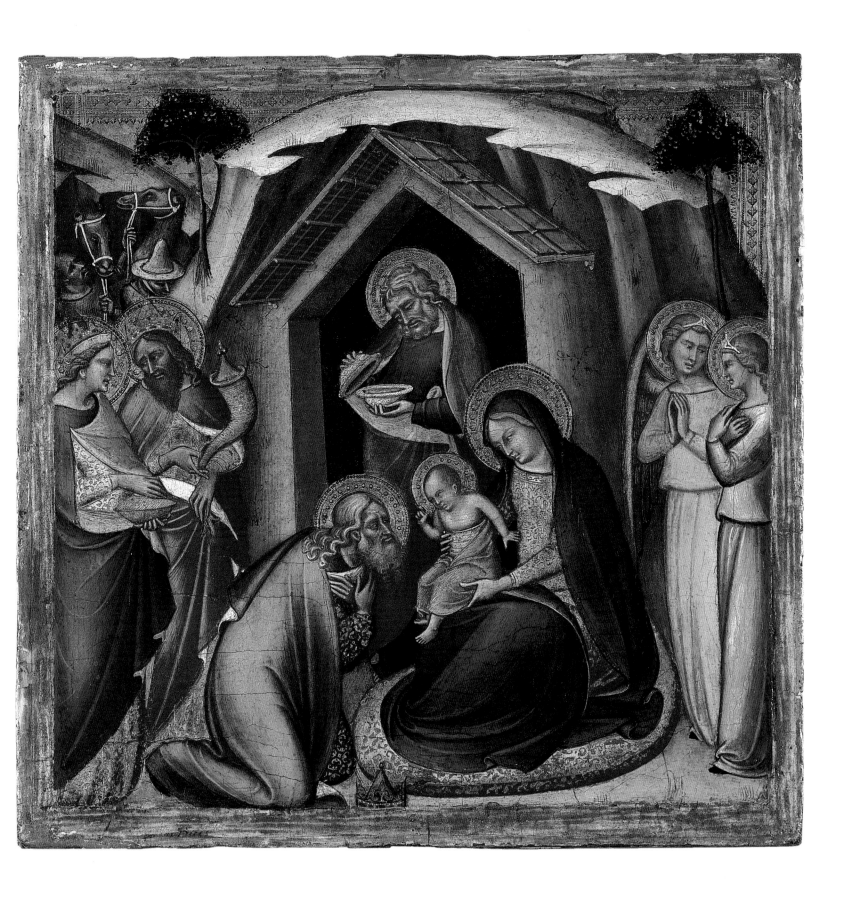

The panel, which has a modern frame, has been thinned down and cradled. An old inscription in pen on the cradling records a former attribution to Taddeo Gaddi. On the lower edge of the modern frame are traces of an inscription ending in 'Bicci'. There is a margin round the painted surface on all four sides which would have been concealed by the original frame but which has now been covered with gesso and gilded, probably at a recent date. The painting was cleaned by Marco Grassi in 1978. The surface, which is covered by a fine craquelure, is in a good state. The underlying bole is visible in a few places, especially at the top, where the gold is slightly rubbed.

Described as 'manner of Taddeo Gaddi' when it was auctioned in 1919, the painting has been universally accepted as a work by Luca di Tommè ever since Perkins proposed the attribution (1924). Berenson (1930–1) records it in the collection of Mr Maitland Griggs in New York, although, at that date, the panel had apparently already been acquired by Robert von Hirsch.[2] Berenson mentions a companion panel (but without explicitly connecting the two works) in the De Young Memorial Museum, San Francisco (FIG I):[3] 'The *Crucifixion* – the fragment of a predella to an altarpiece – is of as fine a quality as Luca di Tommè's *Adoration . . .*'. Later, Meiss (1963) specified that the Hirsch *Adoration* and the San Francisco *Crucifixion* belonged to the same predella, basing himself on similarities of style, size and punch marks. De Benedictis (1979) states that two further panels of the same predella (*Nativity* and *Presentation in the Temple*) are in a private Florentine collection, but provides neither reproductions nor measurements.

Although there is general agreement on the painting's authorship, this is not true of its dating. Perkins (1924) considers it a mature work, as does Meiss (1963), who compares it with the predella of the 1362 altarpiece jointly signed by Luca and by Niccolò di Ser Sozzo in the Pinacoteca, Siena (no.51).[4] This opinion is shared by Wagstaff (1965) and Rusk Shapley (1966), who sees affinities with the *Crucifixion* dated 1366 (Museo Civico, Pisa). More recently Eisenberg (1989) quotes the Thyssen *Adoration* as an example of mid-fourteenth-century painting in Siena. An early date, before the 1362 polyptych, has also been proposed by Fehm (1969, 1971, 1973), who groups the two panels with others to be dated 'from before his collaboration [with Niccolò di Ser Sozzo], as the latter's influence cannot be distinguished in any of them' (1971, p.26).[5]

In fact, the appraisal and chronology of Luca di Tommè's substantial œuvre pivot on the polyptych of 1362, and its stylistic unity accounts for the conflicting opinions regarding the contribution of each artist.[6] The conception of the figures in this altarpiece faithfully reflects, however, the spirit of the older painter, that is, Niccolò. A comparison, for example, between the *St John the Baptist* and the same figure in the panel in Hartford generally recognised as by Niccolò di Ser Sozzo[7] reveals the same dry and incisive use of line although with less emphasis on the sharp, almost caricatural deformation of the features. On the other hand the strong chiaroscuro brings to mind the *St John the Baptist* painted by Luca di Tommè in his polyptych of 1367[8] or another, better preserved panel also of the same saint sold at auction in London in 1972.[9] Compared with Niccolò's figures, the *St Thomas* in the 1362 polyptych is stiffer and more solemn and his pose less elaborate. Niccolò's typical dilated forms, accentuated drawing and whimsical characters are more clearly recognisable in the central panel and in the right wings. It seems to me that Luca's share was mostly concentrated in the left-hand panels of the altarpiece; as for the predella scenes, they are so close to other small-scale works attributed to Luca di Tommè (Fehm (1971, 1973)), that it seems reasonable to ascribe them to him. The high quality of these scenes and the mastery of composition and spatial organization, as well as the lively feeling for narrative and refined execution, find their counterpart, for instance, in the Amsterdam *Flagellation*,[10] which is generally accepted as by Luca even though its dating is controversial.

An idea of Luca's style on a small scale at a later date is provided by the series of four *Scenes from the life of St Paul* (Seattle, Siena and Esztergom), which may have formed part of the lost

Notes

2 According to an annotation on the photograph in the Biblioteca Berenson (Villa I Tatti, Florence), by January 1927 it was in the von Hirsch Collection.

3 The *Crucifixion*, which came from the Achillito Chiesa collection in Milan, was acquired by S. H. Kress in New York in 1927. It was on loan to the National Gallery of Washington between 1941 and 1951 and has been in the De Young Memorial Museum at San Francisco since 1953 (K.34; inv.no.61.44.3). The panel measures 41 × 59.7 cm; see Rusk Shapley (1966) p.59.

4 P. Torriti, *La Pinacoteca Nazionale di Siena. I dipinti dal XII al XV secolo* (Genoa, 1977) p.150.

5 For an earlier dating of the San Francisco *Crucifixion* cf. also S. Padovani in *Mostra di opere d'arte restaurate nelle province di Siena e Grosseto*, exhibition catalogue (Pinacoteca Nazionale, Siena, 1979) p.76.

6 For instance, De Benedictis (1979) p.53; Torriti (1977) p.150.

7 *St John the Baptist*, Hartford CT, Trinity College, no.1237; Zeri (1958) p.10, Rusk Shapley (1966) p.53. C. De Benedictis, 'Sull'attività giovanile di Niccolò Tegliacci', *Paragone* XXV, no.291 (1974) p.56.

8 Siena, Pinacoteca, no.109; Torriti (1977) pp.157–8.

9 Christie's, London, 30 March 1972, lot 78, representing *St John the Baptist* with busts of *Prophets* in the spandrels.

10 Amsterdam, Rijksmuseum, no.1489EI; see Fehm (1973) fig.26.

11 *Conversion of St Paul*, Seattle Art Museum, Seattle WA, no.It.37/Sp.4651; *Sermon of St Paul*, *St Paul led to his martyrdom*, Siena, Pinacoteca, nos.117, 118; *Beheading of St Paul*, Esztergom, Keresztény Muzeum, no.55.156. See M. Meiss, *Black Death*, pp.34–5, note 84; M. Boskovits, *Early Italian Panel Paintings* (Budapest, 1966) no.37; Torriti (1977) p.159. The hypothesis put forward by Fehm (1971, pp.18, 45–7) that the St Paul altarpiece is to be identified with the polyptych today in the Pinacoteca of Perugia (no.80; F. Santi, *Galleria Nazionale dell'Umbria. Dipinti . . .* (Rome, 1969) pp.100–1) fails to convince.

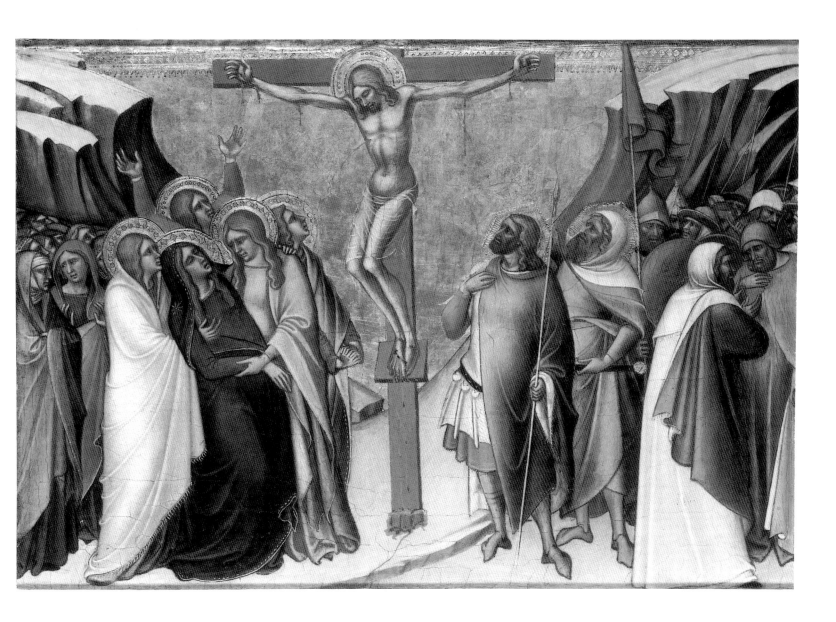

FIG 1 Luca di Tommè,
The Crucifixion (San Francisco,
Fine Arts Museum, gift of the
Samuel H. Kress Foundation)

12 For its discussion in the
literature, Torriti (1977) p.159.
13 *Timken Art Gallery. European
and American Works of Art in the
Putnam Foundation Gallery* (San
Diego CA, 1983) pp.58, 120.
14 F. Bisogni and M. Ciampolini,
Guida al Museo Civico di Siena
(Siena, 1985) p.120, no.372
(where it is attributed to Niccolò
di Ser Sozzo; Berenson, however,
correctly gave it to Luca in 1932).

altarpiece for the altar dedicated to the saint in Siena Cathedral, payment for which was made to Luca in 1374.[11] Here dynamic movement is articulated by elongated figures, whose angular, abrupt gestures combined with a sketchy execution have even suggested attributions to late Trecento Florentine painters such as Spinello or Lorenzo di Bicci.[12] The dense chiaroscuro modelling of the figures brings to mind the polyptych of Rieti (1370) and other similar works, but little remains of the skilled spatial and compositional organization or the careful execution of the 1362 predella.

To come back to the Thyssen *Adoration* and its companion piece in San Francisco, they are certainly closer to the predella of the Siena altarpiece (no.51) than to the *St Paul* scenes. Both are characterized by a greater sense of movement and a delicate technique reminiscent of works such as the triptych in the Timken Art Gallery (San Diego),[13] in which the scene of the *Adoration* presents significant analogies with our panel. A painting which comes even closer in style is the *Annunciation* in the Palazzo Pubblico of Siena,[14] so close indeed in the broad, clear outlines, in the ample, simplified draperies and in the build of the figures that one wonders whether they were not originally part of the same polyptych. Considering, too, that both the Thyssen and the De Young panels reveal a strong debt to Lorenzettian models, one may conclude that they date from relatively early in Luca's career, not far removed from the 1362 polyptych.

Master of the Dotto Chapel active c1290–1315

21 The Crucifixion
The Last Judgement (illustrated p.133)

(a) The Crucifixion
c1290
Tempera on panel, 17 × 18.2 cm; thickness 1.4 cm
Accession no.1977.3

Provenance
D'Atri collection, Paris
Art market, Paris, sold Hôtel Drouot, 18 May 1973, lot C
Stein collection, Paris, by 1976–7
Thyssen-Bornemisza Collection, 1977

(b) The Last Judgement
c1290, tempera on panel, 17 × 18.3 cm
Accession no.1977.13

Provenance
Amadeo collection, Rome, early 1930s
Carlo Foresti, Milan, by 1932
Bruno Canto, Milan, by 1950
I.D.P. Anstalt, Vaduz, 1976–7
Thyssen-Bornemisza Collection, 1977

Literature
Offner, *Corpus*, III/v (1947) pp.253, 254 note 10
R. Longhi, 'Giudizio sul Duecento', *Proporzioni* II (1948) pp.16–18, 45–6
J. Pope-Hennessy, 'The Literature of Art', *Burlington Magazine* XC (1948) p.360
Garrison, *Italian Romanesque Panel Painting* (1949) pp.30, 238, no.676
R. Salvini, 'Postilla a Cimabue', *Rivista d'Arte* XXVI (1950) p.54
C. Brandi, *Duccio* (Florence, 1951) pp.133–4
Galetti and Camesasca, *Enciclopedia* (1951) p.672
Toesca, *Trecento* (1951) p.702 note 229
W. E. Suida, *Handbook of the Samuel H. Kress Collection. Paintings of the Renaissance, Portland Art Museum* (Portland
 OR, 1952) p.10
W. E. Suida, *The Samuel H. Kress Collection in the Isaac Delgado Museum of Art* (New Orleans, 1953) p.6
R. Salvini, 'Cimabue', in *Enciclopedia Universale dell'Arte*, III (1958) p.472
Art Treasures for America, Venice, Rome and Florence, exhibition catalogue (National Gallery of Art, Washington DC,
 December 1961–February 1962) nos.48–9
E. Battisti, *Cimabue* (Milan, 1963) p.109
Pallucchini, *Trecento* (1964) p.74
V. Lazarev, 'Saggi sulla pittura veneziana dei secoli XIII–XIV. La maniera greca e il problema della scuola cretese, I',
 Arte Veneta XIX (1965) pp.19–20
F. Rusk Shapley, *Paintings from the Samuel H. Kress Collection. Italian Schools, XIII to XV Century* (London, 1966)
 pp.6–7
F. Zeri, 'Early Italian Pictures in the Kress Collection', *Burlington Magazine* CIX (1967) p.474
E. Lucchesi Palli, 'Kreuzigung Christi', in *Lexikon christlicher Ikonographie*, II (1970) 614–20
A. Boschetto, *La Collezione Roberto Longhi* (Florence, 1971) pl.1
A. Conti, 'Appunti pistoiesi', *Annali della Scuola Normale Superiore di Pisa* I (1971) p.123 note 1
F. Rusk Shapley, *Paintings from the Samuel H. Kress Collection. Italian Schools, XVI–XVIII Centuries. Addenda to vol.I*
 (London, 1973) p.381
Tableaux Anciens . . . Armes Anciennes, sale catalogue (Hotel Drouot, Paris, 18 May 1973) lot C
E. Sindona, *L'opera completa di Cimabue* (Milan, 1975) p.119 note 66
M. Boskovits, *Cimabue e i precursori di Giotto* (Florence, 1976) p.5
M. Boskovits, 'Cenni di Pepe (Pepo), detto Cimabue', in *Dizionario biografico degli Italiani*, XXIII (Rome, 1979)
 pp.540–1
J. G. Caldwell, *New Orleans Museum of Art. Handbook of the Collection* (New Orleans, 1980) p.25

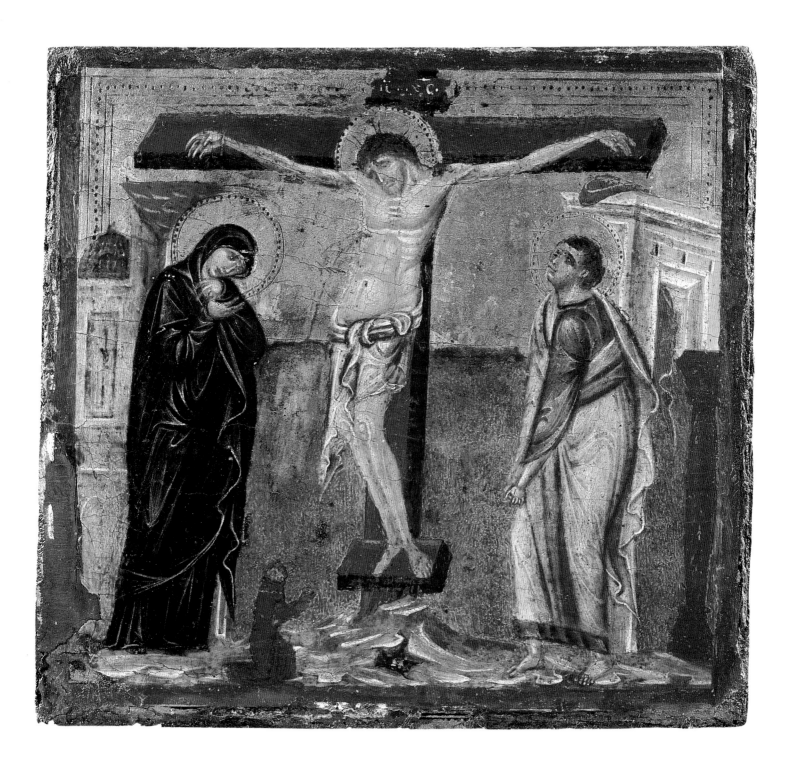

M. Scudieri Maggi in *La Fondazione Roberto Longhi a Firenze* (Milan, 1980) pp.238–9
Thyssen-Bornemisza (1981) pp.212–3, nos.208A, 208B
J. Pope-Hennessy, 'Some Italian Primitives', *Apollo* CVIII, no.3 (1983) p.12
Thyssen-Bornemisza (1986) pp.216–7, nos.208a, 208b
A. Tartuferi in *Le origini* (1985) pp.236, 240 note 42
A. Tartuferi, in *Duecento e Trecento* (1986) pp.278, 282 note 40
L. C. Marques, *La peinture du Duecento en Italie Centrale* (Paris, 1987) pp.167–8, 244 note 174
Thyssen-Bornemisza (1989) pp.234–5

In the first scene Christ's lifeless body hangs on the Cross. At his side are the mourning Mary and St John; in the left foreground is a diminutive kneeling Franciscan friar. The background has a marble gate on the right and buildings representing Jerusalem on the left.[1]

The second scene represents the Last Judgement with Christ standing inside a mandorla, raising his wounded right hand and revealing the wound in his side with his left. Two angels beside him carry the Instruments of the Passion. Below in the centre is a sarcophagus from which emerge the Blessed, called to life by the trumpet of the angel on the left. The other angel, to the right, is rolling up the canopy of heaven on which are the sun, moon and stars.[2]

Both panels are rather rubbed and have numerous small colour losses, but their condition is on the whole fair. In the *Crucifixion* there is a large loss on the lower left side which has been stuccoed and inpainted in grey. The painting was cleaned at some time before it was acquired for the Collection. Christ's body is particularly damaged, as is also the grey area behind the Cross probably representing the walls of Jerusalem, where the few surviving traces of original paint have been inpainted. When the panel was removed from its original frame and separated from the other components (see below), the paint along the edges was damaged. This is also true of the *Last Judgement*, which is otherwise better preserved; there are only a few flaking losses in the paint (to either side of Christ and in his halo) and in the gold ground. The surface is covered by a thin layer of dirt.

To judge from their size, these two small panels formed part of a portable altar, probably a diptych, which is proved to have been of Franciscan origin by the presence of the kneeling friar in the habit of this order. In the *Crucifixion* panel the fine canvas beneath the layer of paint does not extend to the edge of the panel on the right and lower sides, leaving uncovered a thin strip (0.1 and 0.3 cm respectively). This would suggest that it formed the lower right-hand section of a larger panel. The *Last Judgement*, on the other hand, has a strip of bare wood along the left edge (0.3 cm) which would make it the left, and probably lower, section of another panel.[3] Considering that the Last Judgement is usually the last or last but one scene represented on portable altarpieces of this period, one may suppose that there was only one more scene to the right.[4] Taking into account, therefore, the format, dimensions, subjects and technical characteristics of these two paintings, one may conclude that they formed part of a diptych, with two scenes on three tiers in each wing (FIG 1), an arrangement commonly found in Venice and in minor centres along the Adriatic coast.[5]

Of this complex, which was dispersed at an unknown date, three further panels survive: the *Nativity* (17.3 × 18 cm; FIG 1a) which would seem to have belonged to the upper right section of the left shutter, the *Last Supper* (17 × 18 cm; FIG 1b) and the *Capture of Christ* (17.8 × 15.9 cm; FIG 1c). The last named, together with the *Last Judgement*, was in the Amadeo collection in Rome around 1932. The *Nativity* and the *Last Judgement* belonged to Carlo Foresti in Milan, from whom Roberto Longhi acquired the former in 1935; it is now in the Fondazione Longhi in Florence (Scudieri Maggi (1980)). The other panel was bought by a Milanese collector, perhaps Bruno Canto who owned it around 1950 (Scudieri Maggi (1980)). The *Last Supper* and the *Capture of Christ* passed from the Amadeo collection to Alessandro Contini Bonacossi and were acquired by Samuel H. Kress (nos.K361 and 324), who lent them to the National Gallery of Washington. After being exhibited there from 1941 to 1952, the *Last Supper* went to the Isaac Delgado Museum of New Orleans, Louisiana (no.61.59), and the *Capture of Christ* to the Art

Notes

1 On the iconography of the Crucifixion see cat.[12] note 1 and cat.[24] note 1, and Lucchesi Palli (1970) cols.614–20.

2 On the iconography of the Last Judgement, see Offner, *Corpus*, III/v (1947) pp.251–9, and B. Brenk in *Lexikon christlicher Ikonographie*, IV (1972) cols.513–23. Usually Christ the Judge is shown seated on a throne but solutions similar to that of the panel discussed here occur, for example, in a mid-thirteenth-century portable altar (Rome, Museo di Palazzo Venezia) and in the shutters of a triptych (Rome, Schiff Giorgini collection); Garrison (1949) nos.285 and 324.

3 The panel has been trimmed all round; this explains why the lower strip of wood projecting beyond the canvas preparation is missing.

4 This occurs, for instance, in the Venetian diptych in Richmond (Virginia Museum of Art, no.55–11; *European Art in the Virginia Museum of Fine Arts. A Catalogue* (Richmond VA, 1966) p.10, no.3). In the lowest tier of the right wing is the *Last Judgement* with three *Saints* in the nearby section. Conti (1971) has already noted that the Thyssen panels probably followed a similar arrangement.

5 For rectangular diptychs with four scenes on each wing compare, apart from the Richmond diptych, that published by Garrison (1949, p.97, no.240; whereabouts unknown) which is also of Venetian origin and datable to the beginning of the fourteenth century. Series of panels arranged on three levels are also to be found in early fourteenth-century works from Romagna, such as the diptych wing by Giovanni da Rimini (Rome, Galleria Nazionale; C. Volpe, *La pittura riminese del '300* (Milan, 1965) fig.27), or the dismembered diptych by Giovanni Baronzio (Berlin, Rome and Venice; Boskovits, *Berlin. Katalog*, pp.15–8, figs.15–20). The size and proportions of these panels come very close to ours, suggesting that the two complexes may originally have looked very similar.

The Last Judgement [21b]

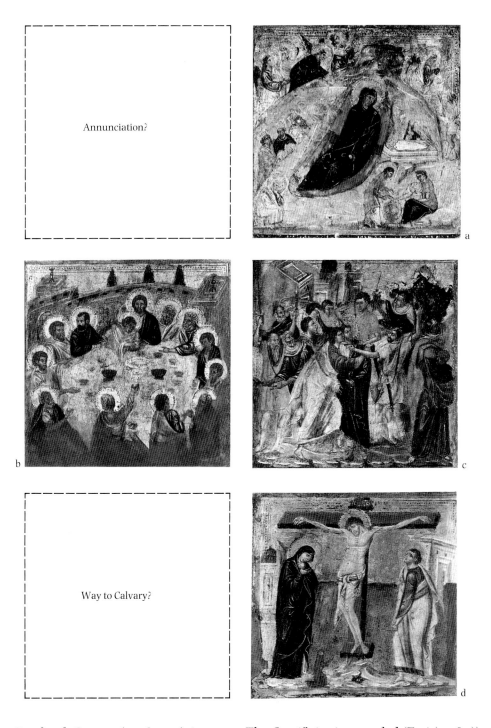

FIG 1 Master of the Dotto Chapel, left and right shutters of a diptych (hypothetical reconstruction):
a *The Nativity* (Florence, Fondazione Longhi)
b *The Last Supper* (New Orleans LA, Isaac Delgado Museum)
c *The Capture of Christ* (Portland OR, Art Museum)
d *The Crucifixion* (Thyssen Collection)
e *The Last Judgement* (Thyssen Collection)

Museum, Portland, Oregon (no.61.55), in 1952. The *Crucifixion* is recorded (Zeri (1967)) with the Paris dealer d'Atri – before it was offered for sale in Paris some time in 1973.

The first mention relating to this complex dates from 1941, when the two Kress paintings were briefly discussed in the catalogue of the National Gallery of Washington, with a tentative attribution to Cimabue.[6] The entry quoted the opinions, privately expressed, of Giuseppe Fiocco, Roberto Longhi, William Suida and Adolfo Venturi, all of whom accepted Cimabue's authorship; that of Frederick Mason Perkins, who attributed it to an anonymous Roman contemporary of Cimabue; and that of Bernard Berenson, who ascribed it to a 'Greek artist active somewhat later than Cimabue'. Neither of the panels now in the Thyssen-Bornemisza Collection is mentioned. The *Last Judgement* was first discussed by Richard Offner in an

Notes
6 *National Gallery of Art, Washington. Preliminary Catalogue* (Washington DC, 1941) pp.41–2.
7 Offner's long and sharply critical review entitled 'The Italians in our National Gallery' written for *Art News* around 1940/1 remained unpublished (galley-proofs in the *Corpus* archives). In particular he observed that the Kress *Last Supper* and *Capture of Christ* 'are parts of a series of four ...' adding that 'the two remaining – and

qualitatively superior – scenes . . .
represent the *Nativity* and the *Last
Judgement*. The exiguous scale, the
color, the archeological details,
the type of iconography, make
these panels indubitably Venetian
. . . It was doubtless the Venetian
character of these panels that led
Mr Berenson to attibute them to a
Greek artist.'
8 A. Brejon de Lavergnée and
D. Thiébaut, *Catalogue sommaire
illustré des peintures du Musée du
Louvre*. II. *Italie, Espagne,
Allemagne* . . . (Paris, 1981)
pp. 167–8, no. 254.

unpublished study,[7] summarised several years later in a note in the *Corpus of Florentine Painting*
(1947). Primarily interested in the iconography of the scene, this scholar noted that the
painting and its companions, although 'attributed to Cimabue . . . are by every stroke and every
feature typically Venetian'. The four known panels were then published by Roberto Longhi in
an article dated 1939, but which appeared only in 1948. Longhi pointed out the close
similarity between these scenes and the 'modi grandemente drammatici' of Cimabue in his
Assisi frescoes. He considered them to be fragments of a 'paliotto forse con un ampio ciclo delle
storie di Cristo', attributable to the Florentine master and executed around 1270. Similarities
with Cimabue's *Maestà* in the Louvre, which originally came from a church in Pisa,[8] suggested
to Longhi that the dispersed altarpiece might have been destined for the same town.

The attribution to Cimabue was regarded with some perplexity by Pope-Hennessy (1948) and rejected by Garrison (1949), who confirmed the connection with Venice. Garrison also attributed a small *Crucifixion* to the same artist (Princeton, Art Museum),[9] and placed the anonymous master's activity in the years 1315–35, giving him the name of the 'Speaking Christ Master'. Salvini (1950, 1958), while denying Cimabue's authorship of the series, still regarded them as Tuscan, by a 'vivace pittore pisano che muovendo dalla cerchia del Maestro di San Martino,[10] guarda a Cimabue'. Most scholars have since tended to accept the Venetian origin of the four panels, among them Brandi (1951), who described their style, however, as 'pre- o para-cimabuesco'; Toesca (1951), who relates the series to the *Madonna and Child and stories of St Agatha* in Cremona Cathedral;[11] Battisti (1963); Lazarev (1965); Rusk Shapley (1973); Caldwell (1980), according to whom the panels were 'part of a large altarpiece roughly contemporary with Duccio's *Maestà*'; Pope-Hennessy (1983), who dates them around 1300; Tartuferi (1985, 1986); Marques (1987); and the most recent catalogue of the Collection (Thyssen-Bornemisza (1989)). They were also held to be Venetian by Zeri, Bellosi and the present writer (see Scudieri Maggi (1980)). After considering the possiblity of Venice, Rusk Shapley had beforehand (1966) cautiously opted for 'Italian School, c1300', which was the opinion expressed by Suida (1952, 1953). The catalogue of *Art Treasures of America* (Washington, 1962) listed the panels as 'Italian, XIIIth Century', while Zeri (1967) regarded the attribution to Cimabue as 'utterly fantastic'. Zeri was the first to identify the *Crucifixion* now in the Thyssen Collection, formerly believed (in the Paris sale catalogue, 1973) to be by a Sienese master of the late fourteenth century, as part of a Christological sequence, and to relate to the series a *Madonna and Child* in the National Gallery of Ireland.[12] On the other hand, Cimabue's authorship has been accepted by Galetti and Camesasca (1951), Boschetto (1971) and, though with reservations, some time ago also by the present writer (1976, 1979). The attribution to the Florentine artist was also cautiously accepted by Scudieri Maggi (1980). According to Conti (1971), these panels exemplify the 'equivoci che il bizantinismo di certe figurazioni ha fatto commettere tra Venezia e l'Italia centrale'; he mentions in this context a diptych (Richmond, Virginia Museum of Fine Arts) which is usually considered a Venetian work[13] but which, in his opinion, could be by a Central Italian or Umbrian artist.

Although there is now general agreement with Offner's view that the artist was Venetian, it must be admitted that the attribution to Cimabue did have some justification. The feverish action, the violent, and at times disjointed gestures of the figures, the deliberately asymmetrical compositions (particularly in the Florence, New Orleans and Portland scenes), as also the stern composure of the features, echoing classical prototypes (in the New Orleans panel and the Thyssen *Last Judgement*), are elements rarely found in Venetian painters following the Byzantine tradition. Our scenes reflect the highly personal and vivid fantasy of a painter who was probably familiar with the artistic trends and events of Central Italy in the last decades of the Duecento and had drawn inspiration from them to make his own message more intense and penetrating. However, the type of composition[14] and the particular way in which the forms are animated, with almost impressionistic splashes of light and well defined compact areas of shade, follow Venetian patterns and recall in particular (as the angular faces roughly blocked in also do) the destroyed frescoes of the Dotto Chapel of the Eremitani church in Padua (see FIGS 2 and 3 and details) and the small group of panels associated with them. Not only the Thyssen and companion panels but also the Cagnola *Crucifixion*[15] and the ex-Bellesi *Crucifixion*[16] are characterized by a free and nervous execution and an arbitrary (perhaps deliberate) disregard of perspective rules. These features and the fact that they also borrow Palaeologan neo-Hellenistic motifs and formulae, and even some archaic iconography,[17] would point to a date around 1290, more or less contemporary with the miniature of 1291 in the Breviary of Spalato (Venice, Museo Correr).[18] The Thyssen panels would therefore belong to the earliest period of the œuvre of the anonymous master tentatively reconstructed under the name of the 'Master of the Dotto Chapel'.[19]

FIG 2 Master of the Dotto Chapel, *The Redeemer* (detail of the destroyed decoration of the Dotto Chapel, Padua, Eremitani church)

FIG 3 Master of the Dotto Chapel, *Angel* (detail of the destroyed decoration of the Dotto Chapel, Padua, Eremitani church)

Notes

9 No.36–18; Garrison (1949) p.102, no.263. The painting is extraneous, in my opinion, to the group of works here discussed and belongs instead to those gathered by Garrison under the name of 'St Pantaleon Cross Master' (p.28).

10 On this artist cf. Longhi (1948) pp.15, 34–5, and A. Caleca in *Duecento e Trecento* (1986) p.626.

11 Longhi (1946) p.21 and Garrison (1949) p.72, no.57.

12 No.868; *National Gallery of Ireland. Illustrated Summary Catalogue of Paintings* (Dublin, 1981) p.80, where it is classified as 'Italian, 14th-century'. Judging only from the photograph, I would regard this rather ruined painting as Central Italian, possibly Tuscan.

13 See above, note 4.

14 The compositional schemes of the New Orleans *Last Supper*, the Portland *Capture of Christ* and the Thyssen *Crucifixion* correspond to formulae frequently found in Venetian painting; cf. Sandberg Vavalà (1929) pp.200f., 231f. and 44f.

15 See R. P. Ciardi, *La raccolta Cagnola* (Milan, 1965) p.25 note 1.

16 See Garrison (1949) p.101, no.257.

17 One may note in particular the motif of the four, rather than the usual three, nails with which Christ is crucified, a disposition rarely found in the representation of this theme after 1300; cf. Sandberg Vavalà (1929) p.113f.

18 See Pallucchini (1964) p.11, figs.12, 14.

19 See further also Artists' Biographies, p.219.

1

Detail [21b] the Redeemer

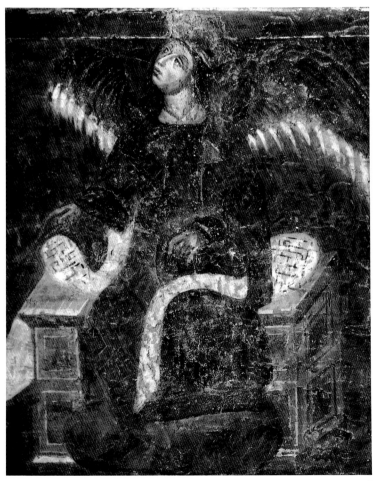

2

Detail [21a] Christ and St John

Master of Forlì active c 1300

22 The Deposition

c 1300–5
Tempera on panel, 19.7 × 13.3 cm; painted surface 18.7 × 12.3 cm; thickness 0.4 cm (thinned)
Accession no.1930.71

Provenance
Private collection, Rome, by 1925
Julius Böhler, Munich, 1927
Maitland F. Griggs, New York, 1929
Thyssen-Bornemisza Collection, by 1930

Exhibition
Munich, 1930, p.20

Literature
E. Sandberg Vavalà, 'Italo-Byzantine Panels at Bologna', *Art in America* XVII (1929) pp.74–7
Sandberg Vavalà, *Croce dipinta* (1929) p.450
Munich (1930) p.20, no.68
W. Suida, 'Die italienischen Bilder der Sammlung Schloss Rohoncz', *Belvedere* XVI (1930) p.175
Rohoncz (1937) p.29, no.80
S. Bettini, *Mosaici antichi di San Marco a Venezia* (Bergamo, 1944) p.28
Garrison, *Italian Romanesque Panel Painting* (1949) p.238
Rohoncz (1949) p.20, no.48
E. B. Garrison, 'Il maestro di Forlì', *Rivista d'Arte* XXVI (1950) pp.61, 65–71, 73–4, 80–1
Toesca, *Trecento* (1951) p.218 note 24
L. Cuppini, 'Aggiunte al Maestro di Forlì e al Maestro di Faenza', *Rivista d'Arte* XXVII (1951–2) p.18
Rohoncz (1952) p.21, no.48
Rohoncz (1958) p.21
Rohoncz (1964) p.21, no.80
V. N. Lazarev, *Iskusstvo Trecento* (Moscow, 1959) p.304 note 356
Thyssen-Bornemisza (1970) p.27, no.58
Thyssen-Bornemisza (1971) pp.75–6, no.58
Thyssen-Bornemisza (1977) p.30, no.58
Thyssen-Bornemisza (1981) p.66, no.58
A. Tambini, *Pittura dall'alto medioevo al tardogotico nel territorio di Faenza e Forlì* (Faenza, 1982) p.49
Thyssen-Bornemisza (1986) p.200, no.194a
J. Pope-Hennessy, *Italian Paintings in the Robert Lehman Collection* (New York, 1987) p.82
Thyssen-Bornemisza (1989) p.221

Christ's body is lifted down from the Cross by the elderly Joseph of Arimathea with St John helping to support the Saviour's left arm. Nicodemus, kneeling, draws out the nail in Christ's feet with a pair of pliers. Left, standing on a small step-ladder, the Virgin embraces her dead Son, while on the two lower steps Mary the wife of Cleophas and Mary Salome kiss his arm and hand. Just visible behind the group of women is the figure of Mary Magdalen. Above the Cross are two mourning angels.[1]

The painting was probably cleaned relatively recently and does not seem to have suffered from older restorations. Its condition is fair, although there are colour losses and abrasions, particularly in the upper part (the left flying angel is virtually lost) and on the left side, where one can barely distinguish the figure of the Magdalen with raised arms. The left part of the Holy Woman in the foreground is also damaged. There are other losses beneath the steps and in the upper left area of the gold ground. The entire surface has suffered from local flaking. Beneath the gold background, instead of red bole, a *terra verde* preparation appears at places (see also cat.[24] below). Along the top and right-hand edges are nail-holes showing where the original

Note
1 The scene follows the Gospel texts of Matthew 27:59–60 and Mark 15:45–7, which record the presence of Joseph of Arimathea, Mary Magdalen and two other Maries, but not Mary the Mother of Jesus, who, however, is always present in representations of this scene. The presence of Nicodemus, generally portrayed as a young man, is recorded in John 19:39. For the iconography see Schiller, *Ikonographie*, II, pp.177–81.

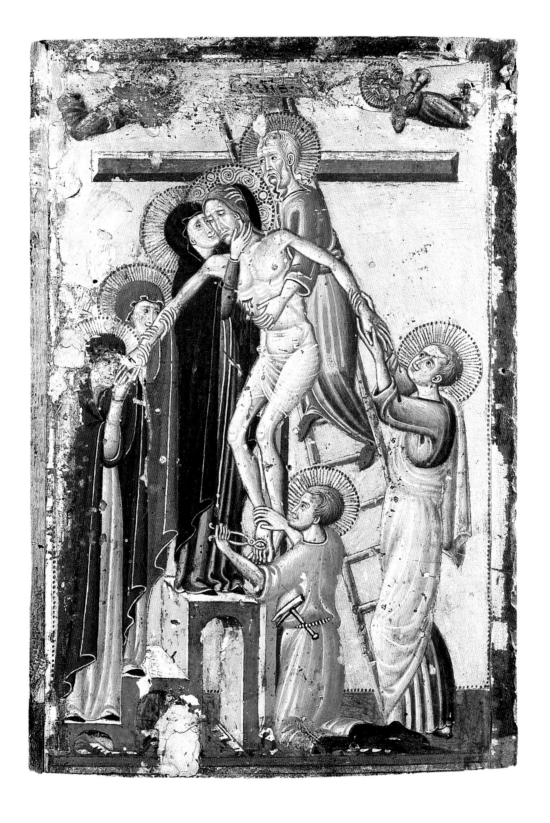

FIG 1 Master of Forlì, tabernacle front (reconstructed)

 a *The Flagellation*
 (New York, Metropolitan Museum, Lehman collection)
 b *The Stripping of Christ*
 (formerly New York, F.M.Griggs; present whereabouts unknown)
 c *Dormitio Virginis*
 (Forlì, Pinacoteca Comunale)
 d *The Deposition*
 (Thyssen Collection)
 e *The Entombment*
 (New York, Metropolitan Museum, Lehman collection)

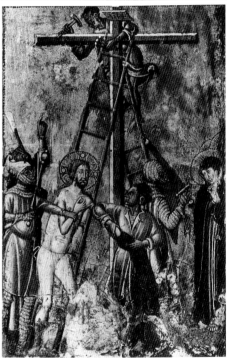

frame was attached. The panel has been trimmed on all sides and its original thickness appears reduced. A small strip of wood, about 0.4 cm wide, has been added along the left edge in modern times. The painting has been given a modern frame, on the back of which in blue pencil is the number '3035' and a label inscribed in pencil 'N.E.a.F.2395'.

The shape of the panel and the fact that there are marks of the original frame along the upper and right edges indicate that the Thyssen *Deposition* occupied the upper part of the right shutter of a triptych or tabernacle. The scene underneath on the same shutter, representing the *Entombment*, was identified by Garrison (1950) as a panel in the Metropolitan Museum, New York (no.1975.1.80, Lehman collection; 20.3 × 13.1 cm; FIGS 1e and 3). The same scholar also identified two further scenes of the left shutter (*Flagellation*, New York, Metropolitan Museum,

Note
2 The motif of Mary and the Holy Women outside the room where the Flagellation is taking place is an iconographic rarity. The only other example known to me is a panel in the Museum of La Valletta, Malta, attributed to the Marchigian Master of Campodonico or to an artist close to Giusto de' Menabuoi (cf. G.Donnini, 'Nuove osservazioni sul Maestro di Campodonico', *Commentari* XXII (1971) pp.326–34), but which is more likely to be by an Emilian painter in the circle of Barnaba da Modena.

Lehman collection, no.1975.1.79; 19.9 × 13.2 cm; FIG 1a; *Stripping of Christ*, formerly in the collection of F.M.Griggs, New York; 19.7 × 13.3 cm; FIG 1b), proposing that the missing central panel represented the Crucifixion. This opinion is also held by Pope-Hennessy (1987). The Crucifixion would provide the logical narrative link between the two shutters but, of course, the central panel could have represented some other subject. Considering that the Virgin is represented in all four scenes – even in the *Flagellation*[2] – it is conceivable that, in contrast to these dramatic and tragic episodes, the central image glorified both Christ and Mary. A possibility would be a Coronation or Assumption of the Virgin and a panel of the latter subject, combined with the *Dormitio*, by the same artist does exist in the Pinacoteca of Forlì (FIG

1c). The measurements of this painting are very close (38×27 cm) to those one would expect for the central panel of the triptych (calculated by Garrison as 40×27 cm);[3] there can be no doubt that they are by the same hand, even if a connection between the *Dormitio* panel and the four other scenes is generally rejected by critics.[4] Indeed, I find it difficult to follow Garrison's argument that they differ in style, or his affirmation that there are no examples in Trecento Emilian painting of the Dormitio Virginis flanked by Christological scenes.[5] It is tempting to hypothesize, considering how thin the panels are of the four Christological scenes, that they originally formed the inner scenes of shutters, painted on both sides, which have been divided into two. The corresponding outer scenes of the shutters may be identified with the *Crucifixion* and *Four saints* (disposed on two levels) also in the Pinacoteca of Forlì, and also painted on extremely thin panels (FIG 2),[6] which correspond approximately in size ($c\,37 \times 11$ cm) to two of the other scenes placed one above the other. This reconstruction would be confirmed by the presence of a dark background (instead of gold) behind the figures in the Forlì shutters, which is usual for the outer side of tabernacle shutters.[7]

Nothing is known of the original provenance of the Forlì paintings. The *Crucifixion* and *Saints*, which entered the Pinacoteca in 1938, came from the Piancastelli collection at Fusignano, near Forlì, while the *Dormitio Virginis* has been in the Gallery since at least 1874.[8] The Thyssen panel and its companion formerly in the Griggs collection belonged to a private Roman collector around 1925,[9] and the two parts in New York were also in a Roman collection in 1946 before being acquired by Robert Lehman.[10]

Once on the art market, the two panels with the *Stripping of Christ* and the *Deposition* were connected with the name of Pietro Cavallini. The origin of this attribution is not known, but already in 1927 Toesca rejected it, proposing instead that they were of the thirteenth-century Umbrian school.[11] This opinion was also accepted by Suida (1930), but in the Munich exhibition catalogue (1930), though Toesca's opinion was quoted, it was preferred to keep the tentative attribution to Cavallini. Meanwhile Offner had recognised the two panels then belonging to Griggs as by the same hand as a *Crucifixion* in the Walker Art Gallery, Liverpool,[12] proposing that the artist was North Italian, probably Bolognese, of the end of the thirteenth century. Offner's proposal was published by Sandberg Vavalà (1929), who contributed some iconographic points in support of it. While the catalogues of the Thyssen-Bornemisza Collection continued to list the painting as attributed to Cavallini (Rohoncz (1937, 1949, 1952, 1958, 1964); Thyssen-Bornemisza (1970, 1971, 1977, 1981)), explorations were being made in other directions. Bettini (1944) believed that the three panels assembled by Offner were of Venetian origin, and that their author belonged 'to the team of masters who supplied cartoons for the mosaics of the Baptistery [of San Marco]'. More recently, in connection with the two panels in the Lehman collection, Szabo was also inclined to accept the artist's Venetian origin.[13] However, Garrison (1949, 1950), who identified further works by the same hand, called the artist the 'Master of Forlì', thereby establishing his origins in the Emilia-Romagna region. He suggested a date for the panels under discussion in the first quarter of the fourteenth century. Toesca (1951) seems independently to have reached a similar conclusion, connecting the *Stripping of Christ* and the *Deposition* with the Forlì *Dormitio*, which was traditionally held to be by a local artist of the early fourteenth century. Garrison's attribution and dating of the Thyssen panel were also accepted by Cuppini (1951–2), Tambini (1982), the more recent catalogues of the Collection (Thyssen-Bornemisza (1986, 1989)) and Pope-Hennessy (1987), who proposed a more specific date towards the 'end of the first quarter of the fourteenth century'.

One may conclude that our panel belongs to the Master of Forlì, an artist formed under both Emilian and Venetian influences.[14] Its date of execution may have been somewhat earlier than that proposed in more recent studies. For one thing, it should be noted that its style shows no reflection of Riminese-Romagnole painting of the first quarter of the fourteenth century, except, perhaps, for some distant analogies with the manner of Giuliano da Rimini's altarpiece of 1307

Notes

3 Usually the Virgin's death is divided into two episodes, Christ receiving the soul of His mother in the form of a child, and the Assumption with Mary, alone or accompanied by her Son, carried to heaven by angels. For the iconography see M. Meiss, 'Reflections of Assisi . . .', in *Scritti di storia dell'arte in onore di Mario Salmi* (Rome, 1962) pp.76–88. For the paintings at Forlì see also G. Viroli, *La Pinacoteca Civica di Forlì* (Forlì, 1980) p.13. The existing frame must have had an outer framing which might have brought the overall dimensions of the painting to approximately 40×29 cm. The thickness of the panel (which has not been reduced) is 1.2 to 1.3 cm.
4 Garrison (1950, p.70) considered the Dormitio 'inadatta come tema centrale fra le scene della Passione', an opinion shared by other scholars. Only Toesca (1951, p.718) believed that the Thyssen and companion panels could have belonged to the same complex as the Forlì *Dormitio*.
5 A well known example is the *paliotto* by the pseudo-Jacopino in the Pinacoteca Nazionale of Bologna (no.217); *La Pinacoteca Nazionale in Bologna. Catalogo delle opere esposte* (Bologna, 1987) p.8f.
6 The two panels have been encased in a box-frame leaving visible only the painted surface and making it impossible to examine or to measure the panel. The measurements given in the text are therefore approximate. An opening in the back of the case shows that the two lateral panels have been thinned down.
7 Frequently the backs of altarpieces or the outsides of tabernacle shutters are less rich and bright in colour, and have a dark background instead of a gold. This is the case, for instance, in the tabernacle of the Blessed Andrea Gallerani, attributed to Guido da Siena, in the Pinacoteca of Siena; P. Torriti, *La Pinacoteca Nazionale di Siena. I dipinti dal XIII al XV secolo* (Genoa, 1980) p.35f. Other examples include the triptych now in the Frick Museum, Pittsburgh, by an Umbrian artist of $c\,1260/70$ (Garrison (1949) p.124, no.327); and the two tabernacle wings at Wildenstein's in 1962 attributed to Taddeo Gaddi (*Religious Themes in Painting from the 14th century onwards*, exhibition catalogue (Wildenstein's, London, 1962) no.2).

Notes

8 See Viroli (1980) pp.11–3. Carlo Piancastelli (1867–1938) began collecting around 1885. A handwritten list of his collection made in 1915 does not include the paintings and they may therefore have been acquired later; see A.Mambelli, *Un umanista della Romagna: Carlo Piancastelli. Memorie raccolte e illustrate* ... (Faenza, 1938) pp.164–71; for the 1915 list, pp.78–83.

9 This may be deduced from a letter of 13 October 1927 (Thyssen archives) addressed by Pietro Toesca to the then owner, Julius Böhler in Munich. Toesca states that he saw the 'tableautins ... chez un collectionneur romain il y a deux ans'.

10 The date of the acquisition is unknown. Garrison (1949, p.242) states that he saw the two panels on the Roman art market in 1946. They passed from the collection of Robert Lehman to the Metropolitan Museum in 1969.

11 In the letter of 1927 quoted in note 9.

12 No.3042; see *Walker Art Gallery, Liverpool. Foreign Catalogue* (Liverpool, 1977) p.118.

13 G.Szabo, *The Robert Lehman Collection. A Guide* (New York, 1975) p.21.

14 Only Viroli (1980, p.13) has recently expressed doubts regarding Garrison's proposed reconstruction of the Master of Forlì.

FIG 2 Master of Forlì, tabernacle back (reconstructed)

a *Four saints*
(Forlì, Pinacoteca Comunale)

b *The Crucifixion*
(Forlì, Pinacoteca Comunale)

in Boston.[15] Furthermore, the iconography of the series discussed here faithfully adheres to the Duecento tradition.[16] Although perhaps slightly clumsy at times, this series of paintings reveals an artist skilled in composing his scenes, orderly in his narrative and meticulous in technique. Even if one were to advance the unlikely conjecture that their author never left Forlì, he could not have failed to be aware of the achievements of artists such as Giovanni or Pietro da Rimini, who were certainly known in Faenza (and probably also in Forlì) by the first decade of the fourteenth century. Our painter seems to have been drawn towards iconographic patterns and traditional compositions of the later thirteenth century, but also reveals some influence of Giotto, who, as is known, was active at Rimini in the very first years of the fourteenth century.[17] Giotto's example may have suggested solutions such as the perspective of the step-ladder on which stand the three Maries, or the foreshortened figure of the kneeling saint (Nicodemus?) in the *Entombment* (FIG 3), seen from behind as he leans forward to support Christ's body.[18] But these innovations are inserted into a figurative world where effects of space are principally used for their ornamental values and in which line is still the dominant means of expression. Considering the notable artistic quality of the Forlì Master, these archaic features would be difficult to explain after the first decade of the fourteenth century.

Notes

15 See P. Hendy, *European and American Paintings in the Isabella Stewart Gardner Museum* (Boston, 1974) p. 110f.

16 The representation of Christ's Cross in a sort of reversed perspective is often found in paintings of the thirteenth century, from the Master of San Francesco (in the fresco in the nave of the Lower Church of San Francesco, Assisi) to Salerno di Coppo (in the lateral scenes of the painted Crucifix in Pistoia Cathedral) and the great miniaturist of the Bible of Clement VII (Paris, Bibliothèque Nationale, MS lat. 18, f. 342). Garrison (1950, p. 72f.) observed other motifs in the series derived from the Duecento tradition, for instance, Christ tied with his face to the column in the *Flagellation*, or the rare episode of the *Stripping* and Mary fainting in the *Entombment*.

17 This dating for the artist's stay in Rimini, put forward by D. Gioseffi ('Lo svolgimento del linguaggio giottesco da Assisi a Padova', *Arte Veneta* XV (1961) pp. 11–24) is now generally accepted; cf. R. Salvini, 'Giotto a Rimini', *Giotto e il suo tempo. Atti del Congresso . . . 1967* (Rome, 1971) p. 70f. and L. Bellosi, *Giotto* (Florence, 1981) p. 26.

18 A version of this motif is already present in the Franciscan cycle in the Upper Church of San Francesco, Assisi (for instance in the scene of the *Death of St Francis*), and quite possibly Giotto also included it in his lost frescoes formerly in the church of San Francesco at Rimini.

FIG 3 Master of Forlì,
The Entombment (New York,
Metropolitan Museum, Lehman
collection)

Master of the Magdalen
active 2nd half of the 13th century

23 The Madonna and Child enthroned
with St Dominic, St Martin and two angels

c1290
Tempera on a gabled panel, 177 cm (sides 151 cm) × 86.5 cm including the original frame; painted surface
164 × 75 cm; thickness (comprising engaged frame) 6.3 cm
Accession no.1961.1

Provenance
Art market, Rome, by 1920
Trotti, Paris
Sangiorgi, Rome
M.Knoedler & Co., New York, by 1952
Thyssen-Bornemisza Collection, 1961

Literature
E.Sandberg Vavalà, *L'iconografia della Madonna col Bambino nella pittura italiana del Dugento* (Siena, 1934) p.36
G.Coor Achenbach, 'A Neglected Work by the Magdalen Master', *Burlington Magazine* LXXXIX (1947) pp.119-29
Garrison, *Italian Romanesque Panel Painting* (1949) p.49, no.177
E.B.Garrison, 'Addenda ad Indicem–III', *Bollettino d'Arte* XLI (1956) pp.309, 312 note 25
Rohoncz (1964) p.52, no.264a
J.H.Stubblebine, *Guido da Siena* (Princeton, 1964) p.85
Thyssen-Bornemisza (1970) p.25, no.201
Thyssen-Bornemisza (1971) p.259, no.201
Thyssen-Bornemisza (1977) p.82, no.201
Thyssen-Bornemisza (1981) p.206, no.201
Thyssen-Bornemisza (1986) p.210, no.201
A.Guerrini in *Duecento e Trecento* (1986) p.607
Boskovits, *Berlin. Katalog* (1987) p.117
L.C.Marques, *La peinture du Duecento en Italie Centrale* (Paris, 1987) p.287
Thyssen-Bornemisza (1989) p.229

Notes
1 For prayers recited with open hands turned upwards, see G.B.Ladner, 'The Gestures of Prayer in Papal Iconography of the XIIIth and early XIVth Century', *Didascaliae. Studia in Honor of Anselm M. Albareda* (New York, 1961) pp.245-75.
2 This is of course the type of the Byzantine Hodegetria (so called after a celebrated image in the church of the monastery of Hodegon at Constantinople), which implies Mary's mediation with her son on behalf of mankind; Shorr, *Devotional Images* (1954) introduction, and H.Hallensleben in *Lexikon christlicher Ikonographie*, cols.168-70.
3 The scroll held by the infant Jesus identifies Christ as the Word and alludes to the Gospel as the means of Revelation; *Lexikon christlicher Ikonographie*, I, cols.337-8, and Hallensleben, cited above.
4 Working from a photograph, Coor Achenbach (1947) read the inscription under the bishop as S.MAXMI', and identified him as St Maximinus of Aix. This has not been questioned in the recent literature except by Garrison (1949), who describes the figure as an 'unidentified saint'.

The Virgin is seated on a high-backed throne terminating in a rounded top and covered by a flower-patterned textile. Emerging from behind the throne are two half-length figures of angels turning towards the Virgin in an attitude of worship.[1] With her left arm she encircles the infant Christ while her right hand is raised towards him in a gesture of intercession.[2] The Child looks up at his mother and blesses her; in his left hand is a scroll.[3] At the foot of the throne to either side are two small figures of saints: the one on the left, wearing the white tunic and black cape of the Dominican order, holds a book; that on the right, dressed in bishop's robes and holding a crook, raises his hand in blessing. Their identity is specified in the inscriptions below, 'S[anctus] Domeni[cus]' and 'S[anctus] Martinu[s]'.[4] Another inscription running along the step of the throne reads 'Ave [Mari]a [Gratia plena] Dominu[s tecum]'.

The frame preserves its original ornamental decoration of gilded stucco flowers. On the back of the panel, which has not been thinned down, is a label inscribed in pen 'Atelier' and the stamped number 'A5117'. There is another label with the number '1129' in red ink and a label referring to its present ownership.

The painting is executed on canvas laid down on wood. Some vertical cracks in the support have emerged on the surface, one above to the left, from the point of the gable down to the Virgin's right shoulder, others running from the lower edge to the hem of her robe; only one of these has caused some colour losses (now filled in) in the Virgin's robe at the centre in the area between her shoes. Old photographs[5] show the painting in an uncleaned state and apparently with a few small retouches, for instance in St Dominic's face. It is not known when the painting was cleaned prior to entering the Thyssen Collection. In its present state the surface looks slightly worn (especially in the faces of the angels and of both saints), and is covered by a deep craquelure which has caused some flaking in the gold ground. There are numerous minute paint losses, scattered throughout, that have been inpainted. On the whole, however, for a painting of this age, the state of conservation is good (see details, opposite page and p.151).

The dossal was almost certainly painted for a Dominican church in Tuscany.[6] Around 1920 it was on the Roman art market,[7] possibly at the Galleria Sangiorgi.[8] It then appeared in Paris and again in Rome[9] before passing into the hands of Knoedler's of New York, from whom it was acquired for the Thyssen-Bornemisza Collection on 3 January 1961.[10]

The painting was first published by Sandberg Vavalà (1934) under the name of the Master of the Magdalen, a proposal that has since been universally accepted. Coor Achenbach (1947), in a detailed analysis of the artist's production, connected it with the *Madonna enthroned* in the Acton collection and with the *Magdalen* in the Accademia, Florence. In her opinion, all these panels should be dated around 1270: 'since Coppo's influence is absent in all the later works of the Magdalen Master, the *Magdalen* (in Florence) may be considered as the initial work of a new phase of the artist, and our painting as a transitional work from his Coppesque phase to the new'. Her dating was accepted by Garrison (1949, 1956) and Stubblebine (1964), who placed the painting's execution around 1270/5, an opinion shared by the authors of the various editions of the Thyssen catalogues (Thyssen-Bornemisza (1970, 1971, 1977 and 1981)). Coor's chronological reconstruction was also accepted by Guerrini (1986), who defined the Thyssen *Madonna* 'forse la più vicina ai modi cimabueschi' in the master's œuvre, and by Boskovits (1987), who again underlined the painting's analogies with the Acton *Madonna* and with that in the Berlin Gemäldegalerie (no.1663), for which he agreed on a date in the 1270s. Marques (1987) suggested a slightly earlier dating, 1265/70, at the beginning of the artist's activity, while confirming the relationship with the Acton *Madonna* and the *Magdalen* in Florence.

Granted that the Thyssen painting belongs to the group of works generally given to the Magdalen Master, it remains to define its place in the artist's chronology. Two works that have so far not been given due consideration may throw some light on the problem: these are two fragments of a dossal in the Accademia Gallery, Florence (nos. Dep.121, 122; FIG 1), and the dossal in the Timken Art Gallery, San Diego (no.1).[11] The two Accademia fragments come from the Florentine church of San Michele a San Salvi, but there are good reasons to suppose that they were originally destined for the church of San Giovanni Evangelista, which was demolished in 1529 together with the adjacent convent of Vallombrosan nuns, who had to move to San Salvi.[12] The church of San Giovanni Evangelista, founded in 1283, was presumably in use several years before its consecration in 1297.[13] A date around 1290/5 for these fragments would seem to be plausible and would confirm the dating suggested by several scholars for the dossal in San Diego[14] which, in the parts executed by our Master, is closely related to the Accademia fragments. Since a number of features common to both these works are also present in the Thyssen panel,[15] the execution of this painting should also be close to the early 1290s. Certain archaic features that had suggested to critics a considerably earlier dating are to be explained, in my opinion, by the artist's attachment to the conventions of his cultural background; although not insensitive to innovations, he remained essentially faithful to formal solutions current in the third quarter of the century, tending to eliminate effects of plasticity and spatial depth, as may be seen in the treatment of the throne and of the highly stylized

Notes

5 Sandberg Vavalà (1934) and Coor Achenbach (1947, p.119) both seem to have published the same photograph, probably taken around 1920.

6 The cult of St Dominic failed to become popular during the thirteenth century; L. Ferretti, *San Domenico. Biografia e iconografia* (Florence, 1921), and G. Kaftal, *Saint Dominic in Early Tuscan Painting* (Oxford, 1948), and it is unlikely that his image would have been venerated other than in a church of the Dominican order.

7 A handwritten note on the photograph published and discussed by Coor Achenbach (1947) simply states: 'For sale, Italy 1920 ca.', while Sandberg Vavalà (1934) refers to the painting as 'già in commercio a Roma'.

8 The 'Sangiorgi Collection' is given as the provenance in a letter of 3 January 1961 from the Knoedler Gallery to Baron Hans Heinrich Thyssen-Bornemisza (Thyssen archives; this may refer, however, to the return of the panel to Rome).

9 Garrison (1956) summarised the information in his possession as follows: 'si sa . . . che la tavola è andata da un antiquario di Parigi ad altro di Roma, il quale la vendette ad uno di New York'; the last was probably Knoedler.

10 This is the date of the letter mentioned in note 8.

11 For the two Accademia fragments representing *St John the Evangelist and St James* and *Scenes from the life of St John the Evangelist*, see Marcucci, *Firenze. Dipinti toscani secolo XIII* (1958), p.54f.; for the panel in the Timken Gallery see R. Offner, *An Early Florentine Dossal* (Pescia n.d.[c1948]) and G. Previtali, *Giotto e la sua bottega* (Milan, 1967) p.30, who proposes a date around 1290. The execution of the scenes of the Magdalen Master was probably assisted by the Master of San Gaggio (see below note 14).

12 It would indeed be unusual for an altarpiece destined for a church dedicated to St Michael and for a locality named after St Salvius not to have had an image of either of these saints. According to contemporary sources, the nuns took with them from their old church several venerated images; see Boskovits (1987) p.86, who lists the previous bibliography.

13 For the dates of the blessing of the foundation-stone, which took

place in March 1283 (1282 Florentine reckoning), and of the church's consecration, see G. Richa, *Notizie istoriche delle chiese florentine*, I (Florence, 1754) pp. 358–60. Since the nuns had settled nearby while the church was being built, they probably made use of the high altar as soon as it was ready for their religious services, furnishing it with a devotional image.

14 Only the central figures of the *Madonna and Child* in this dossal were executed by the Magdalen Master, while the *Episodes from the life of Christ* were painted by the so called Master of San Gaggio; see Previtali (1967) p. 30, M. Boskovits, *Cimabue e i precursori di Giotto* (Florence, 1976) no. 70, A. Guerrini in *Duecento e Trecento* (1986) p. 625.

15 The way the scenes are set and framed by a series of white dots on a silver ground occurs in both the San Diego dossal and in the Accademia fragments. There are also similarities, for instance, between the pose and drapery of St John in the lower left scene and those of the adoring angel on the left in the dossal. The five-petalled rosettes on the frame are also a feature of the Thyssen panel, in which the material covering the throne is very similar to St James's cloak in one of the Florentine fragments.

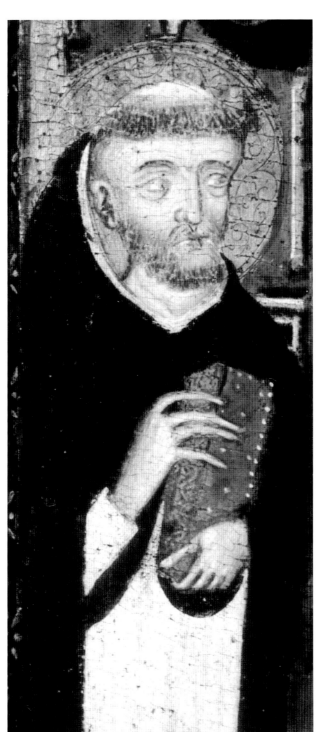

Detail [23] St Dominic

Detail [23] St Martin

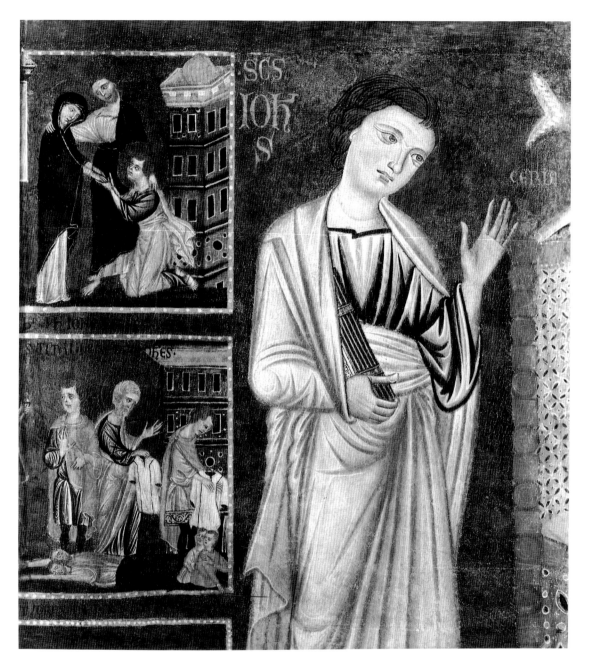

FIG 1 Master of the Magdalen,
*St John the Evangelist and scenes
from his life* (fragment of a dossal,
Florence, Accademia)

Notes

16 The dating of these two major
masterpieces of late Florentine
Duecento painting is still open to
discussion. The most convincing
thesis seems to be that of Bellosi,
La pecora di Giotto (Turin, 1985)
p.162f., who dates the Louvre
painting (no.1260) slightly before
1285 and the Uffizi *Maestà*
(no.8343) around or after 1300,
although, in my opinion, the
latter was executed within the
last decade of the thirteenth
century.

17 For instance, panels with
pointed gables appear relatively
late in the typology of Florentine
paliotti representing the Virgin
and Child enthroned, and haloes
with engraved floral scrolls may
be related to decorative motifs
adopted during the last quarter of
the century. The gothicizing type
of throne with trilobed arches
supported on slender columns
would also imply a similar date.

draperies. There are, however, indications that the artist was inspired by more advanced trends, contained in works such as Cimabue's celebrated versions of the *Madonna and Child enthroned* (Louvre and Uffizi).[16] Parallels with the great Florentine master's far more innovative and qualitatively superior works are to be found in the Virgin's aristocratic, elongated proportions, in the absence of rigidity in her pose and in her benevolent, matronly features expressing a humble and melancholic spirit. It seems to me that there are analogies between Cimabue's later style and the Magdalen Master's more mature works in the swifter and freer handling of the brush, in the way the chiaroscuro is replaced by tonal gradations of colour and the highlights form an autonomous decorative pattern – all aspects of a new technique which tends to alleviate and enliven the grave, sculptural consistency of the forms. Other morphological details, pointed out by Coor Achenbach,[17] also suggest that the date of the Thyssen panel cannot be far removed from around 1290.

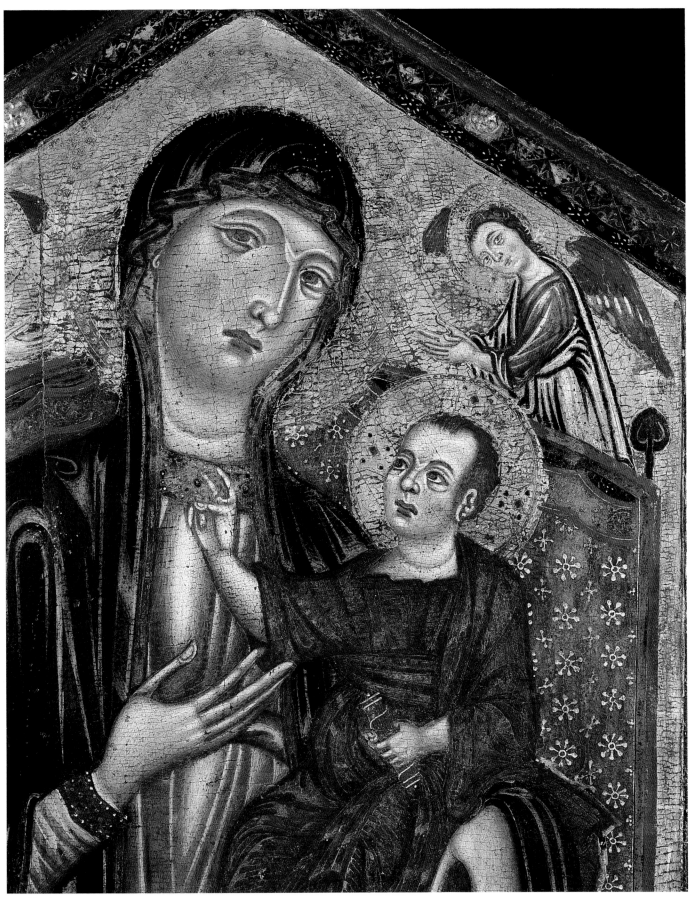

Detail [23] the heads of the Virgin and the Child

Master of the Pomposa Chapterhouse active early 14th century

24 The Crucifixion

*c*1320
Tempera on panel, 29 × 20.5 cm (including original frame); painted surface, 25 × 16.8 cm; thickness 2 cm
 (including frame)
Accession no.1930.23

Provenance
Private collection, Vienna, by 1924
Thyssen-Bornemisza Collection, by 1930

Exhibition
Munich, 1930, p.37, no.122

Literature
W. Suida, 'Aus dem Kreise Giottos', *Belvedere* v (1924) p.129
Munich (1930) p.37, no.122
W. Suida, 'Die italienischen Bilder der Sammlung Schloss Rohoncz', *Belvedere* xvi (1930) p.175
Rohoncz (1937) p.52, no.137
Rohoncz (1949) p.31, no.85
Rohoncz (1952) p.32, no.85
Rohoncz (1958) p.36, no.137
Rohoncz (1964) p.31, no.137
F. Bologna, *I pittori alla corte angioina di Napoli* (Rome, 1969) pp.224, 233 note 265
Thyssen-Bornemisza (1970) p.26, no.97
M. Boskovits, 'Appunti su un libro recente', *Antichità Viva* x, no.5 (1971) pp.6, 13 note 20
P. P. Donati, 'Primitivi alla Finarte e una proposta per Lippo di Benivieni', *Arte Illustrata*, nos.39–40 (1971) p.78
Thyssen-Bornemisza (1971) p.131, no.97
F. Zeri, 'Una Crocefissione giottesco-padovana', in *Diari di lavoro–I* (Bergamo, 1971) pp.33–5
F. Zeri and E. E. Gardner, *Italian Paintings. A Catalogue of the Collection of the Metropolitan Museum of Art. Florentine
 School* (New York, 1971) p.17
Thyssen-Bornemisza (1977) p.47, no.97
Thyssen-Bornemisza (1981) p.107, no.97
A. Brejon de Lavergnée and D. Thiébaut, *Catalogue sommaire illustré des peintures du Musée du Louvre, II. Italie,
 Espagne, Allemagne, Grande-Bretagne et divers* (Paris, 1981) p.255
Thyssen-Bornemisza (1986) p.199, no.97
M. Boskovits in Offner, *Corpus*, III/I, 2nd edn. (Florence, 1986) p.180 note 1
P. Barbieri in *Pinacoteca Comunale di Ravenna. Opere dal XIV al XVIII secolo* (Ravenna, 1988) p.102
Thyssen-Bornemisza (1989) p.218

Christ's lifeless body hangs on the Cross surrounded by four mourning angels; three of them collect the blood flowing from His wounds, the fourth joins his hands in prayer. At the foot of the Cross, to the left, the swooning Virigin is supported by Mary Magdalen and another Holy Woman. Three more women, one with a halo, stand behind them. To the right is a group of men among whom one can distinguish St John the Evangelist, the centurion, several soldiers and a bearded man in profile.[1]

The back of the panel still has traces of its original marbled decoration. It also has the number '1063' in pink crossed out in blue, and a Swiss customs stamp. Both sides of the panel have hinge marks. The right-hand edge, unlike the three other sides, still preserves its original gilding. The painted surface is generally well preserved. The gold ground is somewhat rubbed, and restored here and there, allowing the green preparation to show through. In some places one can see the canvas covering the panel. Woodworm has severely damaged the wood, especially in the lower section.

Note
1 For the iconography of the Crucifixion in general see Schiller, *Ikonographie*, II, pp.98–176. In the group of Holy Women one may easily distinguish the blond tresses and red mantle of the Magdalen holding up the fainting Virgin; for this motif and the iconography of the minor figures in the scene see Sandberg Vavalà, *Croce dipinta* (1929) p.148f. The other women with haloes are Mary the mother of James the Less and Joses (recorded in Mark 15:40 as standing by the Cross), who was frequently identified with Mary the wife of Cleophas (mentioned in the same position by John 19:25), and Mary, mother of the sons of Zebedee (*Acts* 12:12). The bearded man to the extreme right may be Nicodemus, who was supposedly present at the Crucifixion and was believed to be the author of the apocryphal Gospel of Nicodemus.

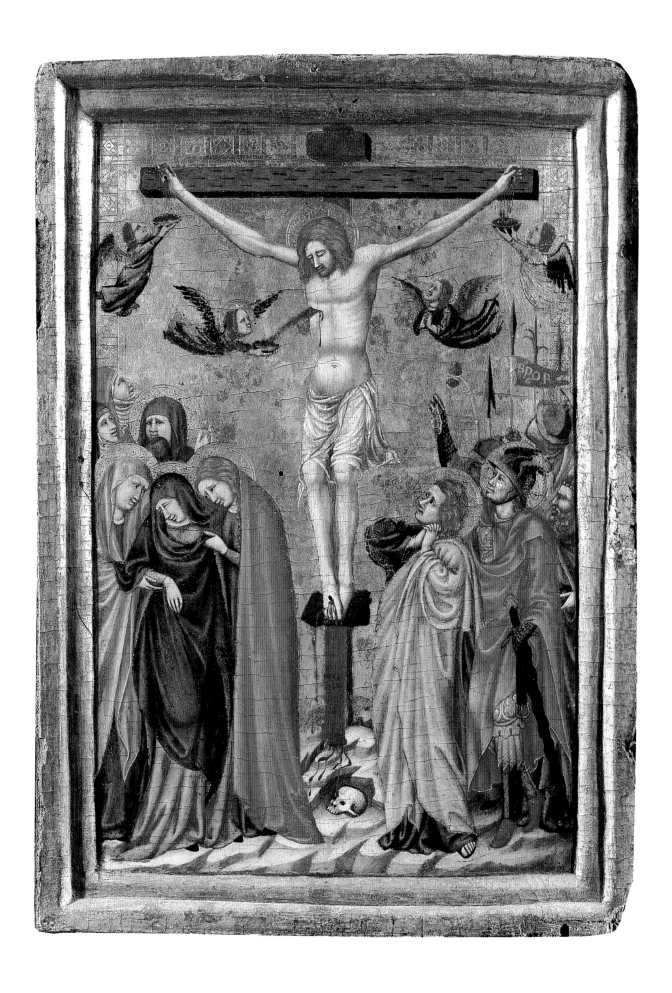

One may gather from the presence of the hinges that the picture originally formed part of a small polyptych, probably composed of four rectangular panels. To the left of the *Crucifixion* there may have been a Passion scene (now lost), possibly the *Way to Calvary*,[2] and together they would have counterbalanced the two *post mortem* episodes on the right of the *Incredulity of St Thomas* and the *Ascension* (both Paris, Louvre; FIGS 1c and d). The dispersed panels composing this small portable altarpiece reappeared only recently: the Thyssen *Crucifixion* in Vienna around 1924, the *Ascension* in Paris in the Salavin collection, where it was first noticed by Zeri (1971), and the *Incredulity of St Thomas* at a London auction in 1979.[3]

When still in a private collection in Vienna, the Thyssen panel was published by Suida (1924) as a work belonging to Giotto's circle, close to three *Crucifixion* scenes in Berlin (Gemäldegalerie, no.1074a), Munich (Alte Pinakothek, no.667) and Strasbourg (Musée, no.201). He also pointed out the similarity in pose between the St John and the same figure in a small triptych (Florence, Museo Horne, no.44); this last has been correctly attributed to the Master of the Medici Chapel Polyptych,[4] while the three others are now generally accepted as by Giotto and his workshop.[5] Suida later confirmed his view (1930), classifying the Thyssen panel as a 'precious work from Giotto's immediate circle', painted around 1320.[6] His opinion was accepted in the catalogue of the Munich exhibition (1930), whereas Heinemann (in Rohoncz (1937, 1949, 1952, 1958)) regarded the painting as Florentine c1350. The problem of the picture's stylistic origins was taken up again by Bologna (1969), who attributed it to the same 'nobilissimo maestro' responsible for the large crucifix in the Oberlin Museum, Ohio.[7] He also identified as earlier works by the same hand a *St John the Baptist enthroned* (Oxford, Christ Church Gallery),[8] a *Coronation of the Virgin* (Valencia, Museum)[9] and a *Madonna* (New York, Metropolitan Museum, no.47.143).[10] According to Bologna, the artist's style fits ideally in the wake of Lippo di Benivieni and of the Maestro di Figline's mature phase and he must, therefore, have been a Florentine painter active around and after 1330, in close contact with Sienese innovations introduced into Florence, especially by Ugolino.

This proposal has failed to convince recent critics. The catalogues of the Collection (Thyssen Bornemisza (1970, 1971, 1977 and 1981)) have preferred to go back to the classification of 'contemporary of Giotto' and the date 'circa 1320'; Donati (1971) has proposed an attribution to Lippo di Benivieni himself and advanced the hypothesis that the Thyssen panel formed part of a diptych together with a *Madonna and Child and saints* in Worcester (Art Museum, no.1922.16).[11] Rejecting Donati's attribution to Lippo di Benivieni, Zeri (1971) identified one of the companion scenes of the Thyssen *Crucifixion* as the *Ascension* then in the Salavin collection and connected both paintings with a small series of panels attributed by him to Giotto's circle in Padua 'possibly around 1340–5'.[12] The present writer (1971), while sharing Zeri's idea of the connection between the *Crucifixion* and the *Ascension* panels, questioned whether they were originally parts of a diptych and whether their Florentine origin was to be totally excluded. The panels are dubitatively considered as Paduan by Brejon de Lavergnée and Thiébaut (1981), who first related the *Crucifixion* and *Ascension* with a third panel representing the *Incredulity of St Thomas*, also in the Louvre. Barbieri (1988), who calls the artist the 'Maestro del Coro Scrovegni', still favours the Paduan connection, while the present writer has recently (1986) expressed his conviction that the artist was a 'Paduan Giottesque' to be identified with the Master of the Pomposa Chapterhouse (see also Thyssen-Bornemisza (1986, 1989)).

While the artist's Paduan origin remains yet to be proved, one can reasonably exclude the possibility that he was a Florentine. Not only does he reveal close stylistic affinities with such works as the frescoes in the presbytery of the Arena Chapel, attributable to Niccolò da Padova, but some of his technical[13] and iconographical solutions are extraneous to the Tuscan tradition.[14] The artist would presumably have received his training in Padua, where Giotto developed the most intensely classicizing phase of his style around 1303–5, exemplified not only by the Arena Chapel frescoes but also by those in the chapterhouse of the Basilica di Sant'Antonio and in the Palazzo della Ragione.[15] In particular, the surprising illusionistic

Notes

2 There is no way of establishing the exact appearance of the small folding altarpiece or the subject of the missing panel. My suggestion is made on the basis of Simone Martini's famous Orsini polyptych (Antwerp, Berlin and Paris; Boskovits, *Berlin. Katalog* (1987) p.155f.). Another example is a polyptych (Venice, Cini collection) stylistically close to Segna di Bonaventura, in which the *Crucifixion* is preceded by an image of the *Madonna and Child* and followed by the *Deposition* and *Entombment* (J.H.Stubblebine, *Duccio di Buoninsegna and his School* (Princeton, 1979) figs.291–2).

3 Both the *Ascension* and the *Incredulity of St Thomas* (sold Sotheby's, London, 28 March 1979, lot 16) now belong to the Louvre (nos.D.L.1973–25 and R.F.1979–19 respectively).

4 Offner, *Corpus*, III/VII (1957) p.85f., with an attribution to the circle of the Master of the Medici Chapel Polyptych.

5 G.Previtali, *Giotto e la sua bottega* (Milan, 1967) pp.315, 343 and 376, and Boskovits (1987) p.67f.

6 See Suida's letter of 25 July 1928 in the Thyssen archives.

7 No.42.129; Offner, *Corpus*, III/VI (1956) p.26, with an attribution to the workshop of the Master of the Corsi Crucifix which, to my mind, should be changed to the Master of the Medici Chapel Polyptych.

8 No.4; Offner, *Corpus*, III/I (1930) p.55f., where it is attributed to the following of the St Cecilia Master, and the new edition of the same volume (1986, p.177f.), where more recent attributions are quoted, including that of the present writer to Lippo di Benivieni.

9 A work probably by an artist of Valencia influenced by Italian models; M.Meiss, 'Italian Style in Catalonia', *Journal of the Walters Art Gallery* IV (1941) p.65, fig.22.

10 See Zeri and Gardner (1971) p.16f.; for its attribution to the Master of the Pomposa Chapterhouse, cf. Boskovits in Offner, *Corpus*, II/I (edn. 1986) p.180 note 1.

11 M.Davies, *European Paintings in the Collection of the Worcester Art Museum* (Worcester, 1974) p.397f., with an attribution to Meo da Siena. Personally, I am more inclined to regard it as the work of a Florentine master close to the Master of the Corsi Crucifix.

12 The connection between the two panels had already been

 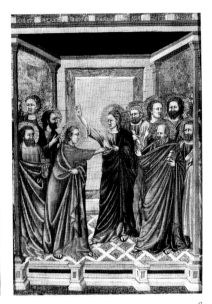

a b c d

FIG 1 Master of the Pomposa
Chapterhouse, hypothetical
reconstruction of a small
polyptych:
a *The Way to Calvary?* (lost)
b *The Crucifixion* (Thyssen
 Collection)
c *The Incredulity of St Thomas*
 (Paris, Louvre)
d *The Ascension* (Paris, Louvre)

made by Zeri in a letter to the
curator of the Thyssen Collection
in 1969. The works attributed by
Zeri to Giotto's followers in Padua
include the triptych in the Frick
Art Museum, Pittsburg
(W.R.Hovery, *Treasures of the
Frick Art Museum* (Pittsburg,
1975) pp.33, 47); the dossal in
the Galleria dell'Accademia of
Ravenna (no.194; A.Martini, *La
Galleria dell'Accademia a Ravenna*
(Venice, 1959) p.145f.), both of
which, in my opinion, are by
Niccolò da Padova, author,
among other works, of a fresco in
Sant'Apollinare at Trento
(N.Rasmo, *Affreschi medievali
atesini* (Milan, 1971) p.126).
13 One may note the presence of
a *terra verde* ground instead of red
bole beneath the gold. This
technique, although known to
Cennini and sometimes used by
Giotto (see D.Gordon, 'A Dossal
by Giotto and His Workshop . . .',
Burlington Magazine CXXXI (1989)
p.524), was rarely adopted by
Tuscan artists. On the other hand,
it was used in the panel by the
Master of Forlì in the Thyssen
Collection (see cat.[22]).

treatment of the architecture and the rigorous classicism to be found in the Basilica frescoes are
faithfully reflected in the mural paintings of the chapterhouse of Pomposa.

The identification proposed here between the severe, cultivated style of the Pomposa frescoes,
which reveal an extremely skilled draughtsman with an exceptional understanding, for that
date, of illusionistic effects,[16] and the small panels of our polyptych, which are less grandiose
and severe in style but more lively and intense in their feeling for narrative, can only be
advanced with caution. Comparison between the illusionistic architecture and classical-
looking sculptures painted in the Pomposa chapterhouse and our panel is impeded by their
difference in scale, technique and subject. Although there is also a fresco of the *Crucifixion* at

14 Of the representations of the *Incredulity of St Thomas* listed
by Sandberg Vavalà (1929) pp.361f., 490–1, those closest to
the Louvre panel are the ivory tabernacle at Salerno and the
fresco by Pietro Cavallini in Santa Maria Donna Regina,
Naples. Even more similar is the interpretation of the scene
given by Andrea da Bologna and his workshop in the church of
Pomposa (M.Salmi, *L'abbazia di Pomposa*, 2nd edn. (Milan,
1966) p.217, fig.435). The *Ascension* showing Christ
enthroned is also rare; in Florentine painting Christ is usually
shown standing (Sandberg Vavalà (1929) p.398f.), but he
again appears seated on a throne and carried by angels in
Andrea's fresco at Pomposa (Salmi (1966) fig.436).

15 See F.Flores d'Arcais, 'Presenza di Giotto al Santo', in *La
pittura del Santo di Padova*, ed. C.Semenzato (Vicenza, 1984)
pp.3–13, and G.F.Hartlaub, 'Giottos zweites Hauptwerk in
Padua', *Zeitschrift für Kunstwissenschaft* IV (1950) pp.19–34.
16 The illusionistic niches containing figures of saints and
prophets are designed in a foreshortening which corresponds
to the point of view of the spectator who enters the room. This
scheme (which probably had symbolic implications) is made
still more effective by the use of colours for the representation
of the *Crucifixion* and *Saints* and monochrome for the *Prophets*.

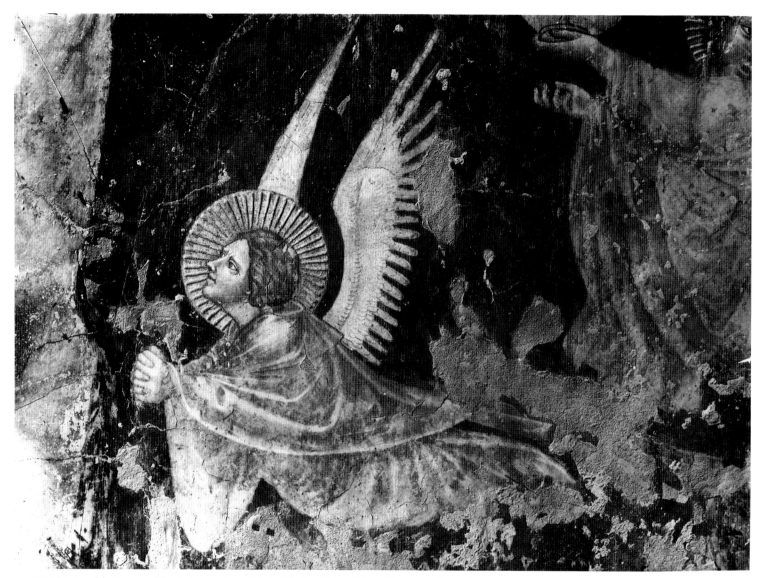

FIG 2 Master of the Pomposa Chapterhouse, *Angel* (detail of *The Crucifixion*, Abbey of Pomposa, Chapterhouse)

Pomposa, its condition is too poor to afford more than a partial point of comparison, for instance in the mourning angels (see FIG 2 and detail). There are similarities with our panel in their elongated faces, slightly sagging flesh, sunken almond-shaped eyes and worried expressions and in the way their pointed noses continue the outline of the forehead, or in the woolly texture of their hair and the stiff draperies with their tubular folds. The same motifs recur in the Metropolitan Museum *Madonna*, which I would be inclined to place chronologically closest to the frescoes. We are also reminded of the Chapterhouse frescoes by the elegant architecture, rich in marble panelling, which provides the setting for the meeting of Christ and St Thomas and by the stately togas worn by the Apostles. The detail of the foreshortened hand of the prophet Isaiah which seems to come forward from the wall is echoed by such motifs as the bent head of one of the soldiers next to the crucified Christ and by the bold foreshortening of the face of one of the Apostles in the *Ascension*.

Detail [24] St John and the centurion

17 For this artist see R.Quirino in *Arte in Valnerina e nello Spoletino* exhibition catalogue (Spoleto, 1983) pp.31–4.
18 P.Scarpellini in Ludovico da Pietralunga, *La Basilica di San Francesco d'Assisi* (Treviso, 1982) pp.265f., 304f. and 328f., with a complete summary of recent opinions.

The Pomposa fresco cycle probably dates from not long after Giotto's stay in Padua and, in any case, must precede 1317/18 when Pietro da Rimini was commissioned to paint the frescoes in the refectory of the same monastery. By that time our anonymous master must have been unavailable, presumably engaged elsewhere, perhaps in Romagna, where he could have experienced the stimulus of artists other than Giotto. His possible contacts with painting in Umbria and Lazio, such as the works of the Master of Sant'Alò,[17] and perhaps the frescoes of the transept in the Lower Church of San Francesco at Assisi,[18] may have inspired the more crowded compositions of his polyptych, or the magniloquent gestures and forceful expressions in keeping with the rhythms and elegance of the new Gothicizing trends. It is to this context, probably around 1320, that the execution of the small polyptych under discussion would seem to belong.

Master of 1355 active *c*1325–75

25 The Coronation of the Virgin with five angels

1355
Tempera on panel, 86 × 52.5 cm (including surviving part of original frame); thickness *c*1.5 cm (thinned)
Accession no.1930.106
Inscription: H[OC] OP[US] FUIT F[A]C[TU]M T[EM]P[O]R[E] FR[ATR]IS PET[RI] D[E] MO[N]TEZAGO.M.CCC.L.V.

Provenance
Private collection, Venice
Thyssen-Bornemisza Collection, by 1930

Exhibition
Munich, 1930, p.21, no.70

Literature
E. Hanfstaengl, 'Castle Rohoncz Collection shown at Munich', *Art News* (16 August 1930) p.18
W. Suida, 'Die italienischen Bilder der Sammlung Schloss Rohoncz', *Belvedere* XVI, no.9 (1930) pp.175–6
R. van Marle, 'I quadri italiani della raccolta del Castello Rohoncz', *Dedalo* XI (1930–1) pp.1368–70
L. Coletti, 'Lorenzo Veneziano im neuen Licht', *Pantheon* IX (1932) p.47 note 1
E. Sandberg Vavalà, 'Semitecolo and Guariento', *Art in America* XXII (1933) p.10 note 9
W. Suida, 'Semitecolo', in Thieme and Becker, *Lexikon*, XXX (1936) p.487
Rohoncz (1937) p.141, no.389
L. Coletti, *I Primitivi. I Padani*, III (Novara, 1947) p.LVII
Rohoncz (1949) p.69, no.233
Galetti and Camesasca, *Enciclopedia* (1951) p.2272
Rohoncz (1952) p.72, no.233
Berenson, *Italian Pictures* (1957) I, p.165
Rohoncz (1958) p.98, no.389
V. N. Lazarev, *Iskusstvo Trecento* (Moscow, 1959) p.246
T. Pignatti, *Origini della pittura veneziana* (Bergamo, 1961) p.74
Pallucchini, *Trecento* (1964) p.123
Rohoncz (1964) p.74, no.389
P. Zampetti, *A Dictionary of Venetian Painters*, I. *14th and 15th Centuries* (Leigh-on-Sea, 1969) p.98
G. Gamulin, 'Una proposta per il Semitecolo', *Commentari* XXI (1970) p.200
Thyssen-Bornemisza (1970) p.23, no.284
Thyssen-Bornemisza (1971) p.355, no.284
L. Grossato in *Da Giotto al Mantegna*, exhibition catalogue (Padua, 1974) no.36
'Semitecolo' in *Dizionario Bolaffi*, X (1975) p.267
Thyssen-Bornemisza (1977) p.109, no.284
M. Natale, *Art Venitien en Suisse et au Liechtenstein*, exhibition catalogue (Pfäffikon and Geneva, 1978) p.87
Thyssen-Bornemisza (1981) p.289, no.284
M. Lucco in *Duecento e Trecento* (1986) p.187
F. Flores d'Arcais in *Duecento e Trecento* (1986) p.658
Thyssen-Bornemisza (1986) p.292, no.284
Thyssen-Bornemisza (1989) p.220
F. Zeri, 'Un'errata attribuzione al Semitecolo (e una rara iconografia di Sant'Antonio da Padova)', in *Scritti in onore
 di Giuliano Briganti* (Milan, 1990) pp.37–42
Dipinti e miniature dal XIV al XVIII secolo, exhibition catalogue by A. Tartuferi (Galerie A. Ribolzi, Monte Carlo, 1990)
 pp.17, 19

Mary is seated beside Christ on a marble throne. She leans slightly forward with her arms crossed on her breast in a gesture of humility as Christ places the crown on her head with both his hands.[1] A rich hanging decorated with a floral pattern covers the throne, behind which appear three angel musicians above[2] the two other angels in adoration, one on either side.

The panel, which has been cut down some 10 or 15 cm below, is slightly warped and a

Notes
1 The most detailed study on the iconographic development of this theme in Italian fourteenth-century painting remains that of Offner (*Corpus*, III/V (1947) pp.243–50). Cf. also, for the significance of Mary's crossed hands, Schiller, *Ikonographie*, IV/2 (1980) p.148f. For the Venetian version of this iconography see p.98.
2 The angel on the left plays the fiddle, the one at the centre a portable organ and the third a psaltery; cf. H. Mayer Brown and J. Lascelle, *Musical Iconography: a Manual* (Cambridge MA, 1972) pp.116f. and 124f.

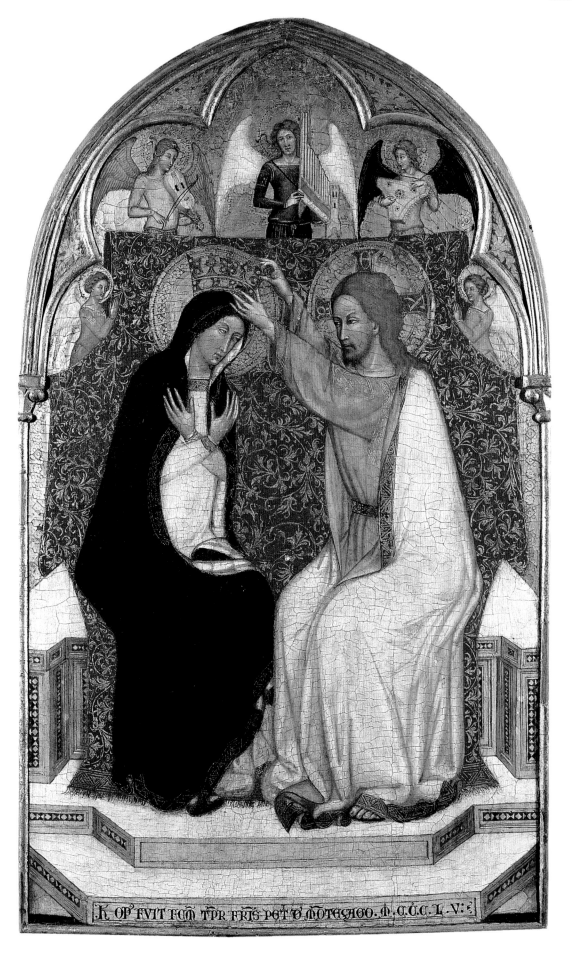

K· OP˜ FVIT TĈ˜ TˉPR FRĨS PĈT˜ O˜ ͠MOTEˉCHOO· M ·C̄·C̄·C̄· L ·V·

FIG 1 Master of 1355, partial
reconstruction of a polyptych:
a *St Louis of Toulouse and St John
the Baptist, with praying friar*
(Monte Carlo, Galerie Ribolzi)
b *The Coronation of the Virgin with
five angels* (Thyssen Collection)
c *St Anthony of Padua heals the
scalp of a wife hung by her hair by
her husband*
(Paris, private collection)
d *St Paul*
(formerly Venice, Vittorio Cini
collection)

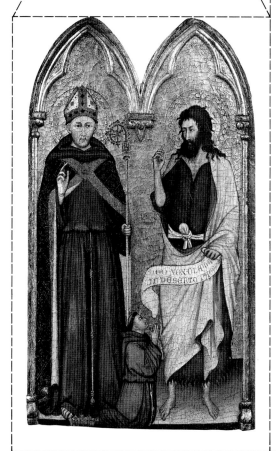

a

pronounced craquelure covers the whole surface. The gold in the upper part of the central arched section is modern. In some areas, particularly the flesh and hair, the modelling is worn as a result of drastic cleaning. A few small colour losses and old retouches are visible in the robes of Christ and the Madonna as well as in some of the faces. Nevertheless, the painting, which was lightly cleaned by Marco Grassi in 1968, is in reasonably good condition. The back of the panel shows a roughly cut and split wood surface and has three dents on either side corresponding to the points where wedges originally secured the frame. There is also a label referring to its present ownership.

This is the central panel of a small polyptych, of unknown provenance, other panels of which have recently come to light. The left wing, which measures 69 × 41 cm and represents full-length figures of St Louis of Toulouse, St John the Baptist and a worshipping Franciscan friar (probably Pietro da Montezago; FIG 1a) was exhibited in 1983 at the Biennale Mostra Mercato dell'Antiquariato in Florence as the property of Carlo De Carlo, and subsequently at the Mostra at the Fiera Mercato in Milan in 1988 as the property of Bruno Scardeoni of Lugano.[3] It is

Notes

3 This painting, reproduced for the first time in *Vivamilano* (the *Corriere della Sera* Supplement) of 3 March 1988, p.24, with an attribution to Semitecolo, was published by Zeri (1990) as the work of an anonymous Neapolitan painter.

4 This miracle took place in 1226/7 when St Anthony was *custos* of the Franciscan convent of Solignac near Limoges; *Acta Sanctorum. Iunii*, II (Antwerp, 1698) p.726f. According to the text of the Legend, the husband of the poor woman, '… plenus ira, cepit illam per capillos; et in tantum traxit huc atque illuc, quod totam illam capillaturam et

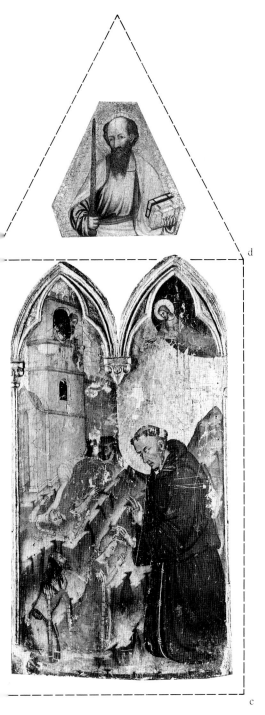

c

d

FIG 2 Detail of the Princess from
the Fidenza fresco (FIG 3)

Detail [25] angel with organ

capillos evulsit. Quod ipsa videns,
crines colligi fecit; et fide
illuminata, capillos super
auriculare posuit; eosque ibi
disponens, caput super eos
inclinavit: mane autem facto misit
ad S. Antonium ut ad eam cito
veniret.' The Saint was somewhat
annoyed to have been summoned
for such a reason, but 'recedens
fecit vocari fratres ... et ait:
"Oremus fratres, et respiciet Deus
(ut spero) fidem suam". Et statim,
Sancto orante, capilli ordinati
mulieris capiti restituuntur ut
prius ...' The painter of the Paris
panel, however, would seem to
have interpreted the story as if the
woman had been hanged by her
hair. The painting's exact

presently (1990) owned by the Galerie Adriano Ribolzi in Monte Carlo. The right wing, which turned up in Turin about 30 years ago, has since been acquired by a private collector in Paris. It represents an unusual episode from the legend of St Anthony of Padua in which the saint heals the scalp of one of his devotees whose hair was torn out by her jealous husband (FIG 1c).[4] This panel originally had a pinnacle with a bust of St Paul, formerly in the Vittorio Cini collection, which has been trimmed down from a triangle to an irregular hexagon (25 × 24.5 cm; FIG 1d).[5] The other pinnacles, which are untraceable, would presumably have represented St Peter (or perhaps St Francis?), and a figure of God the Father.

As for the polyptych's original destination, it is almost certain that it was painted for a Franciscan church, presumably in the province of Bologna (custodia of Parma). The inscription specifies the patron's birthplace as Montezago, in the district of Lugagnano Val d'Arda (province of Piacenza),[6] where frescoes attributable to the same artist are still preserved.

The Thyssen-Bornemisza Coronation was first published in the catalogue of the Munich exhibition (1930) and its provenance was given as 'venezianischer Adelsbesitz'. The painting

had probably entered the Collection only shortly before; in fact, at the date of Suida's expertise of 5 June 1930 it was presumably still on the market. The attribution to Nicolò Semitecolo put forward by this scholar is quoted in the catalogue of the exhibition which opened in the same month; but the painting was exhibited under the name of Jacopo di Cione, an attribution proposed by Raymond van Marle. Van Marle subsequently confirmed Jacopo's authorship (1930/1), followed by Hanfstaengl (1930); most critics, however, preferred the attribution to Semitecolo. According to Suida (1930), this work is a characteristic product of Venetian art, close to Guariento, and can be related to the panels by Semitecolo in Padua Cathedral. Decidedly in favour of the attribution to Semitecolo, confirmed again by Suida (1936), were Coletti (1932), the catalogues of the Collection (Rohoncz (1937, 1949, 1952, 1958, 1964); Thyssen-Bornemisza (1970, 1971, 1977, 1981, 1986)), Berenson (1957), Lazarev (1959), Pignatti (1961), Zampetti (1969) and Flores d'Arcais (1986). Semitecolo's authorship was also accepted with reservations by Sandberg Vavalà (1933): 'if the picture is really by Semitecolo it would ... be an early work under Venetian influence'; by Coletti on second thoughts (1947): 'Semitecolo would come very close to Paolo Veneziano in the Thyssen panel, if it belongs to him'; by Galetti and Camesasca (1951); by Pallucchini (1964): 'influenced by Paolo, but ... on his own level of formal delicacy and subtlety which was later to become the fundamental aspect of Semitecolo's art'; by Gamulin (1970), Grossato (1974) and the *Dizionario Bolaffi* (1975). Only Natale (1978) questioned the connection with the Venetian artist, affirming without further argument that the painting was not of Venetian but of Emilian origin. Lucco (1986) also rejected the attribution to Semitecolo, specifying that it is by an 'artist whose delicate lyricism and subdued, deliberate method of composition are totally extraneous to Venetian culture'. Mauro Natale's opinion is probably based on Federico Zeri's research on the Thyssen painting (letter of 1974 to Baron H.H. von Thyssen in the Collection archive); this scholar, independently of the present writer, has connected the *Coronation* with its companion panels in private hands in Paris and Monte Carlo, suggesting that the polyptych 'was executed in the region of Piacenza'. When the wing with the *Two saints and a donor* was exhibited at the antique dealers' Fair held in Milan in 1988, word soon got round, even in the Press, that it belonged to the same complex as the Thyssen *Coronation*, but without mentioning who was responsible for the discovery.[7] In the latest catalogue of the Collection (Thyssen-Bornemisza, 1989) it is listed as 'Emilian-Lombard Master', quoting the opinion of the present writer. Recently Zeri (1990) has published the three main panels of the altarpiece and has concluded (admittedly after long hesitation) that its author was probably Neapolitan, or rather 'l'anello mancante ... tra le entità divulgatrici, di derivazione (quali ... il Maestro delle Tempere Francescane o quello di Giovanni Barrile) e le presenze fiorentine e senesi a Napoli'. Shortly afterwards Tartuferi (1990) also illustrated the panel in Monte Carlo, noting, with reference to the present writer's opinion, that 'il naturalismo lucido e la precisione formale rilevabili in quest'opera inducono a presupporre un rapporto molto stretto con la cerchia di Tommaso da Modena'.

A first hint in this direction had already been given by Coletti (1947), when he observed that the Thyssen-Bornemisza *Coronation* reflected 'una cultura tommasesca'. The influence of Tommaso da Modena extended to different areas, from Modena to Reggio and, of course, to Treviso, where the Modenese painter left his most significant works. Since he also worked in the Gonzaga Chapel in San Francesco at Mantua, his rich, soft palette and vivid, pulsating figures also came to be known in lower Lombardy. On the other hand in Venice and Padua where Guariento and Semitecolo obtained the principal commissions for paintings, Tommaso had little if any ascendancy. Further clues as to the artistic milieu of the author of the Thyssen panel are provided by analogies in style with the workshop of Jacopino and Bartolomeo da Reggio, both of whom would have been active in Piacenza if, as seems likely, the fresco fragment representing the *Celebration of the Mass* in San Lorenzo is to be included among their early works.[8] The severe, ascetic figures of these Reggian artists, with their reserved expressions and thickly pleated metallic draperies do have something in common with the polyptych here

Notes

measurements are unknown to the present writer.

5 When it was in the Cini collection the (unpublished) fragment went under the name of Francesco Traini.

6 See *Nuovo Dizionario dei Comuni e Frazioni della Repubblica italiana*, 19th edn. (Rome, 1948) p.340. In 1385 the *custodia* of Parma included the Franciscan convents of Parma, Cremona, Borgo San Donnino (the present-day Fidenza), Piacenza, Bobbio and Casalmaggiore; see Flaminio da Parma, *Memorie istoriche delle chiese e dei conventi dei Frati minori, dell'Osservante e Riformata Provincia di Bologna* (Parma, 1760) I, p.xif. A plausible location for the polyptych, if one excepts the smaller conventual houses and those in more remote areas, could have been the church of San Francesco at Piacenza, founded in 1278 and consecrated in 1365 (A. Emmanueli, *Il tempio dei Ss. Protaso e Francesco in Piacenza* (Piacenza, 1868)) or that of Fidenza on which building began in 1345 (G. Laurini, *San Donnino e la sua chiesa* (Fidenza, 1927) p.129). One of the latter's chapels, complete with its altarpiece, was already in use the following year.

7 M. Spagnol, 'Milano: alla Fiera la Nona Biennale dell'Antiquariato', in *La Stampa* (12 March 1988), and an anonymous article in *Vivamilano* (see note 3 above).

8 See A. Ghidiglia Quintavalle, *La pittura gotica padana negli affreschi di San Lorenzo a Piacenza* (Parma, 1970) p.42f.

9 *Ibidem*, p.39f. The author compares the fresco in particular with the *Holy Trinity* fresco in Sant'Agostino at Bergamo (S. Matalon, *Affreschi lombardi del Trecento* (Milan, 1963) p.223), which is, in fact, a work of the first half of the fourteenth century, closely related to the *Tree of St Bonaventura* in Santa Maria Maggiore at Bergamo.

10 See A. Ghidiglia Quintavalle, *Arte in Emilia* (Parma, 1971) p.20, who compares the painting to the fresco of the same subject in Sant'Eustorgio at Milan and notes the influence of Vitale da Bologna

11 This fresco, unpublished so far as I know, represents Christ on the Cross between four mourning angels and heads of the Virgin and St John; see photo Soprintendenza Parma, no.33804.

reconstructed; for instance, there seems to be a family resemblance between the Cini *St Paul* (hitherto not connected with our complex) and the figures in the signed altarpiece by Jacopino and Bartolomeo in the Brera, Milan. However, the anonymous master, whom we baptize 'Master of 1355' after the date in the Thyssen panel's inscription, differs from these two painters in his remarkably subtle modelling and elegant draughtsmanship. He depicts his pale saints with an emphasis on naturalistic detail, and he lights up even the gruesome scene of the *Miracle of St Anthony* with a touch of humour. Attention may also be drawn in this context to the *Coronation of the Virgin* in San Lorenzo in Piacenza, which is very similar in composition to the Thyssen *Coronation*. It is the work of an artist who has been associated in the past with later Trecento Bergamasque painting,[9] but who, in fact, comes closer to the Modenese Serafino dei Serafini and also reveals affinities with the Master of 1355.

Particularly useful, to my mind, towards defining our artist's profile is the *St George freeing the Princess* in the Oratory of San Giorgio at Fidenza (see FIGS 2 and 3).[10] This fresco, which must date from about ten years after the polyptych of 1355, is still richer in the observation of naturalistic details; for instance, in the meticulous description of the castle in the background, or in the sumptuous costumes worn by the protagonists. It also reveals a search for a more refined elegance of line and rhythmic fluidity. Yet the sharpness of the artist's vision remains

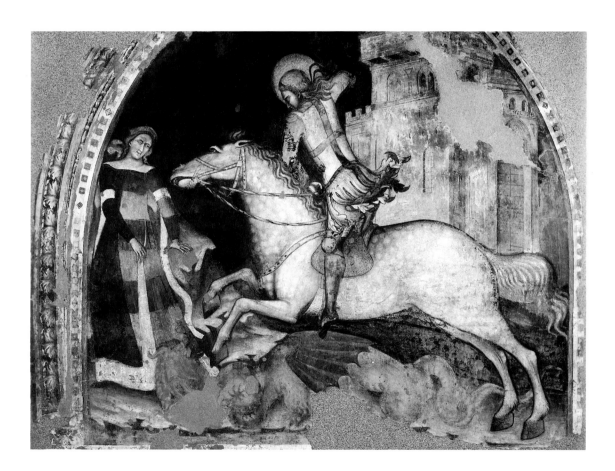

FIG 3 Master of 1355, *St George freeing the Princess* (Fidenza, formerly Oratory of St George, now Cathedral)

unchanged, as also his need to carve out and polish every detail, which results in his freezing the impetus of the horseman and relaxing the dramatic tension of the scene in the over-studied pose of the Princess. The artistic temperament and characteristics of style present in the polyptych of 1355 and in a fragmentary *Crucifixion* (by the same hand) in the church of San Francesco at Piacenza[11] find their ultimate expression in the *St George* of Fidenza.

Niccolò di Tommaso documented c1346–76

26 The Madonna and Child with six saints

c1362/7
Tempera on panel, 87 × 39 cm (including the restored frame); painted surface, 87.5 × 30 cm (main scene,
 52 × 27 cm); thickness 2.2 cm
Accession no. 1930.81

Provenance
Josef Cremer, Dortmund, no.1201, by 1914
Cremer sale, Wertheim, Berlin, 29 May 1929, lot 121
Thyssen-Bornemisza Collection, 1930

Exhibition
Munich, 1930, p.22, no.72

Literature
H. Voss, *Collection Geh. Kommerzienrat Cremer, Dortmund* (Dortmund, 1914) I, pp.5, 24, no.1201
H. Voss in *Sammlung Geheimrat Josef Cremer Dortmund*, sale catalogue (Wertheim, Berlin, 29 May 1929) p.164,
 no.121
A. Scharf, 'Die Primitiven der Sammlung Cremer', *Cicerone* XXI (1929) p.256
P. Wescher, 'Illustrierte Berichte, Berlin', *Pantheon* IV (1929) p.338
Munich (1930) p.22, no.72
R. van Marle, 'I quadri italiani della raccolta del Castello Rohoncz', *Dedalo* XI (1931) p.1368
H. D. Gronau, 'Niccolò di Tommaso', in Thieme and Becker, *Lexikon*, XXV (1931) p.439
Berenson, *Italian Pictures* (1932) p.240
H. D. Gronau, 'Nardo di Cione', in Thieme and Becker, *Lexikon*, XXVI (1932) p.40
Berenson, *Pitture italiane* (1936) p.208
Rohoncz (1937) p.112, no.306
Rohoncz (1949) p.57, no.186
Rohoncz (1952) p.59, no.186
Offner, *Corpus*, III/VI (1956) p.190
Rohoncz (1958) p.77, no.306
Rohoncz (1964) pp.60–1, no.306
Thyssen-Bornemisza (1970) p.25, no.237
Thyssen-Bornemisza (1971) p.295, no.237
Thyssen-Bornemisza (1977) p.91, no.237
Boskovits, *Pittura fiorentina* (1975) p.203 note 108
Dizionario Bolaffi, VIII (1975) p.144
Thyssen-Bornemisza (1981) p.240, no.237
Offner, *Legacy* (1981) p.90
Thyssen-Bornemisza (1986) p.242, no.237
Thyssen-Bornemisza (1989) p.247

The Virgin is seated before a brocade curtain embroidered with gold, holding the Christ Child, who blesses with his right hand and holds a bird, symbol of the Passion and Resurrection[1], in his left (see detail, p.167). Flanking the throne, in three tiers, are two angels above, Sts John the Baptist and Anthony Abbot at the centre, St Bartholomew with a deacon saint and St Nicholas with the archangel Michael below. In the gable is the figure of Christ blessing, seated against a gold ground and holding an open book (see detail, p.169). On the pedestal of the frame are three painted coats of arms divided by partitions containing dragons. The left-hand shield has black and gold horizontal bands, that in the centre black and white horizontal bands, that on the right three hills surmounted by an unidentifiable rampant animal.

Note
1 See H. Friedmann, *The Symbolic Goldfinch. Its History and Significance* (New York, 1946).

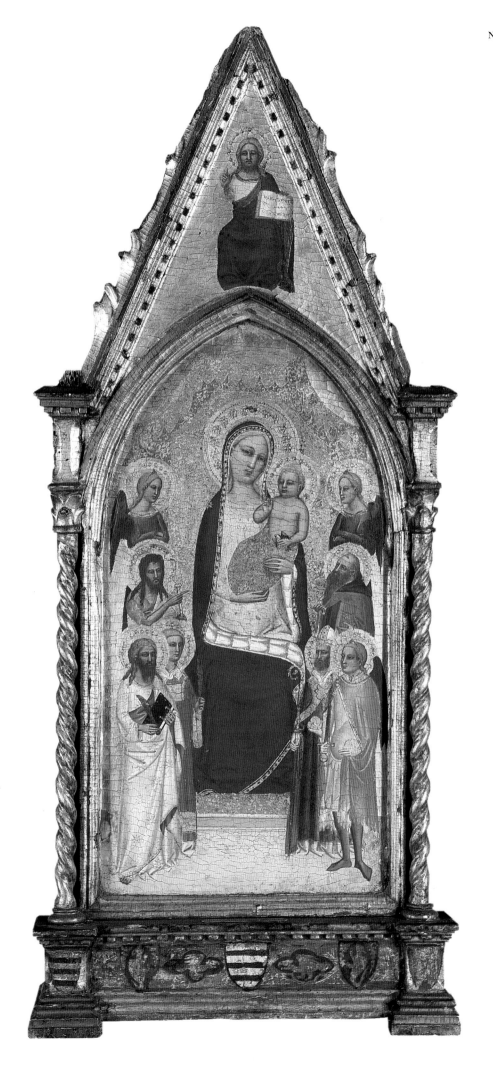

FIG 1 Niccolò di Tommaso, *The Madonna and Child with saints and angels* (above: *Christ in benediction*); *The Adoration of the Magi* (above: the *Announcing angel*); *The Crucifixion* (above: the *Annunciate Virgin*) (Germany, private collection)

On the back is the number '1276' in blue pencil, '2/121' in blue pencil gone over in pink, a pink '1201', a label with the printed number '306', another with 'P.B.174' in pen, another with the number '1201' in pen, and a label with the collection number.

The painting, which was cleaned by Marco Grassi in 1987, is in generally fair condition. A few rubbed parts are visible in the curtain and in the Child's tunic. There are some small retouches in the draperies, particularly in those of the Virgin. During the course of the restoration carried out in 1987, the two small columns framing the panel on either side (see the reproductions of one and a fragment of the second in catalogues up to and including 1881; only one in Thyssen-Bornemisza (1986)), were removed as they proved to be modern. They have been replaced by two modern spiral columns, modelled on the one which previously occupied the space between the painted surface and the frame on the left side.

The painting, which is first recorded in the Cremer collection at Dortmund in 1914 (but was possibly acquired much earlier),[2] originally formed the centre of a small triptych. This must have resembled the slightly smaller triptych formerly in the collection of Dr Fritz Thyssen at Mühlheim-Ruhr-Speldorf, representing the *Madonna and Child with saints and angels* in the centre with the *Adoration of the Magi* surmounted by the *Angel of the Annunciation* on the left shutter and the *Crucifixion* and the *Annunciate Virgin* on the right (FIG 1).[3] In Voss's catalogue of

Notes
2 According to the introduction of the sale catalogue (1929), Cremer began collecting in the 1860s.
3 Published as Niccolò di Tommaso by H.D.Gronau, 'Neue Zuschreibungen an Niccolò di Tommaso', *Belvedere* IX (1930) pp.95–8, figs.63–4. This triptych, measuring 79 × 61.5 cm., was exhibited in Cologne in 1953 (*Frühe italienische Kunst*, Wallraf-Richartz-Museum, June–September, no.22).

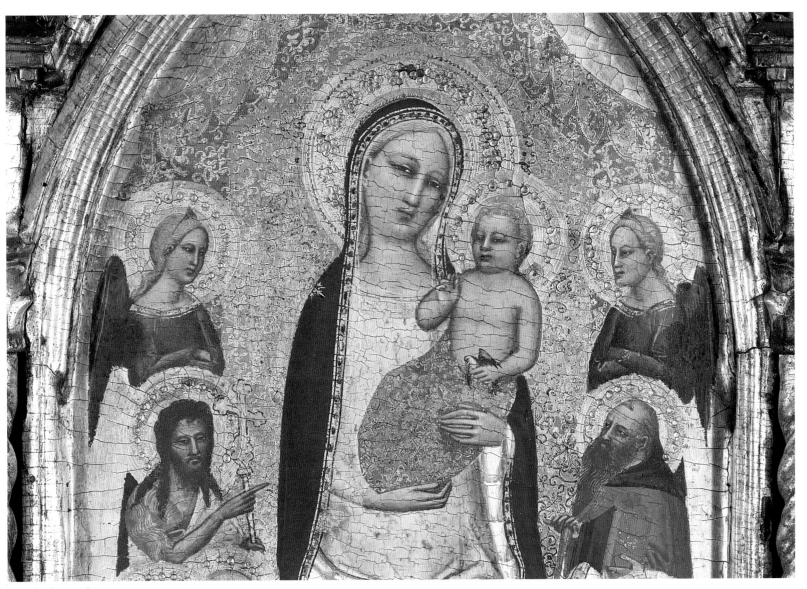

Detail [26] the Madonna

4 *Madonna and Child enthroned with saints*, no.39.103; O.Sirén, 'Pictures in America of Bernardo Daddi...', *Art in America* 11 (1914) p.329, fig.2, as Nardo di Cione.

5 'One may include in this first phase... the *Madonna del Parto* in San Lorenzo, the tabernacle on the corner of via del Sole and via delle Belle Donne in Florence, the *Madonna* in the Thyssen-Bornemisza Collection in Lugano or the triptych in the Galleria Sabauda in Turin.'

the Cremer collection (1914), the painting was attributed to Taddeo Gaddi and described as 'a panel which, considering its date, creates a remarkably free and spacious impression'. In the sale catalogue of the collection (1929) Voss proposed, at the suggestion of Raymond van Marle, an attribution to Nardo di Cione. This view was shared, with slight reservations, by Scharf (1929; 'in all probability') and by Wescher (1929; 'attributed to'), and accepted in the catalogue of the Munich exhibition in 1930. Van Marle (1931) confirmed the attribution, but he erroneously stated that the painting came from the Kaiser-Friedrich-Museum in Berlin. Later, Gronau (1931, 1932) identified the artist as Niccolò di Tommaso, whereas Berenson (1932, 1936) proposed the name of Giovanni del Biondo, a view he no longer sustained in the posthumous edition of his *Lists* (1963). Offner (1956) and more recent critics accept the attribution to Niccolò di Tommaso. The only comments on the panel's place in the artist's œuvre are those made by Everett Fahy (oral opinion quoted in Thyssen-Bornemisza (1971)), who relates the panel to a painting in the Fogg Museum, Cambridge, Massachusetts,[4] and by the anonymous compiler of the entry on Niccolò in the *Dizionario Bolaffi* (1975), who mentions it in connection with some other works[5] and places it in the period of the artist's collaboration with Nardo di Cione (*ie* before the latter's death in 1365).

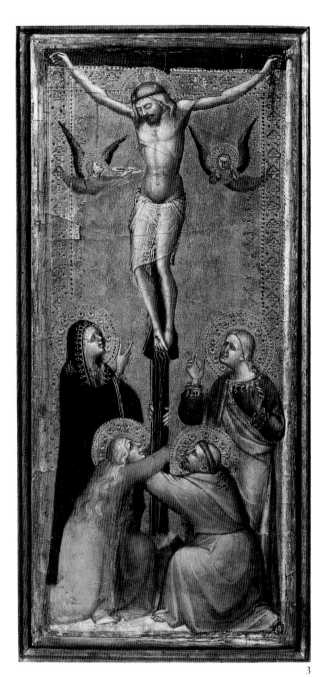

2

3

FIG 2 Niccolò di Tommaso,
The Adoration of the Magi (Venice,
Ca' d'Oro, Galleria Franchetti)

FIG 3 Niccolò di Tommaso,
The Crucifixion (formerly Berlin,
Schweitzer collection;
whereabouts unknown)

Notes
6 No.122; G.Fogolari, U.Nebbia
and V.Moschini, *La R. Galleria
Giorgio Franchetti alla Ca' d'Oro.
Guida Catalogo* (Venice, 1929)
p.137 (as Tuscan School, early
15th century). Later the panel
was attributed to Niccolò di
Tommaso by Berenson (*Italian
Pictures* (1932) p.398), while
Offner (*Corpus*, III/V (1947) p.212
note 1) defined it as 'Cionesque',
without proposing a name.
7 *Die Sammlung E. Schweitzer,
Berlin*, sale catalogue (Cassirer-
Helbing, Berlin, 6 June 1918)
p.25f., no.42, as Ambrogio
Lorenzetti. The painting, which in
more recent times belonged to
Konrad Adenauer in Bonn (sold
Christie's, London, 26 June 1970,
lot 13, as 'Tuscan School') was
given to Niccolò di Tommaso and
connected with the Franchetti
Adoration by the present writer;
Boskovits (1975) p.203 note 108.
8 The measurements given in the
respective catalogues, but which
I have been unable to check, are
30 × 16 cm for the *Adoration* and
30 × 14 cm (probably without the
frame) for the *Crucifixion*.
9 I see particularly close
analogies between the two above
mentioned panels and the
Deposition formerly in the
Massimo collection in Rome
(Gronau (1930) p.97, fig.68).
Other similar works are a small
triptych sold at Christie's, London,
21 June 1968 (lot 18), and the
Last Judgement formerly in the
Larderel collection, Livorno
(U.Schlegel, 'Beiträge zur
Trecentomalerei', *Mitteilungen des
Kunsthistorisches Instituts in
Florenz* XI (1964) pp.66–7, fig.2).
The gestures and in particular the
raised hands with two or three
bent fingers recur frequently in
the frescoes of the Tau church at
Pistoia (1372).
10 One should bear in mind,
however, that differences of this
kind also occur in other
tabernacles by the artist, for
instance in the triptych formerly
in the Fritz Thyssen collection.

No attempt has been made so far to try to identify the missing wings of the triptych. However, it seems likely that the lower part of the shutters, deprived of their gables with the Virgin and Gabriel, may be identified with the *Adoration of the Magi* today in the Galleria Franchetti (Ca' d'Oro, Venice; FIG 2)[6] and with the *Crucifixion* which was formerly in the Schweitzer collection in Berlin and appeared on the Florentine art market around 1972 (FIG 3).[7] Although these two panels have been given discordant attributions, not only are they similar in size[8] and ornamental details, but their style fits in well with Niccolò's works of the 1360s.[9] It seems to me very likely that the Ca' d'Oro and Schweitzer panels belonged together and I am inclined to believe that they formed part of the same triptych as our panel; the only objections would be the absence in the Thyssen panel of a decorative border and the slight differences in the punches of the haloes,[10] besides the somewhat more static and meditative quality of the figures.

The problem remains of our picture's place in Niccolò's chronology, in which there are few dated works. It seems to me very likely that it was executed towards the mid-1360s. The

11 Berenson, *Italian Pictures* (1963) pls. 307, 313, as Niccolò di Tommaso. Offner (*Legacy* (1981) pp. 34–5) attributed both triptychs to, or close to, the anonymous Infancy Master, identified by Boskovits (1975, p. 52f.) with Jacopo di Cione.
12 *Italian Old Master Paintings. Fourteenth to Eighteenth Century*, exhibition catalogue (Piero Corsini Inc., New York, 17 November–8 December 1984) p. 8f., no. 3.
13 At Sotheby's, London, 23 June 1982 (lot 48) and Sotheby's, New York, 15 January 1987 (lot 9).

Madonna and Child with saints is particularly close to a group of works by Jacopo di Cione, including the Florence, Accademia, triptych (no. 8465) and another triptych formerly in Munich (Kaulbach collection).[11] In both these works one finds the same elongated and static forms, with almost unbroken outlines, the same draperies with straight folds, animated by darting lights, and the same delicate modelling of the features, oscillating in expression between coyness and dreaminess. Both the above triptychs, which can be used as a reference in dating our *Madonna* due to the similarity of Jacopo di Cione's work with Niccolò di Tommaso's, are undated, but may be easily situated between two precise moments of Jacopo's stylistic development, represented by the ex-Stoclet (now Corsini) *Madonna* of 1362[12] and a *Madonna and Child with saints* of 1367, which was recently sold at auction in London and New York.[13] Until further evidence should come to light, it seems to me that Niccolò's panel discussed here may also be placed in the same span of time.

Detail [26] Christ in benediction

Paolo Uccello 1397–1475

27 Christ on the Cross, the Virgin and three mourning saints

*c*1460–5
Panel, 45 × 67 cm including frame; painted surface 36.5 × 58 cm; thickness 2.5 cm
Accession no.1930.118

Provenance
Art market, Florence
Gnecco collection, Genoa, by 1927
Goudstikker, Amsterdam, 1928
Thyssen-Bornemisza Collection, by 1930

Exhibitions
Amsterdam, *Nouvelles Acquisitions de la Collection Goudstikker*, 1928, no.34
Munich, 1930, p.95, no.331
Florence, *Mostra di quattro maestri del primo Rinascimento*, Palazzo Strozzi, 1954, no.22bis
Rotterdam and Essen, 1959–60, no.49
London, 1961, pp.54–5, no.111
Tokyo, *Space in European Art*, National Museum of Western Art, 1987, no.40

Literature
Catalogue des Nouvelles Acquisitions de la Collection Goudstikker, exposées à Amsterdam Mai – Juillet 1928, no.34
R. van Marle, 'Eine Kreuzigung von Paolo Uccello', *Pantheon* I (1928) p.242
van Marle, *Development*, X (1928) pp.210, 214
L. Venturi, 'Paolo Uccello', *L'Arte* XXXIII (1930) p.63
Munich (1930) p.95, no.331
G. Biermann, 'Die Sammlung Schloss Rohoncz', *Cicerone* XXII (1930) p.365
A. Mayer, 'The Exhibition of the Castle Rohoncz Collection in the Munich New Pinakothek', *Apollo* XII (1930) p.96
A. Mayer, 'Die Ausstellung der Sammlung "Schloss Rohoncz" in der neuen Pinakothek, München', *Pantheon* VI (1930) p.314
W. Suida, 'Die italienischen Bilder der Sammlung Schloss Rohoncz', *Belvedere* IX, no.16 (1930) p.176
R. van Marle, 'I quadri italiani della raccolta del Castello Rohoncz', *Dedalo* XI (1930–1) p.1372
W. Boeck, 'Ein Frühwerk von Paolo Uccello', *Pantheon* VIII (1931) p.276
Berenson, *Italian Pictures* (1932) p.341
M. Marangoni, 'Una predella di Paolo Uccello', *Dedalo* XII (1932) pp.334–5, 336, 341
R. van Marle, 'Eine unbekannte Madonna von Paolo Uccello', *Pantheon* IX (1932) pp.79, 80
W. Boeck, 'Uccello-Studien', *Zeitschrift für Kunstgeschichte* II (1933) pp.258–60, 262, 274
G. Pudelko, 'Studien über Domenico Veneziano', *Mitteilungen des Kunsthistorischen Instituts in Florenz* IV (1934) p.176 note 1
G. Pudelko, 'The Early Works of Paolo Uccello', *Art Bulletin* XVI (1934) p.259 note 41
V. Giovannozzi, 'Note su Giovanni di Francesco', *Rivista d'Arte* XVI (1934) pp.358–60
W. Boeck, 'Notizen und Nachrichten. Malerei. Italien 15. Jahrhundert', *Zeitschrift für Kunstgeschichte* IV (1935) p.255
M. Marangoni, 'Paolo Uccello', in *Enciclopedia italiana*, XXVI (Rome, 1935) pp.240–1
G. Pudelko, 'Der Meister der Anbetung in Karlsruhe, ein Schüler Paolo Uccellos', in *Das siebente Jahrzehnt. Festschrift zum 70. Geburtstag von A. Goldschmidt* (Berlin, 1935) p.127
Berenson, *Pitture italiane* (1936) p.279
M. Salmi, *Paolo Uccello, Andrea del Castagno, Domenico Veneziano* (Rome, n.d. [1936]) pp.34–5, 84, 112
Rohoncz (1937) p.154, no.431
M. Salmi, *Paolo Uccello, Andrea del Castagno, Domenico Veneziano*, 2nd edn. (Milan, 1938) pp. 41, 43, 107, 109, 152
E. Arslan, review of Salmi (1938), *Zeitschrift für Kunstgeschichte* VIII (1939) p.314
G. Pudelko, 'Uccello, Paolo', in Thieme and Becker, *Lexikon*, XXXIII (1939) p.525
W. Boeck, *Paolo Uccello* (Berlin, 1939) pp.14–16, 110
P. D'Ancona and M. L. Gengaro, *Umanesimo e Rinascimento* (Turin, 1940) p.156
S. L. Faison, review of Boeck (1939), *Art Bulletin* XXII (1940) pp.282–4
B. Degenhart, review of Boeck (1939), *Zeitschrift für Kunstgeschichte* X (1941) p.79
M. Pittaluga, *Paolo Uccello* (Rome, 1946) pp.18–9

E. Somaré, *Paolo Uccello* (Milan, 1946) pp.37, 46

Rohoncz (1949) p.75, no.257

H. Vollmer, 'Meister der Karlsruher Anbetung', in Thieme and Becker, *Lexikon*, XXXVII (1950) p.174

J. Pope-Hennessy, *Paolo Uccello* (London, 1950) pp.25, 164–6

M. Salmi, 'Riflessioni su Paolo Uccello', *Commentari* I (1950) p.26 note 4

Galetti and Camesasca, *Enciclopedia* (1951) p.1850

Rohoncz (1952) p.78, no.257

M. Horster, 'Die Ausstellung "Quattro maestri del primo Rinascimento"', *Kunstchronik* VII (1954) pp.178, 190

E. Micheletti in *Mostra di quattro maestri del primo Rinascimento*, exhibition catalogue, 2nd edn. (Florence, 1954) pp.58, 60, no.22bis

E. Carli, *Tutta la pittura di Paolo Uccello* (Milan, 1954; 2nd edn. 1959) pp.49, 64–5, 72, nos.114–15

E. Sindona, *Paolo Uccello* (Milan, 1957) pp.23, 57

D. Gioseffi, 'Complimenti di prospettiva–2', *Critica d'Arte*, N.S. nos.25–26 (1958) p.138

Rohoncz (1958) pp.109–110, no.431

M. Davies, 'Uccello's *St George* in London', *Burlington Magazine* CI (1959) p.314 note 28

P. D'Ancona, *Paolo Uccello* (Milan, 1959) pp.18–20

L. Berti, 'Una Madonna e degli appunti su un grande maestro', *Pantheon* XIX (1961) pp.300, 304, 306 notes 8, 13

P. Hendy in London (1961) pp.54–5, no.111

A. Parronchi, 'Il Crocifisso del Bosco', in *Scritti di storia dell'arte in onore di M. Salmi* (Rome, 1962) II, p.249

Berenson, *Italian Pictures* (1963) I, p.88

A. Parronchi, 'Paolo Uccello', in *Enciclopedia Universale dell'Arte*, X (Venice, Rome and Florence, 1963) p.467

P. Hendy, *Some Italian Renaissance Pictures in the Thyssen-Bornemisza Collection* (Lugano-Castagnola, 1964) pp.39–40

Rohoncz (1964) p.81, no.431

H. Saalman, 'Paolo Uccello at San Miniato', *Burlington Magazine* CVI (1964) p.560

J. Lauts, *Staatliche Kunsthalle Karlsruhe. Katalog Alte Meister* (Karlsruhe, 1966) p.187

J. Pope-Hennessy, *Paolo Uccello*, 2nd edn. (London, 1969) pp.22, 168, 171–2

G. Marchini in *Due secoli di pittura murale*, exhibition catalogue (Prato, 1969) p.55

Thyssen-Bornemisza (1970) p.106, no.312

Thyssen-Bornemisza (1971) pp.387–8, no.312

E. Flaiano and L. Tongiorgi Tomasi, *L'opera completa di Paolo Uccello* (Milan, 1971) p.98, no.55

P. A. Rossi, 'Indagine sulla prospettiva nelle opere di Paolo Uccello', *L'Arte*, N.S. XVII (1972) pp.92–3

B. B. Fredericksen, *Giovanni di Francesco and the Master of Prato Vecchio* (Malibu CA, 1974) p.30

A. Parronchi, *Paolo Uccello* (Bologna, 1974) pp.23, 89

Thyssen-Bornemisza (1977) p.119, no.312

Thyssen-Bornemisza (1981) p.320, no.312

Thyssen-Bornemisza (1986) p.324, no.312

F. Petrucci in *Quattrocento* (1987) p.727

Space in European Art, exhibition catalogue (Tokyo, 1987) p.148, no.40

Thyssen-Bornemisza (1989) p.255

A. Angelini in *Pittura di luce. Giovanni di Francesco e l'arte fiorentina di metà Quattrocento*, exhibition catalogue (Florence, 1990) p.77

A. Malquori in *Bernardo da Chiaravalle nell'arte italiana*, exhibition catalogue (Florence, 1990) p.130

Detail [27] the crucified Christ

The crucified Christ dominates the centre of the scene with the Madonna and St John the Baptist on the left and St John the Evangelist and St Francis on the right. The Cross, driven into a rock, is only slightly raised from the ground; fixed to its summit is the inscription INRI. Beyond the figures extends a barren, hilly landscape interspersed with patches of grass.[1]

The panel, originally probably the central element of a predella, preserves its original thickness.[2] A protective layer of wax covers the back of the panel, which has a wax seal 'Goudstikker, Amsterdam' and various labels: 'Collectie Goudstikker. Amsterdam N.2006'; 'g.u.s.g.824'; 'N.1'; '431' and an illegible inscription.

The painting is often described in the critical literature as being in bad state. The exact extent of the damage is clearly revealed in a photograph which was taken before May 1927.[3] The warping of the wood had resulted in numerous fine, horizontal cracks (some at the level of the busts of the figures, and another through the ankles of the two saints on the right) and colour losses (especially in the Madonna's mantle at the level of her waist, in the lower part of the Evangelist's robe and in the ground). The painted surface was worn and dirty and there were numerous worm-holes, damaging above all Christ's face. The restoration undertaken in 1927 included laying down the blisters, removing the dirt, which obscured the colours, and inpainting the losses, with an attempt at reconstructing the more damaged parts of Christ's

Notes

1 Parallel to the trend of late mediaeval iconography (already discussed in cat.[12] note 1), which represented the Crucifixion with increasing realism, historical precision and descriptive detail, there was also an opposite tendency to isolate the protagonist or protagonists, presenting them to the faithful without any distracting details. On the origins of this type of iconography, dating from the thirteenth century, see M. Boskovits, 'Immagini e preghiera nel tardo Medioevo', *Arte Cristiana* LXXVI (1988) pp.93–104. The inscription on the scroll is an abbreviation for 'Jesus Nazarenus Rex Iudeorum' (John 19:19); also E. Lucchesi Palli, 'Kreuztitulus', *Lexikon christlicher Ikonographie*, II (1970) cols.648f.

2 Not only its size but the fact that the grain of the wood runs horizontally suggests that the panel formed part of a predella, as already suggested by Pope-Hennessy (1950, 1969).

3 This photograph (Photographic archives, Kunsthistorisches Institut, Florence) is undated, but it was evidently taken before that of May 1927 with Pietro Toesca's expertise. The latter, showing the painting after restoration, was reproduced by van Marle (1928) and other scholars; the Thyssen *Crucifixion* seems to have remained in the same state until 1959 (see below).

head and body and the Baptist's face. These retouches were partially removed when Wilhelm Suhr cleaned the painting again in 1959.[4] Despite the rather flattened appearance of the forms, caused by the loss of much of their original modelling, the painting clearly preserves its original stylistic character.

No other panels of the altarpiece to which the Thyssen *Crucifixion* originally belonged are known. After appearing on the Florentine market,[5] it was acquired early in 1927 by G.B.Gnecco in Genoa with an attribution to Andrea del Castagno. This emerges from a letter of 27 May 1927 by Pietro Toesca, who was the first to recognise the painting as a work by Paolo Uccello. 'In the Crucifixion', he writes, 'one finds not only the underlying perspective, but also the feeling for colour and mixture of details present in Paolo's extremely rare autograph works, and in particular in the predella in the Palazzo Ducale of Urbino. One may observe in both the *Crucifixion* and the predella . . . the same hands with thread-like fingers . . . the same faces with strangely pointed noses; the exaggerated movements, the vivid sense of colour and perspective'.[6] Subsequently the painting was also shown to van Marle who confirmed the attribution to Paolo Uccello in an expertise dated 26 February 1928,[7] specifying that 'it shows us the master not at the outset of his career but already as a well developed artist with his own peculiar morphological types, spectral backgrounds and fantastic colouring'.

In May 1928, after acquisition by Goudstikker of Amsterdam, the painting was exhibited among the dealer's new acquisitions (*Catalogue* (1928)) again under the name of Paolo Uccello. It was published by van Marle in the same year on two separate occasions. This critic inclined for a relatively early date ('executed between 1425 und 1430') and later confirmed his opinion (1930/1, 1932), relating the *Crucifixion* to those early works by Paolo 'which are still strongly influenced by Gothic taste'. At the time of the Munich exhibition, when the painting was already in the Thyssen Collection, most critics seemed to agree on the attribution (Munich (1930) and reviews by Biermann and Mayer (1930), Venturi (1930)). Suida (1930) held a more cautious position: 'while the landscape clearly appears to be by Paolo Uccello, the figures are much closer to Andrea del Castagno'. Later, however, opinions began to differ. Decidedly in favour of Paolo were Boeck (1931; 1933: 'to be dated around 1420'; 1935; 1939) and Marangoni (1932, 1935), who also proposed an early date, while Berenson (1932, 1936, 1963) favoured the name of Giovanni di Francesco, alias the 'Master of the Carrand Triptych'. Pudelko (1934, 1935, 1939) included it, together with other works given to Paolo Uccello by earlier critics, in the catalogue of the 'Master of the Karlsruhe Adoration', a personality he described as 'an extraordinarily fascinating master, belonging stylistically between Domenico Veneziano and Paolo Uccello'.[8]

Berenson's opinion, which was first rejected by Giovannozzi (1934) in favour of Paolo Uccello, seems to have been definitely discarded by most later critics, while the connection with the 'Karlsruhe Master' was taken up again by Vollmer (1950), Pope-Hennessy (1950, 1969), Lauts (1966) and, implicitly, by Faison (1940) and Saalman (1964). Apart from Horster (1954), from Degenhart and Schmitt (1968), who attribute it to an unspecified follower of Paolo Uccello, and from Somaré (1946), Micheletti (1954) and Gioseffi (1958), who have expressed no definite opinion on the panel's authorship, most scholars now believe the Thyssen *Crucifixion* to be by Paolo himself. Some critics accept the attribution without discussion (Heinemann in Rohoncz (1937, 1949, 1952, 1958, 1964) and in Thyssen-Bornemisza (1971); D'Ancona (1959); Ebbinge Wubben in Rotterdam and Essen (1959/60); Hendy (1961, 1964); Berti (1964); Marchini (1969); the authors of Thyssen-Bornemisza (1970, 1977, 1981, 1986, 1989); Tongiorgi Tomasi in Flaiano and Tongiorgi Tomasi (1971); Rossi (1972); Fredericksen (1974); Petrucci (1987)). It is accepted, at least implicitly, by Ragghianti[9] and Longhi,[10] who both identify the 'Karlsruhe Master' with Paolo Uccello. Among those who explain their opinions more fully, Salmi (1936, 1938, 1950), agreeing with Toesca's idea that it is close to the Urbino predella, notes further similarities with the Oxford *Hunt* (see FIG 2)[11] as evidence for its being a late work. This opinion is shared by D'Ancona and Gengaro (1940),

Notes

4 Information given in the catalogue Rotterdam and Essen (1959/60).

5 This is implied by the fact that the photograph mentioned in note 3 was taken by the photographer Fossi of Florence.

6 Toesca's letter addressed to G.B.Gnecco, and his expertise on the back of the photograph mentioned in note 3, are in the Thyssen archives.

7 The panel was apparently shown for the first time to van Marle by Gnecco; on this occasion he went no further than to confirm Toesca's attribution, in writing, on the back of the same photograph (which is now in the Thyssen archives), under the date 20 December 1927. The following year he wrote a more detailed expertise for Goudstikker, a copy of which is also in the Collection archives.

8 The works attributed to this fictitious master were grouped round the *Adoration of the Christ Child with three saints* in the Staatliche Kunsthalle, Karlsruhe (no.404). This painting was first attributed to Paolo Uccello by Charles Loeser, 'Paolo Uccello', *Repertorium für Kunstwissenschaft* XXI (1898) p.83. Subsequently various other attributions were suggested until Pudelko (1934, 1935) assembled the following works under the name of the 'Karlsruhe Master': *Scenes of monastic life* (Florence, Accademia; note 12 below), the Quarata predella (note 13 below), the Thyssen *Crucifixion*, the Jacquemart-André *St George* and the Assumption Chapel frescoes in Prato Cathedral (note 14 below), besides other pictures that are extraneous to Paolo Uccello's œuvre.

9 C.L.Ragghianti, 'Intorno a Filippo Lippi', *La Critica d'Arte* III (1938) pp.xxii–xxv.

10 R.Longhi, 'Il Maestro di Pratovecchio', *Paragone* III, no.35 (1952) p.32 note 8.

11 Ashmolean Museum, no.79a. Loeser (1898, p.87f.) attributed the painting to Paolo Uccello; it has since been generally accepted as one of the artist's late works.

12 No.5381. The painting was connected with Paolo Uccello's circle by Carlo Gamba, 'Di alcuni quadri di Paolo Uccello . . .', *Rivista d'Arte* VII (1909) p.19, who regarded it as by the same hand as the Karlsruhe *Adoration*. Later Boeck (1931) attributed it to Paolo himself and Pudelko (1935), followed by others, to his 'Karlsruhe Master'.

13 This predella, representing
the *Adoration of the Magi* at the
centre and kneeling saints in the
lateral scenes, comes from the
church of San Bartolomeo a
Quarata near Florence (on
deposit, Santo Stefano al Ponte,
Florence). It was published by
Marangoni (1932) as a work by
Paolo Uccello and later referred by
Pudelko (1935), among others, to
the 'Karlsruhe Master'. Salmi
('Paolo Uccello, Domenico
Veneziano...', *Bollettino d'Arte*
XXVIII (1934) p.1f.) attributed it,
together with the Prato Cathedral
frescoes, to a 'Master of Quarata'.
14 The works grouped under the
name of the 'Prato Master',
author of the frescoes (*Four
Virtues* and *Scenes form the Lives of
the Virgin and St Stephen*) in the
Assumption Chapel of Prato
Cathedral, were attributed to the
'Master of Quarata' by Salmi
(1934) and to the 'Karlsruhe
Master' by Pudelko (1935). Other
critics, including Ragghianti
(1938), accepted them as by
Paolo Uccello.
15 In a later article ('Una
conferma uccellesca', *L'Arte*, N.S.
IX (1970) p.104 note 5), Sindona
refers to Berti's 'convincente
discorso critico', in which he
identified the 'Karlsruhe', 'Prato'
and 'Quarata'' Masters with Paolo
Uccello himself.
16 For this crucifix, the
attribution of which is still
controversial, see A. Natali in
*Donatello e i suoi. Scultura
fiorentina del primo Rinascimento*
(Florence, 1986) p.174f., where it
is dated around 1450 and the
attribution to Donatello is
accepted with reservations.
17 Vasari's *Life* of Paolo Uccello
(Vasari, ed. Milanesi, II, p.213)
describes the artist's frescoes at
length and in terms of great
admiration, but refers only briefly
to his panel paintings ('in molte
case di Firenze sono assai quadri
in prospettiva per vani di lettucci,
letti ed altre cose piccole') and
makes no mention of his
altarpieces.
18 For instance, the monk on the
extreme left of the group of
flagellants around the Cross, with
an almost identical profile to that
of St John, or the monk running
in the left foreground, whose
habit has the same stylized folds
created by the movement of his
legs as that of St Francis in the
Thyssen painting.
19 This panel, representing
Christ (practically lost), the
mourning Virgin and St John,
dated 1452, from the Oratory of
the Annunziata at Avane, near

Pittaluga (1946), Galetti and Camesasca (1951), Carli (1954) and, with slight reservations, by Arslan (1939) and Degenhart (1941). Gioseffi (1958), while unable to make up his mind whether to identify Paolo Uccello with the 'Karlsruhe Master', is convinced that the works given to the latter cannot be included in Paolo's early activity. After initially agreeing with Boeck on the painting's early date, Sindona (1957) related it to other works generally held to be by followers of the artist: *Scenes of monastic life* (Florence, Accademia),[12] the predella of San Bartolomeo a Quarata[13] and the Karlsruhe *Adoration*. However, he later accepted Berti's proposal (1961) to include the works given both to the 'Karlsruhe Master' and to the 'Prato Master' in Paolo's œuvre[14] and a date for the *Crucifixion* close to the Urbino predella.[15] Tongiorgi Tomasi (1971) also seems to agree with a late dating, around 1460, and recently Malquori (1990) includes the Thyssen *Crucifixion* among Paolo's works of the 1460s. Parronchi has returned to the problem on several occasions: after drawing attention (1962) to similarities between the figure of Christ crucified and the crucifix attributed to Donatello in the convent of Bosco ai Frati,[16] he dated the painting to 'the second half of the painter's activity' (1963). He later (1974) expressed the opinion that the Thyssen panel is one of the works 'most closely akin' to the frescoes in the Assumption Chapel in Prato Cathedral, datable around 1435, observing that the artist's style appears less developed in these works than in the Avane predella of 1452 (Florence, Museo di San Marco).

Opinions also differ regarding the quality of the Thyssen *Crucifixion*, which is termed a work of 'extraordinary dramatic force' by van Marle (1928), but considered 'of inferior quality' by Pudelko (1935). In Pope-Hennessy's view (1950, 1969), 'the relatively low quality of drawing and execution affords a decisive argument against an ascription to Uccello', while according to Carli (1954, 1959) the 'dryness of its formal idiom, the aristocratic isolation of the limpid and concise volumes, the emphasis on perspective and the very austerity of its inspiration' would confirm the artist's authorship. As to Berti (1961), he regards the work as worthy of Paolo Uccello merely on the grounds of its fine quality.

Considering how many of Paolo Uccello's paintings are lost, it is virtually impossible to reconstruct the chronology of his œuvre with any precision. One must remember that Paolo Uccello was primarily a fresco painter,[17] yet of his works in this medium generally accepted as autograph only the *John Hawkwood* and the clock-face in Florence Cathedral have survived in reasonably good state. Consequently any attempt at dating the Thyssen *Crucifixion* demands the utmost caution. The question of its authorship is, I believe, beyond all doubt. Since it was cleaned in 1959 much of the mawkish inpainting, which probably accounted for the perplexities expressed by a number of critics, has disappeared, and in its present state the picture reveals strong affinities with two of the artist's certain works, the Urbino predella and the Oxford *Hunt*. A number of its features, such as the elegant, rhythmic movements of the figures, silhouetted against the strongly contrasted background, the well-defined flowing contours, the characteristic faces with pointed noses, receding chins and sunken but lively eyes and amazed expressions, the small elegantly gesticulating hands with fingers invariably spread out, the draperies falling in geometrical folds, enclosing the fragile bodies like shells, and lastly the landscape with its undulating line of bare hills with scattered patches of grass seen in foreshortening, all recur in the *Story of the profanation of the Hosts* of the Urbino predella. There are also numerous affinities with the Oxford *Hunt* and the Florence, Accademia, *Scenes from monastic life*, with its fantastic landscape of varied, cut-out forms inhabited by hermits who could well be the kinsmen of the figures in the *Crucifixion*.[18] The design is confident and elegant, while the emotional charge of the scene, not devoid of harshness and even grotesque overtones, finds its counterpart in the Urbino predella.

Apart from the question of date, which on the basis of the above considerations should be placed around 1460, it is interesting to compare the *Crucifixion* with the predella formerly at Avane.[19] In that work the mourning Madonna (FIG 1) is very similar in pose but, huddled as she is in the folds of her cloak, it is the profound pathos of her expression – a feature absent in

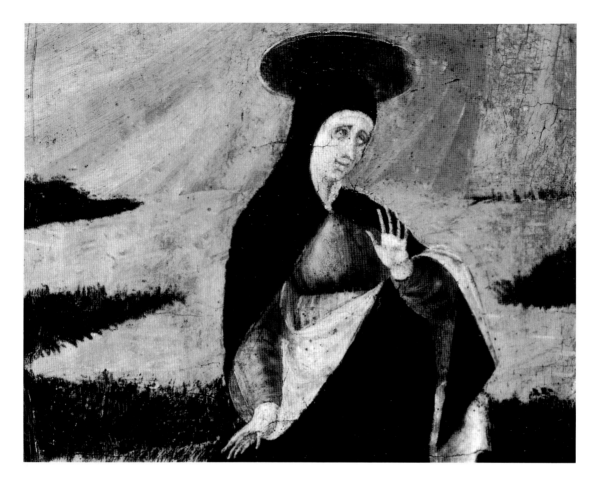

Detail [27] the Virgin

FIG 1 Paolo Uccello, *The Virgin mourning* (detail of a predella, formerly Avane, now Florence, Museo di San Marco)

Detail [27] St John

FIG 2 Paolo Uccello, *The Hunt* (detail) (Oxford, Ashmolean Museum)

both the Thyssen painting and the Urbino predella – that strikes one most. In my opinion, the execution of the Avane predella coincides with a new phase of Paolo's style. During the 1430s and 1440s, when he painted the *Stories of Noah* in the Chiostro Verde of Santa Maria Novella and the three panels of the *Rout of San Romano* and designed windows for the Cathedral,[20] Paolo's style had been dominated by Donatello's influence. After 1452 (the date of the Avane panel) Paolo appears to have been less interested in strong emotions and dramatic, grandiose effects, preferring instead to emphasize the smoothness and rotundity of his forms and the rhythmic complexities of his profiles, with an eye for polished and elegant detail, besides exploiting his proverbial mastery of perspective in a play of ornamental effects. His works dating from these later years, if one includes both those attributed to the 'Karlsruhe' and 'Quarata' Masters and those usually regarded as autograph (such as the San Miniato *Scenes of monastic life*) and also a little known tabernacle of unknown whereabouts (FIG 3) which may be considered Paolo's last known version of the theme of the *Crucifixion*,[21] have various elements in common with the style of Giovanni di Francesco: the ostentatious perspective rendering of architectural settings, the playful realism of the narrative and the somewhat mannered elegance of the gestures. This, probably a consequence of close contacts between the two artists, explains why certain paintings have been attributed alternately to both of them.[22] Essentially, however, the stylistic characteristics of the 'Karlsruhe' group fit into Paolo's œuvre of the 1440s. The Thyssen *Crucifixion*, which has also been accepted as autograph by some critics who consider the 'Karlsruhe Master' an autonomous personality, acts as a link between the paintings grouped round the Karlsruhe *Adoration* and Uccello's latest phase. Excluding, therefore, the possibility of its being an early work,[23] a relatively late dating of the *Crucifixion*, somewhere between 1452 and 1467/8, and presumably closer to the latter, seems reasonable.

Notes

Florence, now in the Museo di San Marco, was originally the predella of an *Annunciation* which was stolen at the end of the nineteenth century.

20 The *Rout of San Romano* series is generally supposed to have been painted after 1451, *ie* after the completion of Palazzo Medici, where they are first mentioned in 1492; Pope-Hennessy (1969) p.152f. Recently, however, Parronchi (1974, p.34f.) and Volpe ('Paolo Uccello a Bologna', *Paragone* XXXI, no.365 (1980), p.20) have proposed a date in the later 1430s; see also P. Joannides, 'Paolo Uccello's "Rout of San Romano": a new observation', *Burlington Magazine* CXXXI (1989) pp.214–6.

The generally accepted dating for the *Noah* frescoes (c1446–8) is also far from certain. Volpe's cautious suggestion (1980) that they were painted shortly after 1440 is probably closer to the truth.

21 The frescos representing *Scenes of monastic life* (San Miniato, cloister) are usually dated around or before 1440; Tongiorgi Tomasi (1971) p.90f. However, Saalman (1974, p.558f.) has shown that they could not have been painted before 1447, the date of the cloister's completion. What remains of this cycle today resembles, both in the figure types and in the landscape, the 'Karlsruhe Master' phase of Paolo Uccello, suggesting a date in the 1450s. Also belonging to this phase is the portable triptych (formerly Knoedler's, New York; fig.3), which has not, so far as I know, hitherto been related to Paolo Uccello, but which Parronchi (1974, pl.24a) attributed to the artist's daughter Antonia, by whom no works are known. To my mind, despite its poor state, it is an autograph work by Paolo Uccello.

22 Various works now given to Paolo Uccello (the *Creation* and the *Fall* in the Chiostro Verde, the Prato frescoes, the fragment with a *Female saint and two children* (Gallerie Fiorentine, Contini-Bonacossi bequest) and the Karlsruhe *Adoration*) were for a while attributed by Longhi to Giovanni di Francesco ('Ricerche su Giovanni di Francesco', *Pinacoteca* I (1928) p.36f.). Later, Longhi (note 10 above) included in Paolo Uccello's œuvre all these works. On the problem see now L. Bellosi's important study in *Pittura di luce. Giovanni di Francesco e l'arte fiorentina di metà Quattrocento* (Florence, 1990) pp.11–45.

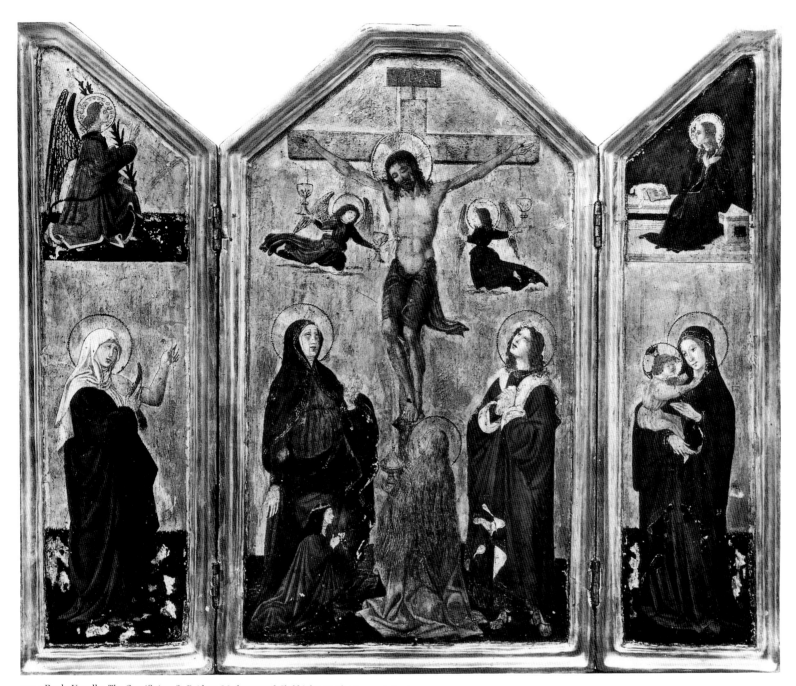

FIG 3 Paolo Uccello, *The Crucifixion; St Bridget; Madonna and Child* (above: *The Annunciation*)
(formerly New York, Knoedler's; whereabouts unknown)

23 Little as yet is known of
Paolo's beginnings as an artist.
The most convincing proposals
are those put forward by Volpe
(1980), while I fail to follow
Bellosi's arguments ('Santa Maria
Novella', *Prospettiva*, no. 37
(1984) p. 88f.) for rejecting
Paolo's authorship for the frescoes
of the *Creation* and *Fall* in the
Chiostro Verde and for his dating
them to the same moment as the
Noah cycle.

Pietro da Rimini active c 1315–35

28 Episodes from Christ's infancy

c 1330
Tempera on panel, 17.2 × 19.7 cm; thickness c 1.5 cm
Accession no.1979.63

Provenance
G.H.Dixon, England
Christie's, London, 1978
Thyssen-Bornemisza Collection, 1978

Literature
Important Old Master Pictures, sale catalogue (Christie's, London, 1 December 1978) pp.32–3
Thyssen-Bornemisza (1981) p.254, no.249A
Thyssen-Bornemisza (1986) p.256, no.249a
D.Benati, in *Le origini* (1985), p.165
D.Benati in *Duecento e Trecento* (1986) pp.204, 651
Boskovits, *Berlin. Katalog* (1987) pp.144–6
M.Boskovits, 'La nascita di un ciclo di affreschi del Trecento: la decorazione del Cappellone di San Nicola a
 Tolentino', *Arte Cristiana* LXXVII (1989) pp.17, 23, 26
Thyssen-Bornemisza (1989) p.262

The composition combines four episodes from Christ's infancy: above right, the *Nativity*, with the Madonna lying on the ground beside the manger, the animals, and St Joseph seated in the foreground; towards the centre, also in the foreground, the infant Jesus is bathed by Zelomi and Salome (the legendary women mentioned in the apocryphal Gospel of St James); above, in the background, is the *Annunciation to the Shepherds* and below, on the left, the *Arrival of the Kings*.[1]

On the whole the condition of the panel is satisfactory but the painted surface and the gold ground are slightly worn. There are also a few light scratches and numerous minute colour losses. In the area between the right hoof of the first King's horse and the back of the midwife seated on the ground are a few larger losses that have been touched in. The panel seems to have been trimmed at the top. Along the other edges is an unpainted strip, a few millimetres wide, which would have been covered by the original frame. The back is painted to resemble variegated white, grey and green marble.

One may deduce from the small size of the panel and the marbled decoration on the back that it formed part of a portable altarpiece (FIG 1). This was probably a triptych with scenes from the life of Christ arranged horizontally on two levels. Two sections from the same complex, which had already been dismembered before 1819,[2] represent the *Presentation in the Temple* and the

Note
1 For the symbolic interpretation of specific elements in the composition (the ox and ass alluding to the incredulity of Israel as expressed in Isaiah 1,3, or to the Church uniting both the Chosen but unfaithful People and the Gentiles, according to the interpretation of St Augustine) and the origin and development of the theme of the First Bath, etc., see Schiller, *Ikonographie*, I (1966) p.69f., who also discusses the connection between the Nativity and the episodes of the Annunciation to the Shepherds and the Adoration of the Magi.

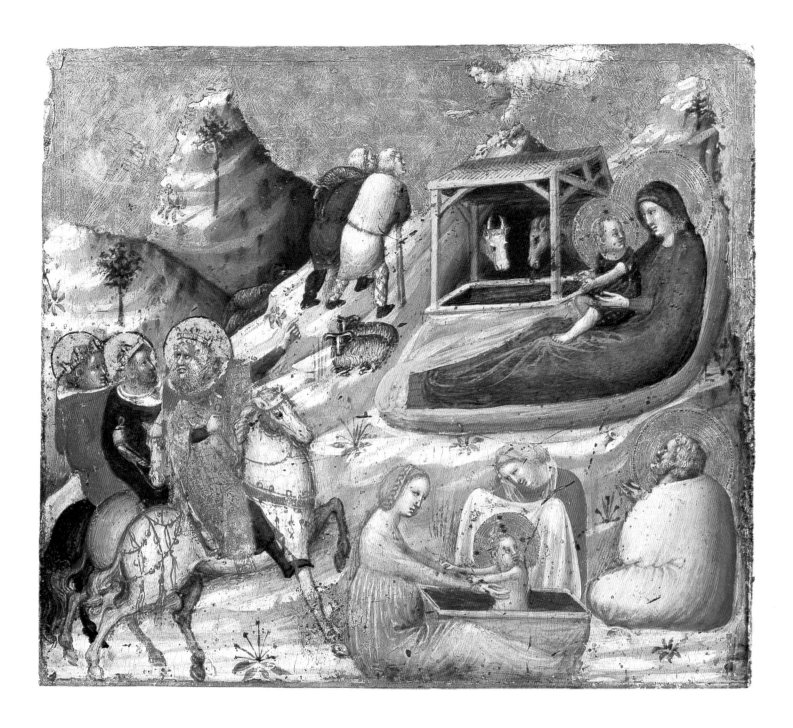

a

Entombment of Christ (Berlin, Gemäldegalerie; FIG 1b and c).[3] Two other fragments with the *Resurrection* and the *Noli me tangere* (FIG 1d), which originally formed a single panel, and were preserved together with the Thyssen panel in the collection of G.H.Dixon until 1978, have since been dispersed on the art market.[4] The almost identical dimensions and thickness of these paintings, the decoration *à ramages* of the gold ground and the concentric circles of the halo decoration, as also the marble imitation panel on the reverse, leave no doubt as to their being companion panels. These features are absent in the *Deposition*[5] and the *Crucifixion* in the Pinacoteca Vaticana,[6] thus confuting the theory that these two scenes also belonged to the same complex.

Notes
2 In that year the two small Berlin panels were listed separately among the paintings of the Solly collection about to be sold to the Berlin Gemäldegalerie; Boskovits (1987) p.144–6.
3 No.1116. The *Presentation in the Temple* measures 18.5 × 20.3 cm, the other panel 18.6 × 20.2 cm. Both were acquired by the Gemäldegalerie of the Staatliche Museen of Berlin in 1821.

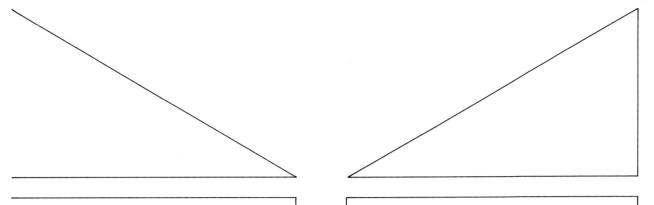

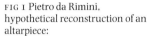

FIG 1 Pietro da Rimini,
hypothetical reconstruction of an
altarpiece:
a *The Nativity* (Thyssen
Collection)
b *The Presentation in the Temple*
(Berlin, Staatliche Museen,
Gemäldegalerie)
c *The Entombment* (Berlin,
Staatliche Museen,
Gemäldegalerie)
d *The Resurrection; Noli me tangere*
(whereabouts unknown)

c

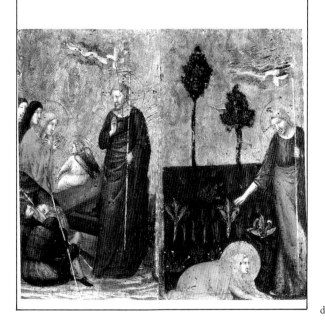

d

4 The *Resurrection* and *Noli me
tangere* measure 17.2 × 9.6 cm
each and, to judge from the veins
in the wood and the marbled
decoration on the backs, they
must originally have formed a
single panel.

5 No.167 (formerly no.56),
19.5 × 21.55 cm. Although the
measurements of the panel are
close to those of the series under
discussion, the incised decoration
of the gold ground is different.

It is possible to reconstruct the appearance of the original triptych from the way the surviving panels have been divided. The *Episodes from Christ's infancy* and the *Resurrection* with the *Noli me tangere* are cut along the top but not on the other sides; the *Presentation* is cut below and on the right and the *Entombment* is cut above and on the left. Their arrangement would therefore have been as follows: on the left wing a lost scene, probably the *Annunciation*, above the *Episodes from Christ's infancy*; in the central panel, the *Presentation* and another lost scene, probably the *Crucifixion*, above, and again a lost scene, perhaps the *Deposition*, next to the *Entombment* below. This leaves the right wing, which probably had the *Descent of Christ into Limbo* above and the *Resurrection* and *Noli me tangere* below.

The panel in the Thyssen Collection was published in Christie's sale catalogue (1978) as by Pietro da Rimini (together with the *Resurrection* and the *Noli me tangere*, which were then separately framed but hinged to the *Episodes of Christ's infancy* to resemble a triptych). In 1965 Volpe[7] had already attributed the panels in Berlin to the same artist, dating them around 1330 and proposing a similar date for the diptych in Hamburg (Kunsthalle)[8] and the frescoes in the churches of Santa Chiara and San Francesco at Ravenna. The five fragments were first discussed together under Pietro's name in the Collection guide book (Thyssen-Bornemisza, 1981) as forming part of a predella and subsequently (1986) as elements of 'an altarpiece ... executed around 1335'. Benati (1986), who refers to them as parts of an 'anconetta', believes 'they should be studied alongside the Paduan frescoes' (ie the rest of a mural decoration formerly in the chapter hall of the Eremitani in Padua and now in the Padua Museum), dating them as far back as the early 1320s. Boskovits (1987) proposed basically the reconstruction given here and noted close stylistic analogies between the Berlin *Presentation* and the frescoes in Santa Maria in Porto Fuori, Ravenna,[9] preferring a date around 1330. It should be remembered that these frescoes were probably executed in the early 1330s[10] and that their author, identified by some critics with Pietro da Rimini and by others with a 'Master of Santa Maria in Porto Fuori',[11] had already been associated by Brandi and Longhi with the two panels in Berlin.[12] On the other hand, those scholars who limit Pietro's œuvre to the works stylistically closest to the signed crucifix at Urbania regard Pietro's development as confined between the presumed early moment of dramatic expressiveness represented by the Urbania crucifix (second half of the second decade) and the Giottesque moment of the Paduan frescoes of c1324.

It is not possible to discuss here at sufficient length all the arguments in support of a date for our panel around or shortly before 1330. This proposed dating is based on a chronology which accepts the data of circa 1318 for the frescoes in the refectory of the abbey of Pomposa[13] as the starting point for our knowledge of Pietro's activity. His style developed in the following decade towards the emotional depth and increasingly complex and imaginative form of expression exemplified by the paintings of the 'Cappellone' in San Nicola at Tolentino (FIG 2),[14] reaching the grandiose classicism of the frescoes in San Pietro in Sylvis and in Padua[15] by the later 1320s. These were followed, in the late 1320s and early 1330s, by the fresco cycles in Ravenna. The narrative element in the series of panels which concerns us here reveals the artist in one of his most lively and intensely poetical moments, and particularly so in the Thyssen Nativity. Here the four episodes are bound together in a single composition, like a sequel on a stage. Pietro achieves this unity by means of a bold use of perspective: for instance, the young woman giving the Child his first bath is slightly larger than the Madonna, whereas the usual iconography in the early Trecento demanded the contrary. The artist introduces entirely new episodes in his story, such as the way in which the oldest King and the Christ Child recognise each other, simultaneously conveying this to the person nearby, or the shepherd with a lamb on his shoulders, listening to the angel's message, who seems to prefigure the 'Good Shepherd'. The atmosphere of the narrative, the free and lively brushwork, the elongated figures and the emphasis on the rhythmic balance of their movements suggest that this series of panels should be placed between the Tolentino frescoes and those in Santa Maria in Porto Fuori, but closer to the latter, in which one notes certain details of costume[16] that are also present in our panel.

Notes

Similar decoration appears in a small *Birth of the Virgin* (18.4 × 20.1 cm; formerly Henckell collection, Wiesbaden), correctly related to the Vatican panel; C. Volpe, *La pittura riminese del Trecento* (Milan, 1965) p.85, figs.235-6. It is likely that both belonged to another tabernacle.

6 No.178; 24.5 × 17 cm. The connection between the Berlin panels (no.1116) and the Thyssen painting was put forward by Benati (1986, p.204), to whom the suggestion had been made privately by Carlo Volpe.

7 Volpe (1965) p.26f.

8 Nos.756-7; reproduced in Volpe (1965) figs.94-5.

9 Compare, for instance, the figure of the prophetess Anna, wrapped in an ample cloak and seen from behind, in the Berlin *Presentation* with that of the young apostle in the *Dormitio Virginis* fresco in Santa Maria in Porto Fuori (reproduced Volpe (1965) fig.218). An earlier version of the same motif occurs in the *Entry into Jerusalem* in the 'Cappellone' of San Nicola at Tolentino (Volpe (1965) fig.255).

10 The unusual representation of the *Stories of the Antichrist* in the Ravenna frescoes would seem to be intended as a political allegory. For historical reasons the date of execution may be placed between 1329 and 1333; cf. F. Bisogni, 'Problemi iconografici riminesi', *Paragone* XXVI, no.305 (1975) pp.13-23.

11 Ever since Lionello Venturi ('A traverso le Marche', *L'Arte* XVIII (1915) p.8) proposed the name of Pietro da Rimini for the cycle at Ravenna, it has been given or related to this artist. Roberto Longhi since 1934/5 ('La pittura del Trecento nell'Italia Settentrionale', published in *Lavori in Valpadana. Edizione delle opere complete di R. Longhi*, XI (Florence, 1973) p.72f.), and subsequently other scholars preferred to distinguish the author of these frescos as a separate personality under the name of the 'Master of Santa Maria in Porto Fuori'.

12 C. Brandi in *Mostra della pittura riminese del Trecento*, exhibition catalogue (Rimini, 1935) pp.xxvi, 202f., and R. Longhi, 'Quadri italiani di Berlino a Sciaffusa', *Paragone* III, no.13 (1952) p.41.

13 The interpretation of an old inscription, which was erroneously transcribed before being destroyed, would suggest that the decoration was executed

between 1316 (the beginning of the papacy of John XXII) and 1320 (the end of the rule of Abbot Henry). This interpretation has found confirmation in the discovery, when the fresco was detached, of a *graffito* on the underlying plaster with the date 1318; M. Salmi, *L'Abbazia di Pomposa* (Milan, 1966) p.162f.

14 See Boskovits (1989) p.3f., who dates the cycle to shortly before the saint's canonization trial in 1325.

15 See C. Gnudi, 'Il restauro degli affreschi di San Pietro in Sylvis a Bagnacavallo', in *Scritti di storia dell'arte in onore di Ugo Procacci*, I (Milan, 1977) pp.120–36. The frescoes were certainly executed by 1332, but the dating of *c*1320 advanced by most recent scholars appears to me a little too early.

16 For instance, one can compare such details of dress as the hood of the two Kings or the hair-do and the dress, with its high waist and large décolleté, of the young woman in the foreground in the Thyssen panel with similar details in the cycle of Santa Maria in Porto Fuori (the *Massacre of the Innocents* and the *Woman on a balcony*, reproduced in Volpe (1965) figs.219–20).

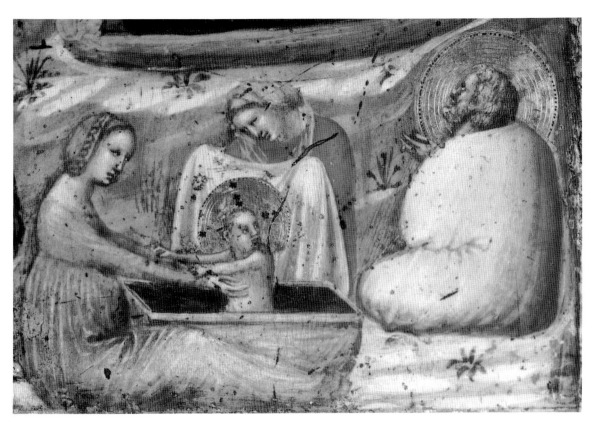

Detail [28] the bathing of the Christ Child

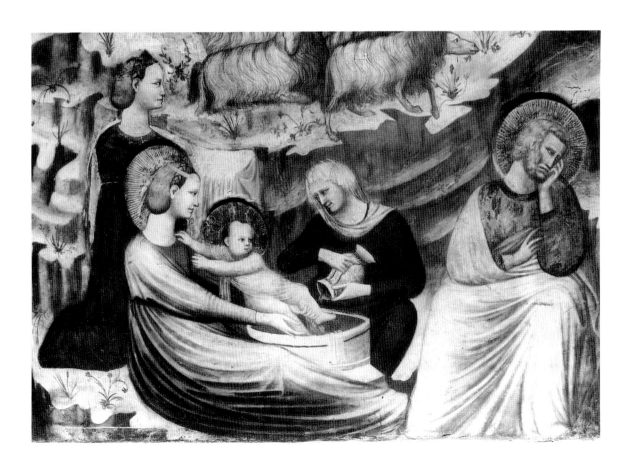

FIG 2 Pietro da Rimini, *The Nativity* (detail) (Tolentino, San Nicola)

Ugolino di Nerio documented 1317–27

29 Christ on the Cross between the Virgin and St John

*c*1330–5
Tempera on panel, 135 cm high at the centre, 95.5 cm at the sides; width 89 cm; thickness *c*3.5 cm
Accession no.1968.3

Provenance
Convent of San Francesco, San Romano, Empoli?
Museo Civico, Pisa (after the suppression of San Romano, 1866?)
Giuseppe Toscanelli, Pisa, by 1883
Heirs of Giuseppe Toscanelli, Florence and Pontedera
Thyssen-Bornemisza Collection, 1968

Exhibitions
USA tour, 1979–80 (not included in the catalogue)
Paris, 1982, no.19

Literature
G.Milanesi, *Catalogue de Tableaux, Meubles et Objets d'Art formant la Galerie de Mr. le Chev.r Toscanelli* (Florence, 1883)
 p.24, no.89 (album, pl.XX)
Cavalcaselle and Crowe, *Storia*, III (1885) p.30
S.Reinach, *Répertoire de Peintures du Moyen Age et de la Renaissance (1280–1580)*, I (Paris, 1905) p.412
Crowe and Cavalcaselle, *History*, 2nd edn., III (1908) p.25
van Marle, *Scuole*, II (1934) p.106
G.Coor Achenbach, 'Contributions to the Study of Ugolino di Nerio's Art', *Art Bulletin* XXXVII (1955) pp.163–4
A.Parronchi, 'Segnalazione duccesca', *Antichità Viva* V, no.2 (1966) pp.3–6
A.Parronchi, 'Una Crocifissione duccesca', in *Giotto e il suo tempo. Atti del convegno internazionale per la celebrazione
 del VII centenario della nascita di Giotto, 1967* (Rome, 1971) pp.311–8
G.Cattaneo and E.Baccheschi, *L'opera completa di Duccio* (Milan, 1972) p.99, no.147
'Ugolino di Nerio', in *Dizionario Bolaffi*, XI (1976) p.197
H.B.J.Maginnis, 'The Literature of Sienese Trecento painting 1945–1975', *Zeitschrift für Kunstgeschichte* XL (1977)
 p.283
J.H.Stubblebine, *Duccio di Buoninsegna and his School* (Princeton, 1979) I, pp.162–3
Thyssen-Bornemisza (1981) p.321, no.312A
A.Rosenbaum in Paris, 1982, p.40
H.B.J.Maginnis, 'The Thyssen-Bornemisza Ugolino', *Apollo* CXVIII, no.3 (1983) pp.16–21
Thyssen-Bornemisza (1986) p.325, no.312a
Thyssen-Bornemisza (1989) p.333

The crucified Christ is surrounded by six angels flying in a circle. To either side of the Cross are the mourning Virgin and St John, originally both full-length figures.[1] This gabled panel has been cut below and reduced by about a fifth of its original height. A strip of wood, reconstructing the lost lower part, restored the panel, bringing its height to 170 cm, in the illustration of the Toscanelli sale catalogue of 1883; this addition was removed when the painting was restored by Marco Grassi in 1978.

The damage suffered by the picture in the past has affected the stability of the wood support rather than the painted surface, which, apart from some lacunae, is relatively well preserved. A vertical crack, from Christ's left shoulder to his feet, has caused losses in the preparation and the paint that have now been repaired. Another less deep crack is visible between Christ's left hand and the angel below. The craquelure is very pronounced. There is a scratch across Christ's body at the level of his waist that continues at intervals in the gold on the right. The gold ground is

Note
1 For the iconographical development of the Crucifixion in fourteenth-century Italian painting see Sandberg Vavalà, *Croce dipinta* (1929) and Schiller, *Ikonographie*, II, p.98f.

Detail [29] the Virgin

badly rubbed revealing the red bole (the same colour has been used to fill in the missing areas of gold). Some worm-holes and other losses in the wood have been left. The larger damages in the gesso and the paint, in Christ's left hand and along the lower edge, have been filled in and inpainted.

Besides being truncated along its base, the sides of the panel also appear to have been slightly trimmed, to judge from the worn, uneven edges and the underlying canvas clearly visible where the wood is broken. Only the gable appears intact: its unpainted edge was originally covered by the frame.

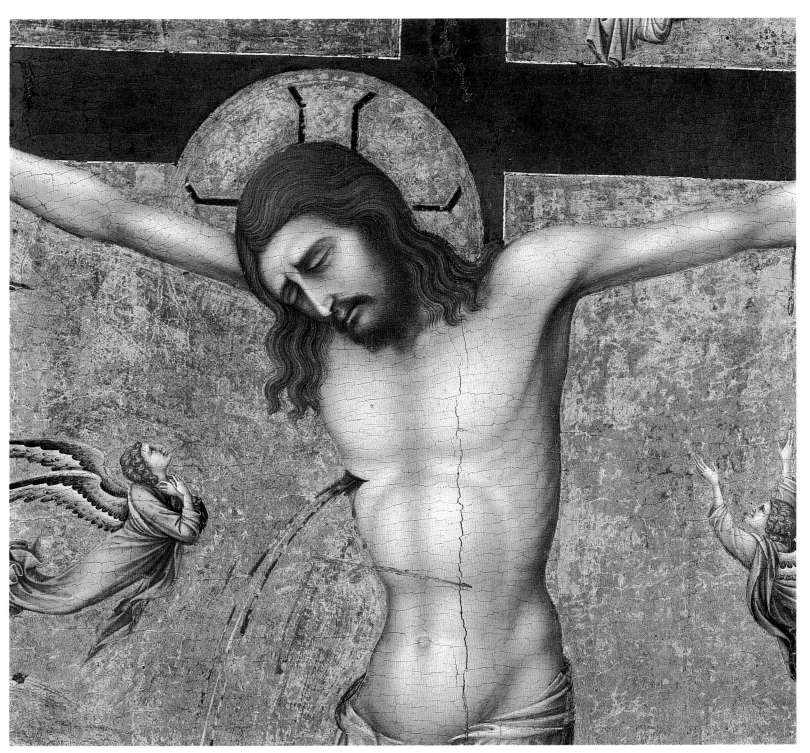

Detail [29] Christ on the Cross

On the back are traces of original stucco, covered by brown paint. The panel has been thinned down on the sides in response to the poor condition of the wood, which is full of wormholes. Along the lower edge are nail-marks, probably dating from the restoration of the panel in the nineteenth century. The upper part of the panel is fixed by a horizontal batten 12.5 cm thick. There is another lower down of 5.5 cm, and the traces of a third one, formerly wedged into the lowest part of the panel, measuring 12.5 cm. Above the latter, to the right, is an incised drawing of a flower. Two holes at the same height on either side of the panel (34.5 cm from the base; 60 cm from the top) probably mark the point at which it was joined to the original frame.

The panel was first published in the Toscanelli sale catalogue compiled by Milanesi (1883). Its provenance was given as the convent of San Romano near Empoli and it was attributed to Duccio. As 'a small panel' still in the Toscanelli collection it was mentioned in the Italian edition of *A New History of Painting in Italy* by Cavalcaselle and Crowe (1885); the two authors quote it in the section on Ugolino stating that the painting has 'qualities that bring to mind the works of Duccio and of Ugolino, although an examination of the original left us uncertain as to which of the two it could really be attributed to'.[2] Since Crowe and Cavalcaselle did not mention this painting in the first edition (1864–6), it may be assumed that it was acquired later. The comment is repeated in their second English edition (1908), where the *Crucifixion* is described in greater detail and stated to have been 'once in the Toscanelli Collection at Pisa'.[3] Reinach's *Répertoire* (1905) follows Milanesi in giving the provenance as San Romano and attributing the painting to Duccio.

Van Marle (Italian edn., 1934) refers to the painting as at 'Pisa, formerly Toscanelli Collection' and leaves it in the limbo of anonymous Duccesque works. Coor (1955) was the first to attribute it definitely to Ugolino, probably after seeing it in Florence when it was in the hands of Toscanelli's heirs. She describes it as '... the well preserved Duccesque *Crucifixion* from the Toscanelli Collection which was in recent years in another private collection in Florence. Despite the fact [she adds] that the latter work is of very high quality, in excellent condition, and of considerable size, and that it was attributed to Duccio by ... Gaetano Milanesi ... it is now virtually unknown'. Without referring to Coor, Parronchi (1966) reproposed the attribution to Duccio. He advanced the idea that the painting could be the missing central pinnacle from the front of Duccio's *Maestà*, confirming his opinion in a subsequent lecture (1967; published in 1971). Baccheschi in Cattaneo and Baccheschi (1972) limited herself to citing Parronchi's theory, which remains without supporters, whereas Coor's attribution to Ugolino has been unanimously accepted by later criticism: *Dizionario Bolaffi* (1976), Maginnis (1977), Stubblebine (1979), Rosenbaum (in Paris (1982)) and the catalogues of the Collection (Thyssen-Bornemisza (1981, 1986, 1989)). All agree that the *Crucifixion* is a key-work in Ugolino's œuvre and date it around 1325; only Maginnis (1983) brings the date forward to 1310–15 and proposes identifying the panel with the altarpiece described by Vasari in the Bardi Chapel in Santa Croce.[4]

The hypothesis, although tempting, implies that at least until the mid-sixteenth century, when Vasari gave a detailed description of the painting he saw in the Bardi Chapel,[5] Ugolino's altarpiece was in its original location. However, granted that it indeed comes from San Romano, it seems extremely unlikely that it would have been transferred from the Franciscan conventual church of Santa Croce to the Observant Minor house of San Romano after the mid-sixteenth century, considering that the two branches of the order had then been divided for over a hundred years.[6] Furthermore, judging from the panel's original proportions it seems likely that it formed the central part of a larger complex, whereas Vasari records only a single painting.

A Florentine and Franciscan provenance is likely, especially since there is apparently no mention of Ugolino's *Crucifixion* in documents or sources relating to the church of Santa Maria di Vaiano or to the adjoining convent of the Observant friars at San Romano. Nor is the picture listed among the works collected by Lasinio in the Camposanto of Pisa from the various religious communities of the Pisan area at the time of the Napoleonic suppression in 1810.[7] The definitive suppression of San Romano, it is true, seems to have taken place only much later, in 1866,[8] and it cannot be excluded that the painting was either requisitioned or brought to Pisa by one of the dispersed friars after that date. This would explain the otherwise unconfirmed information according to which the panel was temporarily assembled with other works removed from conventual houses to form the nucleus of the Pinacoteca Comunale of Pisa in 1875,[9] before being acquired by Giuseppe Toscanelli.[10]

Thanks to its condition, with its paint surface largely uncompromised, the Thyssen

Notes

2 Cavalcaselle and Crowe (1885) p.30. In note 2, p.30, it is stated that 'the Madonna's drapery has been restored'.

3 Crowe and Cavalcaselle (1908) p.25. Note 4, p.255, repeats the remark about repainting 'especially the Virgin's dress'.

4 The altarpiece of the Bardi Chapel in Santa Croce was hypothetically identified by Zeri as the polyptych now in the Bromley Davenport collection, which he considered to be 'by Taddeo Gaddi and other assistants under Giotto's supervision' ('Italian Primitives at Messers Wildenstein', *Burlington Magazine* CVII (1965) p.252. See also F.Bologna, *Novità su Giotto* (Turin, 1969) p.94f. According to M.Gregori ('Sul polittico Bromley Davenport di Taddeo Gaddi e sulla sua originaria collocazione', *Paragone* XXV, no.297 (1974) pp.73–83, Taddeo's altarpiece was probably painted for the Lupicini Chapel in the same church, whereas 'the altarpiece of the Bardi Chapel, which Vasari records as by Ugolino da Siena ... is lost'.

5 Vasari, ed. Milanesi, I, p.455: 'Finally, in the chapel of Messer Ridolfo de' Bardi, in Santa Croce, where Giotto painted the life of St Francis, he executed in the panel of the altar, a Crucifixion with a Magdalen and St John mourning, with two friars at the sides'.

6 For the history of the monastery of San Romano, see P.D.Pulinari, *Cronache dei Frati Minori della Provincia di Toscana*, ed. P.S.Mencherini (Arezzo, 1913) pp.506–8; E.Repetti, *Dizionario Geografico Fisico Storico della Toscana*, IV (Florence, 1841) p.811; F.F.Ghilardi, *Il Santuario della Madonna di S. Romano* (Florence, 1887); P.I.Zari, *Il Santuario della Madonna di S. Romano* (Prato, 1949).

7 See *Affari riguardanti la Commissione sugli Oggetti di Scienze ed Arti 1808–1809*; *Processi Verbali della Commissione di Arti e Scienze del 1810. Documenti riguardanti la provenienza e il passaggio dei quadri appartenuti ai monasteri soppressi*; *Carteggio della Commissione di Scienze ed Arti 1810–1811*; *Affari diversi della Commissione sulla Conservazione degli Oggetti di Scienze e Arti provenienti dalle soppresse Corporazioni Religiose della Toscana dal 1809 al 1819*, MSS in the Accademia di Belle Arti, Florence.

8 I thank Father Lorenzo Lazzeri of the Convent of Ognissanti in Florence for this information.

9 The temporary presence of the painting in the Museo Civico of Pisa is vaguely alluded to by Stubblebine (1979) p.162: 'It was said to have been bought from the Pisa Museum in the 1860s'. For the formation of the collection of works assembled in the Museo Comunale of Pisa, see I.B.Supino, *Museo Civico di Pisa. Catalogo* (Pisa, 1894) pp.vi–vii; A.Bellini Pietri, *Catalogo del Museo Civico di Pisa* (Pisa, 1906) p.vii.

10 Giuseppe Toscanelli (1828–1891), a politician of broad interests, presumably ceased collecting when circumstances obliged him to dispose of part of the family heritage: G.Caciagli, *Pisa* (Pisa, 1970–2) III, p.505.

11 This painting, now on loan to the National Gallery of Edinburgh, came (together with a triptych by Bicci di Lorenzo over which it had been mounted as the central pinnacle) from the collection of Francesco Lombardi, Florence (Stubblebine (1979) p.162, and C.Frosinini, 'Il trittico Compagni', *Scritti di storia dell'arte in onore di R.Salvini* (Florence, 1984) pp.227–31). Like Bicci di Lorenzo's painting, it probably came from Santa Trinita: the Vallombrosan monks of the church complained, in 1816, that they had lost 'a Crucifixion in a small painting painted on gold' (A.Guidotti in *La chiesa di S.Trinita a Firenze*, edd. G.Marchini and E.Micheletti (Florence, 1987) p.398).

12 See Boskovits, *Berlin. Katalog* (1987) pp.162–76.

13 See Stubblebine (1979) pp.168–70, figs.415–8.

14 *Ibidem*, p.172, fig.423.

15 For instance, the Lehman *Madonna* (Metropolitan Museum, New York, no.1875.1.5), the polyptych in Broglio castle in Chianti, a mourning *St John* (K.Frost, New York), and the triptych formerly in San Giovanni d'Asso (Gallerie Fiorentine, Contini-Bonacossi bequest; see Stubblebine (1979) pp.170f., 180f., 163 and 185f., figs.420, 445, 393 and 464. The first two are probably works still of the 1320s, while the Contini-Bonacossi triptych must represent the artist's last phase. There are also interesting analogies between the Thyssen panel and the large painted crucifix in the Servite church in Siena which, although sometimes attributed to Ugolino, is in my opinion by Bartolomeo Bulgarini (see also above p.37, n.12).

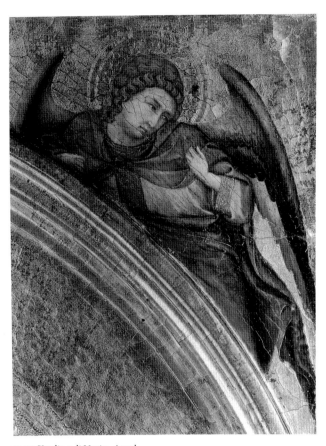

FIG 1 Ugolino di Nerio, *Angel* (detail of a fragmentary altarpiece, Berlin, Staatliche Museen, Gemäldegalerie)

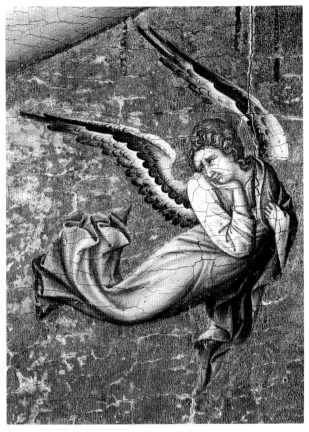

Detail [29] an angel

Crucifixion is one of the most significant of Ugolino di Nerio's extant works. The high quality of the painting, which is powerfully dramatic yet executed with miniature-like precision in all its details, is particularly evident in the elegant modelling of Christ's body, in the delicate rendering of the flesh tones and of the finely pleated loincloth, heightened with white and edged with gold. Equally remarkable are the two composed, mourning figures, enveloped by their softly flowing draperies, and the angels, picked out in enamel-like colours, united in their grief as they encircle the Cross. Close in style to the Thyssen painting is a *Crucifixion* originally also from Florence, in the collection of Lord Crawford and Balcarres,[11] which is smaller in scale but iconographically very similar, and which, to judge from the slower linear rhythms of its design and its more static quality, may be slightly earlier in date. Similarities with the Thyssen painting are also to be found in a polyptych formerly on the high altar of Santa Croce, particularly in certain details of the predella and in the figures of the angels in the spandrels (FIG 1). However, even by comparison with the surviving parts of this grandiose Florentine polyptych, which is datable $c1325/30$,[12] the artist seems here to aspire towards a more ample plastic treatment of form. He accentuates the chiaroscuro contrasts and rhythmic emphasis not only in the agitated flying angels but also in the draperies enveloping the figures in large, deep folds. These features, which link the Thyssen painting with works such as the *Madonna and saints* in the church of the Misericordia, San Casciano Val di Pesa,[13] or the *Madonna* in the Servite church in Montepulciano,[14] and other works,[15] point to a date towards 1330 or even later.

Venetian, c 1 300–10

30 The Virgin and Child; Scenes from the Life of Christ

Tempera on panel, 80 × 102 cm; central panel, 80 × 51 cm (including frame), thickness 0.4 cm; shutters
76.8 × 25.5 cm (including frame), thickness 0.17 cm
Accession no.1934.30.1–3

Provenance
R.Langton Douglas, London, early 1930s
Thyssen-Bornemisza Collection, 1934

Exhibition
Rotterdam-Essen, 1959/60, no.51

Literature
Rohoncz (1937) p.160, no.445
Garrison, *Italian Romanesque Panel Painting* (1949) p.118, no.301
Rohoncz (1949) p.44, no.265
Rohoncz (1952) p.81, no.265
Pallucchini, *Trecento* (1964) p.71
I.Petricioli, 'Triptih iz Ugljana', *Peristil* VI–VII (1964–5) pp.29–35
F.Santi, *Galleria Nazionale dell'Umbria. Dipinti, sculture, oggetti d'arte di età romanica e gotica* (Rome, 1969) p.42
Thyssen-Bornemisza (1970) p.27, no.321
Thyssen-Bornemisza (1971) p.401, no.321
G.Gamulin, *Madonna and Child in Old Art of Croatia* (Zagreb, 1971) p.5 note 23
M.Boskovits, *Pittura umbra e marchigiana fra Medioevo e Rinascimento* (Florence, 1973) p.33 note 42
Dizionario Bolaffi, XI (1976) p.331
Thyssen-Bornemisza (1977) p.122, no.321
D.Sutton, 'Robert Langton Douglas', *Apollo* CX (1979) pp.10, 29 note 14
Thyssen-Bornemisza (1981) p.330, no.321
Thyssen-Bornemisza (1986) p.335, no.321
Thyssen-Bornemisza (1989) p.343

In the centre of the tabernacle the Madonna holds the Christ Child, his hand raised in blessing,[1] on her right arm; in the two spandrels are the Archangel Gabriel and the Annunciate Virgin. The left shutter has four scenes one above the other representing the *Nativity*, the *Presentation in the Temple*, the *Transfiguration* and *Christ before Pilate*; on the other shutter are the *Crucifixion*, the *Noli me tangere*, the *Ascension* and five *Saints* (Clare, Francis of Assisi, John the Baptist, a bishop and a female saint).

The surface has been completely repainted at some unknown date, but probably shortly before the panel appeared on the market, thereby effacing the style of the work. In 1989, at the request of the present writer, Emil Bosshard had X-rays taken of the painting, which are preserved in the Thyssen archives. This examination revealed very few traces of original paint in the central panel, but proved that something more survived under the repaint in the shutters. Subsequently Marco Grassi carried out a cleaning test in the lower part of the left shutter to uncover the original surface, which, although severely damaged by previous overcleaning, nevertheless affords some indication of the painting's style and date (see detail).

Note
1 The type of iconography is that of the *Hodegetria*; see E.Sandberg Vavalà, *Iconografia della Madonna col Bambino nella pittura italiana del Dugento* (Siena, 1934) p.29f., and cat.[23] note 2, above.

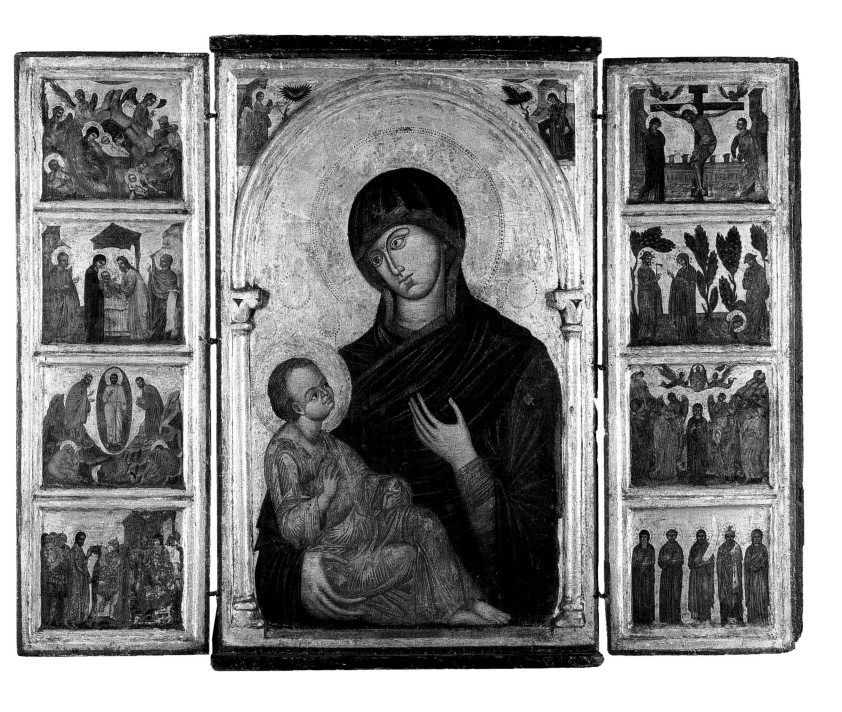

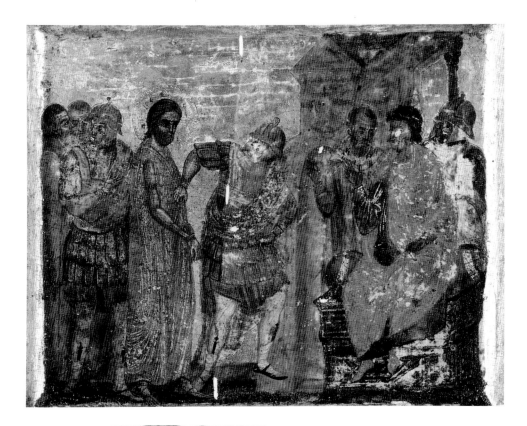

Detail [30], lower part of left shutter, *Christ before Pilate*, after cleaning test

FIG 1 Master of the Santa Chiara Triptych, *Sts John and Paul refuse to worship an idol* (Fiesole, private collection)

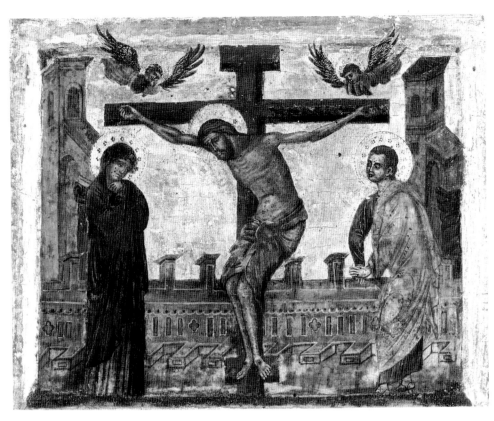

Detail [30], upper part of right shutter, *The Crucifixion*

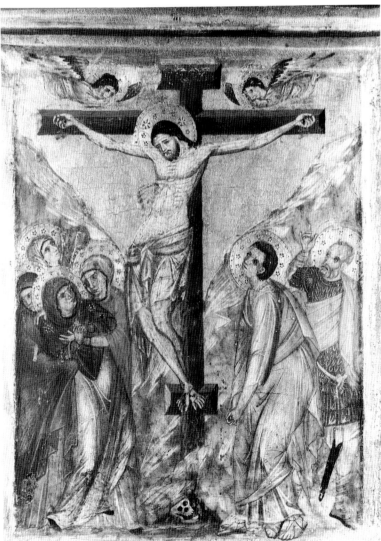

FIG 2 Master of the Santa Chiara Triptych, *The Crucifixion*
(detail of the Santa Chiara triptych), (Trieste, Museo Civico)

The tabernacle, as may be gathered from the presence of Sts Francis and Clare, originally belonged to a Franciscan community. In the early 1930s it was acquired by Robert Langton Douglas who offered it to the National Gallery of Ireland (Sutton, 1979) before selling it to the Thyssen Collection in 1934. The painting was first discussed by Heinemann (Rohoncz, 1937), who accepted Douglas's attribution to Vigoroso da Siena and pointed out analogies with the *St Peter* altarpiece (no.15) in the Siena Pinacoteca[2] and with the polyptych signed by Vigoroso in the Galleria Nazionale of Perugia.[3] The attribution to this Sienese painter, repeated in all the catalogues of the Collection, at first without reservations (Rohoncz (1949, 1952); Thyssen-Bornemisza (1970)) and later dubitatively (Thyssen-Bornemisza, 1971, 1977, 1981, 1986, 1989), has not met with critical consensus. Garrison (1949), describing it as 'considerably retouched', thought it was a Venetian work of the second quarter of the fourteenth century, while Pallucchini (1964) queried its Venetian origin and observed 'specific Riminese influences' in the painting. He compared the Thyssen tabernacle to two other tabernacles in private collections which had already been described as Venetian by Garrison.[4] Petricioli (1964–5) has demonstrated that the artist was of Venetian formation by publishing a work very similar in style and composition still preserved in Dalmatia, a tabernacle from Ugliana (at present in the church of St Francis at Zara; FIG 3), which this scholar convincingly relates to our painting. Petricioli's discovery, although briefly mentioned by Gamulin (1971), has unfortunately escaped the attention of critics outside Jugoslavia, who have limited themselves either to rejecting the attribution to Vigoroso (Santi, 1969)[5] or to expressing doubts on the authenticity of the Thyssen tabernacle (Boskovits (1973); *Dizionario Bolaffi* (1976)). The triptych is mentioned, but without comments on its style, by Sutton (1979).

The results of the partial cleaning carried out on the painting confirm Garrison's intuitive idea, giving further proof of the painting's Venetian characteristics. On closer examination, certain areas emerge as less tampered with (for instance, the figure to the extreme left of Christ before Pilate or the upper parts of the figures of Christ and the Madonna in the Crucifixion; see detail), but it is only judging from the cleaned area that one may identify this as a Venetian work of the early fourteenth century. Since most of the original surface is still hidden by modern repaint, the conclusions reached so far must inevitably remain provisional. However, albeit with due caution, I should like to point out the marked similarities between the Thyssen tabernacle and the works grouped round the St Clare triptych in the Museo Civico of Trieste,[6] in particular with some parts of the latter's central panel (FIG 2) and with two small paintings representing *Scenes from the life of Sts John and Paul* (Fiesole, private collection; FIG 1). The narrative tension contained in the artist's precise and articulated style, his swift and confident draughtsmanship and his free and nervous handling of the brush are echoed in the uncovered parts of our tabernacle, which would seem to belong to a relatively early phase, preceding the Trieste triptych and the Fiesole panels, to be placed in the very first years of the fourteenth century.

Notes

2 This painting, classified by some scholars under the name of the 'St Peter Master', is to be regarded in all probability as a late work by Guido da Siena; see P.Torriti, *La Pinacoteca Nazionale di Siena. I dipinti dal XII al XV secolo* (Genova, 1977) p.41f.

3 Santi (1969) p.41f.

4 Garrison (1949) p.118, nos.300 and 302, respectively from the Stoclet collection, Brussels (present whereabouts unknown) and the Haniel collection, Munich (now Art Institute of Chicago, no.1968.321).

5 It is also implicitly refused by A.Conti ('Appunti pistoiesi', *Annali della Scuola Normale Superiore di Pisa*, ser.III, 1, no.1 (1971) p.115 note 2), where he mentions certain attributions to Vigoroso correctly dismissed by Santi (1969).

6 The portable triptych in the Museo Civico of Trieste, originally belonging to the Convent of Poor Clares of Santa Maria della Cella and later to the Benedictine nuns of San Cipriano, was related by G.Fiocco ('Trésors d'art des églises de Paris', *Arte Veneta* x (1956) p.234f.) to the eighteen panels representing *Scenes from the Life of Christ* in the church of St-Nicholas-des-Champs in Paris. As M.Walcher Casotti (*Il trittico di S.Chiara di Trieste e l'orientamento paleologo nell'arte di Paolo Veneziano* (Trieste, 1961)) has demonstrated, the central panel and the laterals of the triptych are by different hands; she considered the laterals to be by Paolo Veneziano c1328/30 and the central panel by an archaizing collaborator. Pallucchini (*Trecento* (1964) p.68 and figs.227–230) named this presumed collaborator the 'Master of the Santa Chiara Triptych', and to him also tentatively attributed the Paris panels. The present writer, quoted in an entry by L.Tognoli Bardin (*The Martello Collection. Paintings, drawings and miniatures* . . ., catalogue by M.Boskovits and others (Florence, 1985) p.90), observed that the 'Santa Chiara Master' was a predecessor rather than a collaborator of Paolo Veneziano, and referred to him two panels with *Stories of Sts John and Paul* in the Martello collection, an altarpiece in San Giusto at Trieste and a series of panels with *Stories of St Ursula* in a private Florentine collection. Today the attribution of the *St Ursula* series does not seem to be cogent and I would suggest the following sequence for the works grouped under the 'Santa Chiara Master': the Paris *Stories of Christ*, possibly the Ugliana Triptych, the Thyssen tabernacle, the Martello panels, the San Giusto panel, and, c1315/20, the Trieste tabernacle.

FIG 3 Venetian, *c* 1310–20, *Madonna and Child; Scenes from the Life of Christ*
(tabernacle from Ugliana, now Zara, church of St Francis, sacristy)

Venetian, *c* 1360

31 The Madonna of Humility with angels and a donor

Tempera on panel, 68.8 × 56.7 cm; thickness 0.8 cm.
Accession no. 1930.59

Provenance
Private collection, Paderborn
Art market, Munich , by early 1930s
Thyssen-Bornemisza Collection, by June 1930

Exhibitions
Munich, 1930, p.61, no.204
Rotterdam and Essen, 1959/60, no.43
USSR tour, 1987, no.1

Literature
E. Hanfstaengl, 'Castle Rohoncz Collection shown in Munich', *Art News* (August 16 1930) p.18
W. Suida, 'Die italienischen Bilder der Sammlung Schloss Rohoncz', *Belvedere* XVI, no.2 (1930) p.175
A. Mayer, 'The Exhibition of the Castle Rohoncz Collection in the Munich New Pinakothek', *Apollo* XII (1930) p.96
A. Mayer, 'Die Ausstellung der Sammlung "Schloss Rohoncz" in der Neuen Pinakothek, München', *Pantheon* VI
 (1930) p.314
R. van Marle, 'I quadri italiani della raccolta del Castello Rohoncz', *Dedalo* XI (1931) pp.1370–1
M. Meiss, 'The Madonna of Humility', *Art Bulletin* XVIII (1936) p.438
Rohoncz (1937) pp.92–3, no.252
Rohoncz (1949) p.49, no.153
N. Di Carpegna, 'La coperta della Pala d'oro di Paolo Veneziano', *Bollettino d'Arte* XXXVI (1951) p.65 note 7
Meiss, *Black Death* (1951) p.136 and note 16
Rohoncz (1952) p.50, no.153
V. Lazareff, 'Maestro Paolo e la pittura veneziana del suo tempo', *Arte Veneta* VIII (1954) p.84
Berenson, *Italian Pictures* (1957) I, p.128
L. Gallina, *L'Accademia Tadini in Lovere* (Bergamo, 1957) pp.10–1
Rohoncz (1958) pp.62–3, no.252
G. Francastel, *L'Art de Venise* (Paris, 1963) p.191
E. Panofsky, 'Mors Vitae Testimonium', in *Festschrift für L. H. Heydenreich* (Munich, 1964) p.230
Pallucchini, *Trecento* (1964) p.194
Rohoncz (1964) p.50, no.252
Klesse, *Seidenstoffe* (1967) p.447
Berenson, *Italian Pictures* (1968) p.132
M. Muraro, *Paolo da Venezia* (Milano, 1969) p.112
Thyssen-Bornemisza (1970) p.25, no.173
Thyssen-Bornemisza (1971) pp.230–1, no.173
Thyssen-Bornemisza (1977) pp.74–5, no.173
Thyssen-Bornemisza (1981), p.187, no.173
Thyssen-Bornemisza (1986), p.211, no.173
M. Lucco, 'Marco di Paolo da Venezia', in *Duecento e Trecento* (1986) p.634
Thyssen-Bornemisza (1989) p.230

Notes
1 Similar inscriptions are to be found in numerous paintings of this subject, starting with the panel by Bartolomeo da Camogli dated 1346 (Palermo, Galleria Nazionale); for the iconography see Meiss (1951) pp.132–56 and H. W. van Os, *Marias Demut und Verherrlichung in der Sienesischer Malerei* (The Hague, 1969) pp.101–27.
2 According to Panofsky (1964) the skeleton personifying Death 'tenderly recommends the donor for admission to Heaven'. This interpretation is nevertheless contradicted by the inscription. For a discussion of the *memento mori* see P. Ariès, *L'homme devant la mort* (Paris, 1977).

The Madonna, seated on a marble daïs, nurses the infant Jesus seated on her lap. An inscription running horizontally at the level of her halo reads, s[ANCTA] MARIA D[E] HUMILTATE.[1] Three adoring angels hover to either side of the Virgin; the lowest on the right holds a scroll, with the words I[O]TI SO[N]P[RES]SO NO[N] POTRAI FUÇIRE/STA SENPRE PRESTO [PER] DOV[ER] MORIRE, above the donor ('I have overtaken you: you will not be able to escape. Be always ready . . . to have to die'). He kneels in the foreground on the daïs, his hands joined in prayer. Behind is a skeleton, also kneeling, about to embrace him (see detail).[2]

 This painting, which is damaged in some areas by overcleaning, was probably treated shortly

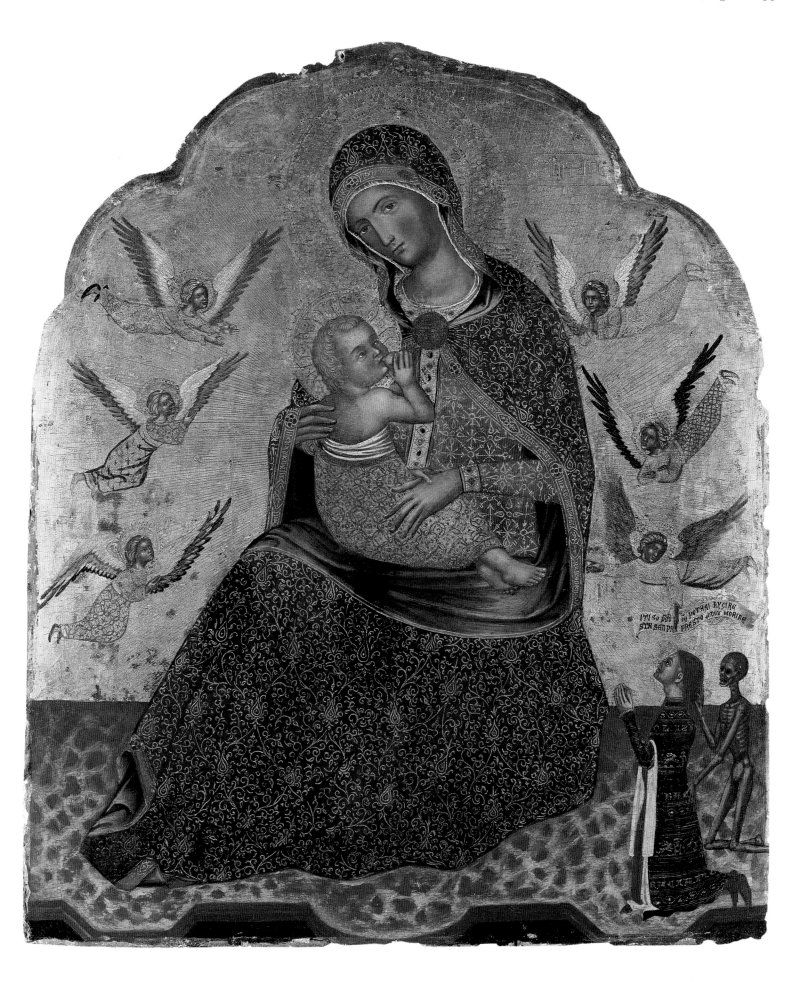

before its acquisition for the Thyssen Collection. There are two large losses in Mary's mantle at the level of her knees (one in the centre, the other to the left), which have been inpainted, as well as another in the Child's back. Numerous small losses in the gold ground, in the Madonna's mantle and in the donor's costume have also been repaired. The faces of the two principal figures are rubbed and much of the modelling of the Virgin's features is lost.

The image, of unknown destination but evidently intended for private devotion, came from an obscure 'gräfischer Besitz, Paderborn' (see Munich (1930)). It was probably still on the market in January 1930, when Georg Gronau wrote an expertise for the panel, and had already been acquired for the Thyssen Collection by the time of the Munich exhibition in June of the same year. Gronau attributed it to Lorenzo Veneziano, while Raymond van Marle, in an expertise dated 20 February 1930, suggested the name of Paolo Veneziano, relating it to the *Dormitio Virginis* in the Museo Civico, Vicenza, signed by the artist and dated 1333. His opinion was accepted in the 1930 exhibition catalogue and also by Hanfstaengl and Suida in their respective reviews (1930). Mayer (1930) was 'reminded at first of the works of the so-called Pirano Master' but also agreed that it was an early work by Paolo.[3] In 1931 van Marle confirmed his opinion stating that the painting was 'singularly beautiful and in a fine state of conservation'. Heinemann, in the various catalogues of the Collection (Rohoncz (1937, 1949, 1952, 1958, 1964); Thyssen-Bornemisza (1971)), endorsed the same attribution. More cautiously, Meiss (1936) first referred to it as 'attributed to Paolo Veneziano' and later (1951) called it 'Venetian c1360', while noting similarities with the *Coronation of the Virgin* (Frick Collection, New York) which was executed by Paolo with his son Giovanni in 1358.[4] Strong doubts on the Thyssen *Madonna* were expressed by Lazarev (1954: 'if not actually a fake, this icon must be regarded as an obscure Venetian painting of the eighth decade of the century'), although he admitted that he knew it only from a photograph. Nevertheless, a number of scholars have continued to accept the name of Paolo Veneziano: Di Carpegna (1951), Berenson (1957), the exhibition catalogues of Rotterdam-Essen (1959/60), Francastel (1963), Panofsky (1964), and the authors of the various catalogues of the Collection (1970, 1977, 1981, 1986). Klesse (1967) preferred to classify the Thyssen *Madonna* as by a follower of Paolo, whereas Gallina (1957) related it – like Lazarev – to a *Madonna of Humility* in the Pushkin Museum, Moscow, and to another *Madonna* (Lovere, Accademia Tadini),[5] which he considered a product of Paolo's workshop, executed perhaps by the young Lorenzo Veneziano. Equally convinced of the connection between these three works, Pallucchini (1964) attributed them to the same hand, which he named the 'Master of the Memento Mori'. In his opinion, 'the Lugano painting originated from Paolo's immediate circle' soon after the middle of the fourteenth century and was painted by an artist who 'was already in touch with Lorenzo's style' and who, later, when he painted the Lovere *Madonna*, came close to Stefano di Sant'Agnese. The conventional name of the 'Master of the Memento Mori' is also accepted in the recent catalogues of the Collection (USSR (1987); Thyssen-Bornemisza (1989)), whereas Muraro (1969) has tentatively suggested that the Thyssen *Madonna* could be by Marco di Paolo, relating it to this artist's only certain work, a *Madonna of Humility* (Kiev, Museum),[6] an idea that has recently been rejected by Lucco (1986).

In point of fact none of the suggestions put forward so far is entirely convincing. The slender and somewhat angular bodies and the loose heavy contours blocking out the forms in the Moscow panel betray a more archaic culture[7] and a less accomplished hand, while the Lovere *Madonna* manifests a more advanced stylistic orientation which reminds one, in certain respects, of Lorenzo Veneziano. The author of the Lovere *Madonna* pays considerable attention to delicately nuanced detail and introduces into his painting a subtle network of rhythms which already look forward to the early phase of Jacobello del Fiore.[8] As for the Kiev *Madonna*, despite a superficial similarity, it reveals (to judge from the reproduction) a more severe expressiveness, more schematic forms and, on the whole, a more hasty and mechanical execution. The Thyssen panel is certainly not easy to classify, considering how frequently this type of composition is to

Notes
3 The polyptych dated 1355 formerly in the Collegiata di Pirano in Istria is generally regarded today as an autograph work by Paolo Veneziano; Pallucchini (1964) p.49f., figs.161–4.
4 No.1930.1.24; see [H.Frick], *The Frick Collection. An Illustrated Catalogue. Vol. II. Paintings* (New York, 1968) pp.266–71.
5 See Pallucchini (1964) p.191, figs.596 and 597.
6 *Ibidem*, p.55f., fig.593.
7 The Moscow panel, which is datable before or around 1350, can be connected, in my opinion, with the wings of a polyptych representing *Four saints* in the Museo Correr, Venice, no.375 (see G. Mariacher, *Il Museo Correr di Venezia. Dipinti dal XIV al XV secolo* (Venice, 1957) pp.94–5).
8 This work, which I would date to the 1380s, is very close to the small triptych in the Walters Art Gallery, Baltimore (no.37.744); both this and the Lovere *Madonna* remain anonymous. See F.Zeri, *Italian Paintings in the Walters Art Gallery* (Baltimore, 1976) I, pp.58–60.
9 Similar, tight-fitting costumes, richly decorated, with sleeves ending at the elbow in a long strip of material hanging down, appear, for instance, in the frescoes of *Stories of St Ursula* by Tommaso da Modena of the mid-1350s (Treviso, Museo Civico) or in the paintings executed in 1367 by Nicoletto Semitecolo for the sacristy of Padua Cathedral (Pallucchini (1964) figs.419–20, 372).

Detail [31] the donor

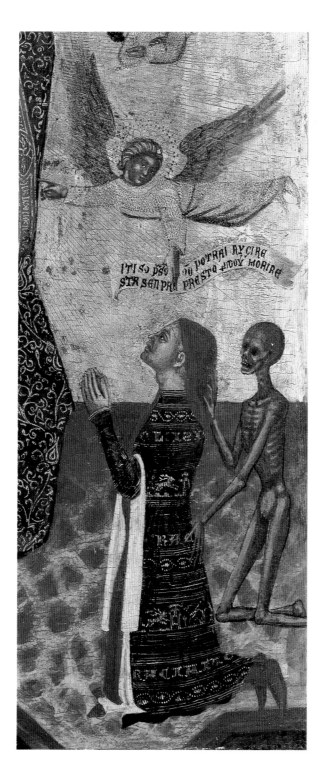

be found in Venetian painting of the later fourteenth century, and also as a consequence of the damage it has suffered. The rich, decorative effect of the materials which are flatly depicted without any attempt at creating volume, the clear outlines giving the impression of being cut out against the gold ground, and the peculiar costume of the donor[9] suggest that it was painted in the third quarter of the fourteenth century, probably around 1360. One may add that where the paint is well preserved, mostly in the angels' faces and in that of the donor, but partly also in the Child's, the execution is extremely lively, composed of short, tight brushstrokes that lend a particular, palpitating character to the painted surface. This technique is rather unusual for

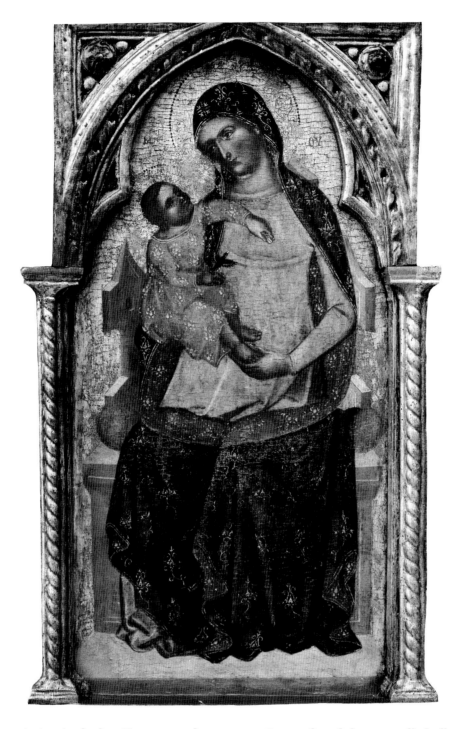

FIG 1 Venetian, *c*1360, *Madonna and Child enthroned* (detail of a polyptych, Kolocep, church of St Anthony)

Venetian painting in the late Trecento, when most artists preferred the enamelled effect of well rounded forms standing out against the luminous gold ground. This peculiarity and the greatly simplified contours would suggest that our painter belonged to an older generation and had received his training still within the first half of the century.

A painting which resembles the Thyssen *Madonna of Humility* both in the rendering of forms and in the facial types is a badly preserved polyptych in the church of St Anthony at Kolocep in Dalmatia, usually connected with documents of 1434/35 but painted roughly a century earlier (FIG 1).[10] This work lacks the deliberately flattened forms and abundant foliage decoration in gold to be found in our panel and in the works of Paolo Veneziano of around 1350. However, the features of the Child, firmly held by his Mother, resemble in the sloping forehead, puffed-out cheeks and rounded eyes and sockets the baby in the Thyssen panel (see detail). Both works

Note
10 For this polyptych, which is badly preserved but still legible in its main parts, see G.Gamulin, *Madonna and Child in Old Art of Croatia* (Zagreb, 1971) pp.133–4. It has been connected with the documents for an altarpiece commissioned in 1424 from Ivan Ugrinovic, because it is the only surviving altarpiece in the church. Its style, however, and type of frame suggest that it is a work dating from the first half of the fourteenth century.

Detail [31] the Madonna

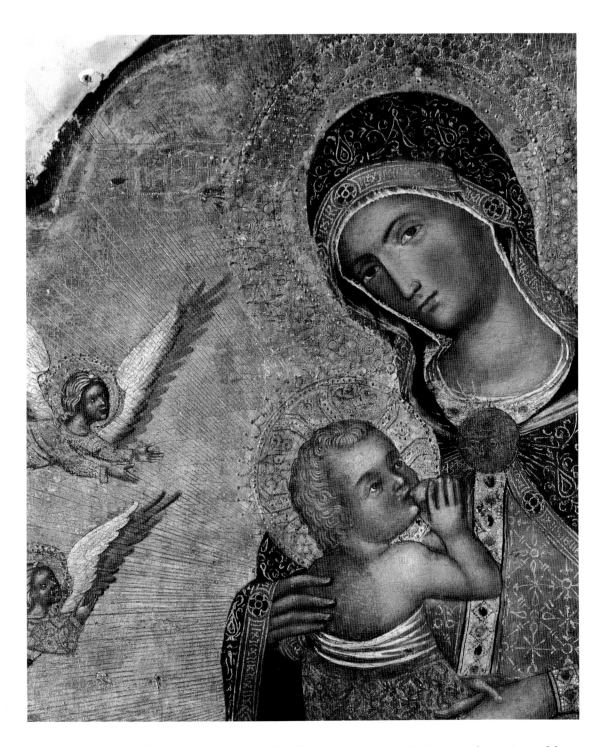

11 No.1923.213; Berenson
(1957), p.120.
12 See Pallucchini (1964)
fig.603. A comparison between
this *Coronation*, signed 'Donatus et
Catarinus picxit' and dated 1372,
and the painting of the same
subject (Venice, Accademia,
no.545) which was signed by
Catarino alone three years later
(S. Moschini Marconi, *Galleria
dell' Accademia di Venezia. Opere
d'arte dei secoli XIV e XV* (Rome,
1955) pl.4) proves that Catarino
could not have collaborated on
the Querini Stampalia panel. He
was presumably responsible for
the lost lateral panels.

certainly belong to the stylistic trend of the Venetian lagoon, which was characterized by a spontaneous and summary rendering of form as opposed to the more elegantly stylized late-Gothic manner. Examples of the same tendency are provided by the early works of Catarino (for instance, the *Madonna of Humility* in the Worcester Art Museum)[11] and of Donato, who signed with Catarino the late *Coronation of the Virgin* in the Galleria Querini Stampalia in Venice.[12]

Now that the Thyssen *Madonna* has been separated from Paolo's œuvre and from the heterogeneous group of works given to the 'Master of the Memento Mori', it seems to me that this painting can be attributed to a workshop belonging to the milieu of Donato, in the second and third quarter of the fourteenth century. It will probably be only a question of time before it is connected with other dispersed works by the same hand.

Vitale da Bologna *c*1300–1359/61

32 The Crucifixion

*c*1335
Tempera on panel, 93 × 51.2 cm; thickness about 0.9 cm (thinned); modern frame
Accession no.1930.122

Provenance
Art market, Florence, 1929
Thyssen-Bornemisza Collection, 1930

Exhibitions
Munich, 1930, p.4, no.14
Bologna, *Mostra della pittura bolognese del Trecento*, 1950, no.21

Literature
E. Sandberg Vavalà, 'Vitale da Bologna e Simone dei Crocifissi', *Rivista d'Arte* XII (1930) pp.4–7
G. Biermann, 'Die Sammlung Schloss Rohoncz', *Cicerone* XXII (1930) p.365
E. Hanfstaengl, 'Castle Rohoncz Collection shown at Munich', *Art News* (16 August 1930) p.18
A. Mayer, 'The Exhibition of the Castle Rohoncz Collection in the Munich New Pinakothek', *Apollo* XII (1930) p.96
A. Mayer, 'Die Austellung der Sammlung "Schloss Rohoncz" in der Neuen Pinakothek, München', *Pantheon* VI (1930) p.314
W. Suida, 'Die italienischen Bilder der Sammlung Schloss Rohoncz', *Belvedere* XVL (1930) p.175
R. van Marle, 'I quadri italiani della raccolta del Castello Rohoncz', *Dedalo* XI (1930–1) p.1372
E. Sandberg Vavalà, 'Some Bolognese Paintings outside Bologna and a Trecento Humourist', *Art in America* XX (1932) pp.20–3
R. Longhi, *Vitale e i suoi affreschi nel Camposanto di Pisa*, lecture (delivered December 1931); 'Berichte über die Sitzungen des Instituts', in *Mitteilungen des Kunsthistorischen Instituts in Florenz* IV (1932–4) p.136
R. Longhi, *La Pittura del Trecento nell'Italia settentrionale* (1934–5), published in *idem*, *Lavori in Valpadana* (Florence, 1973) pp.32–3, 34, 51, 64, 73, 80
M. Salmi, 'La scuola di Rimini', *Rivista del R. Istituto d'Archeologia e Storia dell'Arte* V (1935) p.126 note 33
Rohoncz (1937) p.160, no.446
B. C. Kreplin, in Thieme and Becker, *Lexikon*, XXXIV (1940) p.425
Rohoncz (1949) p.77, no.266
R. Longhi in *Mostra della pittura bolognese del Trecento*, exhibition catalogue (Bologna, 1950) pp.13 and 28, no.21
L. Coletti, 'Sulla mostra della pittura bolognese del Trecento', *Emporium* XXI (1950) p.253
W. Suida, 'Some Bolognese Paintings in America', *Critica d'Arte* XXXIII (1950) p.57
Toesca, *Trecento* (1951) p.741
Rohoncz (1952) p.81, no.266
E. Arslan, *Catalogo delle cose d'arte e di antichità d'Italia. Vicenza, I. Le chiese* (Rome, 1956) p.193
Rohoncz (1958) p.113, no.446
V. N. Lazarev, *Iskusstvo Trecento* (Moscow, 1959) p.225
M. Boskovits, 'Un "Christ de Pitié" bolonais', *Bulletin du Musée National Hongrois des Beaux-Arts* XVI (1960) pp.55, 58f.
C. Gnudi, 'Gli affreschi di Vitale nella chiesa dei Servi di Bologna', *Arte Antica e Moderna*, nos.13–6 (1961) p.76
C. Gnudi, *Vitale da Bologna* (Milan, 1962) pp.58, 61, 70
Rohoncz (1964) p.83, no.446
E. Arslan, 'Vitale da Bologna', *Enciclopedia Universale dell'Arte*, XIV (Vienna, Rome and Florence, 1966) p.830
A. C. Quintavalle, *Vitale da Bologna. (I Maestri del Colore, no. 157)* (Milan, 1966) pls.XIV–XVI
Berenson, *Italian Pictures* (1968) I, p.449
B. Kerber in *Kindlers Malerei-Lexikon*, V (Zurich, 1968) p.686
Thyssen-Bornemisza (1970) p.26, no.322
A. Boschetto, *La collezione Roberto Longhi* (Florence, 1971) pl.10
Thyssen-Bornemisza (1971) p.402, no.322
R. Grandi, 'Vicende artistiche dal XIII al XV secolo', in *Storia della Emilia-Romagna* (Bologna, 1975) p.658
Thyssen-Bornemisza (1977) p.123, no.322
F. Flores d'Arcais, 'Affreschi trecenteschi nel Duomo di Udine', *Arte Veneta* XXXII (1978) pp.29, 30
Thyssen-Bornemisza (1981) p.331, no.322
R. Gibbs, *L'occhio di Tomaso* (Treviso, 1981) p.39

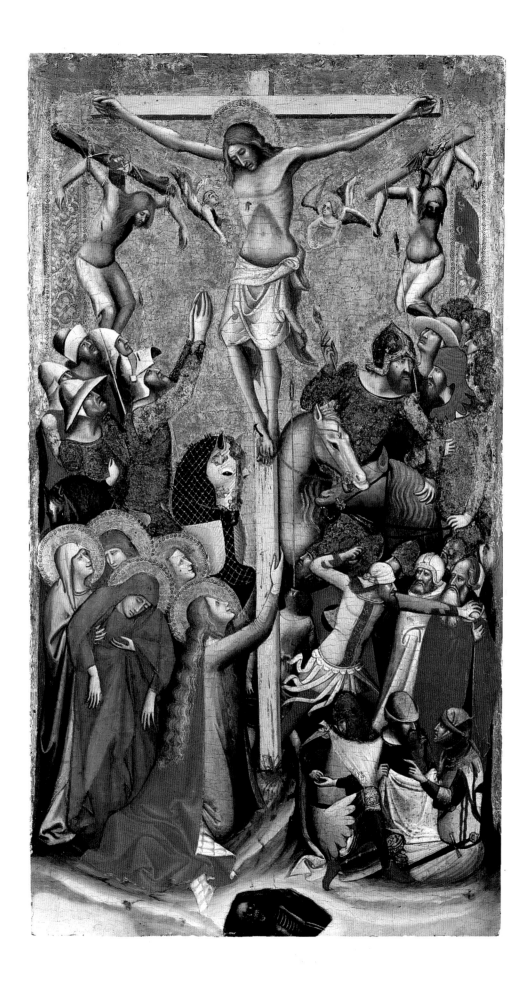

L.Lodi, 'Note sulla decorazione punzonata di dipinti su tavola di area emiliana dalla metà alla fine del Trecento',
 Musei Ferraresi, no.11 (1981) p.62

Thyssen-Bornemisza (1981) p.331, no.322

R.Gibbs, 'A group of Trecento Bolognese Painters active in the Veneto', *Burlington Magazine* CXXIV (1982) p.85
 note 30

B.Breveglieri, 'Il San Giorgio di Vitale e l'armatura bolognese del Trecento', *Carrobbio* X (1984) pp.59, 63

A.Corbara, 'Il ciclo francescano di Francesco da Rimini', *Romagna Arte e Storia* IV, no.12 (1984) p.28

F.Zuliani, 'Gli affreschi del coro e dell'abside sinistra', in C.Furlan and I.Zannier, *Il Duomo di Spilimbergo (1284–
 1984)* (Spilimbergo, 1985) pp.116, 131 note 25, 124, 132, note 35

D.Benati in *Le origini* (1985) pp.180, 182

D.Benati in *Duecento e Trecento* (1986) pp.219f., 670

R.D'Amico, 'Una ricognizione sull'opera di Vitale da Bologna', in *Per la Pinacoteca Nazionale di Bologna. Vitale da
 Bologna* (Bologna, 1986) pp.25–6

M.Medica, 'Le opere di Vitale della Pinacoteca Nazionale di Bologna: proposte di cronologia', *ibidem*, pp.66, 69, 95f.

Thyssen-Bornemisza (1986) p.336, no.322

Thyssen-Bornemisza (1989) p.344

R.Gibbs, *Tomaso da Modena. Painting in Emilia and the March of Treviso, 1340–1380* (Cambridge, 1989) pp.31, 149

Dominating the upright rectangular space is the figure of the crucified Christ between the good and bad thieves, on a reduced scale, whose souls are being received by a small angel and a demon respectively. The crowd surrounding the Cross is divided into groups arranged vertically. Above left, soldiers stand by Longinus, whose hands are raised in prayer after his revelation; below are St John and the Holy Women supporting the Virgin as she faints and the Magdalen on her knees embracing the Cross. To the right, in the foreground, three soldiers draw lots for Christ's tunic; behind, another soldier brutally pushes back the crowd of Jews; further above are mounted soldiers including the centurion, holding a staff. Behind the Cross is Stefaton, with a lance and a pail, walking away. In a hole beneath the Cross is a skeleton.[1] The gold ground is edged with an incised ornamental border *à ramages*.

The panel is trimmed on all sides and truncated above; it has lost its arched top which would originally have contained the inscription on the Cross, other angels and, perhaps, a symbolic pelican.[2] The wood support, which was thinned down when the painting was restored, has a movable cradle. The warping of the wood has resulted in vertical cracks (one from the head of the good thief to Longinus's shoulder; others from the group of seated soldiers down to the frame), along which the paint has flaked. There are also numerous other losses in both the paint and the gold. The principal damages, uncovered in the recent cleaning by Marco Grassi in 1978–9, occur in the Virgin's face (which is practically lost) and in the nearby women, in the soldiers behind Longinus, in the centurion and group of soldiers, in the bad thief and the mourning angels. The silver of the armour is rubbed and oxidised and the drapery of the foreground figures has lost all its modelling as a result of former overcleaning. Once the painting had been freed of old, darkened repaint, the lacunae were inpainted and an attempt was made to reconstruct (not always successfully) the damaged faces. However, the painting as a whole is legible; it has regained its brilliance of colour and preserves its original stylistic character. On the back are various labels: one attributing the painting to 'Baronzio da Rimini', another relating to the Bologna exhibition of 1950, others with inventory numbers of the Thyssen Collection and a Swiss customs stamp.

Notes

1 For the iconography of crowded Crucifixion scenes, which became current in the fourteenth century, see above, [12] note 1, and, for instance, M.Meiss, '"Highlands" in the Lowlands: Jan van Eyck, the Master of Flémalle and the Franco-Italian Tradition', *Gazette des Beaux-Arts*, sér.VI, LVII (1961) pp.272–314. Although Pietro Lorenzetti's fresco in the Lower Church of the Basilica of Assisi is usually regarded as the prototype for this iconography, examples from the beginning of the Trecento already existed in Emilia and the Veneto, such as the frescoes in the abbey of Chiaravalle della Colomba near Piacenza and in the chapterhouse of the Basilica del Santo; Benati (1986) fig.299, and F.D'Arcais in *La pittura del Santo a Padova*, ed. C.Semanzato (Vicenza, 1984) p.8, fig.5. The figure behind the Cross holding a pail is clearly Stefaton; in our painting, however, his sponge has been inadvertently made into a lance in an old restoration. To my knowledge, the motif of the soldier pushing back the group of Jews has no precedent. This theme, which is extremely rare, recurs in a more elaborate form in the well known fresco by Andrea Bonaiuti in the Spanish Chapel of Santa Maria Novella, Florence (R.Offner and K.Steinweg, *Corpus*, IV/III (New York, 1969) p.46f., pl.III(13). Bonaiuti's version, described by Gertrud Schiller (quoted *ibidem*, p.47 note 10) as 'traceable neither in literary descriptions nor in figurative art', was probably inspired by a lost Florentine prototype, by Giotto or Buffalmacco, which could also have been known to Vitale.

2 The ornamental border framing the gold ground along the upper edge is interrupted at the centre; it would originally have followed the outline of the truncated top. In the two other *Crucifixion* scenes by Vitale known to me, in the Johnson Collection, Philadelphia, no.1164, and the Musée d'Histoire et d'Art, Luxembourg, no.1942.74.8 (*Peintures anciennes. Collection du Musée d'Histoire et d'Art* (Luxembourg, n.d. [1967] fig.9) the Cross has a scroll with the letters INRI.

3 This author, evidently as an oversight, mentions the *Crucifixion* under the name of an otherwise unknown Jacopo da Rimini.
4 The critic did not refer merely to an anonymous master but specified that 'Roberto Longhi actually thinks that Vitale was the principal author of the Camposanto frescoes', thus anticipating Longhi's hypothesis put forward the following year in lectures at the University of Pisa and the Kunsthistorisches Institut in Florence (see Longhi (1932, 1934)).
5 See above, note 2. Sandberg Vavalà's attribution of this painting to Vitale is now generally accepted.
6 See L. Bellosi, *Buffalmacco e il Trionfo della Morte* (Turin, 1974).
7 On deposit from the Museo di Santo Stefano; Medica (1986) p.115f.
8 See S. Skerl Del Conte, 'Vitale da Bologna e il Duomo di Udine', *Arte in Friuli, arte a Trieste*, I (1975) pp.15–34, and Flores d'Arcais (1978) pp.24–30, who erroneously attributes the frescoes of the Cappella Maggiore in Udine Cathedral to an anonymous follower of Vitale.
9 Zuliani (1985) p.124.

The *Crucifixion* appeared on the art market in Florence in 1929 and was examined at that time by various scholars. Raymond van Marle, in an expertise dated September of that year, defined it as a 'late production' of Giovanni Baronzio, while Wilhelm Suida, in a written opinion dating from June 1930, attributed it to the Master of the Triumph of Death, named after the great fresco in the Camposanto of Pisa (copies of both letters are in the Thyssen archives). The painting was bought for the Collection in the same year and shown at the Munich exhibition. Some critics (Biermann (1930); van Marle (1930)) confirmed the attribution to Baronzio or agreed that it was by a master from Romagna (Hanfstaengl, 1930);[3] others, like Suida (1930) and, with reservations, Mayer (1930), preferred to give it to the Master of the Triumph of Death, hypothetically identified by Suida (1930) with Vitale da Bologna.[4]

In the meantime the painting was published in the context of a fundamental study on Vitale da Bologna by Sandberg Vavalà (1930). She suggested that the *Crucifixion*, together with another painting of the same subject in the Johnson Collection in Philadelphia,[5] could belong to the artist's early period. Sandberg Vavalà subsequently confirmed her opinion (1932) and it was accepted by Longhi (1932–4), who proposed a slightly different reconstruction of the artist's œuvre: he was more inclined to place the Pisa fresco cycle and the frescoes in Parma (now both generally given to Buffalmacco)[6] and the Thyssen *Crucifixion* after Vitale's documented polyptych of 1353. Longhi formulated his theory in greater detail during a course held at Bologna University in 1934–5. He explained the 'luxurious, decorative appearance, Venetian in character' of the Thyssen painting as a result of the artist's contacts during his stay in Udine. Subsequently, most scholars accepted the attribution to Vitale without further discussion (Salmi (1935); Heinemann in Rohoncz (1937, 1949, 1952, 1958, 1964); Coletti (1950); Suida (1950); Boskovits (1960); Berenson (1968); Kerber (1968); the authors of the catalogues of the Thyssen-Bornemisza collection (1970, 1971, 1977, 1981, 1986, 1989); Grandi (1975); Gibbs (1981 and 1989); Lodi (1981)). Only Toesca (1951) and Arslan (1956, 1966), expressed some doubts, preferring to separate the group comprising the *Stories of St Anthony* (Bologna, Pinacoteca)[7] and the Johnson and Thyssen *Crucifixions* from the rest of Vitale's œuvre, but without excluding his authorship altogether. According to Toesca, they were to be considered the works of 'a gifted follower of Vitale, if not by Vitale himself in a very late moment'.

Longhi's initial idea of a late date has continued to arouse discussion. On taking up the problem again at the time of the Bologna exhibition (1950), he placed the execution of the *Crucifixion* soon after 1345, connecting it with Vitale's frescoes at Mezzaratta, and attributing the Parma and Pisa frescoes to a different hand. A date between 1345 and 1350 was accepted by Boschetto (1971), Flores d'Arcais (1978), Gibbs (1982), Zuliani (1985) and Medica (1986). In particular, the last four critics took into consideration a new argument in favour of a date towards 1348, based on the similarities between the Thyssen *Crucifixion* and parts of the frescoes recently discovered in the Cathedral of Udine.[8] Granted that Vitale's works in Udine must date from 1348–9 and considering that the *Crucifixion* frescoed by a follower of Vitale in the Cathedral of Spilimbergo[9] seems to be based on a composition very similar to that of the Thyssen panel, our picture should date, according to the above critics, from shortly before the artist's stay in the Friuli.

In favour of a late date are Lazarev (1959), Gnudi (1961, 1962), Quintavalle (1966), Breveglieri (1984) and, implicitly, Corbara (1984) and D'Amico (1986). According to their view, which can be summarised in Gnudi's words, the Thyssen panel translates 'into another, more refined, composite and complex manner the expressive, lyrical and fantastic rhythm of the great Gothic works of the years around 1345', and therefore belongs to a subsequent phase immediately following the polyptych of San Salvatore in Bologna.

In his short outline of Bolognese Trecento painting, Benati (1985, 1986) has proposed a different reconstruction of Vitale's chronology. He observes that soon after 1340 Vitale's creativity developed rapidly through a sequence of masterpieces – the four *Stories of St Anthony*

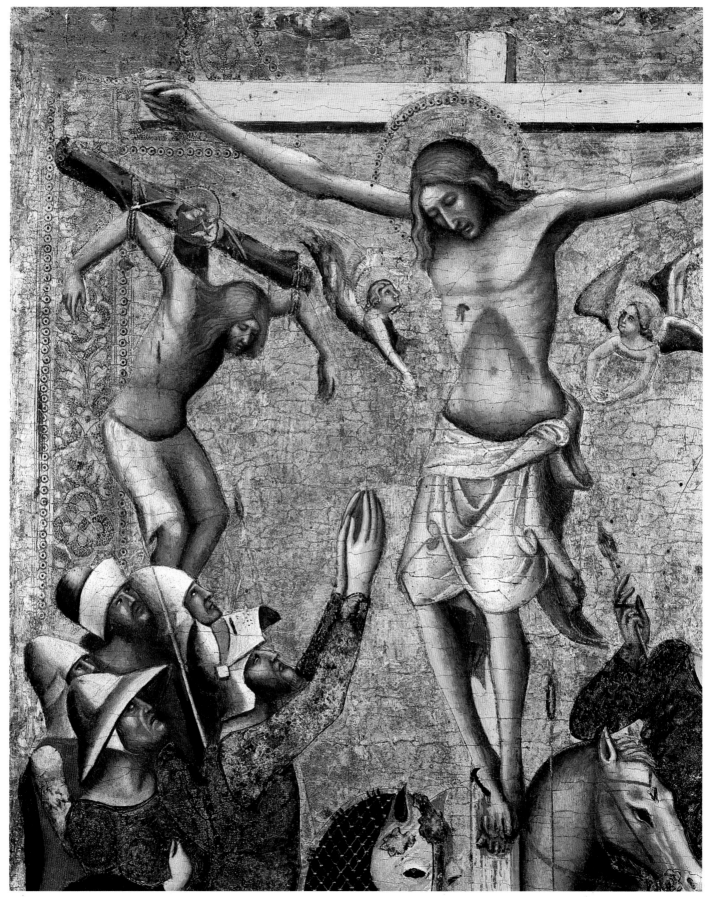

Detail [32] Christ, the good thief and Longinus in prayer

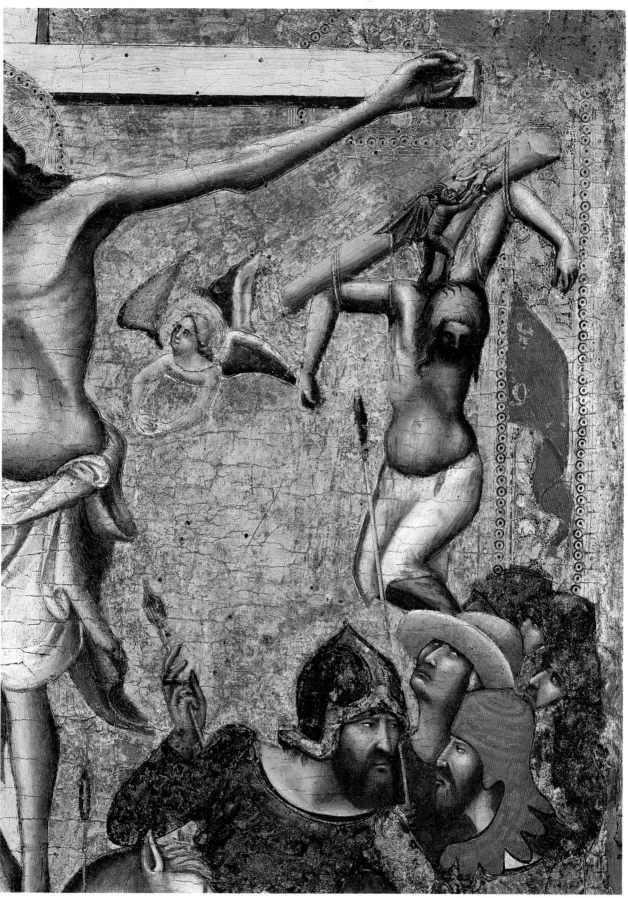

Detail [32] the bad thief and soldiers

Abbot, the Thyssen *Crucifixion*, the grandiose *Nativity* fresco at Mezzaratta – all within a few years, before 1345. He persuasively argues that the Thyssen *Crucifixion* precedes the Pomposa and Udine frescoes, in which Vitale 'aimed at a perfect, elegant narrative cadence and articulated space ... less crowded compared to the *Nativity* of Mezzaratta', and is to be placed therefore earlier than the *Madonna 'dei denti'* of 1345 (dismembered; Museo Davia Bargellini and Collezioni Comunali, Bologna, and private collections), with its 'more affable and aristocratic components' inherent in 'the soft modelling and elegantly emphasized line'. I shall now attempt to explain briefly why I think Benati's approach is correct, although my dating is slightly different.

There is little certainty regarding Vitale's stylistic development since his dated and documented works cover only the brief span of time between 1345 and 1353. But if one compares the style of the *Madonna 'dei denti'* (1345) with that of the *Last Supper* (Bologna, Pinacoteca), which is usually dated to, or around, 1340 but was probably executed earlier, one can observe a change.[10] The latter is the most Giottesque of all the artist's compositions and forms a group with the Johnson *Crucifixion* and the *Coronation of the Virgin* formerly at Budrio,[11] which cannot have been painted much after Giotto's stay in Bologna around 1330.[12] An early date for these works is suggested by the heavy structure and slow movements of the figures, modelled by dense shadows, toned down to give a smooth, rounded surface to the forms. Another reason is the very reduced use of motif punches to decorate the haloes or borders.[13] If we may accept a date around 1330/5 for these paintings, the production of the artist's next phase, preceding the *Madonna 'dei denti'*, would include the *Madonna 'dei battuti'* (Pinacoteca Vaticana),[14] the ex-Stoclet *Coronation*,[15] the Thyssen *Crucifixion*, the *Stories of St Anthony Abbot*, the *St George* (Bologna, Pinacoteca)[16] and, of course, the *Annunciation* and the *Nativity* frescos at Mezzaratta. One may observe in these works an increasing tendency towards strong expression and uncontrolled feeling. The narrative mood is at times extremely dramatic, at others incredibly tender. Most striking is the artist's use of sudden, contorted movements and the way episodes are jumbled together in a steep, irrationally organized space. From the time of the *Madonna 'dei denti'* (1345) and of other related works,[17] Vitale tends to simplify his forms and to cultivate stylistic refinements, novel chromatic effects and more delicate expressions. Among the paintings listed above as stylistically akin, I would regard the Thyssen *Crucifixion* as one of the most remote from the lyrical tendencies developed by the master towards the middle of the century. Certain sharp naturalistic details (such as the swollen abdomen of the bad thief or the strongly individualized features of the soldiers), the complex movements of certain figures (the centurion pointing towards Christ on his right and turning in the opposite direction as he leans forward on his companion's horse, or the soldier seated with one of his legs under him turning suddenly to look at the dice in his hand, or again the violent movement of the soldier pushing back the crowd (see detail)), are much less pronounced or disappear altogether in works of the period of the *Madonna 'dei denti'* or later. Another indication suggesting a date still in the 1330s is the relatively sparse use of punches in the ornamental decoration and certain peculiarities of dress and in the types of armour.[18] In this phase, Vitale was evidently still deeply impressed by the austere and direct realism of Buffalmacco, whose masterwork, the Camposanto fresco in Pisa, has, significantly, already been associated with the Thyssen *Crucifixion*.

Notes

10 Vitale was paid on 9 December 1340 'pro picturis forestarie' of the Franciscans in Bologna; this was a partial payment, to judge from the sum of 'lire 6' (F.F. Filippini and G.Zucchini, *Miniatori e pittori a Bologna. Documenti dei secoli XIII e XIV* (Florence, 1947) p.231). The fact that no further details are given would imply that the work was part of an extensive project to decorate various rooms of the hospice of the convent. One may assume, therefore, that Vitale was being paid for a task begun by him some time before and which was known to all.

11 Presently on deposit in the Pinacoteca Nazionale, Bologna; Medica (1986) p.122f.

12 The date of Giotto's polyptych (Bologna, Pinacoteca, no.284) painted for the church of Santa Maria degli Angeli in Bologna is still controversial. Previtali (*Giotto e la sua bottega* (Milan, 1967) p.122) thinks it was executed shortly before the artist left for Naples in 1328, Elvio Lunghi (in *Duecento e Trecento* (1986) p.577) dates it 1334/5. However, there are good reasons to trust a fourteenth-century record of frescoes painted by Giotto in the Castello di Galliera, which was built outside the city walls of Bologna in 1329–30. This and the documents pertaining to the founding and endowment of the church of Santa Maria degli Angeli by Gera Pepoli in 1330 (L.Frati, 'Giotto a Bologna', *L'Arte* XII (1910) p.466f.) confirm Giotto's presence in the city around that date.

13 It is known that in Siena from at least 1320 and in Florence from the end of the decade (E.Skaug, 'Contributions to Giotto's Workshop', *Mitteilungen des Kunsthistorisches Instituts in Florenz* XV (1971) pp.141–60) motif punches gradually replaced freehand incised decoration in haloes and ornamental borders of panel paintings. This change took place more slowly in Emilia, as may be gathered from the analysis recently made by Lodi (1981). As far as Vitale's works are concerned, in the Budrio *Coronation* there are only very few, simplified motifs, whereas the artist uses both punched decoration and freehand incisions in the *St George fighting the dragon*, in the *Stories of St Anthony* (Bologna, Pinacoteca) and in the Thyssen *Crucifixion*. Rather elaborate tooling composed exclusively of punched motifs is to be found in the *Madonna 'dei denti'*

and in the San Salvatore altarpiece of 1353, while the early Philadelphia *Crucifixion* seems to be decorated entirely freehand.

14 No.17. Gnudi (1962, p.69) dates this panel, which comes from Ferrara, *c*1350; but the solid outlines and compact volumes of the Madonna and Child group, besides the absence of motif punches in the border decoration, would suggest that it was painted considerably earlier.

15 This painting, attributed to Vitale by E.Sandberg Vavalà, 'Vitale delle Madonne e Simone dei Crocifissi', *Rivista d'Arte* XI (1929) p.479, fig,20 has been related by Gnudi (1962, p.70) and others to the so called 'Dalmasio'. However, Medica (1986, p.91 note 24) and Benati (1986, p.221) rightly confirm Vitale's authorship and date it in the mid-1930s.

16 No.6394. Medica (1986, p.105f.) convincingly dates it to the late 1330s (as opposed to *c*1350 proposed by Gnudi (1962) p.52f.), while Benati (1986) places it even earlier in the same decade.

17 That is, the small panels which may have originally flanked the *Madonna* (last recorded in the Lanckoronsky collection in Vienna) and the two wings of a polyptych with *St Peter and a donor* and *St Benedict and James* (Gnudi (1962) pp.29f., 64f.). The compositional arrangement of these two panels would suggest that they were both to the left of the central image; the two right wings would therefore remain still to be identified. If, as is suggested by the measurements and the analogous ornamental decoration, these laterals indeed flanked the *Madonna 'dei denti'*, the proportions of the complex would hardly have fitted the very small Oratory where it is recorded in the eighteenth century. It therefore probably came from the church of Mezzaratta.

18 Similarities in the costumes of the soldiers and executioners have been noted in Vitale's frescoes in Udine (Flores D'Arcais, 1978); but one should add that analogies are also to be found with works of an earlier date. Compare, for instance, the armour of the *St George* in Bologna with that of the soldiers in the *Crucifixion* (Breveglieri, 1984). Similar details even occur in the miniatures of the Missal of Bertrand de Dieux (Biblioteca Apostolica Vaticana, Arch. San Pietro, 63 B), which can be dated 1338 or soon after.

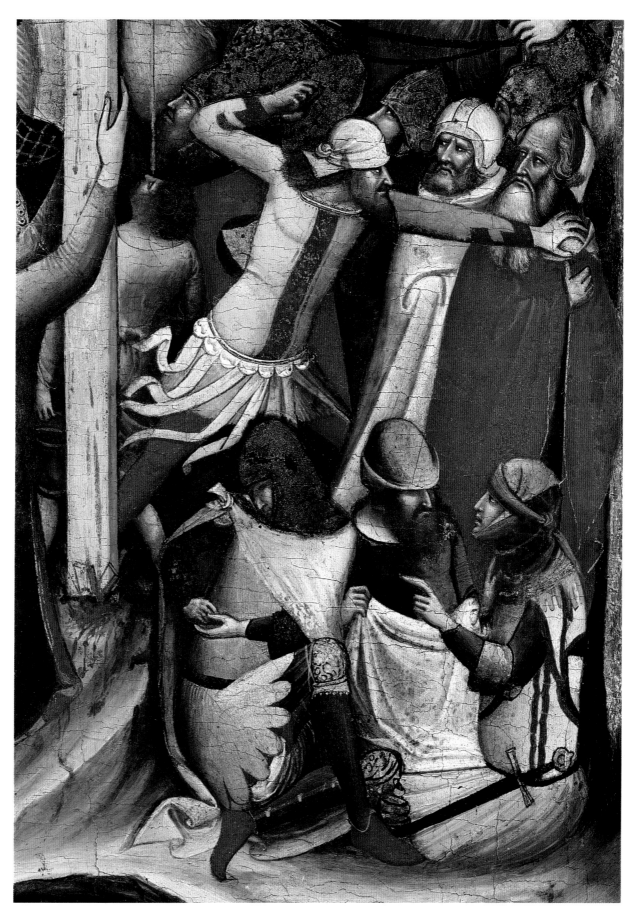

Detail [32] the soldier pushing back the crowd

Photographic acknowledgements

BALTIMORE
Walters Art Gallery [1] FIG 1g

BERLIN
Gemäldegalerie, Staatliche Museen, preussischer Kulturbesitz
[12] FIG 1 [28] FIGS 1b, 1c [29] FIG 1

BOSTON
Isabella Stewart Gardner Museum [4] FIG 1

BUDAPEST
Museum of Fine Arts [7] FIGS 4a, 4f [11] FIGS 2a, 3

CLEVELAND
Museum of Art [17] FIGS 6a, 6c

DETROIT
Detroit Institute of Arts [17] FIG 6h

FLORENCE
Alinari (Anderson, Brogi, Villani) [1] FIG 3 [2] FIG 1 [10] FIGS 1,
2d [11] FIGS 2b, 2e [15] FIG 1 [16] FIG 1 [23] FIG 1 [28] FIG 2
[30] FIG 2
Artini [6] FIGS 1, 2
Biblioteca Berenson, Villa I Tatti [5] FIG 1
Soprintendenza B.A.S. [8] FIG 1 [27] FIG 1

FORT WORTH
Kimbell Art Museum [11] FIG 2i

LONDON
Courtauld Institute of Art, Conway Library [22] FIGS 1c, 2a, 2b
National Gallery [11] FIGS 2g, 2h
Sotheby's [7] FIGS 1, 4c

NANTES
Petrich Jean, Musée des Beaux Arts [9] FIG 1

NEW ORLEANS
New Orleans Museum of Art [21] FIG 1

NEW YORK
Ali Elai [17] FIG 6j
Frick Collection [11] FIG 2c
Lore Heinemann [17] FIGS 6b, 6d
Bruce C. Jones [30] FIG 1
Metropolitan Museum of Art [1] FIG 1c [17] FIGS 6e, 6f, 6g, 7, 8
[22] FIGS 1a, 1e

OREGON
Portland Art Museum [21] FIG 1c

PARIS
Réunion des Musées Nationaux [24] FIGS 1c, 1d

PARMA
Vaghi [25] FIGS 2, 3

PHILADELPHIA
John G. Johnson Collection [10] FIG 2a

POZNAN
Muzeum Narodowe [18] FIGS 1, 2c

SAN FRANCISCO
Fine Arts Museum [20] FIG 1

SIENA
Soprintendenza B.A.S. [17] FIG 1

SPLIT (SPALATO)
Živko Bačić [30] FIG 3

STOCKHOLM
Nationalmuseum [1] FIG 1f

URBINO
Soprintendenza B.A.S. [7] FIGS 3, 4d

UTRECHT
Rijksmuseum [17] FIG 6k

VARESE
Vivi Papi [10] FIG 1b

VENICE
Fondazione Giorgio Cini [25] FIG 1d
Osvaldo Böhm [26] FIG 2
Soprintendenza B.A.A. [21] FIGS 2, 3

WASHINGTON
National Gallery of Art [11] FIG 2d

YORK
City Art Gallery [10] FIG 2e

All photographs not listed above are from the author's archive

Artists' biographies

Andrea di Bartolo

Andrea, son of Bartolo di Maestro Fredi and father of Giorgio di Andrea, also painters, is recorded for the first time in 1389 in the *Breve dell'Arte de'pittori senesi*. He presumably began working in his father's workshop, and during the 1380s collaborated with him on two altarpieces painted for the church of San Francesco at Montalcino. In 1389 Andrea is still recorded as his father's assistant, but by some time in the following decade, when he signed the polyptych for the Pieve of Buonconvento (Padovani (1979)), he probably already had his own shop. At the very end of the fourteenth century, he made a journey to Venice (Freuler (1987)) and may even have travelled as far as Dalmatia, where a painted crucifix by him was preserved until recently in the convent of St Mary at Zara (G. Gamulin, *The painted Crucifixes in Croatia* (Zagreb, 1983) pp.54–6). Andrea is recorded again in Siena in the first decade of the fifteenth century; he worked for the Cathedral (1405/6 and 1410) and painted a polyptych dated 1413 (today in the Osservanza church). In the following years he executed a polyptych for the Franciscans at Tuscania (Tuscania, Cathedral), another for Sant'Angelo in Vado, near Urbino (Milan, Brera and Urbino, Galleria Nazionale), and the large *Assumption* (Richmond, Virginia Museum of Art), painted for patrons at Urbino. He probably returned to the Veneto towards the end of his life since there is a fresco by him in the church of San Francesco at Treviso (Meiss (1955)). Andrea died in Siena where he was buried in 1428.

In his early phase, apart from the dominating influence of his father, he seems to have been primarily interested in the fairylike delicacy of the paintings of Paolo di Giovanni Fei. However, he developed a very individual style and several early Quattrocento artists, for instance Benedetto di Bindo and Giovanni di Paolo, drew inspiration in their turn from the freshness and inventiveness of Andrea di Bartolo's works, even though he proved to be slow in renewing his figurative repertoire and, from the beginning of the century onwards, his devotional paintings are sometimes repetitive and betray signs of fatigue. It is not clear to what extent this decline is to be attributed to the intervention of Giorgio, who collaborated with his father from the first decade of the fifteenth century (Kanter (1986) and Freuler (1987)).

G. De Nicola, 'Andrea di Bartolo', *Rassegna d'Arte Senese* XIV (1921) pp.12–5
C. Brandi, *Quattrocentisti senesi* (Milan, 1949)
M. Meiss, 'Nuovi dipinti e vecchi problemi', *Rivista d'Arte* XXX (1955) pp.119–45
O. Francisci Osti, 'Andrea di Bartolo, in *Dizionario biografico degli Italiani*, III (Rome, 1961) pp.74–5
E. Carli, *I pittori senesi* (Milan, 1971) p.23
S. Padovani, in *Mostra di opere d'arte restaurate nelle province di Siena e Grosseto* (Genoa, 1979) pp.97–101
A. Cecchi in *Gotico a Siena* (1982) p.313
L. Kanter, 'Giorgio d'Andrea di Bartolo', *Arte Cristiana* LXXIV (1986) pp.15–28
G. Freuler, 'Andrea di Bartolo, Fra Tommaso d'Antonio Caffarini, and Sienese Dominicans in Venice', *Art Bulletin* LXIX (1987) pp.570–86

Fra Angelico

Fra Giovanni da Fiesole, whose secular name was Guido di Pietro, is generally known as Fra Angelico, from the epithet 'angelicus' applied to his painting since the sixteenth century. He was born in the Mugello district near Vicchio, about 1390/5, and is first documented as a painter in 1417. Between 1418 and 1421 he became a friar of the convent of San Domenico at Fiesole. Probably dating from the beginning of his career are works such as the altarpiece of San Domenico at Fiesole, that of *St Peter Martyr* (Florence, Museo di San Marco) and the *Madonnas* in Pisa (Museo Nazionale) and Princeton (Piasecka Johnson collection), of which only the *St Peter Martyr* triptych can be securely dated before 1429. The style of these paintings reveals an artist formed close to Gherardo Starnina and deeply influenced by Gentile da Fabriano, but gifted with an independent spirit, a classicizing taste and a capacity for realistic observation which put him on a par with Masolino and Masaccio.

The chronological sequence and even the authorship of many of the works attributed to Fra Angelico are still open to discussion. The documented and dated works of his middle period include the Linaioli tabernacle of 1433, the *Lamentation* for the Compagnia della Croce al Tempio of 1436 (both Florence, Museo di San Marco), the frescoes in San Domenico at Cortona of 1438 and the altarpiece for San Marco in Florence of 1438/40 (now Museo di San Marco), besides the *Last Judgement* (also Museo di San Marco), which was probably painted in 1431. These compositions are characterized by a noble simplicity of form and by a brilliant range of luminous colours. Towards the end of the fourth decade, in his frescoes in the convent of San Marco in Florence, Angelico began to introduce subtle luministic effects, probably inspired by contacts with contemporary Flemish painting. A monumental conception accompanied by refined nuances of detail also characterizes his later frescoes in the Chapel of Nicholas V in the Vatican Palace and those of the Chapel of San Brizio in the Cathedral of Orvieto.

In 1450, after an absence of four years, Fra Angelico returned to his convent at Fiesole as prior. His last works include the decoration of the silver chest for the Santissima Annunziata in Florence (1450/2) and the altarpiece for the convent of Bosco ai Frati (both Florence, Museo di San Marco). In 1453 he was again summoned to Rome to work at Santa Maria sopra Minerva, where he died in 1455.

Vasari, ed. Milanesi, II, pp.505–34
P. V. Marchese, *Memorie dei più insigni pittori, scultori e architetti domenicani* (Florence, 1845) I, pp.212–349
F. Schottmüller, *Fra Angelico* (Stuttgart and Leipzig, 1911)
Mostra delle opere del Beato Angelico, exhibition catalogue (Florence, 1955)
P. S. Orlandi, *Beato Angelico* (Florence, 1964)
E. Morante and U. Baldini, *L'opera completa dell'Angelico* (Milan, 1970)
J. Pope-Hennessy, *Fra Angelico*, 2nd edn. (London, 1974)

Barnaba da Modena

Barnaba di Ottonello Agocchiari was born in Modena around 1328/30. It was probably both here and in Bologna that he received his training as an artist. From October 1361 he is recorded in Genoa and documents of the following year refer to him as a Genoese citizen, which would imply that he had been living there for some time. In 1364, by then a renowned artist, Barnaba painted works for the Doge's Chapel of Genoa. His fame earned him the commission in 1379 to fresco part of the Camposanto of Pisa; however, although he was active in that city during the 1370s, he did not actually work on the Camposanto fresco cycle. In October 1380 he is recorded in Modena and in 1383 once more in Genoa.

Barnaba's earliest works, which include an exquisite small triptych (Bologna, Collezioni Comunali) probably dating from the 1340s, show the influence of Tommaso da Modena, Vitale da Bologna and other Bolognese painters responsible for the frescoes in Sant'Apollonia at Mezzaratta, near Bologna. In his subsequent production, in works such as a *Noli me tangere* formerly in a private

collection in Biella, a *Madonna and Child* in Crema (Stramezzi collection) and a *Madonna and Child* dated 1367 in Frankfurt (Städelsches Kunstinstitut), Barnaba's style gradually became enriched by Gothic rhythms and characterized by a fluctuating chiaroscuro and a predilection for striking gold brocades. A change towards more static forms, simplified outlines and stronger chiaroscuro modelling emerges in the shutters of a diptych dated 1374 (London, National Gallery) and in two more or less contemporary altarpieces in the Cathedral of Murcia, Catalonia. This tendency towards greater solemnity and monumentality and to a more varied compositional organization characterizes the works of his full maturity: the *Madonna* in San Giovanni Battista at Alba (1377), the *Madonna 'dei Mercanti'* (Pisa, Museo Nazionale), the polyptych of Sant'Andrea a Ripoli (Pisa, Archbishop's Palace), and the polyptych of San Dalmazio a Lavagnola (Savona), which has a fragmentary date that has recently been read as 1386.

Although famous chiefly for his somewhat monotonous devotional images, Barnaba reveals imaginative and expressive gifts in his narrative works. His style was to leave a deep impression on painting in the Ligurian coastal area in the last decades of the fourteenth century, particularly on Taddeo di Bartolo and Nicolò da Voltri.

C. Ricci, 'Barnaba da Modena', *Burlington Magazine* XXIV (1913) pp.65–9
P. Toesca, 'Dipinti di Barnaba da Modena', *Bollettino d'Arte*, N.S.II (1922–3) pp.291–4
P. Rotondi, 'Contributo a Barnaba da Modena', *Arte Antica e Moderna*, no.18 (1962) pp.181–4
E. Castelnuovo, 'Barnaba da Modena', in *Dizionario biografico degli Italiani*, II (Rome, 1964) pp.414–18
F. R. Pesenti, 'Barnabas de Mutina pinxit in Janua', *Bollettino d'Arte*, N.S.LIII (1968) pp.22–7
G. Algeri, 'L'attività tarda di Barnaba da Modena: una nuova ipotesi di ricostruzione', *Arte Cristiana* LXXVII (1989) pp.189–210

Bartolomeo di Messer Bulgarini (or Bulgarino)

According to Vasari, Bartolomeo Bulgarini – or as he calls him 'Bologhini' – was a pupil of Pietro Lorenzetti and the author of an altarpiece in the church of Santa Croce in Florence. Born presumably around 1300/1310, the artist appears to have been mainly active in Siena where, between 1337 and 1353, he painted a number of *biccherna* panels (covers for the balance sheets of the Comune; Morandi (1964)) and by the middle of the century he was considered one of the major artists active in Siena (Chiappelli (1900)). In 1370 he became a lay brother of the hospital of Santa Maria della Scala in Siena, for which he painted a panel, signed and dated 1373, which is now lost (Vasari, ed. Milanesi). He died in 1378.

No secure work by Bartolomeo has come down to us. His œuvre was tentatively reconstructed by Meiss on the supposition that the *biccherna* panel for the first semester of 1353, preserved in the State archives of Siena, corresponds to the one for which our painter was paid in that year. Taking this as a starting point, Meiss ascribed to Bartolomeo Bulgarini the works already grouped together under the names of 'Ugolino Lorenzetti' and the 'Master of the Madonna of San Pietro Ovile', and proposed identifying a polyptych in the Museo di Santa Croce, Florence, with the altarpiece recorded by Vasari. This hypothesis, which was still subject to debate until quite recently, has now been confirmed thanks to the discovery of archival data proving that a *Nativity* in the Fogg Museum in Cambridge MA, usually given to 'Ugolino Lorenzetti', was in fact was painted by Bartolomeo for Siena Cathedral around 1351 (Beatson, Muller and Steinhoff (1986)). The master probably received his training in the milieu of Ugolino di Nerio, whose refined manner he enlivened by creating more dynamic compositions and by introducing numerous details drawn directly from life. In a later phase his style tended towards more monumental forms and a vigorous plasticity, approaching that of

Pietro Lorenzetti, while his last works reveal a taste for sumptuous decorative effects and refined colour harmonies.

Vasari, ed. Milanesi, I, p.477f.
A. Chiappelli, 'Di una tavola dipinta da Taddeo Gaddi . . .', *Bollettino storico pistoiese* II (1900) p.2f.
B. Berenson, 'Ugolino Lorenzetti', *Art in America* V (1917) p.259f. and VI (1918) p.25f.
E. T. De Wald, 'The Master of the Ovile Madonna', *Art Studies* I (1923) p.45f.
M. Meiss, 'Bartolomeo Bulgarini altrimenti detto "Ugolino Lorenzetti"?, *Rivista d'Arte* XVIII (1936) p.113f.
U. Morandi, *Le biccherne senesi* (Siena, 1964) p.66
E. H. Beatson, N. E. Muller and J. B. Steinhoff, 'The St Victor Altarpiece in Siena Cathedral: A Reconstruction', *Art Bulletin* LXVIII (1986) p.610f.

Benedetto di Bonfiglio (or Bonfigli)

Benedetto di Bonfiglio di Egidio di Vanni was probably born at Perugia around 1420. In 1445 he was commissioned to paint a *Madonna and Child with two angels* (now lost) for a chapel next to the church of San Pietro and must therefore already have been an artist of some repute. Thereafter until his death in 1496 Bonfigli worked mainly in Perugia, where he held public offices in 1466 and 1471. No traces remain of his participation in the decoration of the Vatican Palace in Rome, for which he received payments in 1450. However, he may then have had occasion to work with Fra Angelico, who exercised a fundamental influence on his style.

In 1453 Benedetto returned to Perugia and the following year he was commissioned to fresco part of the chapel in the Palazzo dei Priori. The commission comprised a *Crucifixion* scene with mourning saints (either not executed or later replaced by another subject) and *Episodes from the life of St Louis of Toulouse*. The acclaim they received on their completion induced the Priori in 1461 to commission the artist to complete the chapel's decoration with *Episodes from the life of St Herculanus*. Besides this task, which dragged on until the artist's death, there are documents relating to numerous other works. In 1467 he collaborated with Bartolomeo Caporali on a triptych for the Chapel of San Vincenzo in San Domenico (Perugia, Galleria Nazionale), and he supplied a number of processional banners for the confraternities of the city (in 1464, 1465, 1472, 1476, etc.), works which reveal a gradual exhaustion of his artistic inspiration.

The lack of documents relating to the artist's early career is compensated by works such as *Adoration of the Christ Child* (Florence, Villa I Tatti, Berenson collection) or the Thyssen *Annunciation*, both of which are datable near or soon after the middle of the century. While still reflecting certain formulae of local late-Gothic painting, these works reveal the strong influence of Fra Angelico and still more of Domenico Veneziano. Like Boccati and Caporali, Benedetto transposes his Florentine Renaissance sources into a fresh and spontaneous manner of his own, enlivened by a particular narrative appeal. At times he may be repetitive or hasty in execution, but he frequently reaches a very high quality both in his precious small-scale works and in his *chef d'œuvre*, the decoration of the Cappella dei Priori.

L. Manzoni, 'Ricerche sulla storia della pittura in Perugia nel secolo XV ... Commentario di Benedetto Bonfigli', *Bollettino della R. Deputazione di Storia Patria per l'Umbria* VI (1900) pp.289–316
W. Bombe, 'Die Tafelbilder, Gonfaloni und Fresken des Benedetto Bonfigli', *Repertorium für Kunstwissenschaft* XXXII (1909) pp.97–114, 231–46
Venturi, *Storia*, VII/I, pp.538–44
U. Gnoli, *Pittori e miniatori nell'Umbria* (Spoleto, 1923) pp.58–62
van Marle, *Development*, XIV, pp.98–128
M. Pepe, 'Benedetto Bonfigli' in *Dizionario biografico degli Italiani*, XII (Rome, 1970) pp.13–15
B. Toscano, 'La pittura in Umbria nel Quattrocento', in *Quattrocento* (1987) pp.366–9

Bicci di Lorenzo

Like his father Lorenzo di Bicci and his son Neri, also painters, Bicci di Lorenzo was born in Florence probably in 1373, according to his

earliest *catasto* record (Milanesi (1878) p.68), or, less likely, in 1368 as is suggested by the *catasti* of 1446 and 1451 (Mather (1948)). He began by training with his father whose workshop he took over soon after 1400, when he enrolled in the guild of the Medici e Speziali (Frosinini (1985)). The earliest work generally attributed to him is the triptych from the church of Porciano (today in the Propositura of Santa Maria, Stia), which is dated 1414. Here his style is still clearly indebted to Lorenzo di Bicci and influenced only superficially, perhaps through Gherardo Starnina, by contemporary Florentine late-Gothic trends. From the following decades there are documents relating to numerous commissions, many of them of importance, which show that as an artist he was very much in demand. His documented works include the frescoes of 1421 in Sant'Ambrogio, Florence, the triptych of 1423 for the Pieve of Empoli, the frescoes of 1433 for a chapel in Santa Croce, Florence, the polyptych of 1437 in the church of San Niccolò a Cafaggio, the frescoes in Santa Trinita, Florence, of 1437 and those in Florence Cathedral of 1439–40. In 1441 Bicci worked with Domenico Veneziano in the Florentine church of Sant'Egidio and in 1445 he was in Arezzo where he began work on frescoes in San Francesco, which were later completed by Piero della Francesca.

Those of his documented paintings that survive (the polyptychs of Empoli and San Niccolò, the frescoes in Santa Trinita and the Cathedral in Florence, and in Arezzo), and numerous other attributed works, show him to be a faithful follower of the Trecento tradition, virtually untouched by the Renaissance figurative world or by the naturalistic interests of the International Gothic style. However, this did not prevent him from borrowing ideas or compositions from the leading artistic personalities of his day, especially Gentile da Fabriano and Masolino. He died in 1452.

Vasari, ed. Milanesi II, pp.63–71

van Marle, *Development*, IX, pp.1–38

R.G.Mather, 'Documents on Florentine Painters and Sculptors', *Art Bulletin* XXX (1948) pp.43–4

F.Zeri, 'Una precisazione su Bicci di Lorenzo', *Paragone* IX, no.105 (1958) pp.67–71

Berenson, *Italian Pictures* (1963) pp.27–32

E.Micheletti, 'Bicci di Lorenzo', in *Dizionario biografico degli Italiani*, X (Rome, 1968) pp.327–30

B.Walsh Buhler, *The Fresco Paintings of Bicci di Lorenzo* (Ann Arbor MI, 1981)

C.Frosinini, 'Il passaggio di gestione di una bottega fiorentina del primo Rinascimento: Lorenzo di Bicci e Bicci di Lorenzo', *Antichità Viva* XXV, no.1 (1985) pp.5–15

Giovanni Boccati

Giovanni di Pier Matteo Boccati (or Boccatis or Boccaccio) was born at Camerino in the Marches presumably about 1410, and certainly before 1420, since on 3 October 1445, when he was granted the citizenship of Perugia, he was apparently of age (*ie* twenty-five years old), and already 'in arte pictoria expertissimus' (Ricci (1834); Feliciangeli (1906)). The following year Boccati received the commission to paint the *Madonna 'della pergola'* (Perugia, Galleria Nazionale), his earliest documented work, which he completed in 1447. An artist with marked individual traits, he appears to have been trained in Umbria, probably at Perugia, where he may have known (and come under the influence of) Domenico Veneziano, who had worked there in 1438.

In 1448 Boccati was at Padua (Fiocco (1931–2)), and the intensely innovative atmosphere that characterized the Paduan scene towards the end of the fifth decade left a permanent impression on his work. This is evident, for example, in the *Madonna 'dell'orchestra'* (Perugia, Galleria Nazionale, no.147), which reveals an interest in Squarcionesque naturalism and perspective, as well as a new feeling for light. The same features characterize the frescoes with warriors and putti he painted in one of the rooms of the Palazzo Ducale at Urbino, which can be dated to the 1450s or slightly later. Between 1458 and 1470 Boccati is

recorded at Camerino. The works dating from this period include the *Coronation of the Virgin* at Castel Santa Maria near Camerino (1463), the triptychs at Seppio di Pioraco (1466) and Nemi di Fiordimonte, and the spectacular and beautifully preserved polyptych of Belforte (1468). During the last decade of his activity Boccati seems to have settled once more at Perugia, where he is documented until 1480. In the works of his last period, for instance in the Orvieto altarpiece of 1473 (to which the predella panel discussed here belonged), his style is more relaxed and serene; he emphasizes the calm dignity of the figures in the main panel and there is a peaceful luminosity in the predella scenes. Although by no means a pioneer, he kept abreast of artistic developments in the area between Umbria and the Marches, influenced in those years by Piero della Francesca.

A.Ricci, *Memorie storiche delle Arti e degli Artisti della Marca di Ancona*, I (Macerata, 1834)

B.Feliciangeli, *Sulla vita di Giovanni Boccati da Camerino* (Sanseverino, 1906)

G.Fiocco, 'I pittori marchigiani a Padova nella prima metà del '400', *Atti del R.Istituto Veneto di Scienze, Lettere ed Arti* XCI–XCII (1931–2) p.1359f.

F.Zeri, *Due dipinti, la filologia e un nome. Il Maestro delle tavole Barberini* (Turin, 1961) pp.54–66 and *passim*

G.Vitalini Sacconi, *La pittura marchigiana. La scuola camerinese* (Trieste, 1968) pp.107–51

M.Bacci, 'Il punto su Giovanni Boccati', *Paragone* XX, no.231 (1969) pp.15–33; no.233, pp.3–21

P.Zampetti, *Giovanni Boccati* (Milan and Venice, 1971)

F.Santi, *Galleria Nazionale dell'Umbria. Dipinti, sculture e oggetti dei secoli XV e XVI* (Rome, 1985) pp.22–9

Cenni di Francesco di Ser Cenni

A Florentine painter and miniaturist, Cenni was enrolled in the guild of the Medici e Speziali in 1369 (D.E.Colnaghi, *A Dictionary of Florentine Painters* (London, 1928) p.69). He worked extensively for churches in and around Florence and also in San Gimignano and Volterra until about 1415. The date of his death is unknown.

The three panels of a polyptych in the church of San Cristofano a Perticaia, Rignano sull'Arno, dated 1370, illustrate the artist's first phase, in the orbit of Orcagna's workshop. His connection with Giovanni del Biondo has been demonstrated by the identification of his hand in the predella of Giovanni's altarpiece of *St John the Evangelist enthroned* (Florence, Accademia, no.444).

Although documents relating to Cenni are scarce, the fact that a number of dated paintings and frescoes has recently been attributed to him has helped to reconstruct his development. These include the frescoes of 1383 in San Donato in Polverosa, near Florence, a fresco of the *Madonna and Child surrounded by the Virtues* of 1393 in the Palazzo Comunale, San Miniato al Tedesco, the triptych dated 1400 in San Giusto in Montalbino, a polyptych of the *Madonna and Child with four saints* of 1408 (Volterra, Pinacoteca), a cycle of frescoes dated 1410 illustrating the *Legend of the Cross* (Volterra, San Francesco), a panel of *St Jerome in his study* of 1411 (San Miniato al Tedesco, Museo Diocesano) and frescoes of 1413 in the oratory of San Lorenzo at San Gimignano.

Numerous other works have been connected with this group on stylistic grounds. Traditionally associated by critics with the school of Agnolo Gaddi, Cenni emerges instead as a follower of Orcagna, in possession of a firm technique and inclined to execute his paintings with extreme care in every detail. He sought to give his images a narrative quality, rich in episodic details and direct observations drawn from life, but he lacked expressiveness and a feeling for dramatic contrasts. The paintings gathered under the conventional name of the 'Master of the Kahn St Catherine' (Berenson (1963)) and the 'Rohoncz Orcagnesque Master' (Offner (1960, 1962, 1969)) are now thought to be by Cenni himself (Zeri (1963); Boskovits (1968)).

Offner, *Corpus*, IV/II (1960) p.50; IV/I (1962) p.74; IV/V (1969) pp.65 note 1, 77 note 3

P. Dal Poggetto in *Arte in Valdelsa dal secolo XII al secolo XVIII*, exhibition catalogue (Certaldo, 1963) pp.36–8

F. Zeri, 'La mostra "Arte in Valdelsa" a Certaldo', *Bollettino d'Arte* XLVIII (1963) pp.252–3

L. Bellosi, 'La mostra di affreschi staccati al Forte Belvedere', *Paragone* XVII, no.201 (1966) p.77

M. Boskovits, 'Ein Vorläufer der spätgotischen Malerei in Florenz: Cenni di Francesco di Ser Cenni', *Zeitschrift für Kunstgeschichte* XXXI (1968) pp.273–92

A. Padoa Rizzo, 'Cenni di Francesco di Ser Cenni', in *Dizionario biografico degli Italiani*, XXIII (Rome, 1979) pp.535–7

Bernardo Daddi

Bernardo, son of Daddo di Simone, was probably born in Florence in the last decade of the thirteenth century. His name appears for the first time in the list of painters enrolled in the guild of Medici e Speziali between 1312 and 1320 (Hueck, 'Le matricole dei pittori fiorentini', *Bollettino d'Arte* LVII (1972) pp.115, 119), and he must therefore have been an established painter by 1320 at least. Scholars are now agreed in dating earlier than Daddi's signed triptych of 1328 in the Uffizi, works such as the polyptych of San Martino at Lucarelli near Radda, or the Tacoli Canacci polyptych (now divided between Parma, Galleria Nazionale, and other collections). From then onwards his activity in Florence is documented until 18 August 1348, when, presumably a victim of the Black Death, he is named as deceased.

Daddi's early works, which also include the frescoes of the Pulci-Berardi Chapel in Santa Croce, reveal both the influence of Giotto's style and a particular interest in artists who did not belong to Giotto's milieu – Lippo di Benivieni, Bonamico Buffalmacco and the Master of San Martino alla Palma – whose attractive narrative vein, fantasy and attention to detail he must have found congenial. The Uffizi tabernacle and the Bigallo (Florence) triptych, both dated 1333, demonstrate his familiarity with the works of Ambrogio Lorenzetti and Andrea Pisano but also illustrate the particular lyrical serenity of Daddi's mature style. His workshop at this date produced a large quantity of small devotional panels, which often repeat the same compositional schemes and do not always maintain the high standard of the artist's more important commissions. He painted altarpieces for Prato Cathedral (Museo Civico and New York, Metropolitan Museum, Lehman collection), for the church of San Pancrazio (Uffizi) and for the Carmine church in Florence (now dispersed among various collections). Simplified forms and a strong architectural sense characterize the compositions of Daddi's late works: the polyptych of 1344 for Santa Maria Novella, the large *Madonna* for Orcagna's tabernacle in Orsanmichele of 1346–7, and the polyptych of San Giorgio a Ruballa of 1348 (London, Courtauld Institute Galleries), which may have been his last work.

Vasari, ed. Milanesi, I, pp.463–9, 673

G. G. Vitzthum, *Bernardo Daddi* (Leipzig, 1903)

Offner, *Corpus*, III/II (1930); III/VIII (1958)

R. Longhi, 'Qualità e industria in Taddeo Gaddi', *Paragone* X, no.109 (1959) pp.31–40; no.111, pp.3–12

F. Zeri, 'Qualche appunto sul Daddi', in *Quaderni di Emblema. I. Diari di lavoro* (Bergamo, 1971) pp.11–6

G. Damiani, 'Bernardo Daddi', in *Dizionario biografico degli Italiani*, XXXI (Rome, 1985) pp.622–7

M. Boskovits, in Offner, *Corpus*, III/III 2nd edn. (Florence, 1989) pp.33–54

Duccio di Buoninsegna

The earliest record of the great Sienese master, who was probably born around the mid-thirteenth century, goes back to November 1278. He received a payment at that date for painting chests destined to hold documents of the Comune di Siena, a modest commission which nevertheless implies that Duccio was already well established in his profession. Of the numerous later documents, those relating to his artistic activity usually refer to minor works, an exception being the *Madonna 'dei Laudesi'* (also known as the 'Rucellai' *Madonna*; Florence, Uffizi) commissioned in 1285 for Santa Maria Novella in Florence. No records survive between 1285 and 1302 and it is likely that the artist was working outside Siena during that period. In December 1302 he was paid for the altarpiece in the Cappella dei Nove (the governing body of Siena) and by October 1308 he was working on the *Maestà*, a grandiose, two-sided altarpiece for the high altar of Siena Cathedral (now divided between the Museo dell'Opera del Duomo and numerous other collections), which he completed in 1311. Duccio is mentioned again in various documents until 1318 and in 1319 he is recorded as deceased.

Around the artist's two documented great works, the *Madonna 'dei Laudesi'* and the *Maestà* in Siena, scholars have assembled a considerable number of paintings, the earliest of which are the Gualino *Madonna* (Turin, Galleria Sabauda), the Crevole *Madonna* (Siena, Museo dell'Opera del Duomo) and the stained-glass window in Siena Cathedral apse, which can be dated to 1288. This group of works reveals affinities with the art of Cimabue, whose intense, severe style is transformed by Duccio into a more refined blend of harmonious forms and brilliant colours. In the works which can be dated around the turn of the century (the *Madonna* in the Pinacoteca, Siena, no.20; the *Madonna* in the Stoclet collection, Brussels; the *Madonna* in the Galleria Nazionale, Perugia, no.29; and the polyptych in the Pinacoteca, Siena, no.28), his figures acquire greater weight and volume, together with an aristocratic elegance in their proportions, and his forms are chiselled and rounded by delicate contrasts of light and shade. Duccio's particular mixture of French Gothic influences and neo-Hellenistic ideals derived from Constantinople emerges most distinctly in the *Maestà* and in other works of the second decade, such as the polyptych in the Siena Pinacoteca (no.47), the *Maestà* fragment in the Cathedral of Massa Marittima, the small triptych in the National Gallery, London, and another in the Siena Pinacoteca (no.35), all of which foreshadow the lyrical style of Simone Martini, who probably received his training in Duccio's workshop.

C. H. Weigelt, *Duccio di Buoninsegna* (Leipzig, 1911)

G. De Nicola, *Mostra di opere di Duccio di Buoninsegna e della sua scuola* (Siena, 1912)

E. Cecchi, *Trecentisti senesi* (Rome, 1928)

C. Brandi, *Duccio* (Florence, 1951)

R. Longhi, 'Prima Cimabue, poi Duccio', *Paragone* II, no.23 (1951) pp.8–13

C. Volpe, 'Preistoria di Duccio', *Paragone* V, no.49 (1954) pp.4–22

M. Meiss, 'The Case of the Frick *Flagellation*', *Journal of the Walters Art Gallery* XIX–XX (1956–7) pp.42–63

F. Bologna, 'Ciò che resta di un capolavoro giovanile di Duccio', *Paragone* XI, no.125 (1960) pp.3–31

E. Carli, *Duccio di Buoninsegna* (Milan, 1962)

F. Arcangeli, 'La Maestà di Duccio a Massa Marittima', *Paragone* XXI, no.240 (1970) pp.4–14

G. Cattaneo and E. Baccheschi, *L'opera completa di Duccio* (Milan, 1972)

J. H. Stubblebine, *Duccio di Buoninsegna and his School* (Princeton, 1979)

J. White, *Duccio* (London, 1979)

Gotico a Siena (1982)

F. Deuchler, *Duccio* (Milan, 1983)

M. Boskovits, 'Il gotico senese rivisitato: proposte e commenti su una mostra', *Arte Cristiana* LXXI (1983) pp.259–76

L. Bellosi, *La pecora di Giotto* (Turin, 1985)

Agnolo Gaddi

Agnolo was descended from a family of Florentine painters: his grandfather, Gaddo Gaddi (possibly to be identified with the St Cecilia Master), belonged to Giotto's generation and his father, Taddeo Gaddi, was one of the major figures in Florentine art of the mid-fourteenth century. His brother Giovanni was also a painter.

Agnolo is first recorded in 1369 when he took part in the decoration of the Vatican Palace in Rome, together with his brother and other artists. He is mentioned in Florentine documents fairly regularly from 1376, but he had probably returned to his home

town before then. A number of works dating from the early 1370s includes the frescoes in the funerary chapel of the Rossi de' Strozzi family in Santa Maria Novella, Florence, a wing of a triptych in the Walters Art Gallery, Baltimore, and a triptych dated 1375 in the Galleria Nazionale, Parma. The volumetric solidity and heavy outlines of the well rounded forms characterizing these early works gradually gave way, during the following years, to more dynamic and crowded compositions. The artist developed unusual, lively colour contrasts and added amusing episodes and a number of realistic details to his narrative scenes. This phase is exemplified by the frescoes in the Castellani Chapel and the choir of Santa Croce, Florence, and also by the polyptychs in the Bode Museum, East Berlin, and in the Gallerie Florentine (Contini-Bonacossi bequest), or the panels in the National Gallery, London, and the Museo Nazionale, Pisa. During his last years Agnolo was active in Prato, where, among other works, he frescoed the Cappella della Cintola in the Cathedral (1392–4). His activity in Florence concluded with a commission in 1394 for an altarpiece for San Miniato al Monte, for which the last payments were made after the artist's death in October 1396. In his last phase Agnolo Gaddi continued his search for linear elegance and rhythmic complexity, while endowing his scenes with more delicate tonal modulations and a gentle lyrical mood; this formula was to have a considerable influence on Florentine painting of the late fourteenth and early fifteenth century, and particularly on Lorenzo Monaco and Gherardo Starnina.

P. Toesca, *La pittura fiorentina del Trecento* (Florence and Verona, 1929)
R. Salvini, *L'arte di Agnolo Gaddi* (Florence, 1936)
H. D. Gronau, 'A Dispersed Florentine Altarpiece and its possible Origin', *Proporzioni* III (1950) pp.41–7
Boskovits, *Pittura fiorentina*, pp.47f., 65f., 117–24, 126f.
B. Cole, *Agnolo Gaddi* (Oxford, 1977)

Taddeo Gaddi

A celebrated Florentine painter (like his father Gaddo and his two sons Giovanni and Agnolo), Taddeo was born about 1300 and enrolled in the Arte dei Medici e Speziali towards 1330. At this date he was already an established master, having painted among other works an important cycle of frescoes (c1328) in the Baroncelli Chapel in Santa Croce. Cennino Cennini states that Taddeo spent 24 years in Giotto's workshop, which probably means that he collaborated with his master over a long period after his apprenticeship. In the Baroncelli cycle Taddeo modelled himself on Giotto but he also introduced into his compositions new formulae: a sort of magniloquence, complex rhythms and a dramatic narrative sense, which he probably derived partly from two sculptors, the Sienese Tino da Camaino and the Pisan Giovanni di Balduccio. He soon emerged as one of the leading artistic personalities in Florence: between 1332 and 1335 he painted for Santa Croce the fresco decoration in the Chapel of St Louis and, in the later 1330s, the panels of the sacristy cupboards (now Florence, Accademia; Berlin, Gemäldegalerie; and Munich, Alte Pinakothek). He also frescoed the chapel of the castle of Poppi in the Casentino and executed numerous portable altarpieces, including two triptychs dated 1334 and 1335 (respectively Berlin, Gemäldegalerie, and Naples, Capodimonte). In 1341/2 Taddeo frescoed the crypt of the church of San Miniato al Monte in Florence, while he continued working in Santa Croce. He also executed a polyptych for San Martino a Mensola, near Florence, and another now in the Metropolitan Museum, New York, which mark a return to Giottesque classicism.

After the middle of the century Taddeo continued to receive commissions in Florence (frescoes in the refectory of Santa Croce, polyptych of Santa Felicita, etc.), but also worked in other Tuscan towns. In 1353 he completed the polyptych for San Giovanni Fuorcivitas at Pistoia, in 1355 the altarpiece for the high altar of the church of San Lucchese at Poggibonsi (now Uffizi) and,

probably in the same period, the *Story of Job* in the Camposanto of Pisa. These works, which combine a measured compositional balance with a sharp observation of realistic detail, tend towards a severe and somewhat monotonous academicism, as if to mark the artist's opposition to the exuberance and lively inventiveness of northern Gothic trends. Taddeo Gaddi died in 1366.

M. Wehrmann, *Taddeo Gaddi, ein florentiner Maler des Trecento* (Stettin, 1910)
O. Sirén, *Giotto and some of his Followers* (Cambridge MA, 1917) I, pp.130–56
R. Offner, *Studies in Florentine Painting* (New York, 1927) pp.59–65
P. Toesca, *Die florentinische Malerei des XIV Jahrhunderts* (Florence and Munich, 1929) pp.52f., 76f.
R. Longhi, 'Qualità e industria in Taddeo Gaddi', *Paragone* X, no.109 (1959) pp.31–40; no.111, pp.3–12
P. P. Donati, *Taddeo Gaddi* (Florence, 1966)
A. Ladis, *Taddeo Gaddi. Critical Reappraisal and Catalogue Raisonné* (Columbia and London, 1982)

Giovanni da Bologna

Giovanni di Salamone di Ser Albertino da Bologna is documented at Treviso in 1377–9 and again in 1382, 1383 and 1385 (Gargan (1978) p.293f.). He is referred to in the documents as a painter and goldsmith and recorded as resident in Venice in 1383/5. His name also appears in a Venetian document of 1389 (Testi (1909) p.296).

There are four known signed paintings by the artist: the *Coronation of the Virgin*, Denver, Art Museum, no.A-E-It-XIV-926; a *Madonna and Child with Angels* (Milan, Brera, no.760); a full-length *St Christopher* (Padua, Museo Civico, no.378); and a processional banner with the *Madonna and Child, saints and brothers of the Scuola di San Giovanni Evangelista* (Venice, Accademia, no.230). None of these is dated; however, there are good reasons for identifying the painting at Padua with that commissioned in 1377 for the Scuola dei Mercanti in Venice (Moschetti (1903)). We also know that the Denver panel belonged in the nineteenth century to Michelangelo Gualandi in Bologna and it is therefore conceivable that it came from a Bolognese church. There is no documentary evidence for the artist's activity in Bologna, probably because he only worked there at intervals. What are presumably his earlier works, the banner in the Accademia and the Brera *Madonna*, incline one to believe that the painter received his training in the Veneto, in the wake of Lorenzo Veneziano and Guariento. The understanding of physical density that characterizes the artist's paintings, already apparent in the *St Christopher* of 1377, points to probable contacts with Jacopo degli Avanzi of Bologna and with Altichiero of Verona, both of whom were active in Padua in the same period. The influence of Jacopo's sharply realistic manner combined with aspirations towards a neo-Giottesque monumentality are apparent in Giovanni's later production, particularly in the Bologna polyptych (Pinacoteca, no.227). Indeed, this monumental and classicizing trend was to dominate Bolognese painting in the late fourteenth century and was to have a fundamental influence, for instance, on the initial phase of Jacopo di Paolo.

V. Moschetti, 'Giovanni da Bologna pittore trecentista veneziano', *Rassegna d'Arte* III (1903) pp.36–9
L. Testi, *La storia della pittura veneziana*, I (Bergamo, 1909) pp.296–302
R. Longhi, *Viatico per cinque secoli di pittura veneziana* (of 1946; published Florence, 1952) pp.47–8
L. Gargan, *Cultura e arte nel Veneto al tempo del Petrarca* (Padua, 1978) p.293f.

Giovanni di Paolo

Giovanni di Paolo di Grazia, called Boccanera, is recorded in Siena as a miniaturist from 1417 and as a painter from 1420 (Bacci (1941); Bähr (1987)). He soon became one of the most successful artists of his day, as is demonstrated by the number of important commissions he received throughout most of his life. Born probably in the last years of the fourteenth century, he trained under the influence of masters such as Taddeo di Bartolo, Gregorio di Cecco

and Benedetto di Bindo, and was particularly receptive to the formal innovations of the International Gothic style. He must have seen miniatures and goldsmiths' work from northern Italy and from beyond the Alps, and have drawn inspiration from the paintings of Gentile da Fabriano, who was working in Siena in 1426.

In the early 1420s Giovanni di Paolo painted for the church of San Domenico in Siena a *Christ suffering and triumphant* (Siena, Pinacoteca, no.212); in 1426 he executed the Pecci polyptych (now divided between the Propositura of Castelnuovo Berardenga and Siena, Pinacoteca (nos.193 and 197), and other places), and in 1427 the Branchini polyptych (central panel, Norton Simon Museum, Pasadena CA). In the 1430s Giovanni absorbed elements derived from Florentine art, which he was to translate into a harsh and excited style of his own, capable of expressing intense feelings and even startling visions. Examples of this are the *Madonna della Misericordia* (Santa Maria dei Servi, Siena); the predella divided between the Siena Pinacoteca (nos.174–6) and the Kröller-Müller Museum, Otterlo; the Osservanza *Crucifixion* of 1440 (Siena, Pinacoteca, no.200), as well as the Uffizi polyptych (no.3255), the triptych in Sant'Andrea in Siena, both dating from 1445, and the Pizzicaioli altarpiece of 1446/47. In the same years he also executed some *biccherna* book-covers (Siena, Archivio di Stato, and other collections) and various miniatures (for instance, Antiphonary G.I.8, Biblioteca Comunale, Siena).

The works of the artist's later period, which include the San Nicola polyptych of 1453 (Siena, Pinacoteca, no.173), the fragmentary triptych of 1457/8 (Palazzo Comunale, Castiglion Fiorentino) and the altarpiece in Pienza Cathedral of 1463, all testify to his fertile inventiveness and superb technical mastery. He continued to develop a very personal adaptation of late-Gothic formulae and rhythms to a Renaissance language of forms introduced by the artists of the younger generation. It was only in works such as the Staggia polyptych of 1475 (Siena, Pinacoteca, nos.186, 189, 324), that Giovanni, by then an old man, began to show signs of fatigue, repeating in a somewhat confused way motifs and patterns of composition from his earlier works. On 29 January 1482 Giovanni di Paolo dictated his will and by 27 March of the same year he was dead.

R. van Marle, 'Il problema riguardante Giovanni di Paolo e Giacomo del Pisano', *Bollettino d'Arte* XII (1925) pp.529–42
J. Pope-Hennessy, *Giovanni di Paolo* (London, 1937)
P. Bacci, 'Documenti e commenti per la storia dell'arte. Ricordi della vita e dell'attività artistica del pittore senese Giovanni di Paolo di Grazia detto Boccanera 1399–circa 1482', *Le Arti* IV (1941) pp.11–39
C. Brandi, *Giovanni di Paolo* (Florence, 1947)
E. Carli, 'Problemi e restauri di Giovanni di Paolo', *Pantheon* XIX (1961) pp.163–77
E. Carli, *Pittori senesi* (Milan, 1971)
G. Chelazzi Dini, in *Gotico a Siena* (1982) pp.358–9
I. Bähr, 'Die Altarretabel des Giovanni di Paolo aus S. Domenico in Siena. Überlegungen zu den Auftraggebern', *Mitteilungen des Kunsthistorischen Instituts in Florenz* XXXI (1987) pp.357–66
C. Strehlke, in *Painting in Renaissance Siena*, exhibition catalogue (New York, 1988) pp.168–9

Lorenzo Monaco

In 1391, when the Sienese-born Giovanni di Pietro became a Camaldolese monk in Florence, taking the name of Don Lorenzo, he had presumably completed his apprenticeship, possibly with Agnolo Gaddi, and must already have been a recognised painter. His earliest works include a predella of *c*1387/8 (Paris, Louvre, no.1302) and the polyptych of San Gaggio of around 1390 (Florence, Accademia; London, Courtauld Institute Galleries; and other collections); they demonstrate that his artistic formation took place in late fourteenth-century Florence, under the combined influences of the Giottesque revival and late-Gothic trends. During the first years of his monastic life Don Lorenzo executed manuscript

illuminations (Florence, Biblioteca Laurenziana, Cor.5, 8 and 1, dated 1394, 1395 and 1396 respectively) and small devotional paintings (*Head of the Virgin*, Amsterdam, Rijksmuseum; images of the *Madonna and Child with saints*, Baltimore, Walters Art Gallery and San Diego, Fine Arts Society; and a diptych, Cambridge, Fitzwilliam Museum, and Pesaro, Museo Civico). In the last years of the fourteenth century he also painted altarpieces: the *Agony in the Garden* (Florence, Accademia) and the Carmine polyptych of 1399/1400 (Florence, Accademia; Toledo, Ohio, Museum, and other collections). In these works, as also in the slightly later *Man of Sorrows* of 1404 (Florence, Accademia), the solid structure of his compositions, the controlled gestures and the emphasis on relief still echo the formal rigour of the Giottesque tradition. During the first decade of the fifteenth century, stimulated by Ghiberti and by Gherardo Starnina, Lorenzo Monaco sought to express poetic feeling enhanced by a gracefully rhythmic use of line. This is apparent in works such as the triptych of 1408 (Paris, Louvre and Prague, National Gallery), the Monte Oliveto polyptych of 1410 (Accademia) and the polyptych of Santa Maria degli Angeli of 1414 (Uffizi), in all of which the lyrical exaltation of ample gestures and flowing rhythms is accompanied by a growing expressiveness in the figures. In his last works, the decoration of the Bartolini-Salimbeni Chapel in Santa Trinita and the *Adoration of the Magi* of 1421/2 (Uffizi), the artist tends to give less emphasis to chiaroscuro contrasts, preferring delicate, light colours and enriching his figurative repertoire with some curious and fantastic motifs. Don Lorenzo was a dominant figure in the artistic life of Florence at the beginning of the fifteenth century and his mature works were influential for Masolino and Fra Angelico. In 1426 Don Lorenzo is recorded as deceased.

Vasari, ed. Milanesi, II pp.17–32
O. Sirén, *Don Lorenzo Monaco* (Strasbourg, 1905)
G. Pudelko, 'The Stylistic Development of Lorenzo Monaco', *Burlington Magazine* LXXIII (1938) pp.237–48; LXXIV (1939) pp.76–81
M. Levi D'Ancona, *Miniatura e miniatori a Firenze dal XIV al XVI secolo* (Florence, 1962) pp.171–3
F. Zeri, 'Investigations into the early period of Lorenzo Monaco', *Burlington Magazine* CVI (1964) pp.554–8; CVII (1965) pp.4–11
L. Bellosi, *Lorenzo Monaco (I Maestri del Colore, no.73)* (Milan, 1965)
Boskovits, *Pittura fiorentina*, pp.87f., 116f., 132–6, 137 and *passim*
M. Eisenberg, *Lorenzo Monaco* (Princeton NJ, 1989)

Lorenzo Veneziano

Nothing certain is known of the life of this artist, whose œuvre is reconstructed today on the basis of a number of signed and dated works. The earliest of these is a recorded but no longer extant altarpiece of 1356 and the latest a *Madonna and Child enthroned* signed 'LAVRECI Đ VENETIS PISIT' and dated 1372 (Paris, Louvre). Between them come various other signed and dated works, the Lion polyptych in the Accademia in Venice (1357/9), the *Mystic Marriage of St Catherine* also in the Accademia (1360), the *Madonna* in the Museo Civico of Padua (1361), the polyptych in the Cathedral of Vicenza (1370) and another polyptych in the Accademia in Venice (1371). No work attributed to Lorenzo seems to be much later than the early 1370s, and it is therefore likely that he died within that decade. The provenance of some of the artist's works suggests that he worked not only in Venice, Padua and Vicenza but also in Bologna, Imola and Udine, and that his fame extended well beyond the frontiers of the Venetian Republic.

Lorenzo Veneziano is perhaps to be identified with the otherwise unknown painter Lorenzo di Nicolò, who is mentioned in the will of his father in 1365 (Testi (1909)). Not only do Lorenzo's early works follow the stylistic orientation of Paolo Veneziano but also, given their exquisite quality, he can be considered the true heir to this leading personality of Venetian Trecento painting. Certain works, such as the Lion polyptych, suggest that he was actually trained in Paolo's workshop. At the same time, the graduated light that gives flexibility to the flesh, the less rigid compositional

structures and the vivid and unusual blends of luminous colours point to his contacts with painting on the mainland. Lorenzo seems to have been particularly drawn to Guariento, but he may also have been influenced by Tommaso da Modena and the young Altichiero. His relaxed and pleasant narrative style, rich in realistic detail and psychological characterization, offers a fascinating vision of a splendid, luxurious, but profoundly human world.

L. Testi, *La storia della pittura veneziana. Le origini* (Bergamo, 1909) pp.133, 208–32

L. Coletti, 'Lorenzo Veneziano in neuem Licht', *Pantheon* IX (1932) pp.47–50

R. Longhi, 'Calepino veneziano', *Arte Veneta* I (1947) pp.80–5

M. T. Cuppini, 'Una croce stazionale di Lorenzo Veneziano', *Commentari* IX (1958) pp.235–43

Pallucchini, *Trecento*, pp.164–81

M. Lucco in *Duecento e Trecento* (1986) pp.182–5, 593

Luca di Tommè

Born probably around 1330, the artist is recorded in the *Breve dell'Arte de' pittori senesi* in 1356 and mentioned in documents of 1357 and 1358. In 1362, together with Jacopo di Mino and Bartolomeo Bulgarini, he formed part of the advisory committee for the demolition of the high altar of the Cathedral and in the same year he signed and dated with Niccolò di Ser Sozzo a polyptych in the Pinacoteca of Siena (no.51).

The difficulty in distinguishing the hands of the two painters in this signed work has led to various contrasting views. Some scholars (Brandi (1932); Zeri (1958); De Benedictis (1979)) believe it to be mainly by Niccolò di Ser Sozzo; others suppose it to be by both artists in equal measure, or even principally by Luca di Tommè (Meiss (1963); Fehm (1973); Chelazzi Dini (1982)). The undeniably strong stylistic affinities between both painters would suggest that Luca was apprenticed to Niccolò di Ser Sozzo, who was already an established artist around 1336 (the period of his signed miniature in the *caleffo bianco* in the Siena State archives). Certainly by 1362 Luca had already made his reputation in his city and elsewhere, as is demonstrated by the public offices entrusted to him and by such works as his *Crucifixion* of 1366 (Pisa, Museo Nazionale), the Capuchin polyptych of 1367 from San Quirico (Siena, Pinacoteca, no.109) and the polyptych of 1370 (Rieti, Museo Civico).

In 1374 Luca was active at Orvieto, working with Ugolino di Prete Ilario, and later, in the same year, he was paid for the altarpiece for a chapel in Siena Cathedral. He received another payment in 1389, together with Bartolo di Fredi and his son Andrea, for the altarpiece of the *Assumption* for the Calzolai Chapel, also in the Cathedral (lost; H. van Os, 'Tradition and Innovation in some Altarpieces by Bartolo di Fredi', *Art Bulletin* LXVII (1985) pp.51–2). There is no further record of the artist after this date.

Luca di Tommè's late œuvre consists of several large polyptychs that have mostly come down to us in a dismembered state. In these works, with their severe and solemn figures of saints and solid, monumental Madonnas, he abandoned the smooth modelling and swinging contours of his earlier manner and tended to conform to a more static and monotonous stylistic formula.

P. Bacci, 'Una tavola inedita e sconosciuta di Luca di Tommè con alcuni ignorati documenti della sua vita', *Rassegna d'Arte Senese*, N.S. no.20 (1927) pp.51–62

C. Brandi, 'Niccolò di Ser Sozzo Tegliacci', *L'Arte* XXXV (1932) pp.223–6

F. Zeri, 'Sul problema di Niccolò di Ser Sozzo Tegliacci e Luca di Tommè', *Paragone* IX, no.105 (1958) pp.3–16

M. Meiss, 'Notes on three linked Sienese styles', *Art Bulletin* XLV (1963) pp.47–8

E. Carli, *I pittori senesi* (Milan, 1971) pp.22–3

S. Fehm, *Luca di Tommè*, PhD. dissertation (Yale University, 1971; University Microfilms, Ann Arbor MI, 1971)

S. Fehm, *The Collaboration of Niccolò Tegliacci and Luca di Tommè* (Los Angeles, 1973)

C. De Benedictis, *La pittura senese 1330–1370* (Florence, 1979)

G. Chelazzi Dini in *Gotico a Siena* (1982), pp.276–80

Master of the Dotto Chapel

The frescoes in the Dotto Chapel, to the right of the apse in the Eremitani church in Padua, came to light during restoration in 1932 but were totally destroyed in 1944. Photographs of the frescoes reveal the hand of a powerful artist active around the first decade of the fourteenth century, whose imaginative and deeply expressive style anticipated certain aspects of the leading Venetian fourteenth-century painter, Paolo Veneziano. Although stylistically close to the San Donato altarpiece, dated 1310, in the basilica of Santi Maria e Donato in Murano, our artist displays a more severe temperament and a more archaic culture, such as may also be traced in a series of small *Scenes from the Life of Christ* discussed under cat. [21], which was first published by Longhi (1948) under the name of Cimabue and attributed by subsequent criticism mostly to an anonymous Venetian master. The same artist was probably also responsible for the portable crucifix in the Cagnola bequest (Fondazione Paolo VI, Gazzada, near Varese), a *Crucifixion* formerly in the Bellesi collection, London, and, possibly, a *Man of Sorrows with mourning angels* formerly in the Stoclet collection, Brussels. This nucleus of works illustrates an important aspect of Venetian painting at the end of the thirteenth and beginning of the fourteenth century which, in contrast to the formal elegance and reserved nobility of the artistic trend of the 'Palaeologan Renaissance', insisted instead on intensity of emotions and solidity of form rendered by means of a free and vibrant brushwork.

R. Longhi, 'Guidizio sul Duecento', *Proporzioni* II (1948) pp.16–7

Garrison, *Italian Romanesque Panel Painting*, p.30 ('Speaking Christ Master')

Pallucchini, *Trecento*, p.205f.

E. Cozzi, 'Gli affreschi della "Cappella angelorum" agli Eremitani di Padova', *Arte Veneta* XXXV (1981) pp.27–40

Master of Forlì

A nucleus of works by this anonymous artist active in the Romagna around 1300 was put together by Richard Offner under the name of the 'Master of the Griggs Spoliation' (Sandberg Vavalà (1929)). In the absence of evidence regarding the provenance of these works, both Offner and Sandberg Vavalà thought the Master was of Bolognese origin. The identification of further works (Garrison), three of them in the Pinacoteca of Forlì, makes it likely that this town was a centre of the artist's activity, which presumably extended to other towns in Emilia-Romagna. His stylistic origins can reasonably be traced back to the shop of another anonymous local artist of the later thirteenth century, the so-called 'Master of Faenza' (Cuppini (1951–2)).

The œuvre of the Master of Forlì, consisting of small, carefully executed devotional panel paintings, has given rise to various critical and chronological evaluations. Garrison believed him to be a retardataire artist active in the first half of the fourteenth century and possibly even later, who distinguished himself among his contemporaries by his inventiveness and 'feeling for composition', being 'particularly skilled at perfecting the models of others and making them more dramatic'. Cuppini agreed on the dating but, in his opinion, the artist's 'clumsy search for space' and 'stylistic limitations' were those of a 'reactionary' figure, only capable of painting 'scenes based on repetitive heads, empty glances and inexpressive, scowling faces rendered in a uniformly dry and meticulous technique'. Sandberg Vavalà, and more recently Pope-Hennessy (1987), are of the opinion that the cultural backwardness of the artist has been exaggerated and that his activity really belongs to the first quarter of the fourteenth century. Recent studies on Duecento painting even lead one to suppose that the Master of Forlì began his career still earlier, at the end of the thirteenth century. He seems to have been influenced by the classicizing trends of Venetian painting and, later, by Giotto's early works at Rimini. Far from being isolated from the stylistic developments of his time, he emerges as a subtle and imaginative

representative of early Trecento painting in Emilia-Romagna.

E. Sandberg Vavalà, 'Italo-Byzantine Panels at Bologna', *Art in America*
XVIII (1929) pp.64–84

E. B. Garrison, 'Il Maestro di Forlì', *Rivista d'Arte* XXVI (1950) pp.61–81

L. Cuppini, 'Aggiunte al Maestro di Forlì e al Maestro di Faenza', *Rivista
d'Arte* XXVII (1951–2) pp.15–22

A. Tambini, *Pittura dall'Alto Medioevo al Tardogotico nel territorio di Faenza e
Forlì* (Faenza, 1982) pp.49–52

J. Pope-Hennessy, *Italian Paintings in the Robert Lehman Collection* (New
York, 1987) pp.82–5

Master of the Magdalen

We owe the first reconstruction of this anonymous master of the
later thirteenth century to Sirén (1922), who grouped a number of
works around a painting of *Mary Magdalen and eight scenes from her
life* (Florence, Accademia, no.8466) under the name of the
'Magdalen Master'. None of the paintings attributed to the artist so
far is securely datable and they are sometimes considered products
not of a single hand but of a kind of working association, dating
from between the later Duecento and the early Trecento (Marcucci,
1958). Nevertheless, the common authorship of the majority of
these paintings is confirmed by their stylistic homogeneity;
although not innovative, their manner is straightforward and
displays both human warmth and rich decorative effects. The
Magdalen Master's trends in taste and style were similar in many
ways to those of Meliore and Corso di Buono, and, like the latter, he
probably began working around or a little before 1260. The bold
outlines and static forms of his dossal in the Yale University Art
Gallery, New Haven (no.1871.3), or of his triptych in the
Metropolitan Museum, New York (no.41.000.8), recall Meliore's
Uffizi dossal of 1271 (no.9153) and place them in the same period.
The artist's later works reveal a growing mastery of form, more
complex movements and greater ability in the use of drapery to
underline the limbs, as is shown by the Madonna altarpieces in San
Michele at Rovezzano, in the Acton collection, Florence, in the
Gemäldegalerie, Berlin, and in the church of San Fedele at Poppi. In
the last two images, in particular, the carefully modelled forms
standing out against a schematic backdrop present analogies with
Corso's frescoes in the church of San Lorenzo at Montelupo
Fiorentino (1284) and would seem to belong to the same decade.
Probably later in date is a group of more loosely executed works, in
which the linear rhythms and richly patterned stuffs blend together
to form an essentially flat, decorative ensemble. These include the
Magdalen panel (Florence, Accademia) and the *Madonna* at the
centre of the dossal in the Timken Art Gallery, San Diego (no.1),
both of which were presumably painted still within the last decade
of the thirteenth century.

O. Sirén, *Toskanische Maler im 13. Jahrhundert* (Berlin, 1922) pp.264–75

R. Offner, *Italian Primitives at Yale University. Comments and Revisions* (New
Haven, 1927) pp.11–2

G. M. Richter, 'Meliore di Jacopo and the Magdalen Master', *Burlington
Magazine* LVII (1930) pp.223–36

G. Coor Achenbach, 'Some Unknown Representations by the Magdalen
Master', *Burlington Magazine* XCIII (1951) pp.73–8

C. L. Ragghianti, *Pittura del Dugento a Firenze* (Florence, n.d. [1955])
pp.100–6

L. Marcucci, *Gallerie Nazionali di Firenze. I dipinti toscani del secolo XIII*
(Rome, 1958) pp.49–56

A. Tartuferi in *Duecento e Trecento* (1986) pp.276–7

A. Guerrini in *Duecento e Trecento* (1986) p.607

Master of the Pomposa Chapterhouse

The name has still not been discovered of the artist who painted,
probably around 1310/5, the important cycle of frescoes in the
chapterhouse of the Benedictine abbey of Pomposa, at the mouth of
the Po. Critics have noted various influences derived from the
figurative culture of Romagna, Roman mural painting, Bolognese
miniatures of the early Trecento and Giotto's fresco cycle in the
Arena Chapel at Padua. Far from being an imitator, the artist was a
highly individual and accomplished painter who modelled himself
on both the spirit and the formal aspects of classical art. Few panel
paintings can be attributed to the Master of the Pomposa
Chapterhouse, and among them the *Madonna and Child* (New York,
Metropolitan Museum, no.47.143) and the Thyssen *Crucifixion* are
generally given to Florentine painters of the early Trecento. A
different classification was suggested by Zeri (1971), who identified
a companion panel to the Thyssen painting, proposing that they
both belonged to the circle of Giotto's Paduan followers. This idea,
which is now generally accepted, also holds good both for another
recently discovered panel belonging to the same series and, of
course, for the New York *Madonna*.

To judge from these works, their author seems to have been a
painter active in the first decades of the fourteenth century. He may
have trained in Giotto's Paduan workshop in the early years of the
century and continued his activity in the same city, apart from
periods in other North Italian centres. One may presume that he
remained in touch with art in the Emilia-Romagna region also after
his activity at Pomposa around 1310.

H. Beenken, 'The Chapter House Frescoes at Pomposa', *Burlington Magazine*
LXII (1933) pp.253–60

F. Zeri, 'Una "Deposizione" di scuola riminese', *Paragone* IX, no.99 (1958)
pp.46–8

M. Salmi, *L'abbazia di Pomposa*, 2nd edn. (Milan, 1966) pp.149–61

F. Bologna, *I pittori alla corte angioina di Napoli* (Rome, 1969) pp.224, 233
note 265

F. Zeri, 'Una Crocifissione giottesco-padovana', in *Diari di lavoro–I*,
(Bergamo, 1971) pp.33–5

D. Benati, 'Maestro del Capitolo di Pomposa', in *Duecento e Trecento* (1986)
p.598

Master of 1355

This anonymous personality, active within the second and third
quarters of the fourteenth century in western Emilia and probably
also in lower Lombardy, can be reconstructed thanks to a group of
works centred around a polyptych dated 1355; these are now
dispersed between various collections (see cat. [25]). The Master's
artistic background and formation (which probably took place
around 1330/40) find a parallel in some respects in Jacopino and
Bartolomeo da Reggio, known from a signed portable altarpiece
(Milan, Brera, no.416), and in the Master of the Coronation of San
Lorenzo, named after the painting at Piacenza (Ghidiglia
Quintavalle (1970) p.30f.) His style combines echoes of the harsh
expressiveness of early Trecento Bolognese painting with the
influence of Tommaso da Modena's more subtle naturalistic
approach; the two artists were probably not only acquainted but
may even have worked together. Our anonymous Master's hand
can also be recognised in a fragmentary *Crucifixion* in the church of
San Francesco at Piacenza and in a detached fresco of *St George
freeing the Princess*, formerly in the Oratorio di San Giorgio at
Fidenza and today in the church of San Donnino in the same town.
It reveals the artist's increasing interest in descriptive naturalism
and a typically Lombard predilection for incisive linearity and
formal precision.

A. Ghidiglia Quintavalle, *La pittura gotica padana negli affreschi di S. Lorenzo a
Piacenza* (Parma, 1970) p.39f.

Eadem, Arte in Emilia, 4. Capolavori ritrovati e artisti inediti dal '300 al '700
(Parma, 1971) p.20

D. Benati, 'Bartolomeo e Jacopino da Reggio', in *Duecento e Trecento* (1986)
p.556f.

F. Zeri, 'Un'errata attribuzione al Semitecolo (e una rara iconographia di
Sant'Antonio da Padova)', in *Scritti in onore di Giuliano Briganti* (Milan,
1990) pp.37–42

Niccolò di Tommaso

Niccholaus or Niccholaio Tommasi was enrolled in the Arte dei
Medici, Speziali e Merciai of Florence in, or soon after, 1346. The
artist seems to have begun his training in the circle of Maso di

Banco prior to joining the workshop of Nardo di Cione. Apart from witnessing the latter's will in 1366, Niccolò's association with Nardo and his brother Jacopó is confirmed by a document recording that in 1370 he supplied the drawing for a polyptych commissioned for San Pier Maggiore in Florence, which was afterwards executed by Jacopo di Cione.

In 1370 Niccolò is documented in Pistoia (where he had apparently already been active), engaged to work for the church of San Giovanni Fuorcivitas. A year later he was in Naples, where he signed and dated the polyptych in the church of Sant'Antonio (Naples, Capodimonte) and painted other works in and near the city (frescoes in the castle of Casaluce and in the Charterhouse at Capri). On his return to Tuscany, he executed a large cycle of frescoes in the Tau church at Pistoia, completed in 1372. He is last recorded in Florence in 1376.

Niccolò's earliest known works are a *Madonna and Child with saints and angels*, dated 1359 (sold Sotheby's, Montecarlo, 20 June 1987, lot 301) and the fresco representing *St Zeno and St James the Great with two angels and the arms of Pistoia*, dated 1360, in the Palazzo Comunale, Pistoia. After initially producing a gracefully bland and candid transcription of Nardo di Cione's style, Niccolò di Tommaso gave his paintings a more volumetric and monumental quality under the influence of Giovanni da Milano and of Andrea Bonaiuti's frescoes in the Spanish Chapel in Santa Maria Novella (1366/8). Examples are the triptych in Turin (Galleria Sabauda), panels representing the *Madonna and Child* (Acton collection and the Oblate convent at Careggi, Florence) and the polyptych divided between the Musée Fesch, Ajaccio, and the Museo Horne, Florence. But it is above all in his late masterpiece, the series of frescoes in the church of Sant'Antonio del Tau at Pistoia, that he displayed to the full his gift for fresh and lively narrative, rendered in a free and broad technique.

R. Offner, 'Niccolò di Tommaso', *Art in America* XIII (1924) pp.21–37
Idem, 'A Ray of Light on Giovanni del Biondo and Niccolò di Tommaso', *Mitteilungen des Kunsthistorischen Instituts in Florenz* VII (1956) pp.181–92
F. Bologna, *I pittori alla corte angioina di Napoli, 1266–1414* (Rome, 1969) pp.326–30
L. Gai, 'Nuove proposte e nuovi documenti sulla Cappella del Tau a Pistoia', *Bollettino Storico Pistoiese*, ser.III, v (1970) pp.75–94
Boskovits, *Pittura fiorentina* (1975) pp.35–6, 202–4
A. Tartuferi, 'Appunti tardogotici fiorentini: Niccolò di Tommaso, il Maestro di Barberino e Lorenzo di Bicci', *Paragone* XXXVI, no.425 (1985) pp.3–16

Paolo Uccello

Paolo di Dono di Paolo, one of the most restless and versatile protagonists of the early Renaissance, was born in Florence in 1397. 'Uccello' was probably a nickname, known to all, which the artist usually added to his Christian name. Paolo received his training in Lorenzo Ghiberti's workshop, where he is first recorded in 1407. By 1415, when he was admitted to the guild of the Medici and Speziali, he was already an independent artist. The reconstruction of his early activity is still controversial, but the frescoes of the *Creation* and the *Fall of Adam* (Florence, Santa Maria Novella, Chiostro Verde), if they really belong to him, probably date from the early 1420s.

In 1425 the young artist made his will and left for Venice, where he worked for a number of years as a mosaicist. By 1430 he was back in Florence and probably received about that time the commission for an important fresco cycle in the Assumption Chapel in Prato Cathedral, which was eventually completed by Andrea di Giusto. Although often attributed to a fictitious 'Prato Master', this cycle represents perhaps the climax of Paolo's early style, in which stimuli of Donatello's realism merge with a formal elegance and a chromatic range inspired by Fra Angelico's works.

In the early 1430s Paolo frescoed a *Nativity* in the church of San Martino in Bologna and in 1436 he was commissioned to paint the commemorative fresco of *John Hawkwood* in Florence Cathedral.

The strong three-dimensional quality of this image and its austere monumentality also characterize other works dating from the following years, the three scenes of the *Rout of San Romano* (Florence, Uffizi; Paris, Louvre; and London, National Gallery) and the *Stories of Noah* in the Chiostro Verde.

In 1443 he painted the clock-face on the inside of the façade wall of Florence Cathedral and supplied cartoons for some of the stained-glass windows. Towards 1445 he moved to Padua where he painted frescoes, now lost, in Casa Vitaliani. Back in Florence, he frescoed the cloister of San Miniato al Monte with *Scenes of monastic life* (the 'Thebaid') and executed a number of panel paintings, including the altarpiece for the Oratorio dell'Annunziata at Avane, near Florence (1452), two versions of *St George fighting the dragon* (London, National Gallery, and Paris, Musée Jacquemart-André), and a *Hunt* (Oxford, Ashmolean Museum). The predella representing the *Story of the profanation of the Host*, painted for the Corpus Domini Confraternity of Urbino (Urbino, Galleria Nazionale), probably dates from his documented stay in that city between 1467 and 1468. His tax return of 1468 states that he was no longer able to work and he died in Florence in 1475.

G. Pudelko, 'The Early Works of Paolo Uccello' *Art Bulletin* XVI (1934) pp.231–59
M. Salmi, *Paolo Uccello, Andrea del Castagno, Dominico Veneziano*, 1st edn. (Rome, 1936); 2nd edn. (Milan, 1938)
W. Boeck, *Paolo Uccello* (Berlin, 1939)
J. Pope-Hennessy, *Paolo Uccello*, 1st edn. (London, 1950); 2nd edn. (London, 1969)
L. Berti, *Paolo Uccello* (I Maestri del Colore, no.29) (Milan, 1964)
E. Flaiano and L. Tongiorgi Tomasi, *L'opera completa di Paolo Uccello* (Milan, 1971)
A. Parronchi, *Paolo Uccello* (Bologna, 1974)
C. Volpe, 'Paolo Uccello a Bologna', *Paragone* XXXI, no.365 (1980) pp.3–28

Pietro da Rimini

The name 'Petrus de Armino', although unrecorded in any known document, appears on a painted *Crucifix* formerly belonging to the Chiesa dei Morti at Urbania, near Urbino, and now preserved in the local parish church. The same name is alleged to have been inscribed on a fresco of *St Francis* in the church of San Nicola at Iesi, with the date 1333. However, this fresco, which has been detached and removed to the Franciscan convent of Montottone (near Fermo), appears to differ stylistically from the Urbania *Crucifix*. On the other hand, there are strong similarities between the *Crucifix* and the frescoes by a Riminese painter formerly in the cloister of the convent of the Eremitani at Padua (today in the Museo Civico). Although the Padua cycle is undocumented, it is known that the polyptych on the high altar of the Eremitani church was signed by Giuliano and Petruccio da Rimini in 1324. It is likely, therefore, that the author of the frescoes (and the co-author of the lost altarpiece) was the same artist who painted the signed *Crucifix*.

Around this small nucleus scholars have reconstructed an œuvre that is still expanding. Pietro has emerged as an artist of major importance, although his personality remains to be fully defined. He was probably responsible for the cycle of frescoes in the refectory of the abbey of Pomposa, and since these are datable to c1318 they would be his earliest known work. The attribution to Pietro of the frescoes in the 'Cappellone' of the church of San Nicola at Tolentino (shortly before 1325), although probable, is also controversial, while there is greater agreement over his participation in the frescoes of the apse of San Pietro in Sylvis near Bagnacavallo. The works usually accepted as autograph also include the frescoes in Santa Chiara and in San Francesco at Rimini, besides a series of small devotional panels scattered among various museums and collections. But there is disagreement over the authorship of the frescoes, largely destroyed in the Second World War, in the church of Santa Maria in Porto Fuori near Ravenna, which were probably executed between 1329 and 1334.

Pietro had a primary rôle in the development of painting along

the Adriatic coast, from the Veneto down to the Marches, during
the first half of the fourteenth century. Alongside the refined
classicism of Giovanni da Rimini and the somewhat prosaic
narrative style of Giovanni Baronzio, Pietro introduced a poetical
trend full of dramatic feeling and emotional intensity that had no
equal in the artistic achievements of the Adriatic area in the third
and fourth decades of the century.

M. Salmi, 'Nota su Pietro da Rimini', *Dedalo* XIII (1933) p.149f.
C. Brandi in *La pittura riminese del Trecento*, exhibition catalogue (Rimini,
 1935) pp.202–3
Toesca, *Trecento*, pp.724–5
A. Martini, 'Appunti per Ravenna riminese', *Arte Antica e Moderna* VII
 (1959) pp.310–24
C. Volpe, *'La pittura riminese del Trecento* (Milan, 1965) pp.23–9
D. Benati in *Duecento e Trecento* (1986) pp.650–1
M. Boskovits, 'La nascita di un ciclo di affreschi del Trecento: la decorazione
 del Cappellone di San Nicola a Tolentino', *Arte Cristiana* LXXVII (1989)
 pp.3–26

Ugolino di Nerio

Ugolino, the son of Nerio and the brother of Guido and Muccio, all
painters, is documented in Siena from 1317 to 1327 and was
probably born towards the end of the thirteenth century. His date of
death is given by Vasari in the first edition of his *Vite* as 1339, and
in the second edition as 1349. According to Vasari, Ugolino was
also active in Florence, where he painted a *Madonna and Child* on
panel for the loggia of Orsanmichele; the polyptych over the high
altar of Santa Maria Novella; the altarpiece for the Bardi Chapel in
Santa Croce, representing *Christ on the Cross between Mary
Magdalen, St John and two Franciscan donors* (all of which are lost);
and the polyptych for the high altar of Santa Croce, now dispersed
between various collections. The surviving parts (London, National
Gallery; Berlin, Gemäldegalerie; New York, Metropolitan Museum;
Philadelphia, Johnson Collection; Los Angeles, County Museum)
reveal close links with the Duccesque tradition, enlivened,
however, by the emphatic rhythms of his contours and an amused
and very attentive observation of detail, in keeping with the stylistic
innovations of Simone Martini.

Using the Santa Croce altarpiece, which must belong to the mid-
1320s, as a point of reference, critics have made various attempts
to order Ugolino's recognised works chronologically. For instance,
the *Crucifixion* (Siena, Pinacoteca, no.34), still Duccesque in
composition but already touched by Pietro Lorenzetti's dramatic
style, would seem to belong to his earliest phase, around the mid-
1310s. Slightly later, around 1320, seems a likely date for some of
his polyptychs (Cleveland, Museum of Art, and Siena, Pinacoteca,
no.39), which present parallels to Simone Martini's altarpieces of
that period; and the polyptych in Williamstown MA (Clark
Institute), with its more complex layout and more elegant poses,
followed them. In the next decade, towards the end of Ugolino's
career, come an altarpiece of the *Madonna and Child enthroned with
saints* (San Casciano Val di Pesa, church of the Misericordia) and
the triptych of San Giovanni d'Asso (Gallerie Fiorentine, Contini-
Bonacossi bequest), both of which differ from his earlier production
in their emphasis on plasticity and in the deeper emotional
participation of the figures.

Vasari, ed. Milanesi, I, p.454f.
C. H. Weigelt, *Die sienesische Malerei des vierzehnten Jahrhunderts* (Florence
 and Munich, 1930) pp.19f., 77f.
P. Bacci, *Dipinti inediti e sconosciuti di Pietro Lorenzetti, Bernardo Daddi ecc. in
 Siena e nel contado* (Siena, 1939) pp.123–51
F. M. Perkins, 'Ugolino da Siena' in Thieme and Becker, *Lexikon*, XXXIII
 (1939) pp.542–4
G. Coor Achenbach, 'Contributions to the Study of Ugolino di Nerio's Art',
 Art Bulletin XXXVII (1955) pp.153–65
H. Loyrette, 'Une source pour la reconstruction du polyptique d'Ugolino da
 Siena à Santa Croce, *Paragone* XXIX, no.343 (1978) pp.15–23
J. Stubblebine, *Duccio and his Followers* (Princeton, 1979) pp.157–75
C. Volpe in *Gotico a Siena* (1982), p.141

Vitale da Bologna

Vitalis or Vitalinus Aymi de Equis was probably born in Bologna
around or soon after 1300. He must already have been an artist of
renown by 1330, since he was paid in March of that year for the
fresco decoration of the Odofredi Chapel in San Francesco, one of
the principal churches of his city. These frescoes, as also those he
painted in the Chapel of San Lorenzo in 1340, no longer exist.
Fortunately still extant is the large fresco of the *Last Supper*, which,
like the fragmentary *Resurrection* (both Bologna, Pinacoteca), is
probably related to the works commissioned from the artist
between 1330 and 1340 by the Franciscans of Bologna.

Vitale's earliest works reveal the influence of the so-called
'pseudo-Jacopino' and of early Trecento Riminese masters. His
grandiose compositions and certain bold foreshortenings also
reflect the art of two Florentine painters active in Bologna in the
early 1330s, Giotto and Bonamico Buffalmacco. In 1343 Vitale
was commissioned to execute four wooden statues for Ferrara
Cathedral and two years later he signed and dated the polyptych of
the *Madonna 'dei denti'*, for the eponymous oratory in the suburban
church of Sant'Apollonia at Mezzaratta (now divided between the
Museo Davia Bargellini, the Collezioni Comunali di Bologna and
private collections). By this time, the artist must already have
completed his share of the decoration inside the church of
Mezzaratta (detached frescoes in Bologna, Pinacoteca). Universally
considered his masterpiece, the impassioned spirit, frenzied
rhythms and range of expressions contained in this work anticipate
the late-Gothic style of the last decades of the fourteenth century, to
which period it has sometimes been dated. In 1348 Vitale moved to
Udine, where he frescoed two chapels in the Cathedral. His frescoes
in the Servite church in Bologna are dated by some critics before his
journey to Udine, by others, more convincingly, after his return in
1349. In 1351 he dated the frescoes in the apse of the abbey
church of Pomposa and in 1353, according to the commissioning
contract, he should have completed the polptych of the church of
San Salvatore (Bologna, Pinacoteca). In this final phase of his
career, which also includes a *St Ambrose* (Pesaro, Museo Civico)
and a *Madonna of Humility* (Milan, Museo Poldi-Pezzoli), Vitale
simplified his compositions. His narratives became more laconic
and his forms, embellished with sumptuous ornament and refined
colouring, acquired a more delicate and luminous modelling, but
without any loss in expression or dramatic tension. He is recorded
as still living in 1359 and in 1361 he was dead.

C. Malvasia, *Felsina Pittrice*, I (Bologna, 1678)
F. Filippini, 'Vitale da Bologna', *Bollettino d'Arte* VI (1912) pp.13–32
E. Sandberg Vavalà, 'Vitale delle Madonne e Simone dei Crocefissi', *Rivista
 d'Arte* XI (1929) pp.449–80; XII (1930) pp.1–36
C. Brandi, 'Vitale da Bologna', *Critica d'Arte* II (1937) pp.145–52
L. Coletti, *I Primitivi. I Padani* (Novara, 1947) pp.xxiii–xxvi
R. Longhi, 'La mostra del Trecento bolognese', *Paragone* V (1950) pp.5–23
C. Gnudi, *Vitale da Bologna* (Milan, 1962)
F. Arcangeli in *Natura ed espressione nell'arte bolognese-emiliana*, exhibition
 catalogue (Bologna, 1970)
C. Volpe, 'La pittura emiliana del Trecento', in *Tommaso da Modena e il suo
 tempo* (Treviso, 1980) pp.237–48
D. Benati, 'Pittura del Trecento in Emilia Romagna,' in *Duecento e Trecento*
 (1986) pp. 218–9, 221, 670
R. D'Amico and M. Medica, *Per la Pinacoteca Nazionale di Bologna. Vitale da
 Bologna* (Bologna, 1986)

Index

Public collections and churches are indexed in the first instance under location; private collections in the first instance by name. Paintings are listed by artist; only those in the Thyssen Collection are also listed by subject in the first instance

Page numbers in bold refer to illustrations